PHOTOGRAPHS BY PAULA COURT

PERFORMA 11
STAGING IDEAS

ROSELEE GOLDBERG

AFTERWORD BY CLAIRE BISHOP EDITED BY JENNIFER PIEJKO

Performa 11: Staging Ideas is published as a record of the fourth Performa biennial, Performa 11 (November 1–21, 2011).

Author
RoseLee Goldberg

Editor
Jennifer Piejko

Consulting Editor
Lana Wilson

Head of Performa Research and Archives/Photo Editor
Marc Arthur

Designer
Stacy Wakefield

Photographer
Paula Court

Indexing
Onni Nickle

Title Page
Elmgreen & Dragset, *Happy Days in the Art World*, a Performa Commission, 2011. Photo by Paula Court.

Printing
RR Donnelley

Published by Performa Publications

Performa, a nonprofit multidisciplinary arts organization established by RoseLee Goldberg in 2004, is dedicated to exploring the critical role of live performance in the history of twentieth-century art and to encouraging new directions in performance for the twenty-first century. In 2005, Performa launched New York's first performance biennial, Performa 05, followed by Performa 07 (2007), Performa 09 (2009), and Performa 11 (2011).

This publication is supported by Laura Brugger and Ross Sappenfield, the Consulate General of Denmark, Derek Eller Gallery, Gladstone Gallery, Lisson Gallery, Luhring Augustine Gallery, Marlborough Gallery, Royal Norwegian Consulate of New York, and Zabludowicz Collection.

Printed in China.

ISBN 978-0-615-70258-2

Performa
100 West 23rd Street, 5th Floor
New York NY 10011
T + 1 212 366 5700
F + 1 212 366 5743
www.performa-arts.org

Distributed by:
D.A.P./Distributed Art Publishers
155 6th Avenue, 2nd Floor
New York NY 10013
1-800-338-BOOK
www.artbook.com

CONTENTS

Where Mediums Collide by RoseLee Goldberg 13

PRELUDE
The Red Party 20

CHAPTER ONE

STAGING IDEAS: PERFORMA COMMISSIONS

Opening Night: Elmgreen & Dragset 28

Elmgreen & Dragset, *Happy Days in the Art World* 29

Interview: Ingar Dragset 34

Interview: Michael Elmgreen 36

Liz Magic Laser, *I Feel Your Pain* 44

Liz Magic Laser: "Muse: The Interview" 51

Ragnar Kjartansson, *Bliss* 54

Ragnar Kjartansson: An Operatic Reality 58

Ragnar Kjartansson: Bliss 63

Shirin Neshat, *OverRuled* 66

Interview: Shirin Neshat 70

Mika Rottenberg and Jon Kessler, *SEVEN* 78

Interview: Mika Rottenberg and Jon Kessler 82

Simon Fujiwara, *The Boy Who Cried Wolf* 92

iona rozeal brown, *battle of yestermore* 98

Tarek Atoui, *Visiting Tarab* 108

Gerard Byrne, *In Repertory* 114

Frances Stark, *Put a Song in Your Thing* 118

Interview: Frances Stark 122

Laurel Nakadate and James Franco, *Three Performances in Search of Tennessee* 130

Guy Maddin: *Tales from the Gimli Hospital: Reframed* 136

Interview: Guy Maddin 143

Ming Wong, *Persona Performa* 146

CHAPTER TWO

TRANSLATION, MOVEMENT

Boris Charmatz: *Musée de la Danse: Expo Zéro* 154

Interview: Boris Charmatz 162

Eleanor Bauer, *(BIG GIRLS DO BIG THINGS)* 168
Trajal Harrell, *Antigone jr.* 174
Jonathan Burrows and Matteo Fargion, *Cheap Lecture/The Cow Piece* 178
Mai-Thu Perret, *Love Letters in Ancient Brick* 180
Shelly Nadashi, *Refrigerating Apparatus* 184
robbinschilds, *Instruction Construction* 186
Jack Ferver with Michelle Mola, *Me, Michelle* 187

CHAPTER THREE

SPEAKING WITH SOUNDS

Robert Ashley, *That Morning Thing* 190
Robert Ashley and His Legacy 196
Interview: Robert Ashley 200
Varispeed, *Perfect Lives Manhattan* 204
Ed Atkins, Haroon Mirza, and James Richards, *An Echo Button* 206
Otomo Yoshihide and Christian Marclay, *Turntable Duo: Otomo + Marclay* 210
L'Encyclopédie de la parole, *Chorale* 212
Nicoline van Harskamp, *Any Other Business* 214
Andrea Geyer, Sharon Hayes, Ashley Hunt, Katya Sander, and David Thorne,
Combatant Status Review Tribunals, pp. 002954–003064: A Public Reading 216
Mateo Tannatt, *Pity City Ballet* 220
Stewart Home, *Psychedelic Noir* 222
Lili Reynaud-Dewar with Mary Knox and Hendrik Hegray, *Interpretation* 223
Performa Radio 224
Pablo Helguera, *The Well-Tempered Exposition, Book One, Part II* 226
Nils Bech with Bendik Giske and Sergei Tcherepnin, *Look Inside* 227
Justin Vivian Bond, *Full Moon Tranifestation Circle* 228
Matthew Stone, *Anatomy of Immaterial Worlds* 229
Dennis McNulty, *The Eyes of Ayn Rand* 230

CHAPTER FOUR

SMALL UTOPIAS

There is No Such Place: Constructivist Utopia Now 234
Tyler Ashley, *Half-Mythical, Half-Legendary Americanism* 240
Liz Glynn, *Utopia or Oblivion Parts I and II* 242
Raphaël Zarka, *Free Ride* 246
Athi-Patra Ruga, *Ilulwane* 248
Interview: Athi-Patra Ruga 250

Tamar Ettun, *One Thing Leads to Another* 256
Christine Sun Kim with Lukas Geronimas, *Feedback: Nonstop (1 of 6)* 257
Aslı Çavuşoğlu, *Words Dash Against the Façade* 258
Laurent Montaron, *The Invisible Message* 260
Public Movement, *Positions* 261

CHAPTER FIVE
CONSTRUCTIVIST SOURCING

33 Fragments of Russian Performance 264
Out of Town: Andrei Monastyrski & Collective Actions 273
Andrey Kuzkin, *Natural Phenomenon* 276
Reflections on Vsevolod Meyerhold's *The Magnanimous Cuckold* 278

CHAPTER SIX
UNTITLED

Rashaad Newsome, *Tournament* 282
Will Cotton, *Cockaigne* 284
Wu Tsang, *Full Body Quotation* 286
Daidō Moriyama, *Printing Show–TKY* 287
Spartacus Chetwynd, *The Lion Tamer* 288
Ursula Mayer, *Gonda* 290
Maria Petschnig, *See-saw, seen-sawn* 292
Jonathan VanDyke, *With One Hand Between Us* 293
MPA and Amapola Prada Revolution, *Two marks in rotation.* 294
Elena Bajo, *A Script for a Form* 295
Eric Steen, *Brew Day/Brew Pub* 296
Ben Kinmont, *An Exhibition in Your Mouth* 298
Interview: Ben Kinmont 300
ACTION ACTUAL: The (S) Files 2011 304
Alison O'Daniel, *Night Sky* 305

CHAPTER SEVEN
STAND UP

Performa Ha! 308
Interview: Michael Smith and Jayson Musson 310
Not Funny 316
Nathaniel Mellors, *Ourhouse* 322

Jonathan Meese, *WAR SAINT JUST (FIRST FLASH)* 323

CHAPTER EIGHT
FLUXUS

Fluxus Weekend 326
The Ginger Island Project 328
Guido van der Werve, *Effugio No. 2 Running to Rachmaninov* 330
Zefrey Throwell, *I'll Raise You One…* 331
Alison Knowles with Jessica Higgins, Joshua Selman, and Clara Selman,
Beans All Day 332
Jonas Mekas, *Fluxus Cabaret* 334
Rainer Ganahl, *Credit Crunch Meal* 335
Philip von Zweck, *A Project by Philip von Zweck* 336
Nam June Paik, *Global Groove* 338
Bibbe Hansen on Al Hansen 339
Fluxus Shop 340
Fluxus & Otherwise: A concert in triangle 342

CHAPTER NINE
PERFORMA INSTITUTE

Performa Institute 346
Broken English 352
Dennis Oppenheim: *PROPOSED CURRICULUM ON
CONTEMPORARY ART AND PERFORMANCE* 354

CHAPTER TEN
MALCOLM AWARD

The Malcolm McLaren Award 362
Malcolm McLaren: Tributes by Greil Marcus and Michael Bracewell 365

POSTSCRIPT

Performania by Claire Bishop 371
About Performa 373
Performa 11 Credits 374
Book Contributors 380
Index 381
Acknowledgements 384

Where Mediums Collide

BY ROSELEE GOLDBERG

For Performa 11, we picked up where we left off with the previous biennial, jumping in at the point in art history, Russian Constructivism of the 1920s, where performance by visual artists was an underlying force of the avant-garde, in art and politics as much as in theater, dance, and street parades. It was a time when artists, theater directors, filmmakers, choreographers, and musicians brought their ideas, histories, and specialties to the same table as it were, triggering an extraordinarily fertile decade of art and theater that would shape the culture of the twentieth century. We wished to reveal that history but also to see how contemporary artists bring about a similar collision of mediums today.

Performa's focus on the history of art makes it unlike any other biennial. Most take as their starting point the two-year interval between biennials, using the time span to assess current shifts in art making and to take the cultural temperature of the times. The Performa biennial looks at art historical precedent because it must: there is a story to be told, a neglected history to resurrect. Even as we commission new work and encourage, through our curatorial programming, material that encompasses ideas about the fast-moving here and now, we are committed to showing multiple threads of performance history from the past. Systematically proceeding through that history, we bring it into the contemporary spotlight.

Thus, each Performa biennial is an extension of the last, an

accumulation of scholarship and expertise built on the one be-fore. Performa has an ongoing team of curators, art historians, researchers, and producers that accrues extensive knowledge about performance, its history, its contemporary forms around the world, and about producing performance by visual artists, with each iteration. Even as we prepare for the current bienni-al, long-term research is in motion for a future one. Performa is always in process: an ongoing investigation into the ways in which live performance by visual artists has shaped the history of twentieth-century art and indicating how it is moving ever closer to the center of artistic practice in the twenty-first.

A historical anchor is the investigative starting point for each biennial; it establishes a broad set of markers with which to illuminate and understand the present day. For Performa 09, it was Italian Futurism, with its radical manifestos to take art out of the studio, the academy, and the museum, into the streets and variety and movie theaters, to insist on a visionary aesthet-ic across all disciplines, and to spread its beliefs of "the new" and "the future" like a virus, through popular newspapers, radio, public demonstrations, and nightly events. For Performa 11, Russian Constructivism, and the utopian impetus that it represents almost one hundred years later, was a touchstone for considering how performance was used by artists then, in 1920s Russia, to communicate shifts in political and economic tides to a broad public, and how earlier styles of visual story-telling, such as the Living Newspaper, might be interpreted in relation to contemporary performance and current affairs. An exhibition, "33 Fragments of Russian Performance," the first ever to showcase a century of live art in Russia, was presented in a specially designed installation in the upper-level class-rooms of the Performa Hub.

Moving between disciplines, shifting gears from one set of vocabularies, attitudes, and histories to another, Performa 11 established a series of connecting lines that splayed out like a

many-ribbed fan from the starting point of the art world. More than one hundred and thirty artists, as well as choreographers, composers, and filmmakers, each with their own sensibilities and references, showed their very different ways of thinking in a range of media, taking elements from one discipline or another as needed to articulate their ideas. If they stepped onto a stage, which they did frequently in this edition of the biennial, it was not because they did so to engage with the history of theater, its traditions of scripts and role playing, or its basic assumption that spoken language is the underlying measure of all things dramatic. Rather, they used the stage as a platform for the display of images and concepts which they inhabited as though they were moving parts of a three-dimensional storyboard.

If they used film, it was as a means to extend beyond the screen, placing musicians along its base not so much to provide sound for silent pictures, as Foley artists would, but to add layers of tangential impressions made with an assortment of found musical instruments, noisemakers, and a quartet of singers as the images on-screen rolled over from one scene to another. If dance, it was of the body as a container of dance history, its own portable museum of muscle memories deposited over centuries. In each instance, close examination of a particular discipline was made possible through the license for limitless exploration that the art context provides, a permissive arena in which artists vie to articulate a highly nuanced reflection of the present.

The differences between theater and visual art performance, between dance in the art world and dance in the trajectory of classical dance history, between spoken language and song, came to the surface with each production. Reflecting on creativity and how ideas emerge in the slow motion of waiting (Elmgreen & Dragset), or staging a life as a series of pictorial vignettes that line up like developmental markers in a psychol-

ogy handbook (Simon Fujiwara), or drawing a life-size picture book of an extended internet sex chat, the to-and-fro rhythms of its messaging—"he said, she said"—presented on a proscenium stage (Frances Stark) provided rich material for delineating how live performance by visual artists differs from theater created by playwrights. For theater (even experimental theater) is the sum of many parts (playwright, director, dramaturge, stage designer, costume designer, lighting designer), while performance in visual art is the result of a singular vision, with the artist commandeering all parts of the whole. Theater begins with text and uses it as a compass to take audiences from start to finish where some sort of resolution inevitably lies. Viewers of art want no such guidance; they prefer to make their own way from visual clue to visual clue, parsing out the fragments of the metaphoric puzzle before them.

For the visual artist, live performance provides a broad canvas on which to layer images and concepts, to add complexity and strangeness to their heightened visual insights. Staging their ideas in theaters, where audiences sit in comfortable seats viewing work frontally at a measured distance, extends the time allocated to looking. It makes viewers pay attention with a concentration quite different from that given to artwork in a gallery. Each work stands alone in its venue, both frame and container, carefully chosen with the specifics of content, scale, and mood indicated by the work. Each also stands alone in its separate location, in one part of town or another, not in a series of connected rooms as in a museum, where complementarity of aesthetic or intellectual argument from one place to the next matters. Rather, the journey from one to the other venue, from one to the other kind of performance, provides time for large pictures and unlimited references to be distilled and absorbed. Subject matter covers a broad range of topics; like the pages of an international newspaper, with its special sections on metropolitan life or international affairs, and its

cinema, science, literature, and sports pages, Performa reaches across vast ranges of the cultural landscape: an ancient Arab music collection from Lebanon; a Swiss choreographer's fascination with an American cartoon cat; a South African coming-of-age ritual symbolically staged in a swimming pool.

Finally, all roads lead to the Hub, both centerpiece and junction for the crossroads of multiple conversations that Performa harnesses, and Performa Institute, launched with this biennial, as a school for thought, elucidation, and commentary by artists and everyone else. Like the city, which draws intelligence, spirit, and deeply held opinions and aspirations from hundreds of different communities, Performa Institute is a central pulse for the endlessly inventive urban project that is New York.

Prelude

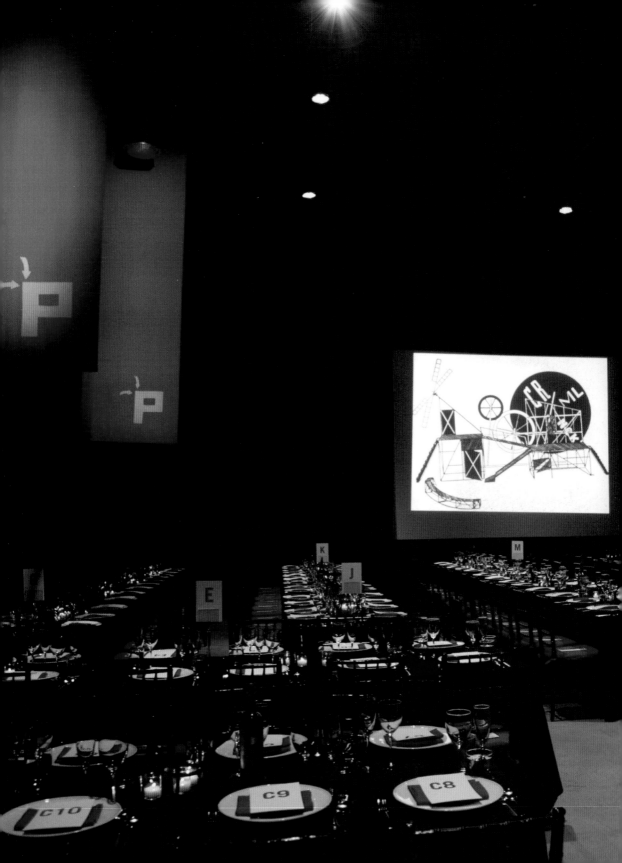

THE RED PARTY

With each new biennial, I try to imagine the most direct, the most immediate way to involve people in the selected historical anchor of the biennial. How might we envelop people, in a single night, in a magical four or five hours, in the exuberant visions of artists from an earlier historical moment? Russian Constructivism of the 1920s provided an extraordinary menu of ideas, both intellectual and artistic, on which to build a three-dimensional night to remember that touched every aspect of that vast utopian project.

Looking to the art and productions of the most breathtakingly original artists of the period in all media—Kazimir Malevich, Alexander Rodchenko, Lyubov Popova, El Lissitzky, Vladimir Mayakovsky, Vladimir Tatlin, Varvara Stepanova, Vsevolod Meyerhold, Dziga Vertov, and Sergei Eisenstein, amongst many others—who took the revolutionary political framework as a launchpad for building an entirely new culture, our team got to work. Tatlin's famous tower was alluded to in a floor-to-ceiling scaffold, serving as both watchtower and elevated podium for our agile master of ceremonies, the actor Alan Cumming; while the centerpiece of the party, inspired by *The Magnanimous Cuckold,* the mechanized theater "machine" designed by Popova, was perfect for staging performances by innovative artists of our own times: Rob-

The Red Party, *2010.*
Photo by Paula Court.

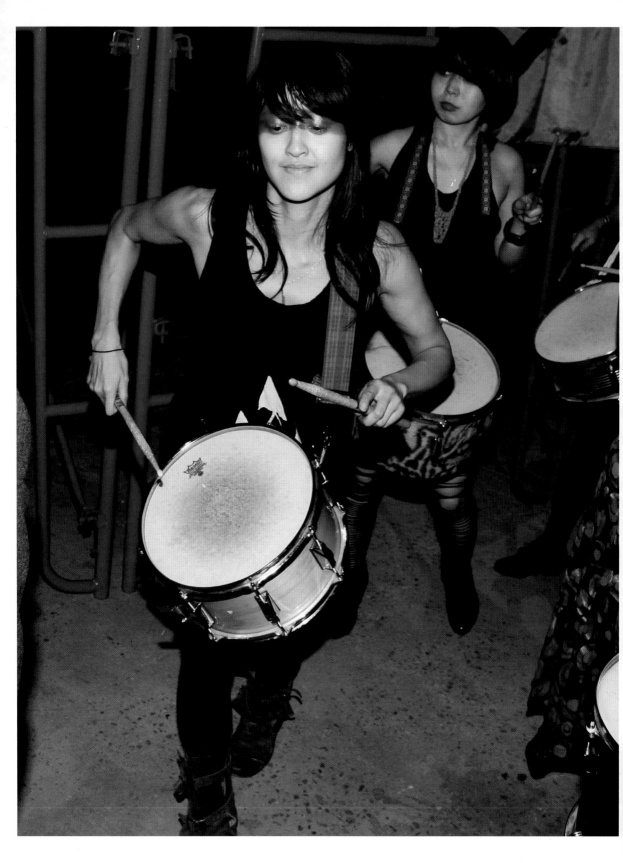

Above: Performa staff at The Red Party, *2010. Photo by Paula Court. Below: Lecocq's* Girofle-Girofla, *first staged by Aleksandr Tairov in his Kamerny Teatr (Chamber Theater) in 1922.*

At left: Chica Vas performs at The Red Party. *Photo by Paula Court.*

ert Longo, Barbara Sukowa, Jon Kessler, Yvonne Rainer, Nick Hallett, and Zach Layton. Graphic highlights in the form of a series of banners hung from the high vaulted ceiling of the vast industrial space, recalling the masters of text-and-image combines, Rodchenko, Lissitzky, and the Stenberg brothers. Some guests brought the graphic theme to ground level, wearing especially made hats designed by Erik Bergrin based on Georgy Yakulov's orbit-shaped headpieces for *Giroflé-Girofla*, Charles Lecocq's nonsensical opera, directed by Alexander Tairov in full Constructivist mode in 1922.

THE RED PARTY

MASTER OF CEREMONIES ALAN CUMMING

PROGRAM

7:00
Cocktails and Hors D'oeuvres
A performance by Barbara Sukowa with Robert Longo, Jon Kessler and Mike Skinner
Excerpts from Yvonne Rainer's *Assisted Living: Good Sports 2*
Performed by Pat Catterson, Patricia Hoffbauer, Yvonne Rainer, Keith Sabado, and Sally Silvers
DJ Tikka Masla

8:00
SEATED DINNER
A toast to Shirin Neshat
Live Auction of Producer Credits for Performa 11 Commissions

9:00
Padded Cell by Jennifer Rubell
Passed Dessert
A performance by Sexual Engeries School: Leningrad with Zach Layton, Nick Hallett, Brian Chase and Mike Skinner
DJ Pierce Jackson

ALL NIGHT
Installations by artists Zach Rockhill and Kyle Goen
Quickie red couture for all by KRELwear
Silent auction of Performa Editions and Ephemera

SILENT AUCTION
UPSTAIRS ON THE MEZZANINE

The following artists have generously donated works to our Performa Editions and Ephemera Silent Auction to support our "Production Fund" for emerging artists. Please bid often and generously for these one-of-a-kind artworks and editions, most of which are the result of a past Performa project.

BRODY CONDON / SANFORD BIGGERS / GELITIN
JAPANTHER / ISSAC JULIEN / JESPER JUST
KELLY NIPPER / DARIA MARTIN / MELIK OHANIAN
SERKAN OZKAYA / ADAM PENDLETON / AIDA RUILOVA
LAURIE SIMMONS / CHRISTIAN TOMASZEWSKI /
ROBERT WILSON

ABOUT RUSSIAN CONSTRUCTIVISM
A movement that was active from 1913 to the 1940s, Russian Constructivist artists were committed to making work of a social purpose that was also aesthetically adventurous and compelling. The intellectual and creative achievements of Russian artists of the post-Revolutionary years continue to influence artists in a broad range of disciplines with their freshness, vision, and undimmed relevance.

THE RED PARTY DECOR
Designed by Zach Rockhill, The Red Party's set is inspired by the 1922 production of *The Magnanimous Cuckold*, widely considered not only the first, but also the quintessential Constructivist production. With the script of Fernand Crommelynck's satire, director Vsevolod Meyerhold and set designer Lyubov Popova revolutionized theater. Meyerhold's production rejected theatrical naturalism on all fronts, including stage construction, scenery, props, costumes, and actor movement. The kinetic structures of Popova's set—revolving doors, ramps, chutes, ladders, and wheels—provided the ideal environment for actors to employ the acrobatic bio-mechanic performance technique developed by Meyerhold, and embodied the metaphor of the "stage as laboratory". New York artist Kyle Goen honors the Constructivists' intuition for dynamic graphic design in a series of banners that hang from the ceiling. Aleksandr Rodchenko, El Lissitzky, and the Stenberg Brothers produced some of the most innovative compositions that combine text and image.

HONOREE

SHIRIN NESHAT

Celebrated for her extraordinary feature-length film *Women Without Men*, which received the Silver Lion Award at the 2009 Venice International Film Festival, Iranian-born visual artist Shirin Neshat has gained worldwide acclaim for her riveting work in photography, film, and video installations. Performa is proud to honor Shirin Neshat for her extraordinary artistic achievements, for her remarkable ability to work across disciplines, creating important and exemplary work with each new project, and for her courage in making her first live performance, *Logic of the Birds*, which was commissioned by RoseLee Goldberg in 1999 and would become part of Goldberg's inspiration for launching Performa in 2004.

Less than four weeks after the attack on the Word Trade Center, in October 2001, *Logic of the Birds* was presented in previews at the Kitchen in New York, and made its full premiere in 2002 as part of the Lincoln Center Summer Festival. An evening-length work featuring singer Sussan Deyhim and thirty performers against a backdrop of a large film triptych, *Logic of the Birds* was based on a twelfth-century mystical poem by Sufi master Farid al-Din Attar. This poem's rhymed couplets of 4500 lines provided the outline of an epic narrative for Neshat; 30 birds in search of a leader, discovering at journey's end that all were leaders. As a metaphor for individual and collective responsibility, Neshat's rendering of this masterpiece of Persian culture provided an exquisitely poignant counterpoint to the horrors of downtown Manhattan at that time and the jihad, suicide missions, and fraught history of Middle Eastern and Western politics associated with it.

Neshat is the winner of numerous awards, including the Grand Prix of the Kwangju Biennial in Korea (2000), the Golden Lion Award, and the First International Prize at the 48th Venice Biennial (1999). Her photographs and videos have been included in recent exhibitions at the Kunsthalle Wien, the Serpentine Gallery, the Wexner Center for Arts, the Art Institute of Chicago, SITE Santa Fe, the Tate Gallery, the Musee d'Art Contemporain de Montreal, and Franklin Furnace in New York. Her work has also been featured in numerous international exhibitions, including the Whitney Biennial, the Biennial of Sydney, and the Lyon Biennial.

M3NU

HOUSE INFUSED VODKAS
BEET + HORSERADISH > POMEGRANATE + GINGER > CRANBERRY + CORIANDER

TARTARES
GRAND STEAK TARTARE + SOURDOUGH CROUSTADES > PRIME SIRLOIN TARTARE + YUKON GOLD CHIPS > YELLOWFIN TUNA TARTARE + CARAMELIZED COCONUT RICE > RUBY BEET TARTARE + SPICED BLACK RADISH TILES

SEATED DINNER
GRAND BORSCHT vegan with red cabbage, wild mushrooms, beets, leeks, turnips
SIDES You are encouraged to enjoy this deconstructed borscht by adding each element to your soup as you desire. Each will change the flavor and experience!
CRISPY PARSNIP PANCAKES > GLAZED DELICATA SQUASH > ROASTED CAULIFLOWER > CHARRED BRUSSELS SPROUTS > BALSAMIC LENTILS > SHAVED GREEN APPLE + CARROTS > BRAISED OXTAILS + SHORTRIBS > CRISPY DUCK LEG CONFIT + GARLIC SAUSAGE > APPLEWOOD SMOKED BACON LARDONS > CREME FRAICHE, CHIVES, DILL
WINES OF CHILE: Amayna Sauvignon Blanc 2009 > Ventisquero Queulat Carmenere 2008

DESSERTS
PADDED CELL installation by Jennifer Rubell
RED VELVET CAKES + POMEGRANATE ICING
MAGENTA MACAROONS

THE RED PARTY FASHION
Hats for The Red Party, designed by Erik Bergrin, take Georgy Yakulov's costume design for the 1922 adaptation of *Girofle-Girofla* as a point of departure. Theater impresario Alexander Tairov revamped this 1874 Charles Lecoq comedic operetta by incorporating elements of cabaret and dance hall culture. In the Tairov production, the Chorus Girls' lavish hats and billowing pantaloons exuded a joie de vivre that permeated Russian theater in the 1920s and that Performa now celebrates. In addition, designer Karelle Levy will create "quickie couture" for guests of The Red Party who want to accessorize their attire on the spot.

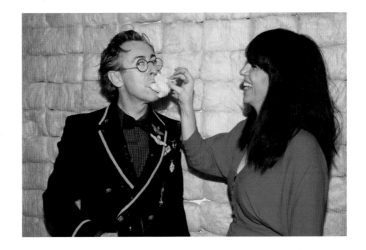

The Red Party *MC Alan Cumming with Jennifer Rubell inside Rubell's* Edible Padded Cell, *2010. Photo by Paula Court.*

At left: The program and menu for The Red Party.

Continuing the color palette, an entire dinner menu of red food was put in the mouths of diners for them to fully digest the critical mass of concepts being served throughout the evening. Pomegranates and borscht, a selection of tartares, and crispy parsnip pancakes, as well as the Russian national drink, vodka, in all shades of red, designed by culinary masters BITE and Producing Director Esa Nickle, preceded Jennifer Rubell's ultimate dessert: a walk-in "padded cell" lined with cotton candy, which had visitors tearing at the walls, recalling Stalin-era madness and the tragedy of Gulag prisons. Such reflections on the past and the present, on the playful and the profound, served as the starting point for a year's worth of research that would be realized in all its complexity in the Performa 11 Biennial.

—RoseLee Goldberg

The Red Party, *Performa's gala celebration, took place on November 6, 2010.*

Chapter One

STAGING IDEAS

ELMGREEN & DRAGSET

Happy Days in the Art World

SKIRBALL CENTER FOR THE PERFORMING ARTS / A PERFORMA 11
COMMISSION / CO-PRESENTED BY SKIRBALL CENTER FOR PERFORMING ARTS

Michael Elmgreen and Ingar Dragset have shared a career since 1995. In their own words, they are "each half an artist" or a "two-headed monster." They're both six-foot-three and, over the years, have even developed a tendency to dress alike. On the occasion of this interview, both artists are wearing shirts with fine checks that match their sneakers. Elmgreen's ensemble is red and black. Dragset's is royal blue and white. A doting mother might color code her twin boys in such a way. When they appear at public events, they consult each other in advance (to confirm divergent clothing) so they don't turn up looking, as they put it, "like Gilbert & George." Elmgreen and Dragset met in a gay bar called After Dark in Copenhagen in 1994, became lovers, and then began collaborating a year later. Elmgreen was a fledgling poet who had staged his words on video, while Dragset was involved in the performance and street-theater scenes. Neither had gone to art school, although Dragset had attended a couple of years of university, engaged in studies that he describes as "part clown, part Shakespeare."

The men were lovers for nine-and-a-half years. When they broke up, they wondered whether they could continue as artistic partners. They canceled and postponed several exhibitions, but followed through with one for Tate Modern. "As artists, you can turn negative situations into positive ones," explains Dragset. "You can put your situation on covert display." The artists started out with several ideas for Tate, but in the end,

Elmgreen & Dragset, Happy Days in the Art World, 2011. Performance view with Joseph Fiennes and Charles Edwards. Photo by Paula Court.

the exhibition was reduced to a sculpture of a dying sparrow. Titled *Just a Single Wrong Move* (2004), the work consisted of a taxidermied bird with an animatronic component, which made it twitch in endless death. The artists think that their work has improved since their romantic split. "If you survive a breakup, it gives you the strength to make the stakes higher," says Elmgreen.

Many Elmgreen & Dragset works involve domestic doubling. *Marriage* (2004) consists of two white porcelain sinks whose stainless-steel drainpipes are tied in a knot. It was one of the first sculptures the artists made after they broke up. The sinks are the same shape and size, suggesting an egalitarian relationship, tainted only by the sense of mutual enslavement evoked by the bondage below. More recently, the artists made a work titled *Gay Marriage* (2010), which is made up of two urinals with entangled pipes. Neither has a great desire to get married. "Why can't you marry three people?," says Elmgreen. "Then it might start to get fun!"

The artistic duo has also made sculptures of bunk beds in which the top bunk faces down and pairs of doors that are linked together by a single chain lock. "Every time we put something in singular form, it feels a bit funny," says Dragset. "I believe in the idea of soul mates," says Dragset. "I don't know if I can say anything clever about it, but . . . relationships need to be mutually inspiring to last."

Any working partnership is psychologically complex and difficult to explain, but Elmgreen & Dragset seem to be at an uncharacteristic loss for words when I ask about their division of labor. "We have no particular skills," says Elmgreen after a long pause. "I am a Cancer. You are a Leo," volunteers Dragset. "I hide under my shell and walk slowly sideways. You are a fiery kick-starter." Eventually, one detail captures my imagination. When the artists are working from the studio in Berlin, Dragset is the one who drives their beat-up Range Rover. Elmgreen knows everything about cars, but he doesn't have a driver's license because, as he admits, he would be "much too aggressive behind the wheel." Elmgreen, although physically fairer, is the psychologically darker side of the artistic duo. He has a more

Elmgreen & Dragset, Happy Days in the Art World, *2011. Performance view. Photo by Paula Court.*

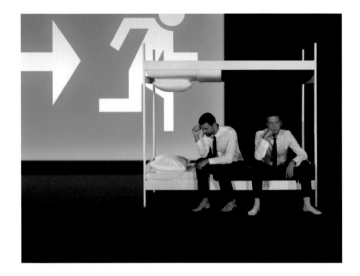

menacing demeanor, despite his ample charm.

The name Elmgreen suggests a landscape painter; "Dragset" sounds like a cross-dressing performance troupe. Together, the names befit a Scandinavian law firm. The pair never sought to become "Elmgreen & Dragset," but they found that organizers of group exhibitions invariably dropped their first names. "We don't see ourselves as a brand," says Dragset. "We do not aspire to being Bang & Olufsen."

"What impelled Elmgreen and Dragset to become artists?," I wonder. "Our initial ambition was to express our worldview more publicly," says Dragset. "It was not so much that we thought we were special. It was about a lack. We missed seeing our perception of the world represented."

"I don't have the taste in my mouth or smell in my nose of being an artist," says Elmgreen. "I'm a cultural producer." Dragset disagrees. "I'm an artist. I wouldn't call myself anything else. Just as I'm gay and wouldn't call myself 'queer,'" he says. "I remember very well making the decision to accept myself as an artist. I had my thirtieth birthday in New York City. We had a residency there. Up until that point I had felt embarrassed, then I thought, 'Fuck it.' I can be an artist just as much as anyone else. There is no set definition of how to behave."

"These identity groups are so last-century. You were a gay

artist in the twentieth century," says Elmgreen with a mischievous glint at his artistic partner. "In general, I would say that we are far too busy to be artists. We make artworks, publish a book, design a T-shirt, curate a show, do a theatrical performance; so many things." He looks into Dragset's eyes to think. "We are like small mice, avoiding being trapped or cornered. We change our formal language quite often, but you can never escape from yourself." Elmgreen pauses, then adds, "Our work is not a symbol of something bigger. It is not about universal truths. All we do is tell small lies."

—*Sarah Thornton*

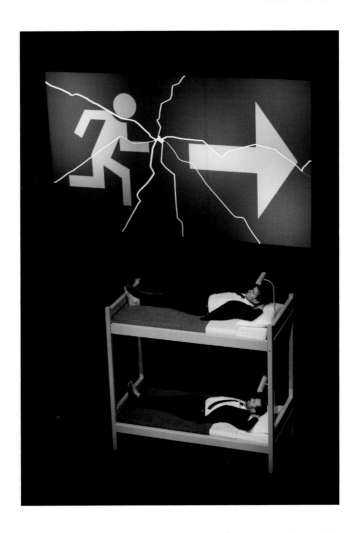

Elmgreen & Dragset, Happy Days in the Art World, *2011. Performance view with Joseph Fiennes and Charles Edwards. Photo by Paula Court.*

At left: Elmgreen & Dragset. Photo by Elmar Vestner. Courtesy Studio Elmgreen & Dragset.

Interview

INGAR DRAGSET

IN CONVERSATION WITH ROSELEE GOLDBERG

ROSELEE GOLDBERG (RLG): I'm interested in the fact that all your work seems to have something to do with performance. I know you come out of theater originally, so can we talk about your theater background? Tell me about what it meant to go into theater, what you were doing when you met Michael.

INGAR DRAGSET (ID): I would start a little further back. Who was it who wrote that song, "Should I Write a Book or Should I Go On Stage?" It's really the post-punk years, being a teenager in '84, 85. That was the beginning of my theater years, having this drama class [in high school] as part of my curriculum. I also was part of a theater group that staged summer shows in a historical fort outside the city of Trondheim. And then I studied drama and theater sciences at univer-

sity, which combined practical theater practices with theory and theater. And that's when your book [*Performance Art: From Futurism to the Present*] popped in there, one of the books we had to read.

RLG: How was it regarded?

ID: It was a natural part of the curriculum. For me, it was great, useful, when I moved to Copenhagen, as well as when I started doing art with Michael. I didn't know anything about contemporary art, only names: Carolee Schneemann, Allan Kaprow [from your book]; that was all I knew of contemporary art. I didn't know Damien Hirst or Jeff Koons. I went to Copenhagen to go to a theater school that was in the Lecoq tradition. I never did traditional theater. This was more based on physical theater and perfor-

mance theater, and comedy tradition, meaning anything from Commedia dell'arte to Shakespeare to more modern or contemporary. We even had clowns and mimes and acrobatics. Visual-based, definitely not word-based. So, that was a good starting point for me in a way, making that transition from theater into visual arts. What I was really fascinated about when I met Michael and his friends was how fast you could go from one idea to something you present to an audience—compared to theater, which takes so many people, and has such a heavy production apparatus. And I felt like it was a revelation for me to see. That scene was so vibrant and fast compared to theater, and much more personal. That's one of the great things with performance: It has more of a personal edge to it. It's more revealing in terms of identity and who we are, and most theater productions aren't like that.

RLG: I'm always being asked the difference between performance and theater—and it's obvious to list some of the differences—the division of labor: the writer, the set designer, director. Your point about the speed of making a piece adds another interesting factor. Ok, so then you meet Michael. How did you come up with your first piece?

ID: Michael wanted to do some knitted objects for a small show he was doing in an artist's studio in Stockholm and I said, "I can knit, I'm quite good at it." Then I came to the opening in Stockholm. These knitted objects were lying, kind of cautious, in the corner of the space; you were supposed to interact with them, but Swedish people are quite stiff, not so naturally engaging with anything. Nobody touched those objects. Basically, Michael and I ended up sitting in each corner playing with these things, and that became our first performance without us even knowing it. Then, having proven my knitting skills, the knitting performances came quite naturally from that.

RLG: What is your first memory of a performance inside an art museum?

ID: I think the first work we did inside the museum space was a long cloth where I knitted at one end and Michael unraveled the piece at the other. It was in 1995, part of the annual spring show of new Danish art at Kunsthal Charlottenborg in Copenhagen.

RLG: Let's talk about the piece specifically for Performa, *Happy Days in the Art World*. We've been talking now for quite a while….

ID: As you said, we've been talking about this for many years, so it had been in the back of our minds. We were quite exhausted and a little burned out after Venice [Elmgreen & Dragset occupied both the Danish and Norwegian Pavilions at the Venice Biennale in 2009]. So we took a break for a few months, traveling and reading and writing and bringing along a lot of books and authors we liked and things that have inspired us and we ended up reading Samuel Beckett's plays again, Beckett having all these sets of characters: the husband/wife, master/servant in *Endgame*, two parents in the trash can. We were reading Beckett and recognizing ourselves in so much of the dialogue.

RLG: You went separate ways to take a break, and you decided to read these Beckett books?

ID: It wasn't a decision like that. I think I was maybe reading them, but it's never really important who is doing what because we're always so all-around on everything. I called Michael and said maybe we should do a Beckett play but do it ourselves. We should do *Waiting for Godot* because there are so many bits

in it that reminded us of our everyday conversations. Michael's favorite is *Happy Days*, so we wanted to do that as well. So we sat down and tried to mix and match, but realized it's better to try to write something ourselves in the style of Beckett and make it more personal again. We tried to join different plays and then we added stuff and that went really well. Then we said, "Okay, let's cut all the quotes out. Fuck Beckett!

RLG: So did that say for you, "Hey, I'm getting back to theater?" Was there any sense of coming back to your beginnings again?

ID: To theater, yes, coming back to it has been really great in many ways. There's something to theater that I really love. The teamwork can be fantastic and people are often very specialized in their fields. So, coming back to theater at a higher level has been really great, whereas fifteen, twenty years ago it felt more like a struggle. We've been lucky to have these brilliant collaborating partners, and we have more experience and resources now.

RLG: You started with the play. Did you think about New York at all? It's interesting, you're so big in Europe but you haven't been seen in New York that much.

ID: Not New York specifically, but Performa, yes. New York featured in the play in an early stage, you could say. And so knowing that you might be interested in it, at least, we were excited about presenting it to you.

RLG: It is interesting that working in the art world, it's like you're putting a "frame" around theater.

ID: We are using the material of theater as we use other art forms. I think we have a quite similar approach to this as we've had in other productions. You have to take the art form seriously. We make a four-meter-tall bronze sculpture for Trafalgar Square in London, and we really go into the traditions of sculpting, and material tests, and drawing on people's long experience in the field. And that's also what we're doing in theater. In our whole production, there are so many different forms and strings.

RLG: If you were talking to theater students or a theater critic, is there one thing you would say you like about being back in theater?

ID: It feels like the right time to sit people down and to have them experience something for an hour—being quiet, being focused, having people turn off their cell phones, having a common experience of something. In the art world, people's attention is pretty unfocused. People are on their Blackberries, waving at someone. Making a work [in a theater] demands a different kind of focus in terms of audiences and the way they participate.

RLG: The whole idea of Performa is to slow down time. What I thought was fascinating at one rehearsal that I saw was that the actors were you, the real characters were you, so *Happy Days in the Art World* is a double portrait of you.

ID: You make people commit in a different way. Back to what I said in the beginning: Performance, not only being more personal and identity-based, can also bring the personal into theater. It's still about us and what interests us.

RLG: As far as your relationship, you've shown that it's possible to divorce yet still work together. You've maintained the most important and valuable things of the original relationship. How will that play out in the future? As you say in *Happy Days in the Art World*, "Are we one, are we two?"

ID: It's a combination. Like any marriage, it's a combination of a constant negotiation, but also having a belief in this being it. You have to have a strong core role, a belief that you can do amazing things together.

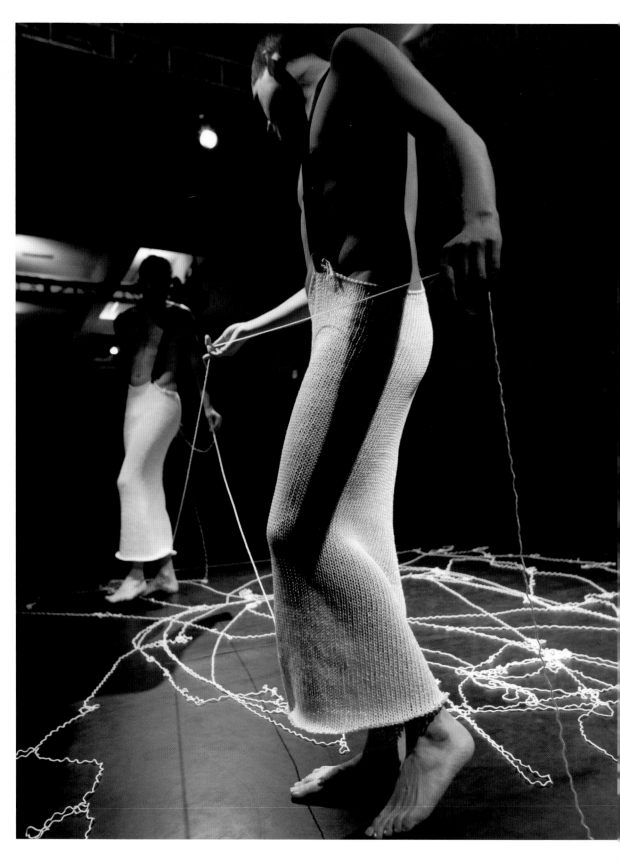

Interview

MICHAEL ELMGREEN

IN CONVERSATION WITH ROSELEE GOLDBERG

ROSELEE GOLDBERG (RLG): Let's go back to the beginning. How did you start as an artist?

MICHAEL ELMGREEN (ME): I started out doing poetry in Denmark, and some of my poems I presented on computer monitors at a venue that happened to be an art space. I had no relation to visual art at that point, but I wanted to make texts—presented live in a spatial setting instead of in the regular book format—texts that would morph in front of people's eyes. I went to this art space that I knew because it was very close to the most well-known shopping mall in Copenhagen. When I asked, "Can I present my text works here? I'm not an

artist," they said yes. After that I suddenly started to get these weird invitations to do art as well. So, by coincidence, I stumbled onto the art scene, and then I met Ingar, who came from a theater background, and we wanted to do something together. For us, meeting in the middle meant doing performances. We started doing performances in low-key artist-run spaces and once even in a public restroom—projects organized by young curators. All of our performances in the beginning were outside the established art institutional system.

RLG: What was the first move into the system? You were both living in Denmark at the time.

Elmgreen & Dragset, Untitled, 1996. The artists unravel long white knit skirts off of each other. Performance view, 2011. Photo by Paula Court.

Elmgreen & Dragset, Paparazzi, *2010. The piece was re-presented at the Elmgreen & Dragset live retrospective during Opening Night of* Performa 11. *Performance view, 2011. Photo by Paula Court.*

ME: Yeah, and neither of us had any art education. The contemporary art scene of our generation, in '95, was very underground in Denmark until the so-called "Scandinavian Miracle." One could say we were the last generation of innocent artists: We had no clue or consideration about the system as such—the market and galleries; we just did our stuff.

RLG: Your work has a lot of humor. You seem to take great pleasure in your projects. I know it's hard to talk about humor, but can you talk about it?

ME: Humor is important when you want to say something very serious. But I don't like the term "irony" because it implies making fun of or poking your finger at someone. We like to speak about difficult topics, but we also like to do it in a way

where it becomes digestible. Shannon Jackson said that we do more real theater in our installations than we did with *Drama Queens.* It makes us think that maybe Elmgreen & Dragset have been doing theater all along?

RLG: People are always asking me the difference between theater and performance. One of the answers is pretty straightforward. In theater, there is a division of labor—playwright, director, actor, dramaturg, costume designer, lighting designer. In visual art, you are making the piece. Everything is your material; you are directing the director.

ME: It's a completely different working process. We are the initiators, no matter if we do a piece of architecture, an art installation, a design, curate a show, or write and stage a play—it's an art project every time.

We know you have trouble with theater, so we wanted to do something to make you like it.

RLG: When I saw you with the actors in rehearsal, instructing them how to *be you,* I thought that maybe theater is interesting after all.

ME: We love to highlight things that are unpopular—topics, aesthetics. It's important to do the wrong thing.

We thought, "What should it be about?

We were at a stage where we asked ourselves where we could go next, not only having the challenge of making a new work, but also who we were. We wanted to find ways that would put us on thin ice again. And then we thought, why not a play about the artistic process? How do you refresh yourself and keep up the excitement so that things don't become business as usual in that process? Maybe because we never planned to be in the art scene, we continuously look at it as a lab.

RLG: We understand that a large part of the audience for your performances come from the art world, but what about those who don't?

ME: We wrote our script with Tim Etchells, who is based in theater, and he knows better than us how a script should function. We did our play *Drama Queens* (2007) with him. This time, he was a sort of script doctor for us. He is very good at identifying what is not understandable unless you're part of a particular scene—it was slash, slash, slash to our script. I think it's possible to get something out of *Happy Days* without any knowledge of the mechanisms of the art scene because these mechanisms are also embedded into a lot of other areas of our society today.

RLG: For example?

ME: General talk about the market—investments, the 2007 gold rush of the markets, the euphoria and hysteria and then the disparity when the recession kicked in—such phenomena have been experienced in many areas of our society. And the moral questions a public figure faces—such questions apply not only to visual artists but anyone who is vain enough to stand in the spotlight. In the script we also describe the conflict between two persons who have gone through ten years together, then splitting up. How could we maintain all of the beautiful things we had together after the love part of the relationship was over? How was it possible to continue in a dignified way? *Scenes from a Marriage* was a big inspiration. Bergman is always haunting us. I love Bergman—I'm really afraid I'll be reborn as him. I even have his stomach disease. There's a big danger of being reborn as either Bergman or a goldfish.

RLG: Where did you get this idea of being reborn as either him or a goldfish?

ME: As a goldfish, you're alone in a bowl—you are the center point and you can circle around endlessly, but because you have a short memory you will constantly experience the world in a fresh way. [*Laughs*] It turned out that Foucault already had said that he wanted to be reborn as a goldfish, too.

RLG: You connect with Foucault?

ME: It would be fun to be in the same bowl.

RLG: We'll get you a goldfish for the dressing room. Back to Bergman—he's always there for you. Is it because he's Scandinavian?

ME: He has this profound critique of people who want to "do good things," the evilness of people who want to do good for others and impose their "compassion" on their victims in their own ego-centric moralistic manner—something which is rather present in today's politics: this patronizing need of some people to do good things for others. That's a fantastic worldview because a lot of problems in the world come from people claiming that they know what is the best for others. There's also something Scandinavian that is so well depicted in his films: our highly neurotic mentality, our claustrophobia due to the tiny countries we live in—it's like, we could break down if the bus is five minutes late. I find his dialogues fantastic.

RLG: We should also focus on the retrospective we're doing on Opening Night.

ME: Yeah, we've never even seen two performances staged in the same space, so seeing plenty of them side by side will be completely new.

RLG: Each piece tells a different story, and covers a lot of the history of AIDS politics. There's been a lot of sadness, but these pieces take a very different direction.

ME: We grew up with significant names in the art world at that time, like González-Torres, who dealt with this serious topic of HIV, but also Robert Mapplethorpe, though we couldn't relate to his artistic language in the same way, I think. It is important to make images not only of gay identity but masculine identity, which hasn't really been taken as seriously as women's investigations into their identities.

RLG: That is true—feminists have looked at issues of femininity and being female in many different ways. When you're looking back on your earlier pieces—for example, the spooning piece that you first performed in Cuba [*24/7/365*, 2009], are you putting these issues into a Cuban context as well?

ME: That piece is very explicit, and showing it in Havana caused a real problem. Cuba is extremely homophobic, partly communist, party Catholic; it's really hard to be gay there. It was a wonder that the performance was not censored.

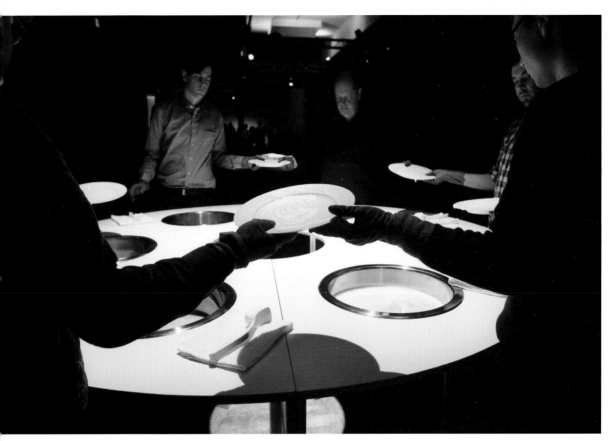

Elmgreen & Dragset, Ongoing, 2003. Six men rhythmically wash dishes and pass plates. The piece was re-presented at the Elmgreen & Dragset live retrospective during Opening Night of Performa 11. *Performance view, 2011. Photo by Paula Court.*

RLG: What about the relationship to Sarah Thornton [author of *Seven Days in the Art World*]? Was your reference to her a way to talk about the anthropology of the art world?

ME: We experienced twenty-four hours with Sarah in our studio while she was writing a text for our book *Trilogy* and at the same time working on a portrait of us for her own upcoming publication, which is sort of a follow-up to *Seven Days in the Art World*. Her working method and way of being were a great inspiration for us.

RLG: What you and Ingar have together is beyond a marriage: You have a whole life together. What will it be over the next hundred years?

ME: I have no family, so Ingar is my family. We are critical of a lot of mechanisms in the art world, and we wouldn't be able to cope without having each other. Doing it together, the collaboration and ongoing dialogue between us, is still the reason to continue.

LIZ MAGIC LASER

I Feel Your Pain

THE SVA THEATER / PERFORMA 11 COMMISSION / CO-PRESENTED BY THE SCHOOL OF VISUAL ART'S VISUAL AND CRITICAL STUDIES AND BFA FINE ARTS DEPARTMENTS

With *I Feel Your Pain*, Liz Magic Laser furthered her investigations into the dramaturgy of politics and everyday life. Employing the format of the Living Newspaper, a theatrical presentation of current events that was popular in Russian Constructivist agitprop of the 1920s and '30s, she restaged sequences from contemporary political interviews and press conferences. The event took place in a movie theater, and actors stood among the audience as they reenacted theatricalized, emotional declarations taken from televised sound bites of American politicians, such as John Boehner or Hillary Clinton, who were hoping to elicit public sympathy and support. These performances were captured by three camera operators and projected live onto the movie screen so that audience members saw themselves and the performers simultaneously.

Following the narrative arc of a romantic comedy (and, at eighty minutes, running about the same amount of time), *I Feel Your Pain* opened with a "first date" adapted from a Glenn

Liz Magic Laser, I Feel Your Pain, 2011. Performance view. Photo by Paula Court.

Below: Liz Magic Laser, I Feel Your Pain, *2011. Performance view, with Rafael Jordan and Annie Fox. Photo by Paula Court.*

At left, top: Liz Magic Laser, I Feel Your Pain, *2011. Performance view. Photo by Paula Court. Below: Liz Magic Laser,* I Feel Your Pain, *2011. Collage. Courtesy Various Small Fires, Los Angeles.*

Beck interview with Sarah Palin on Fox News in January 2010, climaxed in a raucous boxing match between "a whistleblower" and "the accused," and concluded with a mash-up of public apologies by politicians such as Anthony Wiener and Arnold Schwarzenegger. All of the texts were comprised of actual quotations. Interludes featured a clown who pantomimed for the audience while an offstage voice dramatized passages from manuals for pickup artists and politicians, as well as academic texts on the politics of emotions. The performance offered satirical commentary on political sentimentality and simulated authenticity in an era of manufactured consent.

—*Tom Williams*

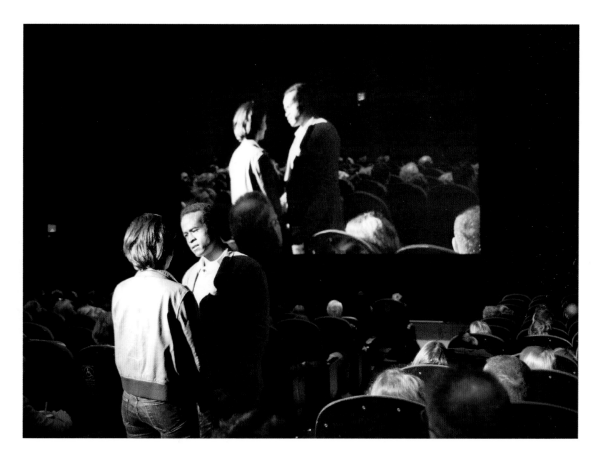

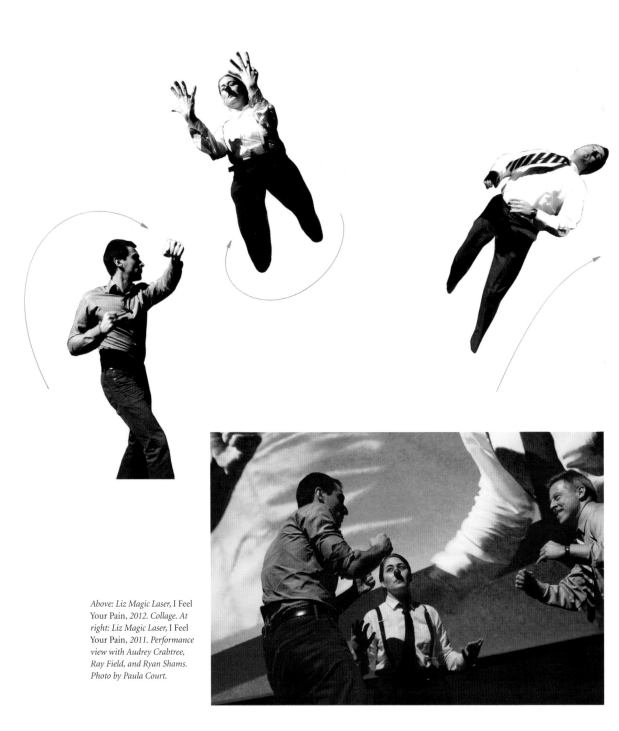

Above: Liz Magic Laser, I Feel Your Pain, *2012. Collage. At right: Liz Magic Laser,* I Feel Your Pain, *2011. Performance view with Audrey Crabtree, Ray Field, and Ryan Shams. Photo by Paula Court.*

At right: Liz Magic Laser, I Feel Your Pain, *2011. Performance view with Ray Field and Kathryn Grody. Photo by Paula Court. Below: Liz Magic Laser,* I Feel Your Pain, *2011. Collage.*

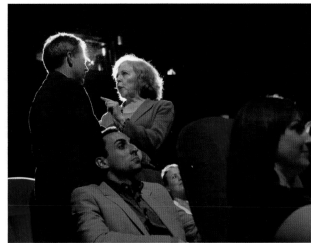

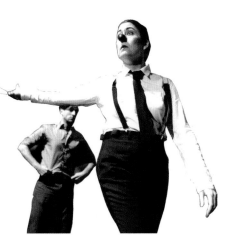

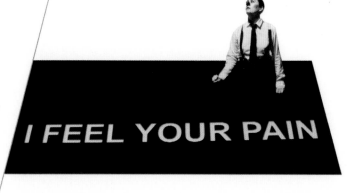

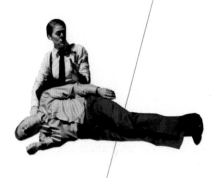

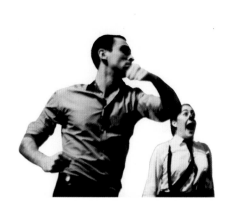

Liz Magic Laser, I Feel Your
Pain *(Collage #11), 2011.*

"MUSE: THE INTERVIEW"

BY LIZ MAGIC LASER

In the fall of 2009, after my first solo show received some attention, I began to get interview requests. Something about this demand made me recoil at first. I suppose it provoked performance anxiety, yet it also sparked a perverse fascination. The interview scenario seemed so contrived and artificial. It calls upon artists to stand outside their work and articulate their "real" intentions.

At a time when "the real" must be bound in quotes, the appetite for the interview and its pursuit of authenticity has paradoxically intensified. The pressure on artists as well as politicians and other luminaries to display the true meaning of their work has only increased.

American political journalists invented the interview in the mid-nineteenth century. Before the 1860s, even directly quoting politicians was unheard of. The political interview emerged as a new egalitarian discourse between public figure and reporter. Initially, Europeans found the interview vulgar because it undercut the reverence traditionally accorded to public figures. The status of aristocrats and politicians had been predicated on distance and propriety. This decorum was suddenly under siege by a democratic revolution that sought to undermine the preeminence of power. It was no longer sufficient for a person to fulfill his or her official role; now you also had to construct a substantial inner self to be exposed—to be performed—for the public. The interview helped transform the politician from a superior into a social equal.

Today, the interview positions the artist—who experienced similar transformations in the twentieth century—as the reality behind the work. The interview is the document of a highly cultivated presentation of self that ultimately as-

sumes the form of a written script. With this form in mind, I turned one of my first interviews into a project. The curator Christopher Lew, with whom I had worked on my MoMA PS1 performance, *Flight*, in April 2010 (it was performed again in Times Square, 2011), suggested doing a magazine interview. Since he knew all of the performers involved in that project, I proposed a collaboration: seated in the bleachers of an empty amphitheater in downtown Manhattan, we conducted a group interview with the entire cast. The interview was then transcribed, edited, and reenacted on the amphitheater's stage before a sparse audience of passersby. The results were published as a theatrical script called *InterAct* on the *Art Journal* website, complete with stage directions.

Shortly thereafter, I came upon a peculiar interview of Sarah Palin by the conservative pundit Glenn Beck. It was supposedly their first meeting, and Beck began by telling Palin, "I want to read you what I wrote about you in my journal last night." It sounded so contrived, like an adolescent come-on. There was a strange contradiction between its private premise of intimate dialogue and the very public conditions of its reception.

I Feel Your Pain, my recent project for Performa 11, opens with an adaptation of that Beck/Palin interview. The dialogue is recast as a lovers' discourse between two wide-eyed activists on a first date at the movies. I wanted to restage this extreme contradiction of Beck reading from his journal, this manipulative disclosure of personal feelings, in a context that is anything but intimate. I decided a movie theater was the appropriate setting because of its paradoxically collective dimension: it's a public space in which audience members gather to have individual experiences of the private dramas unfolding on-screen. The performance was staged in an actual movie theater, in the midst of the audience. Eight actors performed a sequence of scenes tracing the progression of a romantic relationship using dialogue adapted from dozens of political interviews. As the actors performed, footage captured by three roving cinematographers was projected onto the screen in a continuous live feed. I acted as real-time editor to produce and screen the film as it was being performed.

Today, distinctions among cinematic, personal and political modes of behavior have collapsed. The performances we see on film and television shape our own actions. There has been an increasing demand for politicians to display their personal political convictions to a national agenda by revealing themselves. The politician performs a sort of rupture, and we see who they really are. This supposed breach of decorum is now being highly produced in order to orchestrate public opinion. These conditions are embedded

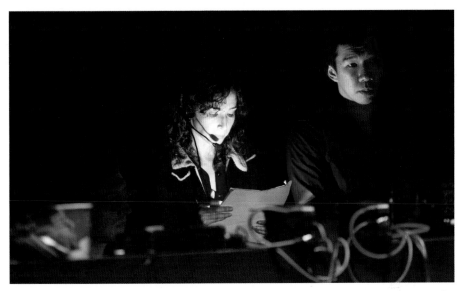

The artist in rehearsal for I Feel Your Pain. *Photo by Paula Court.*

in the interview's form, and I wanted to bring them into high relief.

In an era when the authentic self has been so thoroughly deconstructed, our demand for authenticity seems only to grow. The pervasiveness of the interview corresponds to this ever-increasing desire. But the interview is perhaps better understood as a transformative instrument that produces its subjects as much as it reflects their intentions. Sociologist Erving Goffman wrote in *The Presentation of Self in Everyday Life* that "[the self] is a dramatic effect arising diffusely from a scene that is presented." In the interview, the "scene" is both a commentary on one's public performance and a performance in its own right. Yet if the self is a result of the performance, then we don't stage the interview so much as the interview stages us.

In its prevalence today, the interview has often become a site where public life is supplanted by sentimentality, personal disclosure and political demagoguery. My recent work aspires to put these operations on display and in so doing to restore some of the interview's early democratic potential. Rather than offering the "reality" behind public life and public lives, the interview could become a space where people are challenged and transformed.

Originally published in Art in America, *March 2012. Courtesy BMP Media Holdings, LLC.*

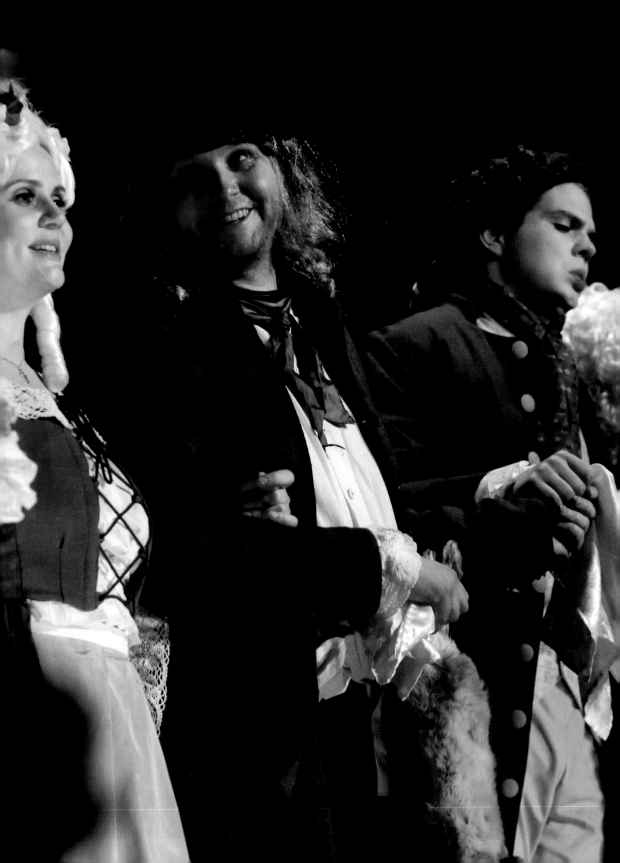

RAGNAR KJARTANSSON

Bliss

ABRONS ARTS CENTER / PERFORMA 11 COMMISSION

Early on in our discussions about his Performa Commission, Ragnar sent me a description of the work as he saw it. "The performance is based on the finale of Mozart's *The Marriage of Figaro*," it began. "It will be looped live, amongst traditional scenery, with ten singers, costumes, and an orchestra. The part will be performed again and again (circa fifty times) for approximately two hours." A later text described a six-hour performance—the artist himself will also sing, it added—while the final press release stated boldly: "Ragnar Kjartansson presents a twelve-hour-long performance that will repeat the delirious final aria of Mozart's 1786 opera…" Such is the promise of Performa Commissions: to fully realize an artist's vision and to take it into new and entirely unexpected realms. For Kjartansson, who was raised in the theater and who says he has been fascinated by repetition—in rehearsals, and of performances—from an early age, "the last act of that opera has for years been my infinite moment of bliss."

—*RoseLee Goldberg*

Ragnar Kjartansson, Bliss, 2011. Performance view, 11:57 pm. Photo by Paula Court.

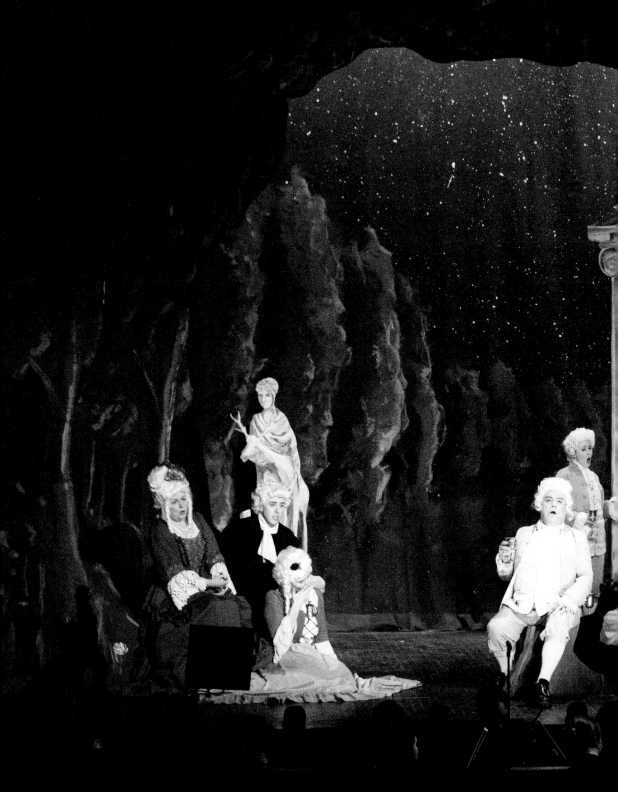

Ragnar Kjartansson, Bliss,
2011. Performance view, 2 pm.
Photo by Paula Court.

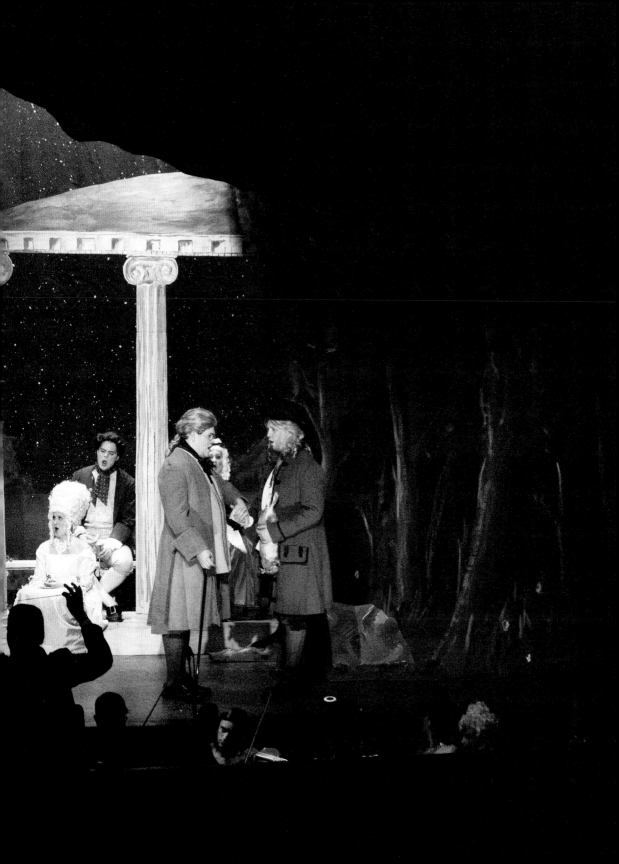

AN OPERATIC REALITY

BY CLAIRE BISHOP

*B*liss, by Ragnar Kjartansson, built on the Icelandic artist's previous experiments with music and forms of endurance performance. A full orchestra and a group of Icelandic opera singers in period dress sang the final two minutes of the last aria in *The Marriage of Figaro* (1786), on a live loop for twelve hours. The climax of Mozart's opera, the aria "Contessa Perdono" is a sublime sequence in which the Count (played by renowned tenor Kristján Jóhannsson) asks the Countess for forgiveness; she grants it (thereby asserting her superiority), and the rest of the court is moved to join in:

> *Count: Countess, pardon me!*
> *Countess: I am gentler, and I grant it*

you.
All: Ah, all will now be happy.

Because the performance began at noon and was scheduled to run until midnight, with visitors allowed to walk in and out, I kept delaying my arrival at Abrons Arts Center. I was also suspicious of Kjartansson's strong conceptual underpinning: Did I actually need to see the entire work? At 8 pm, I finally padded into the auditorium with a glass of prosecco. There were about ten people seated, easily outnumbered by the orchestra players and performers onstage. Normally, walking late into an opera is a shameful affair; you keep your head down and scurry to your seat as unobtrusively as possible. Here, I could stand

Ragnar Kjartansson, Bliss, *2011. Performance view, 3 pm. Photo by Paula Court.*

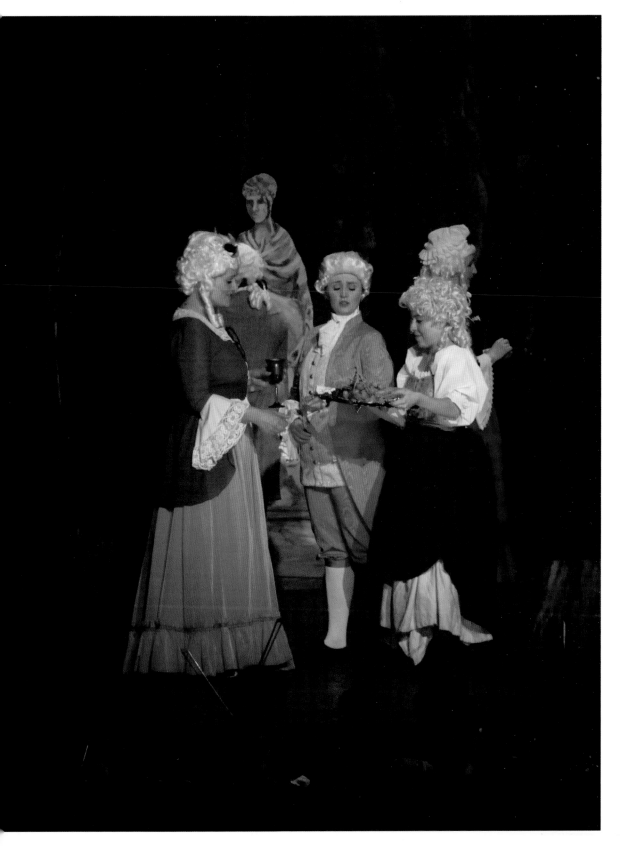

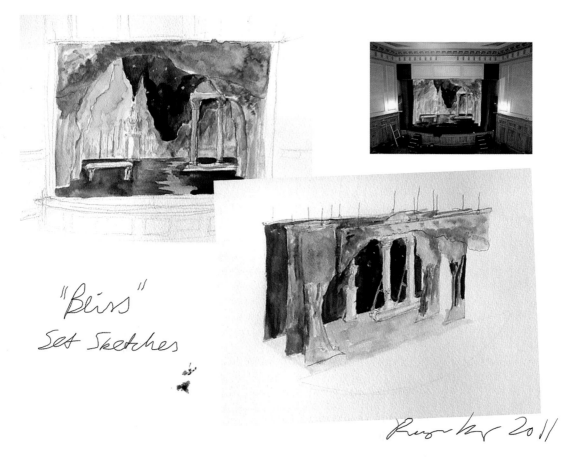

"Bliss"
Set Sketches

Ragnar Kjartansson, artist renderings for the set of Bliss, *2011. Courtesy the artist.*

and relish the entire scenario: A painted set, complete with trees and pergola, formed a backdrop to ten singers in full eighteenth-century court attire (wigs, britches), singing their hearts out to a nearly empty auditorium. This dazzling spectacle immediately exceeded my expectations.

As one rendition after another came to a close, to be taken up once again by the Count, followed by the orchestra, I realized that Kjartansson's choice of music was genius: Far from being one of Mozart's catchiest tunes, this was a spare yet complicated melody that I could never quite grasp or remember, so each repetition felt new yet completely comforting. Each cycle saw the performers adopt

a different configuration on the stage; various female singers took turns as the Countess, while Jóhannsson played the Count for the duration of the piece (and reportedly did not leave the stage once to go to the bathroom). At the same time, the machinery for sustaining this twelve-hour epic became the main event rather than a subplot: Members of the orchestra occasionally clambered out of the pit for toilet breaks, or a servant carrying a tray of silver goblets arrived on stage with refreshments for the singers. The conductor, who had cracked open a bottle of bourbon shortly before my arrival, grew ever more flamboyant with his gestures, and the bottle was passed around the orchestra. Eventually, at half past ten, a hog roast was brought on stage; in one particularly memorable moment, the Count paused to finish his mouthful, holding back the next iteration for a few delicious, empowered seconds of relish.

I had planned to stay half an hour at most, but this transition of video logic (the mechanical loop, identical every time) into performance proceedings (human, fallible, exhausting) was too compelling to leave. As the hours passed until midnight, I realized that at its core, *Bliss* concerned the slow work of entropy: As the conductor got drunker, and the performers grew more fatigued, professional accuracy was replaced by an unpredictable tempo and an abandonment of character. Despite the eigh-

teenth-century costumes, the scene was utterly in the present: One girl constantly flirted with another, while others were clearly desperate to sit down. But since the audience was drinking too—and in the last hour, cheering the performers on at the end of each rendering—this was all welcome entertainment.

Kjartansson's imposition of endurance onto the poise of classical accomplishment produced a different type of operatic experience, one in which professional personae collapsed into live personalities. One of the work's most diverting features was the perpetual beaming ecstasy of Ragnar Kjartansson himself, onstage dressed as a gardener, clutching a dead rabbit, an amateur singing alongside professionals. By the end of the twelve hours, the performers had involuntarily created their own narrative, competing with the operatic diegesis.

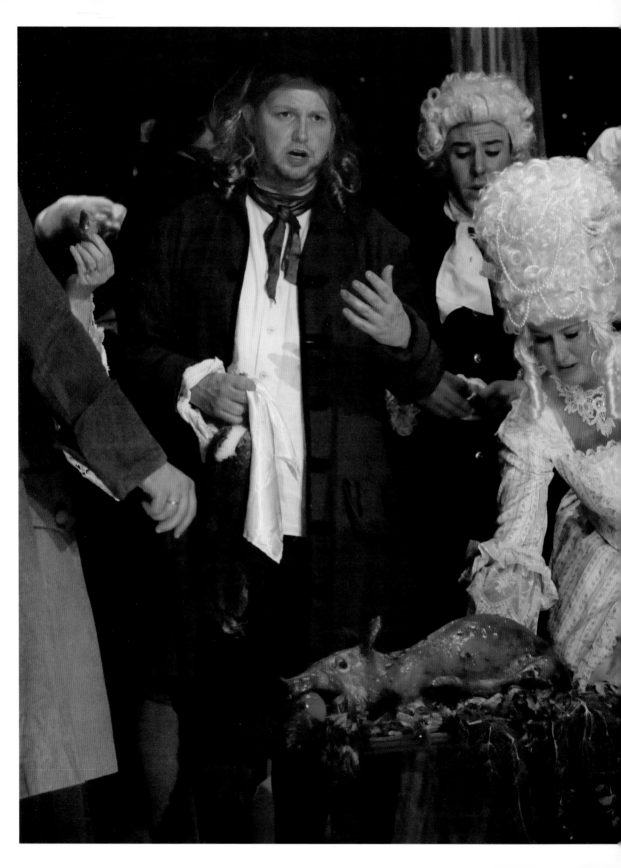

BLISS

BY JERRY SALTZ

Ragnar Kjartansson's twelve-hour operatic performance *Bliss*, at the Abrons Arts Center auditorium, saw audiences cheering in the aisles, crying in their seats, struck dumb, and lifted high by the transforming, hallucinatory power of the Rococo and the amazing sight of an artist earnestly, even desperately trying to cut through twenty-first-century irony. It's a masterpiece. The performance started at noon, when ten Icelandic opera singers took the stage in eighteenth-century folk costume, including Kjartansson himself dressed as a peasant carrying a stuffed dead hare. Then all began to sing the ravishing, almost ecclesiastic two-minute finale of Mozart's *Marriage of Figaro*. This divine refrain consists of only three lines. A philandering count begs his wife's forgiveness, singing (in Italian), "Countess, pardon me." She responds, "I am gentler. And I grant it to you." Hearing her, everyone fills with joy and sings together, "Ahh, all will

Ragnar Kjartansson, Bliss, 2011. Performance view, 11:35 pm. Performers eat suckling pig onstage. Photo by Paula Court.

be now be happy." Those two minutes repeat, cycling over and over—for twelve hours. Sort of.

The Count sings in a deeply human, crestfallen tenor. We are he: erring, hopeful, feigning, flawed. Mozart has the Countess respond with swelling notes that soar as beatifically and spiritually as any in Western music, piercing any heart who hears them with a kind of inexplicable, redemptive forgiveness. "Have my ears ever heard anything this heavenly before?", you wonder. It is, of course, the love and beauty before the terror: The age of Mozart, Watteau, Fragonard, Boucher, Chardin, and early Goya preceded collapse, revolution, Napoleon, and finally Goya's *Disasters of War*. Kjaartansson keeps this fall from grace at bay: *Bliss* is his *Groundhog Day* way of letting us linger in an Elysian Fields of repeating redemptive beauty and love.

I found myself in this suspended state for whole periods of *Bliss*. So, apparently, did the singers, who—although seemingly taxed beyond endurance—carried on, stopping only for seconds, then starting again. My wife and I began applauding at the end of each cycle, shouting "Brava!" and "Bravo!" in an otherwise silent auditorium; the rest of the audience began to join us, and the appreciation seemed to power the singers through the first two hours. Then I left.

When I came back at around 4:45 pm, decay, or possibly delirium, had set in. The noble lead, Kristján Jóhannsson, who didn't take a bathroom break for

the entire twelve hours, was starting to sound frayed. The incredible Countess and her towering pearl-bedecked wig sometimes stood silently for cycles, clearly preserving her voice. Meanwhile, one of the other excellent sopranos stepped in to save a sister. I watched musicians trying to stretch their hands, massaging fingers, the wind players massaging flaming lips. Singers sat on fake tree stumps, supporting one another, offering gentle strokes of encouragement, wiping each other's sweat. Worrywart psychosomatic that I am, this rubbed off on me. My throat became sore; I grew tired, slaphappy. Through it all, Ragnar, trained by our tenor for this performance, sang with an imploring, beatific smile, always in the moment, chasing beauty. Deftly employing opera's inbuilt schisms between language, music, text, and sound, he used classic seventies-style endurance art to see if it was possible for him and art audiences to escape self-awareness, always simultaneously inside and outside ourselves, in a moment but somehow observing it. In this case, we were all aware that Ragnar was earnestly trying to get around irony, which made *Bliss* ironic; which was then transformed by Mozart and Ragnar into earnestness again; which then flipped back through the repetition.

For me, Ragnar is an anti-Marina (Abramović, that is). Instead of seeing narcissism, egomania, and glamorous existential suffering, I glean something Icelandic—a way of courting chaos with fortitude, a sense of the absurd and ac-

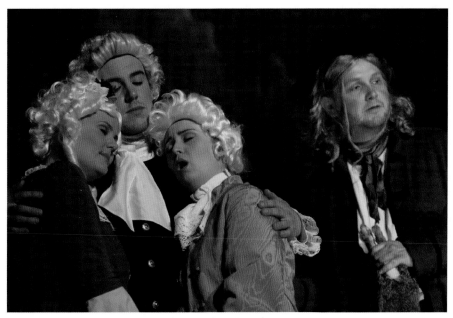

Ragnar Kjartansson, Bliss, *2011. Performance view. Photo by Paula Court.*

ceptance. There were no histrionics, no audience members trying to take over the proceedings, no melodrama. I imagined what American performers might do in these straits: shedding garments, removing wigs, vacating the stage to rest. Instead, these Icelanders moved into entropy by drinking more, accepting some abject, doomed state they and we are all in. Maybe it comes from living in the dark for four months every winter.

As we neared midnight, the rational American in me freaked out. You could feel many in the audience carefully counting down the minutes, anticipating the amazing conclusion. Then Icelandic time kicked in. Out of nowhere, at about 11:50 pm, the conductor raised the orchestra to a booming crescendo, stood on his chair, and waved his arms wildly, imploring the singers to let loose. At the end of that aria, at ten to midnight, he ended the performance. Everyone went bananas, breaking into wild applause, raising glasses, cheering, shouting. People began rushing back from the lobby and the bathrooms, startled to have missed the finish. A backstage party followed, to which everyone was invited. Suckling pig was served; wine flowed. As I left at 2 am, a bunch of the singers—including women from the great Icelandic band múm—joined Ragnar and the lead tenor, locking arms and belting out Schubert lieder at full volume. All I kept thinking, and still do, was: *I have to go to Iceland.*

Originally published in New York *magazine, November 23, 2011.*

SHIRIN NESHAT

OverRuled

A PERFORMA COMMISSION / CEDAR LAKE

Shirin Neshat's film installations of the late 1990s, with their stark black and white images of men and women facing each other across impassable political and cultural divides, the sounds of their separation filling the distance between them, had a way of lodging in the minds and emotions of viewers caught in their midst. Such powerful visual storytelling, cinematic choreography, and surround sound had all the makings of live performance, which Neshat would later translate into *Logic of the Birds (2001)*, an evening-length stage production based on a twelfth-century mystical poem with 4,500 lines of rhymed couplets by Sufi master Farid al-din Attar involving thirty performers, a lead singer, and a stunning film triptych of startlingly beautiful and haunting landscapes. *OverRuled* similarly began with Neshat's video and

Shirin Neshat, OverRuled, *2011. Performance view with Mohammad Ghaffari. Photo by Paula Court.*

filmmaking sensibilities at the fore. Based on an earlier work, *The Last Word (2003)*, an eloquent and unsettling film opposing censorship and creativity, it showed the interrogation of a female writer by a fierce-looking male figure seated at a long table amongst shelves stacked with books and documents. The set for *OverRuled* was the same as the earlier work, as was the appearance of young men in long white shirts and black trousers, pacing back and forth as they filed and rearranged archival references and evidence against the accused. Joined by singers and a platoon of soldiers, *OverRuled* folded history and current affairs into a potent dissertation on politics and religion, using music, song, and rhetoric to articulate the back-and-forth between the forces of authority and the aspirations of artists for individual freedom. With intimations of the Iranian tribunals of 2010, in which artists and intellectuals were investigated by government forces following the uproar of protests by the Green Movement against the perceived fraudulent elections of the previous year; references to the tenth-century trial of Sufi mystic Mansur Al-Hallaj, and censorship of writers, artists, and filmmakers in contemporary Iran, *OverRuled*, both ritualistic in its structure and rapturous in its sound and poetry, showed again Neshat's ability to make riveting artwork from complex and profound source material. For her, live

Shirin Neshat, OverRuled, *2011. Production still. Photo by Paula Court.*

At left: Shirin Neshat, Over-Ruled, *2011. Performance view with Shadi Yousefian and Mohsen Namjoo. Photo by Paula Court.*

performance adds a level of intensity and direct connection to the audience. "I see performance art as an opportunity to have a collective event, where the artists and the audience have a shared experience," she said.

—RoseLee Goldberg

Interview

SHIRIN NESHAT

IN CONVERSATION WITH ROSELEE GOLDBERG

ROSELEE GOLDBERG (RLG): Shirin, it's been ten years since your first-ever performance, *Logic of the Birds* [commissioned and produced by this interviewer], and here we are producing a second, your Performa 11 Commission, *OverRuled*. It would be really interesting to hear from you what it means to work "live" and the role of performance in relation to your work in other media.

SHIRIN NESHAT (SN): Let me begin by saying that ever since I've become active as an artist, I've taken a very nomadic approach to art forms. I have moved rather quickly from photography to video, to performance art, and then toward cinema. At times, I've wondered, "Why so much change? Why am I so restless?" And I've come to the conclusion that, ultimately, an artist's work is a reflection of the artist's life and personality. I've learned to live as a nomad. I'm constantly on the move. I've never stayed in the same place for very long. I've embraced the idea of new beginnings, and I've felt the need to reinvent myself. In fact, I am terrified of stagnation and repetition. When I made the transition to filmmaking, as ambitious and difficult as that process was, I enjoyed the challenge and the element of the unknown very much. In many ways, all these transitions have kept me on my edge, and have made me feel vital and relevant—not in respect to the art world but to myself as an artist, feeling that I'm still learning, growing, and experimenting. Going back to photography, I remember my first series, called *Women of Allah* (1993–97), had a performative quality in the way that I posed for the images and played various

Shirin Neshat, OverRuled, *2011. Performance view. Photo by Paula Court.*

roles. Later, with the videos, the physical design of the installations created a situation where the audience was seated between the two screens, witnessing the story in two parts, never quite able to watch both sides at the same time. Therefore, the audience literally became a participant in the piece, as they were physically divided and engaged with the narrative. Later, cinema taught me about reconsidering the audience, as I moved out of the gallery and museum walls, away from a purely commodity-driven enterprise and toward a general public. When I first did live performance, I was

terrified. Unlike film and photography, where you can take time and edit, there is something unnerving about live performance, where you lose a certain amount of control and you find yourself at the mercy of chance, accidents, and the chemistry of the audience and of the performers.

RLG: Can you talk further about being terrified by live performance, and also about the difference between working in live mode and in film? They are such different worlds. In live performance, you can rehearse for weeks. I remember

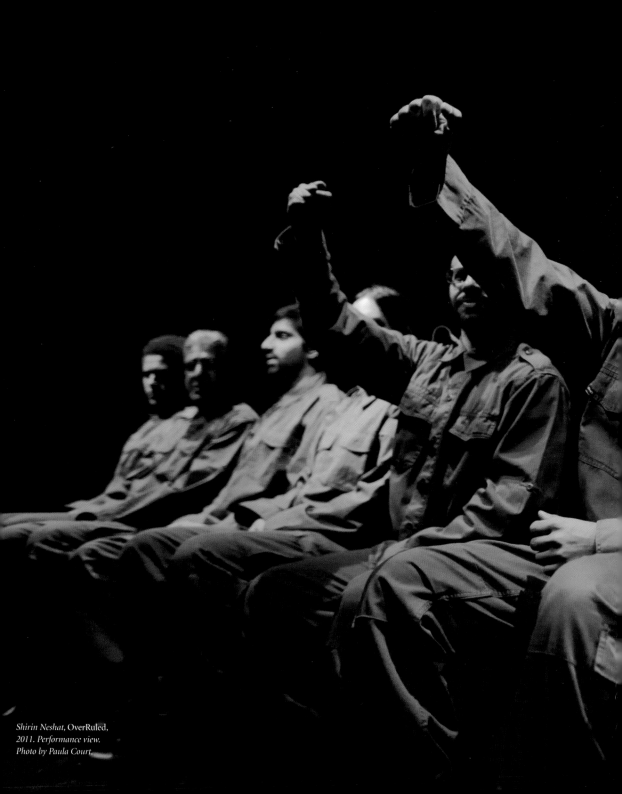

Shirin Neshat, OverRuled,
2011. Performance view.
Photo by Paula Court.

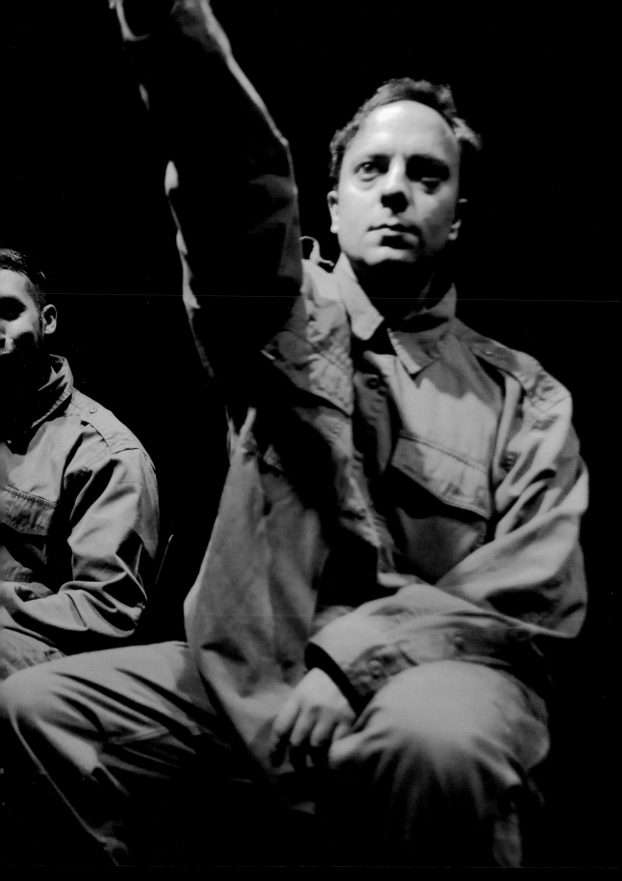

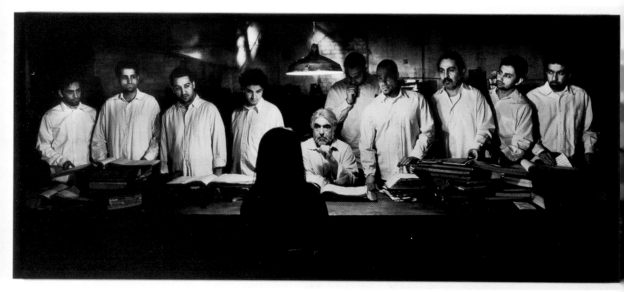

Shirin Neshat, The Last Word, *2003. Production still. © Shirin Neshat. Courtesy Gladstone Gallery, New York and Brussels.*

you asking me once, "Why do we need a whole week for rehearsal?" I said, "You will be grateful for that week later on." Afterwards, you told me, "Thank goodness we had that week. It has taken so long to figure it out." You do need time to build the work during rehearsal. Another thing you said that was fascinating to me was, "Eye contact—you said that there was something incredible about being with the audience." Could you talk more about this?

SN: The first live performance I did was *Logic of the Birds* (2001). I was coming from making photographs and ten-minute-long video pieces, so the idea of making a piece that lasted around

sixty minutes and that had a form of development (a beginning, middle, and an end) became a challenge. I realized that coming from still images and short videos, I rarely thought about the audience's attention span, as they could simply walk away. But in both film and live performance, you have the audience's full attention for much longer; therefore, one has to carefully calculate the narrative comprehension as well as the pacing and dramatic arc to keep the audience interested. I struggled with all of this at the beginning, as I realized that I was far more experienced in creating provocative images than in telling stories. The most helpful decision, in that regard, was to surround myself with people who have

the skills and necessary experience, such as my longtime collaborator and partner in life, artist and filmmaker Shoja Azari. Throughout the past many years, I have learned that, as artists, we must not overestimate ourselves. For example, just because we have made short videos, we are not qualified to make a feature-length movie; or if you have done photography, you are not necessarily fit to direct a performance piece. While we must take risks and experiment, we must respect and learn that every art form has its own language and set of rules. So blurring the boundaries between forms comes with a certain amount of education, responsibility, and, of course, excitement and anxiety!

RLG: How did your first live piece, *Logic of the Birds*, affect your subsequent work? Now that you are doing another performance, are you ready to go through that anxiety again?

SN: The first time I even allowed myself to think about a live performance was when we were shooting *Rapture*, a video I made in Morocco back in 2000. There were several highly choreographed moments, as one hundred women in black veils moved about in a natural landscape and one hundred men in white shirts moved through a fortress. As the men's and women's bodies moved in lines, circles, and triangles in juxtaposition with each other, an odd visual and aesthetic experience was created, not unlike a dance performance. The live experience of watching these bodies move in various landscapes was so incredible that I suddenly thought about how powerful it would have been if my audience had been physically present to watch the actual scene live, as opposed to encountering only its representation in the form of a video.

RLG: And what thoughts about your

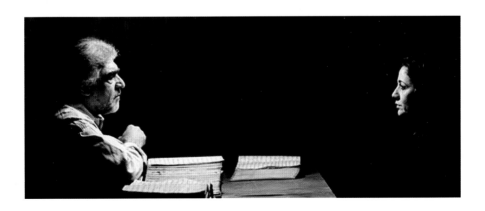

second performance piece?

SN: With *OverRuled*, I wanted to create a new experience for the audience, where for the first time they might feel that they are actually entering one of my videos or film sets. So there would no longer be a separation between the art and the viewer. I see performance art as an opportunity to have a collective event, where the artists and the audience have a shared experience. I suppose that is what interests me, as it is with filmmaking: the notion of community and redefining ways in which artists can engage and communicate with various audiences.

QUESTION FROM THE AUDIENCE (QA): What inspired you to make *Turbulent* (1998)?

SN: *Turbulent* was a piece that focused on the subject of how women are deprived of the experience of music and public performance in Iran. The video installation presented two projections on opposite walls, and the audience was seated between them. On one side, a male singer sang to a full theater, and on the other side, a female singer sang to an empty theater. If the male singer's passionate song was traditional, the female singer's powerful voice broke all rules of traditional music and pioneered its own expression. So at last, the piece became a form of confrontation between the

masculine and the feminine and between the conformist and the rebellious. I've felt that from most of my past work, *Turbulent* is the piece that has been unanimously understood, possibly due to the use of music that struck an emotional chord with the audience and offered a truly universal resonance.

QA: Your work is formed and influenced by cultural issues. Does your community in your country of origin have access to your work? How do you think your work empowers those communities, especially women?

SN: As most of you are aware, Iran is a dictatorship and artists such as me pose a problem for the government. I haven't actually been able to go back since 1996, but thanks to technology, the Internet, and the power of piracy, my work has been widely seen there. I was really shocked to discover how many people had seen *Women Without Men* (2009), even in small towns, all throughout Iran. Culture has a great place in Iranian society, and artists are central to the social and political discourse. Since the 2009 election, artists have been very vocal through their work, through their participation in protests, and through speaking in the media against the regime. Oddly enough, for a country that censors, arrests, and imprisons its artists, artists have become the government's

Shirin Neshat, OverRuled, *2011. Performance detail. Photo by Paula Court.*

greatest threat and art has become a form of resistance. One of Iran's most important living filmmakers, Jafar Panahi, has been sentenced to six years in prison and banned from making films for twenty years in punishment for his recent films, but also for being active in the Green Movement. I think all such artists' lives are at risk, whether they are living inside or outside Iran.

QA: What do you think of the revival of performance art? Performance is more accepted now than it was ten years ago. Why do you think this is happening?

SN: I am not as knowledgeable about the history of performance in the West as I should be. My inspiration for live performances is rooted in my Middle Eastern background. I see what I am doing less as a piece of theater than as an "event," which relates to my interest in activism and in bringing together politics and art to the general public.

Excerpted from a conversation between RoseLee Goldberg, Shirin Neshat, and an audience, hosted by the New York Public Library on October 5, 2011, in celebration of the publication *Performa 09: Back to Futurism.* Originally published in Julieta Aranda and Carlos Motta's Performa 11 project, *Broken English.*

MIKA ROTTENBERG & JON KESSLER

SEVEN

NICOLE KLAGSBRUN PROJECT SPACE / PERFORMA 11
COMMISSION

Mika Rottenberg's videos of women engaged in absurdist acts of production use the body as a primary tool; Jon Kessler makes video-rich kinetic sculptures. Both address social and political topics, and share a Rube Goldberg-esque approach to make their point. Their collaborative effort, *SEVEN*, a thirty-seven-minute performance and film, was predictably complex. Amid a standing audience in gallerist Nicole Klagsbrun's project space in Chelsea, seven performers of varying race, age, and body type donned spa robes and bathing suits to engage in the ritual-like production of "chakra juice," which was bottled, instantaneously "transported" across the Atlantic, and reactivated to produce a spectacle in the southern African savanna.

SEVEN's New York actors each represented a chakra—vital energy centers located at seven points in the body—and its corresponding color, and they took turns clocking in and pedaling a stationary bike to power a potter's wheel set inside a saunalike Plexiglas- and wood-framed "chakra

Mika Rottenberg and Jon Kessler, SEVEN, 2011. Performance view. Photo by Paula Court.

Mika Rottenberg and Jon Kessler, SEVEN, *2011. Performance views. Photos by Paula Court.*

juicer." There, another performer sat, spun, and sweated, while an engrossed technician in a lab coat and face shield oversaw the intricate distillation of each performer's perspiration. This "juice," encased in a clay cylinder, was then sent off through a pneumatic tube, and the audience next saw—via video—the chromatic sweat received by a lab technician in rural Botswana. Colored lights corresponding to each chakra indicated the progressive stages of completion, and when the spectrum was illuminated, it was clear that all seven vials had been delivered. The performance culminated on-screen in Chelsea, as the tubes were ceremoniously carried to the Botswana desert, unpacked, and poured into the arid earth in front of a small audience. The resultant spectacular, Disney-esque mirage was met with cheers from the audience in New York.

—*Katie Sonnenborn*

Interview

MIKA ROTTENBERG & JON KESSLER

IN CONVERSATION WITH KATIE SONNENBORN

KATIE SONNENBORN (KS): I'd like to begin with the genesis of *SEVEN*. Where was this work born, and how did the various pieces of it come to be?

MIKA ROTTENBERG (MR): For a long time, Jon and I thought it would be really cool to do a piece together because there are certain things in our work that connect: mechanisms, sort of jerry-rigged systems, and humor. The idea of collaboration had been in the air for a while, and when the Performa Commission came up, it seemed perfect because I wanted to really use it as an opportunity to make an experimental piece, whatever that means—try mediums that I hadn't tried before. And I think collaboration always pushes that because you're a little less responsible in a way, so maybe you allow yourself a little more experi-

mentation. So we talked about it for six months, and then we zoomed in on this one idea.

KS: A compelling aspect of the piece is the synchronicity between the film and the performance. You made the film first; how much of the performance had you mapped out in your mind?

JON KESSLER (JK): It was not a complete script; Mika had lots of things she knew she had to cover, but a lot of it came from the building of the piece itself. It was sort of like it couldn't be made until it was made. But I think what's more interesting is that six-month period of brainstorming and talking: We had some really wacky ideas—dropping things out of planes, and UPS trucks coming to the gallery and shipping stuff to Africa. And

then at a certain point we thought, "Wait, we really have to do this thing," and so real, practical conditions set in, and we started to nail down a sense of the "real," as imaginary as that was going to end up being.

MR: It was successful for me because we both really cared about what the viewer would get out of it, and we made a piece that is really communicative. There was no gap between what we thought we were doing and how it was perceived, hopefully.

KS: It's very cohesive. That's why I am so curious about the making of the film, because it is so integrated into the performance.

MR: Jon worked on all the sculptural elements in the gallery, and I worked on the film, and we had a lot of freedom within our respective parts. The really experimental aspect, as Jon was saying, was that we didn't know how it would turn out. We put the ingredients in, and we activated it.

JK: Mika had to get onto a plane with two people, and certain objects, props,

were then going to echo the actual performance. So, in some ways, we were writing the prequel and the sequel at the same time: We were writing the future and sending something off in a time capsule.

KS: How scripted were the performances? Did the performers in either, or both, locations play a significant role in determining how the piece developed?

MR: In Botswana, it was a real challenge because the people we were working with had barely even seen a TV, let alone a film or performance video art. It was a challenge to work with them, but I had a translator. They thought we were mad at first, but by the end, they became more and more convinced that maybe we knew what we are doing and we weren't these crazy people from New York with LEDs and weird suitcases. We also worked with cinematographer Mahyad Tousi and editor Steve Hamilton, so it was really good to have that kind of support, and it gave me faith that it was going to be cut right.

KS: And the performers in New York? Did aspects of the piece change over the three-week run?

Mika Rottenberg and Jon Kessler, SEVEN, 2011. Film stills.

JK: Well, the protagonist, the most important person, was the lab technician.

MR: Asia.

JK: That's right, Asia. We did a casting call, and Mika really took charge of that because she works with real people. [*Laughs*] I don't, and she's really good at that. All walks of life were represented—the fashion model and the tall guy and the fat dumpy guy; we were really looking for the whole mix. And then we had a person whom we sort of settled on to be the lab technician but who couldn't really get the cues. There were a lot of cues—I don't know if it really comes off that way for the viewer, but you really have to be paying attention. You don't have much downtime, and you're cued with something virtual, something mediated.

Asia came after we fired the original lab technician, and we kept saying to her, "Don't act so much—it's just a job, you're just going through the motions." She is an amazing performer, and she was connecting with the audience and the audience was connecting with her. It worked.

MR: Part of the success was due to the fact that she is an athlete, a wrestler, and we found that someone needs to be either a dancer or an athlete to be able to perform for so many hours. It can't be a regular person.

KS: Yes, it seems like a very taxing performance. Jon, you mentioned Mika works with people. One difference I see between your work is that for Mika, the relationship between the viewer and the performer is mediated, and the viewer watches, but doesn't enter, the piece. In contrast, Jon, you sometimes implicate your viewer, trapping her in the crossfire through real-time video relay. Did the collaboration on *SEVEN* reveal anything about your individual practices, particularly with respect to the relationship between the viewer and the action?

JK: You are right about the different ways in which we approach the spectator, but actually the space itself brought the two together. We were not necessarily looking for something as small as Nicole's space, but there was this incredible intimacy between the performers and the audience that we liked. If we had done it in a proscenium situation, where you are watching from afar, it wouldn't have been as interesting.

Let's talk about the end, because for me that was such a success, but it also tells you about the nature of collaboration. Part of the collaborative process is that you brainstorm, you workshop, you go back and forth, but from collaborations that I've done, they always ended up being separate parts of the whole. Like, I'll take Paul Auster's text and Christopher Wool's paintings and I'll put

them together on a sculpture [as in *Word Box*, 1992], and that's the collaboration. In this case, Mika really had a vision for the ending—she was seeing something that had a *Fantasia* quality to it. We had gone through a lot of different possibilities; there were going to be fireworks…

MR: Yes, that was the hard part—finding out what we could do that would be climactic.

JK: It was so important because it was the climax of the whole performance, and we wanted to give people something; we wanted to honor those thirty-something minutes that the audience had sat there.

KS: I thought the end was great. There was a joyous moment in the gallery when everybody was clapping, and we saw the people in Botswana clapping. The feeling of connection superseded the rational understanding that those moments were not actually simultaneous.

Let's talk about the political subtext of the narrative: the chakras, the life forces, to and from Africa; the sweat from the New York art world; a ritual passage from New York back to the soil of the savanna. Could you talk about the politics of production, of spectacle, and how you see them relating to *SEVEN*?

JK: I guess we address those issues without being ideological or didactic, so that

the art comes first and it's embedded with ideas that drive the work forward. It could be seen as totally frivolous or it could be seen as having real agency. This performance is generous to us and our audience in so many different ways.

KS: What about the relationship between the hyper-commercial context of Chelsea and the remote savanna? The extreme polarity of the locations seems to be an essential aspect of the work.

JK: We didn't know it was going to be in Chelsea when we made it. We talked about church locations on the Lower East Side that Performa would find for us. Chelsea came later.

MR: But it was important for us that it would be in New York and that it was for Performa. And so, to turn it around in Africa, the performance is supposedly about this group of people sitting in the middle of the savanna. It's about that idea—the spectacle, the payoff.

JK: We were very concerned because we did not want it to be an exploitative situation.

MR: Yes, and in the end, we thought we should bring the people from the village in Botswana [to New York]. It was important to me that they should receive a performance too. And the amazing

Jon Kessler, sketch for SEVEN, *2011.*

thing was that our filming was an amazing performance for them; I didn't have to juggle or do fireworks. Watching my crew and me trying to rig this crazy suitcase that Jon made, with the lights and the cameras—this bunch of weird white people trying to make video art—was a performance for them.

KS: The context of the production of the chakra juice in a very commercial space impacted the way that I understood the work. If you reprised it in a different scenario, would you change the piece?

JK: Location was important, but we are looking to travel the piece. The extreme polarity would exist almost the same

in a museum in Paris or at the Venice Biennale. The work would get reconfigured and changed, and we'd find local actors—local performers, because everybody has chakras.

KS: We're now more than a year past the performance—has it changed in your mind? Is there an aspect of it you'd like to address that we have not touched on?

JK: We both felt that this piece is very special because you could really see aspects of Mika's and my work, but it's not something that either one of us would have made without the other. It was like one plus one equals three.

MR: Yeah, you can't give a hundred percent because you have to leave room for the other person. So you both give fifty percent, and you receive two hundred percent.

KS: It was beautifully complex, absurd, and a pleasure to watch. What were the particular challenges for you, Jon?

JK: It was a challenge to reverse engineer the machines to anticipate the function, which we would be inventing.

KS: And you, Mika?

MR: I learned because I work with people, and I attempt to direct them, and

I never think I'm a good director. Working live, the actors are actually making a much bigger effort than if it were filmed. I was expecting the opposite, so that was a bit challenging—how to appear real, even though it was real.

KS: And did you find that it got harder as the three weeks progressed?

MR: It was a lot easier. I think the performers get excited by people and overact. When you shoot, they are so tired from shooting the same thing so many times that they are tired enough to not really act, and that's what ends up in the film.

JK: We must have looked at fifty, sixty people, and we settled on seven performers. It was sort of like *Gilligan's Island*, where everyone had their funny personality and basically stuck with it the whole time. We lived with them for, like, a month, and they lived in these sweaty conditions. We made the conditions as nice as we could: We had bathrobes, water, candy, juice, but we were asking them to get into a sauna every twenty minutes. They were troupers. A lot of them were actually out-of-work actors.

MR: Yeah, I was worried about their chakras!

*Jon Kessler and Mika
Rottenberg, SEVEN.
2011. Film still.*

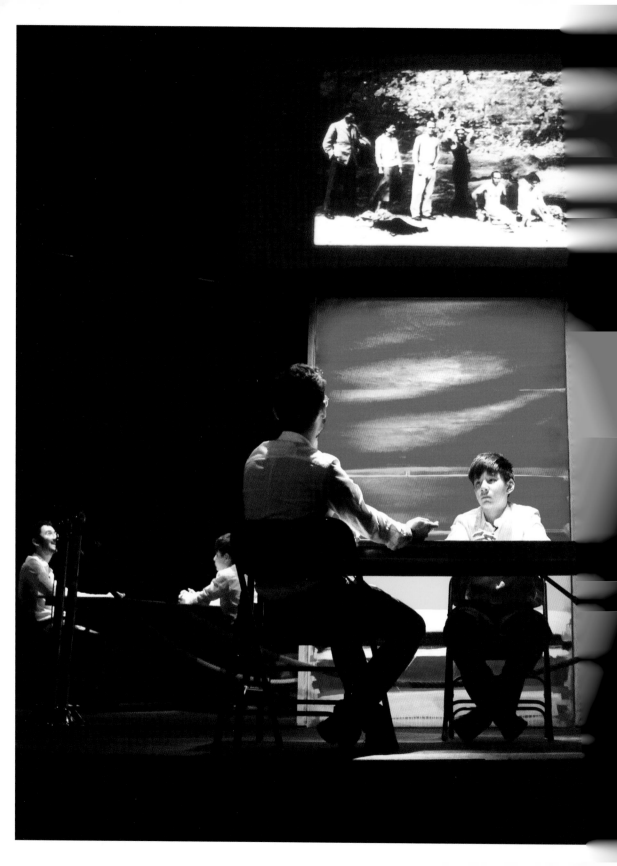

SIMON FUJIWARA

The Boy Who Cried Wolf

ABRONS ARTS CENTER / PERFORMA 11 COMMISSION

Simon Fujiwara's work is inextricably linked to his own biography, yet he is plagued by surrogate identities. His live performances, writing, installations, and films veer from the intimate to the absurd, creating engaging and loaded narratives that are candid inquiries into culture, history, sexuality, and politics. Through the stories and anecdotes crafted by his assumed personae, he questions our notions of historical and collective memory and examines its malleability. He is a conceptual artist with a subversive and infectious sense of humor.

Simon Fujiwara, Artist rendering of The Mirror Stage, *2009–2012, act one of* The Boy Who Cried Wolf. *At left: Simon Fujiwara,* The Boy Who Cried Wolf, *2011. Performance view. Photo by Paula Court.*

Born in London in 1982, Fujiwara divided his childhood between Japan, Europe, and Africa, completing a degree in architecture at Cambridge University before moving to Frankfurt, where he studied fine art at the Städelschule Hochschule fur Bildende Kunst. Fujiwara assumes the collective roles of author, actor, and anthropologist while enlisting friends and family members as various collaborators and actors in performances about personal and family relationships, art history, and politics. By engaging diverse modes of conveyance from slideshows to talk shows, Fujiwara channels his own psyche, history, and culture through a kaleidoscopic lens. Fragmented elements are tightly woven together into episodes that are conceptual, hilarious, and poignant inquiries into our constructions of reality. His works guide the audience through a labyrinth of absorbing narratives where momentum steadily builds through forged connections.

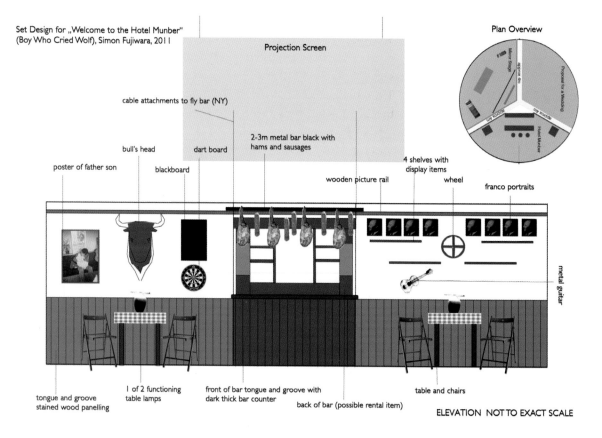

Set Design for „Welcome to the Hotel Munber"
(Boy Who Cried Wolf), Simon Fujiwara, 2011

Plan Overview

Projection Screen

cable attachments to fly bar (NY)

2-3m metal bar black with hams and sausages

bull's head

dart board

4 shelves with display items

poster of father son

blackboard

wooden picture rail

wheel

franco portraits

metal guitar

1 of 2 functioning table lamps

front of bar tongue and groove with dark thick bar counter

table and chairs

tongue and groove stained wood panelling

back of bar (possible rental item)

ELEVATION NOT TO EXACT SCALE

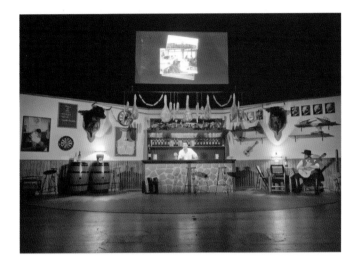

The set of The Boy Who Cried Wolf *during act two,* Welcome to the Hotel Munber. *Photo by Paula Court.*

At left: Simon Fujiwara, artist rendering of Welcome to the Hotel Munber *(2010), act two of* The Boy Who Cried Wolf.

The Boy Who Cried Wolf is a theatrical performance, set in three parts with three different set designs, which take place on a revolving stage. The piece brings together two of Fujiwara's performance works, *The Mirror Stage* (2009–12) and *Welcome to the Hotel Munber* (2010), with a new work created in New York for Performa 11, *Proposal for a Wedding.* In its simplest essence, the ensemble abstracts Fujiwara's discovery of his sexuality, his family's history in Spain, and a found roll of film. The result is a fictive and entertaining two-hour-long illustration of Fujiwara's derailment.

The first act, *Mirror Stage*, a semiautobiographical coming-out story, forms the first act. It takes place at Tate St. Ives, Fujiwara's hometown museum. An actor portraying an eleven-year-old Simon and the artist himself both gaze at an Abstract Expressionist painting by Patrick Heron. Fujiwara queries his younger persona about the sexual epiphany that follows, in order to examine the psychological and cultural underpinnings of this encounter.

The stage for the second act, *Welcome to the Hotel Munber*, is the bar that Fujiwara's parents owned when they lived in Spain under Franco's rule in the 1970s. Serenaded by a Spanish guitarist, Fujiwara reads aloud from and critiques a failed attempt at an erotic novel he wrote about their lives.

The third act, *Proposal for a Wedding*, is based on the con-

Bottom: The cast of Aladdin take a well-deserved bow

First along: Mr Hulme and nine bonny bridesmaids

Second along: A ghostly scene from Adrian Kramskoy's Be it ever so humble (Rendalls)

Bottom Left: After Magritte

Photos: Angela Cannon

Yearbook photograph of Simon Fujiwara and Phineas Pett in a production of Aladdin *in London, 1999. At left: Simon Fujiwara*, The Boy Who Cried Wolf, *2011. Performance view. Photo by Paula Court.*

tents of a camera Fujiwara found in the back of a New York City taxicab. After developing the film, he discovers that the camera belonged to a seemingly normal and happy couple: Their banal photographs document three weddings they attended. Fujiwara and his best friend from high school, actor Phineas Pett, attempt to farcically restage all the weddings themselves, exploiting the strangers' privacy, yet revealing nothing surprising. Through their mockery, they discover they have more in common with the strangers than they hoped.

In this epic narrative, Fujiwara's childhood, family history, and life as an artist and human being are mined through engaging episodes, simultaneously sampling from political and cultural history. Fujiwara is an ingenious storyteller, one who both excavates and concocts juicy histories and animates them with exaggeration and humor. In his works, we become voyeurs in a complex space of self-reflexivity and analysis, and we are utterly captivated.

—*Jens Hoffmann*

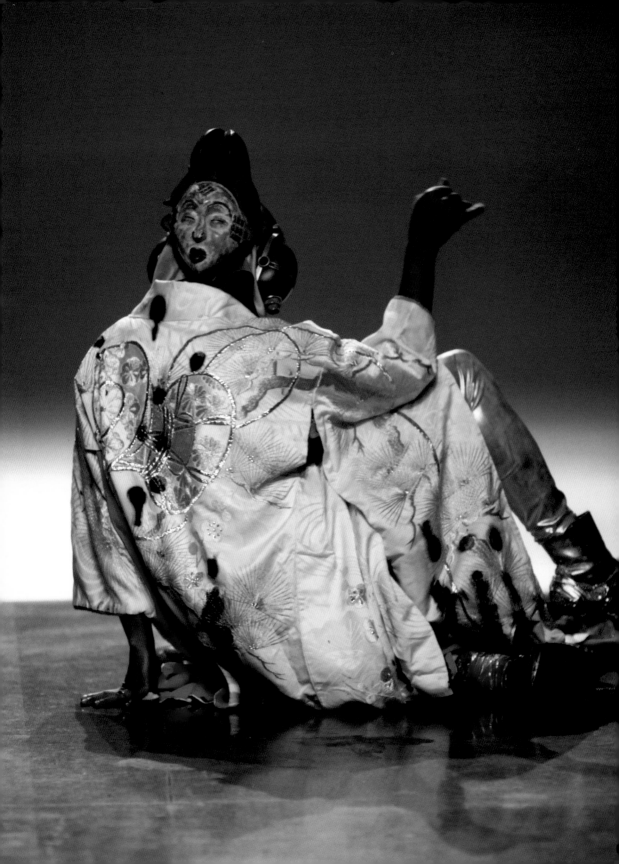

IONA ROZEAL BROWN

battle of yestermore

SKYLIGHT WEST / PERFORMA 11 COMMISSION

Iona rozeal brown's Performa Commission, *battle of yestermore*, was a remarkably complex, multivalent, and polyvocal work, and the artist's first live performance. It brought to life the aesthetics and content of her richly colored paintings of voluptuous figures draped in patterned kimonos and wearing elaborate headsets amidst intricately drawn boom boxes and turntables. Brown's fantastical hybrid compositions, which combine the seemingly incommensurable cultures of American hip-hop and Japanese kabuki and Noh theater, further blended the hyper-stylish movement vocabulary of "voguing," made famous in the Harlem ballroom scene that began in the 1960s and reached its height in the eighties. Together, the vibrant resources of these theatrical and dance histories combusted into a deliriously sensual and strikingly visual performance.

Brown's interest in Japanese performance extends back to her childhood in Washington, D.C., where she first saw Kabuki theater, and where she began what would become a lifelong devotion to the overwhelming elegance, grace, and form of Kabuki master Band Tamasabur V, and which would take her to Japan in 2001 to further her studies. Coming of age as she did in the 1980s, with hip-hop as a multifarious collection of art forms, including breaking, graffiti, rap music, and DJing, and which was enormously popular in Japan while she was there,

iona rozeal brown, battle of yestermore, 2011. Performance view. Photo by Paula Court.

led brown to search even more closely for points of contact between the ancient theatrical form and the contemporary hip-hop scene. The connections would soon be incorporated in brown's paintings, but it was not until *battle of yestermore* that the full extent of her research would be put to use. Having long dreamt of producing a contemporary Kabuki performance that would fuse pop culture idioms and hip-hop music as well as the sophistication and precision of Kabuki style, it was with the Performa Commission that she would finally be given the opportunity as well as the support and context to realize her vision.

Combining voguing, hip-hop, and Kabuki in *battle of yestermore* into an aesthetic entirely her own, brown's performance showed the striking similarities that exist between the three artistic forms. One such affinity is the "battle." In both voguing and hip-hop, the battle constitutes the entire structure, meaning, and significance of the performance, whereas in Kabuki, it plays an important role in the act immediately following the opening or directly preceding the end, ensuring advancement of the plot, drama, and excitement. All three of the performance styles also place emphasis on geometric formation: In breaking, it is the circle, or cipher, in which the dances take place; in voguing, it is the line formed within the dance movements; in Kabuki, it is the stage set. What matters, however, is the fluidity, improvisation, and technique demonstrated by individual performers within these frames and their rules. Kabuki stage sets, similar to runways used in voguing, feature a walkway that extends into the audience and on which the most dramatic aspects of the performances take place. Then there is the formal sensibility of sheer excess among the three forms as expressed in clothing, jewelry, and costumes, the extensive training required to master their techniques, and the nature of public spectacle inherent to their styles of presentation. However, these instances of excess and spectacle as seen in voguing, hip-hop, and Kabuki are all manifestations of the theatricality of everyday life—the continual theater of daily life that establishes our reality.

The awe-inspiring and remarkable Benny Ninja and Javier

iona rozeal brown, E.I.N. intrusion (watch out for the big girls). (After Yoshitoshi's "Onogawa Kisaburo, from One Hundred Tales of Japan and China"), *2008. Mixed media on panel. Courtesy of the artist and Salon 94.*

Ninja of the renowned House of Ninja, who captivated the audience in their leading roles as *onnagata*, did not disappoint, mesmerizing all with their languid and dazzling voguing moves. The House of Ninja, one of the most important voguing collectives, was established by the legendary Willie Ninja, an extraordinary performer and paradigmatic fixture in ball culture who influenced and worked with pop culture icons such as Madonna and Malcolm McLaren. In Kabuki tradition, male actors impersonate women, playing the female characters by transforming into an onnagata, or "woman-role." KAE, deftly performed by Javier Ninja, was replete in geishalike white makeup, a fantastic matte brown fabric headpiece resembling

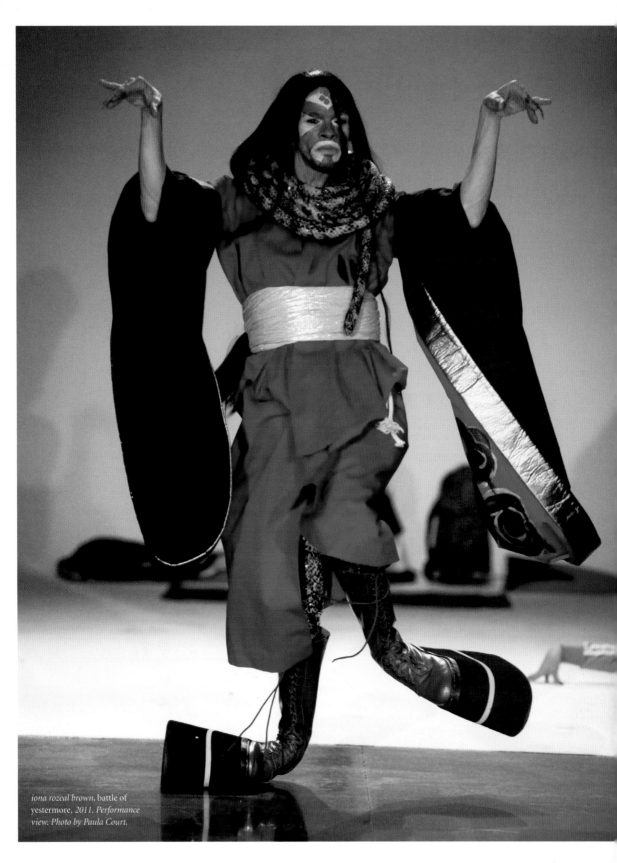

iona rozeal brown, battle of yestermore, *2011. Performance view. Photo by Paula Court.*

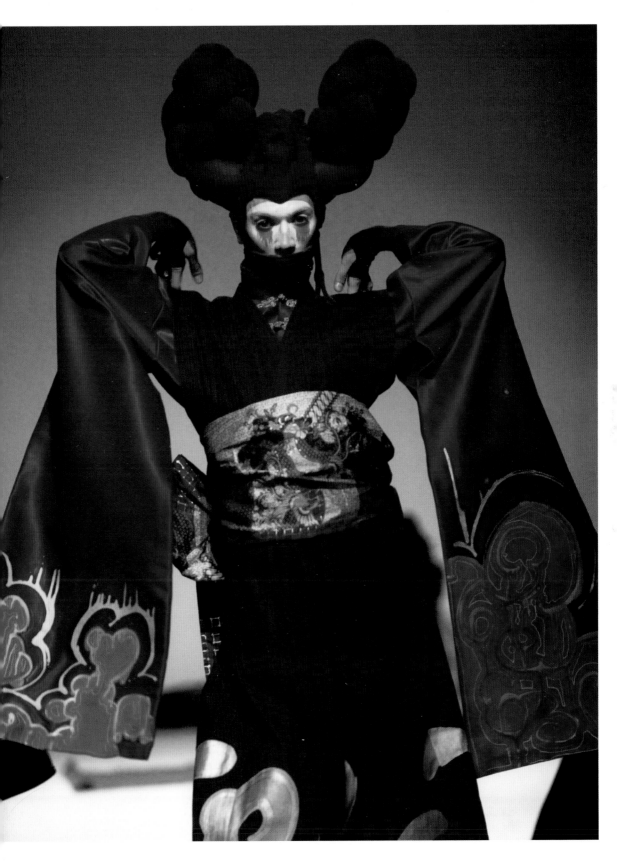

elaborately braided dreadlocks, attired in a royal blue and magenta floral-print kimono, with a long sweeping navy and gold dress billowing underneath, fastened by a turquoise-and-gold-patterned *taiko musubi obi*, and carrying a cerulean and java-colored paper parasol. The utterly captivating and visually compelling costumes were designed by brown, who also illuminated them with hand-painted flourishes, in collaboration with stylist Brent Barkhaus.

Javier Ninja, escorted by the Attendants (classical support performers in traditional Kabuki theater) who assisted him, executed several dressing rituals such as opening his parasol, putting on his shoes, and adjusting his kimono. With the Attendants, he then encircled the audience through a series of methodical syncopated popping, sliding, and wobbling lunge movements, casting larger-than-life shadows on the walls. KAE enacted a coy dance of seduction throughout his performance, as his svelte limbs elegantly transitioned through a range of fantastic gestures, nimbly manipulating his long, flowing kimono sleeves.

The incomparable Benny Ninja in green, white, and red geometrically painted makeup; a massive, metallic serpentine necklace; a claret, gold, and black kimono of epic proportions; and a pair of silver platform lace-up boots that were at least a foot high, fiercely walked the stage, hypnotizing the Attendants and audience alike with his silver finger claw, rendering them motionless. The magnificent current Father of the House of Ninja then sashayed down the runway, manipulating his arms and hands in a highly stylized presentation unique to voguing, involving hand and wrist illusions and limb contortions at the joints, including ankles, in a kinesthetic flow.

Javier Ninja and Benny Ninja ultimately faced off through a mind-boggling number of voguing movements, at times mirroring one another. Shade was thrown at the "B-girls" as gestures of boredom: Benny Ninja twirled his long black hair while looking at them. B-girls, or "break girls," perform a style of street dancing, or breaking, that originated in the black communities of New York City in the 1970s. During the finale, the two aesthetic styles of battling converged: A mixture of

voguing and breaking collided in a simultaneous freestyle.

battle of yestermore began in near-total darkness with Monstah Black (dancer Reginald Ellis Crump) prancing up and down the center of the stage. Dressed in a gleaming silvery-taupe kimono with crimson-red trim and shiny metallic leggings with his head swaddled in a silk chartreuse scarf, his elegant and lean arms alternated from one being outstretched with flexed wrist to the other bent at the elbow, occasionally cupping his enormous black headphones. Shoulders, torso, arms, hips, and legs undulated and swayed as he strode in perfect balance, at times crouched low or with legs extended, walking in massive, heel-less gold platform boots, occasionally revealing an African mask worn on the back of his head.

The Attendants accompanying Javier Ninja were Ana "Rokafella" Garcia, G.I. Jane, a.k.a. Rossana Villaflor, and Jennifer "Beasty" Acosta, and with Benny Ninja were Lisa "MonaLisa" Berman, Yuko "Uko SnowBunny" Tanaka, and Jennifer "Lady Beast" Viaud. The Attendants were costumed in Asian conical straw hats, Adidas track suits, backpacks covered in a mélange of swatches of traditional Japanese fabrics, graffiti-painted Adidas shell-toe sneakers, and legwarmers. The Attendants took their turn performing an array of classic break moves such as locking, popping, freezing, uprocking, and downrocking with astounding swagger.

battle of yestermore, a forty-minute piece, featured text by Mendi Obadike, who served as *griot*, or storyteller, throughout the performance, as she relayed a narrative that revolved around an epic battle between princesses. Keith Obadike performed live sound alongside brown as she spun beats at the turntables. Together, they seamlessly interweaved African tribal beats, jazz swing, and syncopated house music. The flow of the performance, with its dramatic pacing—beginning with slow movements, then quickly speeding up, and abruptly ending—was reminiscent of the structure of Kabuki and Noh.

—*Adrienne Edwards*

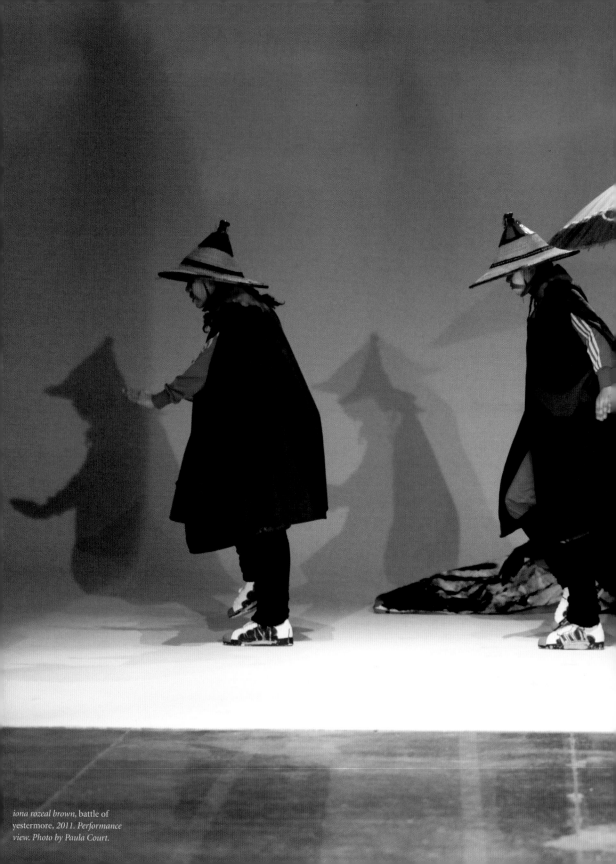

iona rozeal brown, battle of
yestermore, *2011. Performance
view. Photo by Paula Court.*

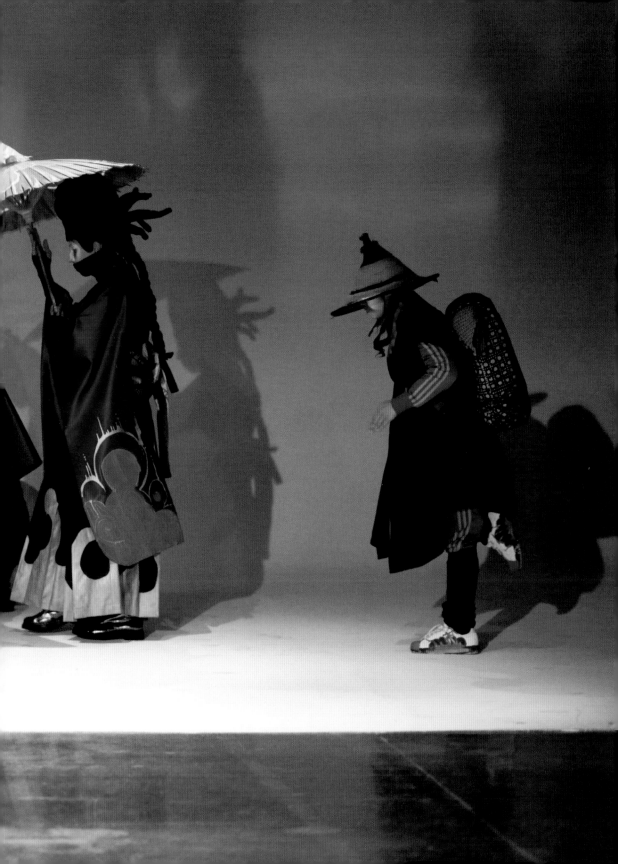

TAREK ATOUI

Visiting Tarab

SIR STAGE37 / A PERFORMA 11 COMMISSION WITH SHARJAH ART FOUNDATION

When he was growing up in Beirut, Tarek Atoui had little interest in Arabic music. He wasn't alone; many Lebanese of his generation, myself included, tuned in to mainly American and European music. He left Lebanon in 1998 and moved to France, where he studied contemporary and electronic music at the French National Conservatory, in Reims. Since he graduated in 2003, he's been traveling the world performing his own brand of sound art, which relies on manic body movements to control the sounds of machines he builds himself. Much of it involves knob turning, he says, "like playing systems of faucets."

Atoui has made music about Lebanon before—this piece, from his *Un-drum* series, draws upon his arrest and torture during the 2006 war—but it wasn't until he received an invitation to participate in Performa 11 that he immersed himself in his own musical heritage. After some preliminary research, he decided to focus on *tarab*, a trancelike effect associated with a form of Arab art-music from the early twentieth century. (To get a taste of tarab, listen to the Sufi singers Abdel Nabi al Rannan and Asma al Koumsariya.) Atoui was attracted to the improvisation, which binds the audience to the performer. "Tarab is not a music genre but a state of 'melotrance' that you reach after being exposed to music for a certain amount of time," Atoui told me. Tarab, he said, "used to happen in courtyards, where people would come and sit for hours."

While he delved further into tarab, Atoui remembered hearing about Kamal Kassar, a Lebanese lawyer, musician, and collector of traditional Arabic recordings. Kassar had spent years scouring the Middle East and beyond for rare old 78-rpm discs

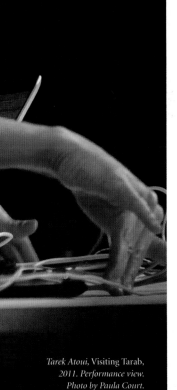

Tarek Atoui, Visiting Tarab,
2011. Performance view.
Photo by Paula Court.

Research materials, clockwise from top left: musician Kamel al Khoula, singer Abed al Hamouli, musician and composer Dawood Hosni, and singer Abdel Hay Hilmi.

and studio tapes dating back to 1903. Atoui invited musicians he wanted to collaborate with for the Performa commission—from the experimental hip-hop musician DJ Spooky to Tokyo-born composer Ikue Mori—to Lebanon to peruse Kassar's stash. "The idea was to open up the collection to a number of musicians from different practices but all related to sampling," Atoui said. He saw this as an opportunity to not only educate other musicians but also himself. "Even though I am from this culture and this region, I knew as little as they did."

Kassar, who has created a foundation to digitize and preserve his collection, proved to be an avid teacher. In his climate-controlled music pavilion in the Lebanese mountains, Kassar

treated the musicians to hour-long lessons in Arabic music history. These not only included recordings played on an old gramophone but also archival images and film footage as well as live performances. "Kamal created this environment that was like being in a space out of time," Atoui said.

As he went through the music, Kassar explained the difference between Arabic forms such as *doulab, qasida, taqsim,* and *samai.* (Those of us who have not enjoyed Kassar's private lessons can learn more on the websites Maqam World and Traditional Arabic Music.) To render the music more accessible to his guests, Kassar divided the material into sections—urban, rural, religious, etc. Mori was drawn to a rhythmic form called *bashraf;* others found an affinity with the breathing of Koranic music, drumming from the north of Egypt, Sufi music from the south. After choosing the tracks that appealed to them, the visitors returned home to work on their own compositions for Performa.

They kept in touch with Atoui, who had to figure out how to bring all the pieces together. "A lot of them were careful about not offending this culture," Atoui told me. "They were very precise about how they cut sentences to the meaning of the songs."

At Performa, Atoui strung the works of the sixteen invited musicians into three suites of about an hour and a half each. The performance opened with Atoui's own composition, based on a traditional set of Egyptian violin solos filtered through his custom-made electronic contraptions and interrupted by a variety of samples of film and ambient sound. After his solo, each of his collaborators took the stage to play his or her own piece, with Atoui returning several times during the evening to improvise. He directed another tarab session the following March in Sharjah, in the United Arab Emirates, this time with an Arabic orchestra and seminars on traditional and contemporary music. If his generation were better informed about their musical heritage, Arabic music would, Atoui says, "take a completely different shape."

—*Nana Asfour*

Adapted from the New Yorker *website, November 4, 2011.*

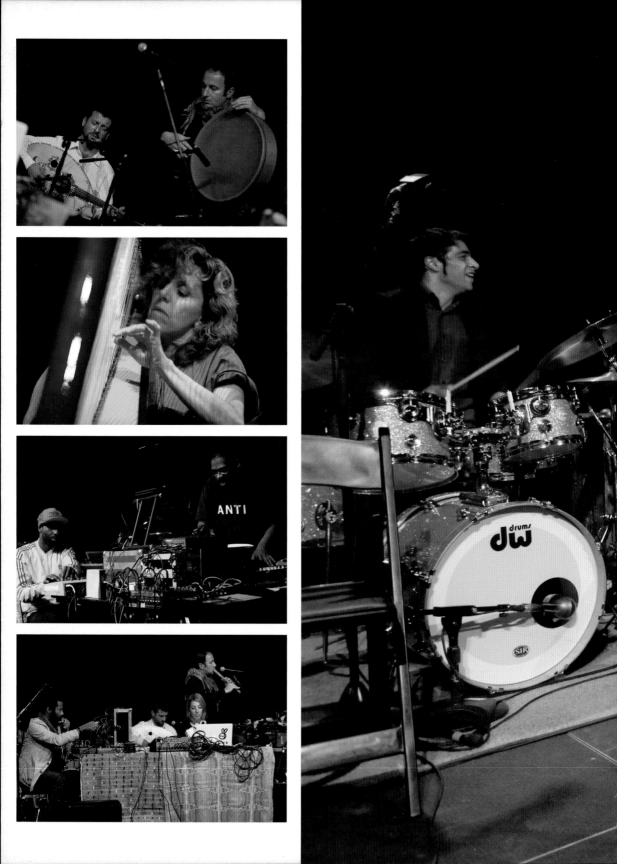

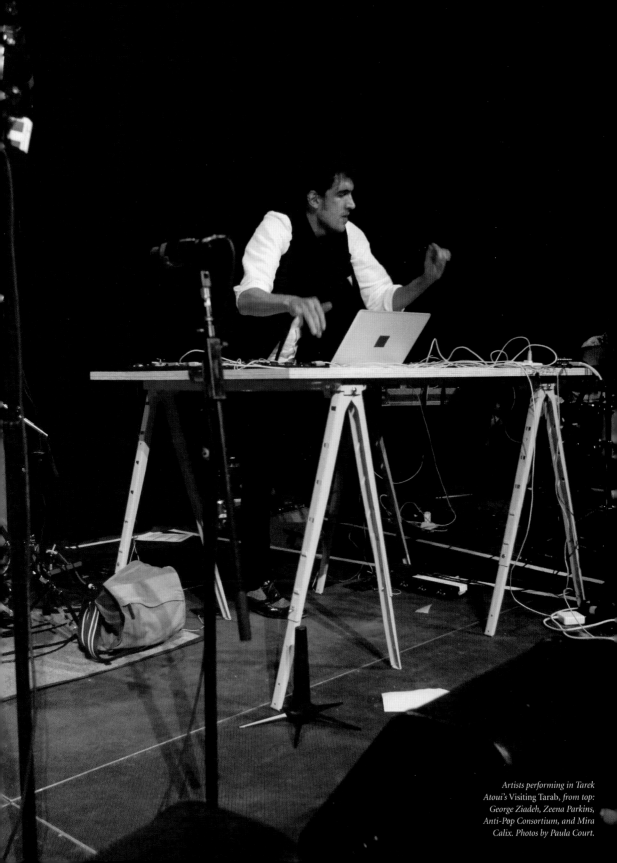

Artists performing in Tarek Atoui's Visiting Tarab, *from top: George Ziadeh, Zeena Parkins, Anti-Pop Consortium, and Mira Calix. Photos by Paula Court.*

GERARD BYRNE

In Repertory

ABRONS ARTS CENTER / PERFORMA 11 COMMISSION

A one-night event, Gerard Byrne's minimalist *In Repertory* took place in a dark, low-ceilinged storage space under the main stage of the Abrons Arts Center. Revealing his long-standing interests in theater and literature, the artist examined the machinery of theater—front-of-house, backstage, rehearsal space, lighting board—which he used to populate a confined space that was both theatrical in content and sculptural in form. Byrne added a number of stage props—a tree, a construction with noose (replicas of sculptures by Isamu Noguchi and Alberto Giacometti), and a briefcase and a pair of old shoes (a reference to Samuel Beckett's *Waiting for Godot*).

A casting agency assembled local actors to audition for "an experimental performance" with their own prepared monologues. Without explanation, a stream of actors, young and old, entered one by one to audition, surprised by the close proximity of the audience in the basement space, the props, and Byrne standing nearby with a cameraman. The artist whispered stage directions to the actors and gave instructions to the cinematographer. Fragments of well-known plays (*Romeo and Juliet*, *Waiting for Godot*, *Love's Labour's Lost*) filled the air as the actors performed amongst the various elements of the setting, which enhanced, subverted, and colored their presentations.

Byrne has used such conceptual manipulation throughout his career. He brought Brechtian staging techniques to *1984 and Beyond*, a video installation based on a *Playboy* roundtable discussion published in 1963, which was presented at the Irish Pavilion in the 2007 Venice Biennale; *A thing is a hole in a thing it is not*, 2010, a multichannel film installation whose title borrows from Carl Andre and explores Minimalism's staginess and

Gerard Byrne, In Repertory, *2011. Installation view. Photo by Paula Court.*

self-awareness, with sculptures as props in the modern museum; and in the series *A country road. A tree. Evening.* (2005–2007), he photographed roads in his native Dublin that again resemble the backdrop for *Waiting for Godot.*

In Repertory collapsed theater- and art-world models in unexpected ways. With Byrne as sculptor and director, and the performers as objects and actors, he changed the meanings of both. All the while, the audience, coming and going, interrupted the rarely seen backstage economy of the rehearsal. The work seemed at once archaic in its sparse modernism and absolutely immediate in its presence.

—*Dougal Phillips*

Gerard Byrne, In Repertory, *2011. Installation view. Photo by Paula Court.*

FRANCES STARK

Put a Song in Your Thing

ABRONS ARTS CENTER / PERFORMA 11 COMMISSION /
CURATED BY MARK BEASLEY

Frances Stark's *Put a Song in Your Thing* was the musical coda to her ninety-nine-minute video *My Best Thing* (2011), a "soap opera" with animated cartoon figures and text drawn from her experience of online sex chats, in particular with an Italian man named Marcello, whose broken English, mispronouncements, and misunderstanding of Stark's colloquialisms revealed the humor and poignancy of their deeply intimate yet technologically cold and distant exchanges. Presented as a large-scale video projection, Stark added various elements—herself dressed as a telephone, sonically assaulted by a dub-inspired sound system designed by British artist Mark Leckey, as well as a duet with Bronx-based daggering star Skerrit Bwoy—transforming the initial "virtual relations" of the video into a live, pounding performance onstage.

Put A Song in Your Thing began with a projection of Stark as her outsized digital robotic avatar self, stretched across a scrim onstage, with Stark appearing in her telephone dress behind the scrim, addressing a joke to the audience about Pagliacci, a depressed clown who couldn't find solace in his own laughter. While the texts on-screen continued their same back-and-forth rhythms that drove the internet chat between the artist and her random partners online, the edited audio conversations between Stark and her virtual internet lovers reflected the various stages of courtship, from flirtation through virtual fondling to post-coital chat. In a later act, Skerrit appears sitting astride a large ladder—similar to those he leaps from during his stunts as a hype man for the pop group Major Lazer—while Stark read aloud their correspondence, detailing her admiration

Frances Stark, Put a Song in
Your Thing, *2011. Performance
view. Photos by Paula Court.*

for his work and expressing her hope that they could work together in the future. The final section with Skerrit Bwoy was a highly choreographed series of feigned sexual acts, with Stark now wearing a fishnet unitard, leap-frogging over Skerrit, or swinging by her legs from his waist in fast circles to the ragga rhythms. *Put a Song In Your Thing* ended with Stark jumping from the stage into the audience, landing face-down on a strategically placed pillow, in a feat much like those seen at Jamaican dancehall daggering parties.

Stark may be the first artist to successfully grapple with and retrieve art from the messy text and video courtship of online social interaction. Rather than an expression of technological remove, the work spoke of something primal: that ultimately fragile, sometimes desperate, and very human desire to connect.

—Mark Beasley

Interview

FRANCES STARK

ON SKYPE WITH MARK BEASLEY

FRANCES STARK (FS): Hola! I'm here but I'm fffrrraaazzzzllled and moody and therefore would prefer not to speak so as to avoid winding myself up.

MARK BEASLEY (MB): Is typing speaking?

FS: No, typing is not speaking.

MB: That sounds metaphysical, it wasn't meant to be. OK, so let's get into it. I wanted to begin with Chatroulette. I read that you described it as "a form of seduction that takes place through typing"; through writing, essentially.

FS: Where did u read that?

MB: *The New York Times*!

FS: hahaha (blush). Well I sooo want to avoid talking about Chatroulette at all, to be honest.

MB: We can move on. . .

FS: But I think that the significant thing is the seduction through writing. Chatroulette involves video and nakedness, so it's a bit of a stretch. Essentially the important stuff all happened on Skype with people I met on Chatroulette. So if Chatroulette is never mentioned again in relation to me I'd be happy.

MB: OK, so you moved programs, you met people on the unmentionable, and you transferred that conversation to Skype?

FS: The writing is a kind of superfluous exchange given the video…and the

reason typing is involved is because of a language barrier…and speech is somehow too intimate, especially when people are too shy or unable to speak English.

MB: You translated texts, right?

FS: From other languages, yes. Early on, mostly.

MB: Did the broken English make it more or less interesting?

FS: More, of course.

MB: Of course.

FS: But what happens with the typing is that the voice is apprehended through a standardized font. Everyone has the same font, and so the particularities are manifest in the letters and spaces rather than in audible tone.

MB: Like concrete poetry?

FS: Indeed.

MB: Is poetry something that appeals to you?

FS: Marcello and I had a little exchange about "concrete poetry." I hate poetry ahahahahahahhhahahahahaha

MB: :)

FS: If the guys were in the real world, I'd be turned off by their bad style or their aftershave. Instead, I'm charmed by the spelling and awkwardness of the ESL. Well, you know I LOVE that which is poetic, though you'd have to pay me to read the poems in the *New Yorker*!

MB: I've always seen you as a destroyer of flowers! OK, so the thing with CR is that it's removed, wiped down, unreal

FS: NO CR ahahaha

MB: OK, :) I'm nixing mention of CR.

FS: Thanks :) I think I hate the word Chatroulette so much…and so sick of it being mentioned that I don't want to talk about it. It's just the street where you pick people up…and all the real exchanges developed in individual video chats.

MB: I haven't read any of the poems in

the *New Yorker*; in fact, I don't read the *New Yorker*. OK, so let me marshal my thoughts.

FS: Damn, Skype is very time-wasting! See how typing is so deferring and elliptical…I'll shut up, marshal away.

MB: OK, so after many years of writing for art magazines, writing your own essays, and those supporting friends or other artists' work, you hit a period of time when for some reason you were unable to write. At some point, your engagement with a social networking site, essentially a sex chat room, leads you to meeting and communicating with strangers. Did you know that that would lead to writing? Like the kids in *Nightmare on Elm Street* go into dream state (the virtual) and come out clutching Freddy's hand?

FS: I didn't know it would, not at all—it was an indulgence or a transgression, and when I noticed how immersed in it I had become I said to myself, "WAIT I'M WRITING"—but I said this before many times in many places—but the crucial thing with regard to our project is that our commission came out of the *I've Had It! and I've Also Had It!* performance in Aspen, and that project originally was only connected to the telephone dress, the videophone-y chapter of *Infinite Jest* and the problem of being "promiscuous" in the art world etc…and it was during

the prep of that project that I stumbled into my new habit. . . and as I became more drawn into the videophone exchanges, presaged in DFW's *Infinite Jest*, I became less interested in scripting and staging an art performance.

MB: Why was that?

FS: I became less interested in and more critical of the kind of, "Oh, contemporary artists can do operas or whatever the fuck they feel like" regardless of whether they have talent. (This strikes me as a bit too harsh as I like to include myself in that harsh assessment of artists.) I was just more inspired by the stories that were unfolding with the boys.

MB: It's also a form of promiscuity, right? Avoiding the category monster.

FS: And the other question behind *I've Had It* was, of course, "Why can't you assemble yourself and write?"

MB: So, Frances, why couldn't you "assemble yourself and write?"

FS: So, during the development of the psuedo-opera monologue thingy—I realized I had been LITERALIZING the promiscuity metaphor.

First answer to that question was because I'm making art shows—which is for me a form of writing even if people

couldn't totally see that, but, of course, I wanted to be able to write as well, but I couldn't think linearly or discursively anymore

maybe cuz of teaching or mothering or work or a combo of all three

but the second answer became: cuz I'm cruising young men and getting drunk off my ability to seduce and the fact that I'm not an unsexy or unappealing person like I thought, but rather sexy

and that my brains plus my body were a…winning combo and they were generating layers of stories.

MB: OK, so writing, there are those artists that define everything they do as writing. Is that something you feel, on some level?

FS: It wasn't until after the first incarnation of the *I've Had It* thing that I realized I was in fact writing and that I would prefer to think and live as a writer rather than as an art "exhibitionist"—it's writing with a capital W—as in DFW—ahahah. Henry Miller was my first major model of what an artist is and he was a fucker and a writer ahahah

MB: Hahahah

FS: a life liver…liver…ahahha gross

OK, so the fundamental question behind the Performa thing is more about performance than writing in a way. Or

writing is a performance?

and *My Best Thing* kind of sprung fully formed before we could even get to our project, fully formed, but premature

and because I didn't see that coming, it complicated the pressure to follow thru with a "theatrical" performance…I wanted a *gesamstkunstwerk* or something, and opera is traditionally that, and it's a libretto plus music. And with *My Best Thing* the libretto was my chats and the music was dancehall.

MB: The libretto from Skype. The music connected to your chief collaborator, Skerrit Bwoy.

FS: but before that and with our thing the music was Haydn, a *divertimento* called "Echo," meant for two trios in two separate rooms. I loved that structure and divertimento is by definition not so serious, same with dancehall: pure sex, pure urge, so I went back to *The Torment of Follies*—the show from Secession that [Mark] Leckey commented on by saying, "like notes to a pedagogical opera" and I put Gombrowicz's words to music and that to me was my performance and if you remember our first time seeing the space for *Put a Song in Your Thing* at Abrons [Arts Center], I said I just want to show the text with the music and that's my performance and it was like, NOOO, there has to be a body on stage as promised, and that was the

I like you.

I'm not an art expert.

You fall in love with a lot of writers.

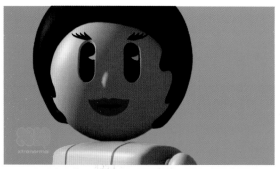

I'm in a serious rebel period.

Who ends feeling perfect?

I'm risking in Italy

you have an impressive analysis capability.

Frances Stark, My Best Thing, *2011. Video stills. Video, color, sound, 99 minutes.*

part I could never figure out beyond involving Skerrit in some unknown way. Skerrit Bwoy was a hype man for Major Lazer, and he's famous for jumping off of ladders onto women who laid there on the ground with their legs spread. But the fact that it seemed almost as if it was done on command or out of context. I was inspired by that, but also felt like maybe it was odd—like it was like me jumping and doing what anybody would ask me to do and I found I would rather do what a naked twenty-two-year-old asked me to do than a curator or gallerist. Being a real whore for no money was more rewarding than being a metaphorical whore for prestige.

 lol

MB: That's the headline quote right there

FS: The whole thing seemed to become about my not having a stage presence yet thinking I have some KICKASS SKYPE presence.

MB: Ah, yes!

FS: So somehow it made sense for Skerrit to provide the professional presence that was expected of me. In the end the whole performance was a mess and yet miraculously it worked on some level.

MB: I was looking back through our Skype convos in 2011 and I started to

feel really bad about the amount of times you'd asked to be let off the hook, and I wouldn't let it go.

FS: and I think we should try to address—honestly—how I compromised myself to good effect. I think we need to acknowledge the ridiculousness of it; I think that your inclusion of Leckey saved the day, and of Nadya [Wasylko, the photographer]. That photo shoot was the backbone of the whole thing.

MB: That picture of you and Skerrit is killer!

FS: It's about black men allowing me to write. Skerrit is an angel.

MB: Why black men?

FS: Well, historically disenfranchised men, but the picture is a black man—screaming "USA"—and with a big dick that is offering me a MIC/PENCIL, and my voice is my open mouth receiving the...OK, actually I could very seriously deconstruct that image.

MB: Do it!

FS: It is about COCK/AMERICA/TELE-COMMUNICATION. . . I'm still HEAVILY into all this stuff—really the disenfranchised men of color. . . and how the genres of dancehall and rap are genres

Poster for Put a Song in Your Thing. *Photo by Nadya Wasylko.*

of meaning-making that became more inspirational to me than old, white, recycled, polite art stuff. We can go straight to the heart of the neo-primitivist charge if you like. . . I don't have an ounce of shame about any of it.

MB: Frances Picasso.

FS: ahahahah. . . I met a person on an airplane (Skerrit Bwoy) who I had seen in a video that inspired me to explore a certain genre of dance and music and we became friends and he agreed to participate in my unresolved experiment. I felt that he was being exploited a bit by Major Lazer—though I didn't pursue that line explicitly, but that was supposed to be the thing about me bringing the ladder and instead of asking him to jump, asking him to listen to my sincere thoughts about what he might mean in my life

(to clarify, the airplane—I met, by chance, the person who had ALREADY inspired me). . . and instead I would jump, I would jump off the godforsaken Performa stage and straight onto a black man.

MB: And you say you don't like poetry. . . switching the jump was major unlazer! OK, so can we talk about Mark Leckey's *Big Box*?

FS: Leckey had been trying to communicate to inanimate objects, and so there is a line of questioning there about embodiment or what is inside matter, and my sculpture/costume…the title was ALREADY about that, "the inchoate incarnate"—(that's the title).

FS: I will have to round up all the titles of those costumes but….

FS: THE INCHOATE INCARNATE

FS: That's my three-word poem, which I'm thinking of sending to the *New Yorker*. I never thought of it as music, getting a girl out of her pants.

MB: Poetess!

FS: hahahaha

MB: How did it feel to be blasted with sound?

FS: It actually wasn't loud enough.

MB: Too bad.

FS: I liked the—omg, forgot the genre title name—but shit—what's it called…I liked the pure music bit the best.

MB: Electronica? Jungle?

FS: No that insane hardcore shit

MB: Gabba

FS: YES there were lots of phone-ring samples.

MB: Can you recall at what moment we introduced Leckey and why?

FS: Well, not precisely, but it was something that was a blessing in disguise. It was just pure luck despite it being jumbled. All I know is that the women I spoke with were so inspired and bowled over by my ballsiness, if you will—but the whole thing was really a mess, structurally, but the spirit was there. The pictures look good, though. ahahhahaa

MB: The spirit was correct! It fought for something that wasn't stagey, plastified or drained of life. It was a momentary encounter without repeat performance. It avoided the rhetoric of theater, and that's what made it tricky, risky and kind of nerve-wracking. Would Skerrit show, would the dance come together?

FS: Yes, that's why I think in this thing we need to face the awkwardness head on, and not try to smooth over the stupid bits.

Because what I ended up doing at Gavin Brown's [*Osservate, leggete con me*] was kind of what I was asking to do when I first got to Abrons—but it wasn't somehow acceptable.

I was like, look, I want a bunch of people in seats to read what I wrote, to music, and that's what I want. But instead I had to go up and do what I did.

MB: Two years on, I'm still intrigued by what happened that night. Putting a song in your best thing, your moving from online encounter to digital avatar to fleshy presence, was one of the more compelling decodings of what it means to live in a socially networked age.

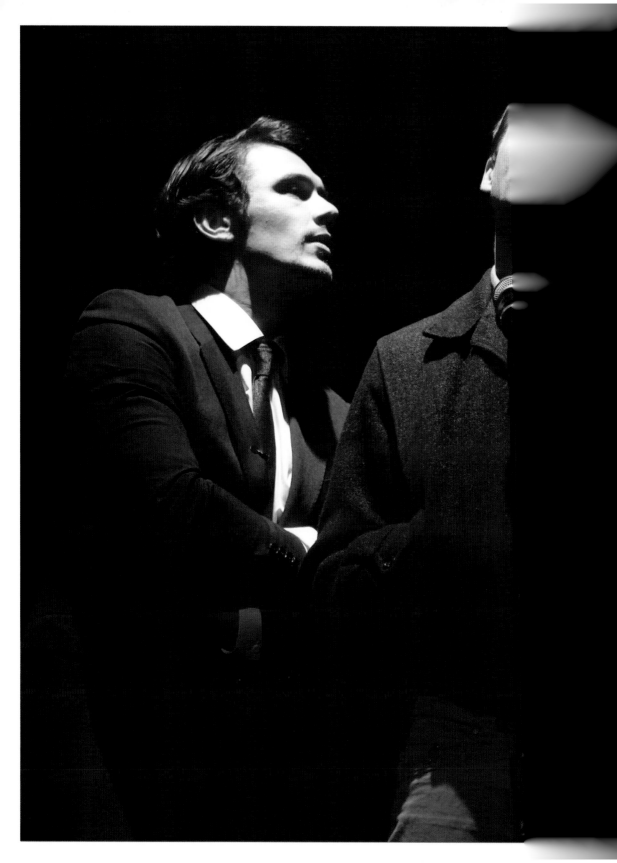

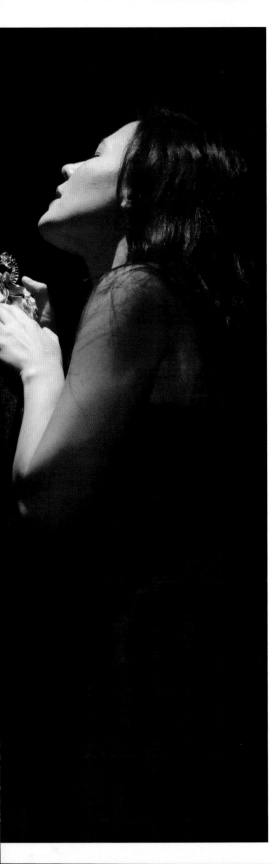

LAUREL NAKADATE & JAMES FRANCO

Three Performances in Search of Tennessee

ABRONS ARTS CENTER / PERFORMA 11 COMMISSION / CO-COMMISSIONED BY PADDLE8

Tenn died in a hotel room. I think the official cause of death was choking on the cap of a pill bottle. I don't know. Nobody liked his plays at the end. Theater director Gregory Mosher told me about one of Tenn's last birthdays when nobody showed; sad. Think about all the people connected to Tenn: Paul Newman, Marlon Brando, Elia Kazan, Vivien Leigh, Karl Malden, Sidney Lumet, Kim Stanley, Eli Wallach, Ben Gazzara, etc. Who was left at the end? A lonely death.

*

We wanted to reach Tennessee. We wanted to touch the young Tenn. We found a psychic medium; She would help us talk to Tennessee. We did it in front of an audience.

Laurel Nakadate and James Franco, Three Performances in Search of Tennessee, *2011. Performance view with Ryan McNamara. Photo by Paula Court.*

Did she reach him? For real? Who knows, who cares—what matters was the effort. (She said she reached him. He said that I resembled a young Marlon Brando. *Thanks!*)

*

We wanted to reach out to the audience and bring them into the performance. We did the Gentleman Caller scene from *The Glass Menagerie* as acting karaoke; people from craigslist could volunteer to perform as Laura opposite a video projection of me, while I and Laurel critiqued the performances. When we'd had enough, we'd yell, "Next!"

*

We wanted to explore Tenn's work, but not as a straight play; we wanted to get underneath it. We had five different kinds of performers do one of Tom's monologues from *The Glass Menagerie*: a Broadway actor, a strange indie film actor, and a few performance artists. We saw all sides of Tenn.

*

Three movements to make contact. I think we did. We made a connection to the dead. Because artists never die: They live on in their work.

—*James Franco*

Laurel Nakadate and James Franco, Three Performances in Search of Tennessee, *2011. Performance view. Photo by Paula Court.*

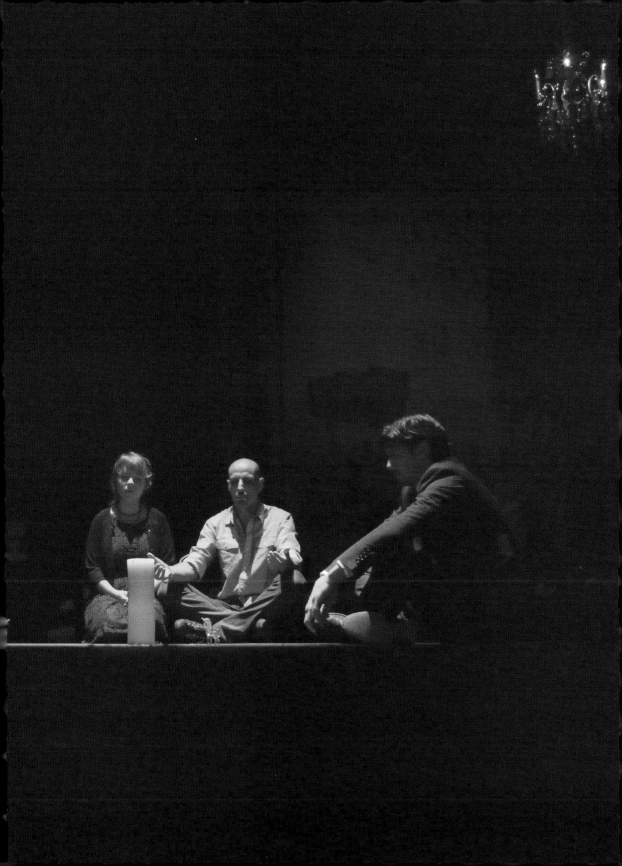

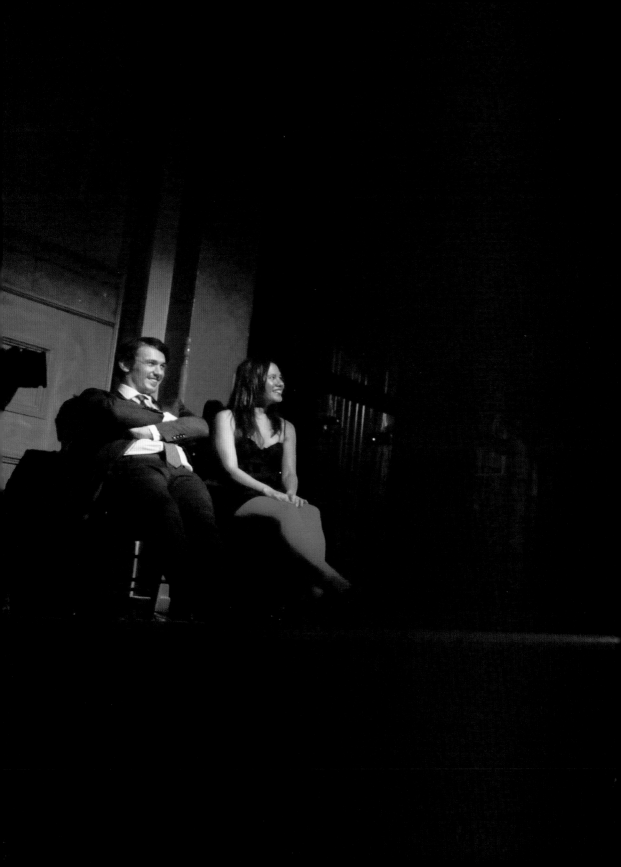

Laurel Nakadate and James Franco, Three Performances in Search of Tennessee, 2011. Performance view. Photo by Paula Court.

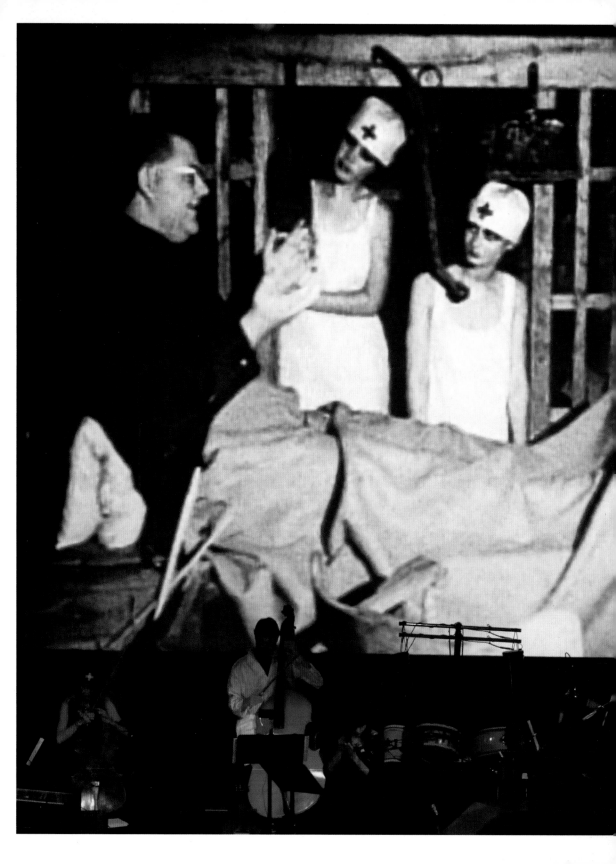

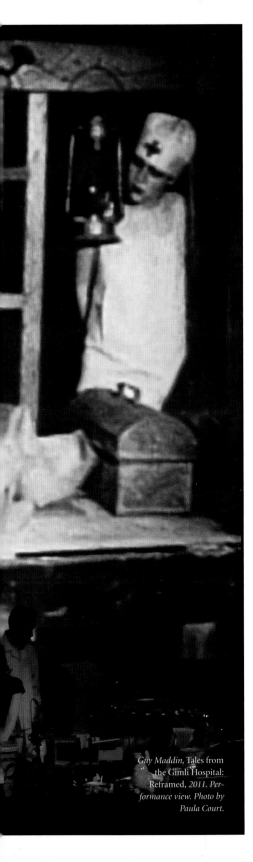

Guy Maddin, Tales from
the Gimli Hospital:
Reframed, *2011. Per-
formance view. Photo by
Paula Court.*

GUY MADDIN

Tales from the Gimli Hospital: Reframed

WALTER READE THEATER / PERFORMA 11 COMMISSION /
CURATED BY LANA WILSON

O Mount Askia!
Your Eruptions have put us in Boats
and sent us to scar new Lands
But from across the celibate Ocean
you cast your nets and haul us back
to your smoldering bosom

These lines, referring to the volcanic erup-
tion that forced many Icelanders to flee their
country in the 1870s, seeking permanent refuge in
what would later become the Manitoba province
of Canada, open Guy Maddin's 1988 film, *Tales
from the Gimli Hospital*. Twenty-three years later,
the same words were whispered by Icelandic
musician Kristín Anna Valtýsdóttir, onstage at
the beginning of *Tales from the Gimli Hospital:
Reframed*, an ambitious live performance that re-
invented the original tale with a new soundtrack,
using techniques inspired by the classic Icelandic
sagas to retell this story. The result was a haunting
performance that cast the film in an entirely new
light, revealing not only the hidden dimensions of
the original work but also why this groundbreak-
ing debut has acquired a nearly mythological
status for Maddin's followers.

When it was first released, *Tales from the Gimli
Hospital* was a hit on the midnight movie circuit,
as audiences delighted in its bizarre, darkly
humorous content—as well as Maddin's unique

blend of gorgeous expressionist aesthetics and a low-budget, B-movie sensibility. The narrative, which is constructed in onion-like layers of stories within stories, is dreamlike and elliptical, centering on the jealousy and madness instilled in two men sharing a hospital room in a remote Canadian village. Trying to win the affection of the nurses who care for them, these men engage in a storytelling battle of sorts, part fact and part fiction, which ultimately leads to a shocking revelation that ends their friendship forever.

The framing story of the entire film, however, is much simpler and realer—right down to the Big Gulp slurpee clutched by one of the characters. Two children sit in a hospital room, where their *Amma* (the Icelandic term for "grandma") tells them a story, as their mother lies ailing in the bed next to them. At the end of the film, once the drama of the two men in otherworldly Gimli is complete, we land back in the hospital room, and in the present day, where we realize that the entire tale—and its tales within tales—have all been part of Amma's effort to distract the children from the fact that their mother has passed away. Stories as a way to stave off sadness, stories as a way to escape and divert, stories as a way to elevate the lives of small people to enormous heights—it was an interest in these themes that led composer Matthew Patton to create a new score for *Tales from the Gimli Hospital* that would capture the underlying tragedy of the original film in a new way. Maddin jumped at the opportunity to truly "reframe" his first production, turning it into a performance carefully conceived by him at all levels that would fuse voice, music, image, and sound into a remarkable new whole.

Maddin and Patton gathered an acclaimed group of musicians to collaborate in composing and performing the new score, which ultimately centered on Valtýsdóttir, the former frontperson for Icelandic band múm, as a narrator who performed the dialogue in a bewitching mixture of singing and speaking, just as Icelandic sagas were historically passed on to younger generations. Valtýsdóttir played every character in the film herself, sometimes using multiple microphones and vintage tape recorders to add fuzzy distortion, at other times

picking up a guitar to lead the other musicians in song. Her persona ranged from angelic to ferocious, and the concentrated energy emanating from her seat centerstage left audiences in a rapt and palpable silence.

This level of concentration was in fact needed to perceive the nuances in the score, which mixed forty-eight different tracks of live music and sound effects, layering electronics over the top. Ethereal string and vocal elements were provided by Icelandic musicians—Gyða Valtýsdóttir (cello), Borgar Magnason (double bass), and María Huld Markan Sigfúsdóttir (violin)—who designed their parts to layer original melodies with Icelandic folk songs and works by contemporary composers such as Arvo Pärt, reflecting the complex refractions of characters' memories in the film. The Aono Jikken Ensemble, a Seattle-based trio (William Satake Blauvelt, Dean Moore, and Naho Shioya) who had previously worked with Maddin on his *Brand Upon the Brain* (2006), used an elaborate setup in which drums, bells, and other classical string and percussion instruments mingled with unexpected props such as squeaky dolls, hay, sandbags, a toy piano, kazoos, and a large aquarium complete with a fake diver and treasure chest. These props were deployed to make ingenious "Foley" sound effects for the film—dropped sandbags became footsteps in the brush, crackling bubble wrap became flames consuming a wooden barn.

The fact that all of these elements came together to form such a transportive experience is testament to the abilities of all the artists involved. Maddin even cut some new footage into the original film—parts of an impressionistic short he made eleven years after *Gimli*, featuring the original actors, plus dreamy full-color footage of Valtýsdóttir swimming in the nude—to add to the layers of memory suffusing the film already as well as to connect it more directly to the present. "I always liked the idea that tales have a very elliptical logic, one that's closer to music than to literal history," Maddin has said. With *Tales from the Gimli Hospital: Reframed*, he brought his own past full circle, letting the ancient and contemporary coexist in a sublime new way.

—*Lana Wilson*

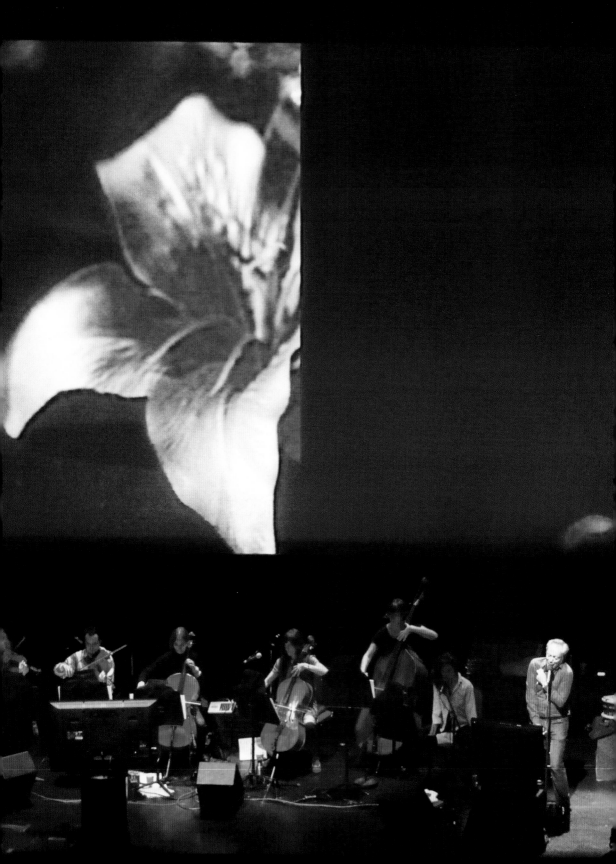

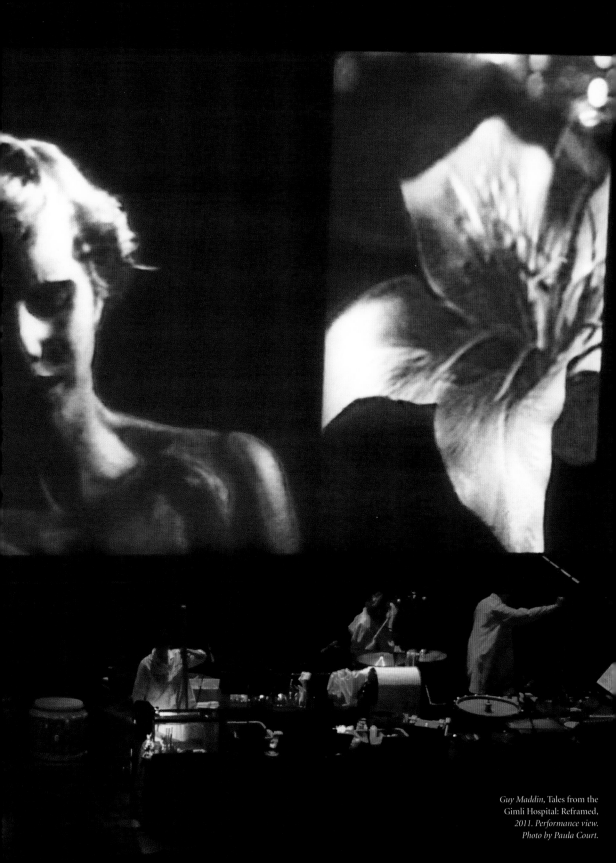

Guy Maddin, Tales from the
Gimli Hospital: Reframed,
*2011. Performance view.
Photo by Paula Court.*

Interview

GUY MADDIN

IN CONVERSATION WITH SCOTT INDRISEK

SCOTT INDRISEK (SI): Why did you think *Tales from the Gimli Hospital* was a good match for a performance of this sort?

GUY MADDIN (GM): One of my reasons for making the movie in the first place was that Canadians seem to be the worst at self-mythologizing. Every other country in the world, especially the United States, sitting smack dab against us, seems to do it with amazing ease. The myths that have evolved give US citizens a sense of what they once were and help point them in some cockeyed direction for the future. Canadians see their past in life-size rather than bigger-than-life terms. I thought that by 1988, when time was running out on the century, I could take a little piece of my own local history and mythologize it overnight.

And then twenty-three years later someone offered to score the movie and play it live at Performa for me. I thought, "That's not enough, just to recycle an old movie with a new score, play it live with some sound effects. Maybe the movie can take on the life of a natural myth, degenerate, turn into something slightly different." I wanted to see how I could change the tone of it a little bit, affect the way it now smells and feels and looks. I did add back some deleted stuff.

SI: What, specifically?

Left: Musicians in Tales from the Gimli Hospital: Reframed. *Photos by Paula Court.*

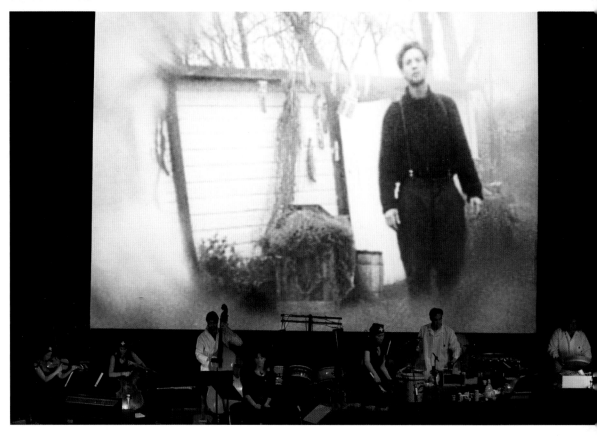

Musicians in Tales from the Gimli Hospital: Reframed. *Photos by Paula Court.*

GM: There's a "deleted" scene that I actually shot eleven years after I shot the movie. One of the leads, Michael Gotti, was in a car accident and was trying to recuperate. He couldn't walk. He had huge chunks of his life wiped out by amnesia—after hitting a moose. But I noticed that he hadn't really changed much in appearance. The female in the movie, Angela Heck, hadn't changed much either. I thought it'd be fun, good therapy for all of us, to get together and shoot a so-called deleted scene. We sat and improvised with the camera and made a little tale within a tale within a tale.

For years I regretted not cutting that into the movie as an additional layer of narrative within the multilayered narra-

tives the movie has to offer. I was able to slide it in without feeling guilty this time. It reminded me of the process of manufacturing tales, the way word-of-mouth tales are burnished, adapted, changed, bowdlerized, and finally arrive at something like permanence.

A live performance takes on all the risks that the telling of a word-of-mouth tale does. It comes out a bit different each night. The new score—which was composed by all of the performers who appear on stage, along with Matthew Patton—is really sacred-sounding, much more lugubrious than my original recorded track of sampled stuff from late-night movies, little snatches of atmosphere that I had added before. Now it's quite different. It really dials down the laughs, which are already very few in the movie, or represses them so much, I hope, that with a large enough audience the laughs will be much more misshapen and exuberant. It does seem like more of a mock tragedy. It has also become a song—like the *Song of Roland* or one of those ancient sagas. I also think of *Sunrise: A Story of Two Humans* (1927), by F. W. Murnau.

SI: You've rewritten the narration.

GM: Just a little bit, in the spirit of retelling something. Kristín Anna Valtýsdóttir, a founding member of the Icelandic group múm, more or less sings the narration in that old Icelandic fashion.

SI: You've done live performances of your films before. Would you say this one is more elaborate?

GM: The live elements are less tacked on, less gimmicky. The score has been created organically, with some of the music being written originally, but some of it also drawing from old Icelandic folk songs that the musicians brought with them, their own interpretations.

There's definitely no sheet music for it. If our musicians' bus were to go off a cliff, there's no way local session musicians could recreate the score. In that way, it survives as a tale retold, preserved in a human head. If one of them is slightly off or just forgets, everyone is unmoored. Just to hear them debriefing one another afterward: "What the hell just happened?" They break into broken English, half Icelandic. It's kind of a choral work in itself.

This interview was originally published in the November 2011 issue of Modern Painters.

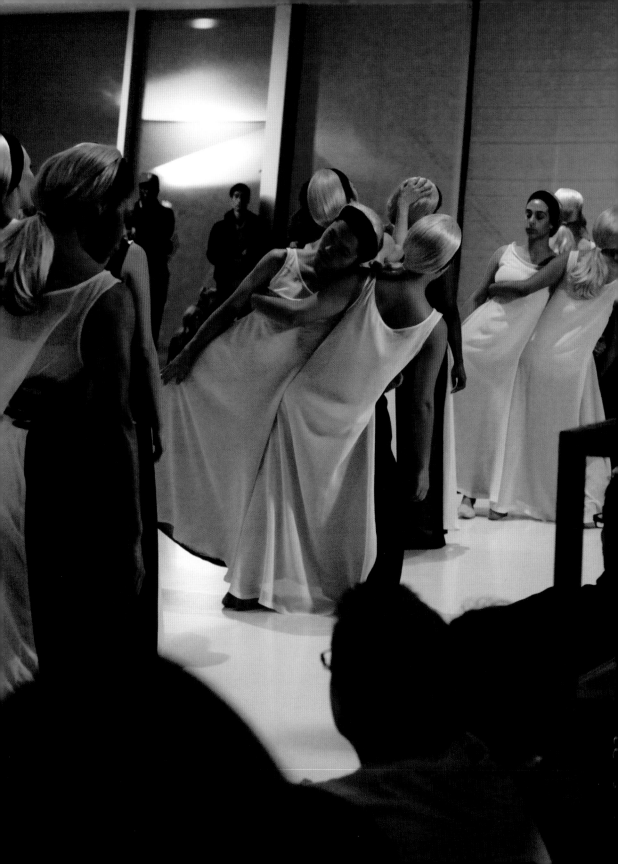

MING WONG

Persona Performa

MUSEUM OF THE MOVING IMAGE / PERFORMA 11
COMMISSION / CURATED BY DEFNE AYAS

Ming Wong, a Singaporean artist of Chinese heritage who is known for appropriating cinematic material, staged an homage to *Persona* (1966), the film that critic Susan Sontag referred to as director Ingmar Bergman's masterpiece and one of the major works of the twentieth century. Sontag described *Persona* as a series of variations on the theme of "doubling," although she saw "violence of the spirit" as its central theme, while the filmmaker himself emphasized the "necessary illusions" that enable us to live.

Wong used the newly reopened Museum of the Moving Image as a series of doors and windows onto the subtext of the film itself. He transformed the long wall of the entranceway into a projection screen, with multiple images of eyes, noses, hands, and other body parts cascading along its surface as viewers walked into the museum. On another wall in the main reception area, he projected a video of the Swedish island of Fårö, where the movie is set; waves crashed along

Ming Wong, Persona Performa, *2011.*
Performance view. Photo by Paula Court.

Ming Wong, Persona Performa, *2011. Performance view. Photo by Paula Court. At right: Audience members at MoMI. Photo by Paula Court.*

the shore, and the shrouded figure of death from Bergman's *The Seventh Seal* was occasionally seen in profile. Meanwhile, in one of the museum's small viewing theaters, *Persona* was screened in its entirety.

The audience was seated on benches in front of the wide staircase that bifurcates the main hall of the building. A young boy, dressed in white, stood in for the artist as he maneuvered a 35-millimeter film projector on a mobile stand, focusing its bright light on a long line of performers, men and women, all dressed in black-and-white shifts and identical blonde wigs, as they made their way one by one down the stairs. The audience was then invited into the main theater, where the same actors, now in pairs, moved in choreographed formation, repeating gestures and dialogue of *Persona*'s two main characters, nurse Alma and her patient, Elisabet. Projected on-screen, the many "personas" multiplied infinitely as the boy director stayed close to the action, watching from his chair at the side of the stage.

—*Defne Ayas*

The artist's research materials for Persona Performa, *including stills of Ingmar Bergman's* Persona, *Robert Altman's* 3 Women, *Rainer Werner Fassbinder's* The Bitter Tears of Petra von Kant, *Woody Allen's* Love and Death, *photographs by Eadweard Muybridge, a photograph of Marcel Duchamp descending a staircase, and photos of the interior of the Museum of the Moving Image in Astoria, Queens.*

TRANSLATION, MOVEMENT

BORIS CHARMATZ

Musée de la Danse: Expo Zéro

PEFORMA HUB / PERFORMA 11 PREMIERE / CURATED BY
BORIS CHARMATZ AND MARTINA HOCHMUTH.
LEAD CURATOR: LANA WILSON

M*usée de la Danse: Expo Zéro*, by French choreographer Boris Charmatz, reversed one of the main conventions of Performa: inviting visual artists to work on the stage. Instead, Charmatz relocated his practice away from a proscenium theater and into a former school, the kind of abandoned space now typical of the visual art biennial. Five classrooms, together with corridors and storage cupboards, were given over to a flowing, overlapping array of performances by choreographers, dancers, an actor, an artist/curator, a writer, an architect, and a philosopher. (The full list of participants includes Alex Baczynski-Jenkins, Eleanor Bauer, Jim Fletcher, Valda Settlefield, Lenio Kaklea, Heman Chong, Jan Liesegang, Fadi Toufiq, and Marcus Steinweg.) Some pieces were on a loop, some were improvised, and some involved the audience.

When I first walked into one of the classrooms, five people were engaged in an exercise that involved running and jumping and flapping their arms in the air. Gradually, I realized

*Boris Charmatz, Musée de la Danse: Expo Zéro, 2011.
Performance view. Photo by Paula Court.*

that the tall guy in the beard and red T-shirt at the center of this activity was Charmatz himself, leading some kind of impromptu workshop for a group of volunteers. At the end of it, he thanked the group and came over to me. Would I be staying here for a while?, he asked. Could I spend some time in the room while he demonstrated something around me? I agreed to lie down, close my eyes, and *listen* to a dance. I remained there for nearly an hour while Charmatz flurried around me, swishing, leaping, stamping, and occasionally pausing to address the audience. I had no idea how much time had gone by; eventually, a friend nudged me to get up, as the performance was long over. I sat up, bleary-eyed, to find the whole room looking at me; I had become the performance.

Other works also invited us to become part of the work, but more slyly, and in a manner that was often only noticeable to a handful of other visitors: Lenio Kaklea moved gracefully behind those who meandered in the space or stood watching, making subtle movements with her hands and arms behind their backs. Another performer discreetly asked certain visitors to repeat out loud the phrases that Jim Fletcher was shouting down the corridor, and then to leave the building. With no labeling or explanations, it took time and conversation with others to decipher the structure and rhythm of each performance.

One of the sneakiest exchanges was a one-to-one encounter with Heman Chong, which took place in a walk-in closet. Under the pretext of personally recommending a book for you to read, Chong asked you to speak about yourself for three minutes—an excruciating amount of time. After much umming and ahhing, I ground to a halt after less than a minute; he pondered my words carefully and eventually recommended I read the Strugatsky brothers' *Roadside Picnic* (1971), a novel I had been meaning to tackle for many years. He gave good reasons for why I would enjoy it, and I was relatively satisfied with the transaction . . . until I met a friend who had been recommended the same book. A conversation with yet another friend revealed that she too received the same advice. Slowly it dawned on me: Everyone was recommended *Roadside Picnic*, because the point was not to have a book personally chosen for

Boris Charmatz, Musée de la Danse: Expo Zéro, 2011. Participant Eleanor Bauer (dancer/choreographer). Performance view. Photo by Paula Court.

you but to reveal your narcissism in thinking this was possible. Again, we became the performance—alongside Chong's consummate display of forging a connection between the content of this novel and each visitor's self-description.

Although Charmatz translates *Musée de la Danse* as "dancing museum" rather than "museum of dance," his use of an institutional framing device for movement—the least collectible of cultural forms—managed to reimagine the categories of both museum and collection afresh. It also opened to negotiation the difference between amateur and professional competences: Not all of the performers were dancers or choreographers, nor were the visitors, but at some point during a visit to the *Musée de la Danse*, everyone seemed to swap roles, wittingly or unwittingly. Discreetly underscoring the pedagogic dimension of the work was the educational location, with blackboards still on the walls. This was an impromptu school of participatory performance, in which simple actions were conceptually reframed to provide a continuous and textured commentary upon the possibilities of choreography and the site of its reception.

—*Claire Bishop*

Above: Boris Charmatz, Musée de la Danse: Expo Zéro, *2011. Reenactment of Joseph Beuys's Untitled (Hand Circle). Performance view. Photo by Paula Court.*

At right: Boris Charmatz, Musée de la Danse: Expo Zéro, *2011. Participant Jim Fletcher (actor). Performance view. Photo by Paula Court.*

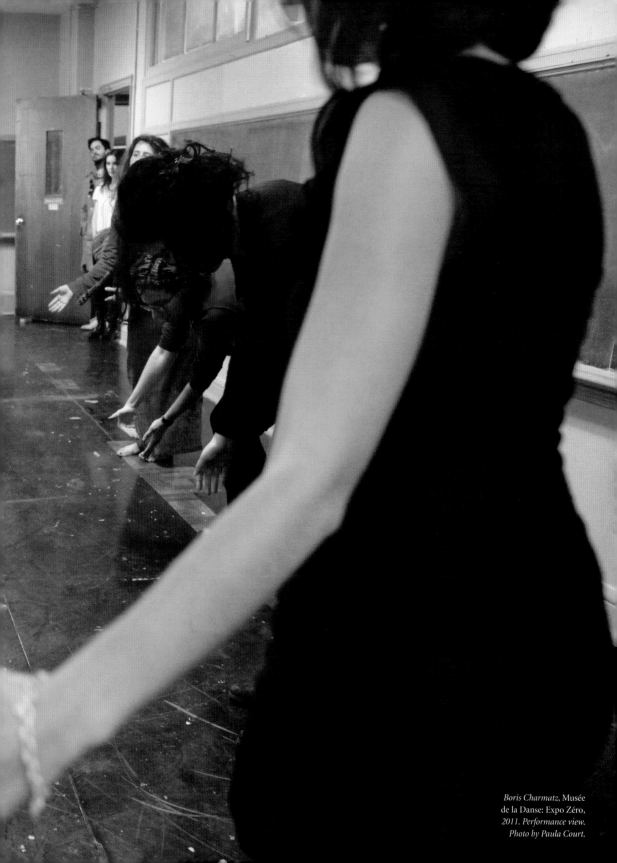

Boris Charmatz, Musée de la Danse: Expo Zéro, 2011. Performance view. Photo by Paula Court.

Interview

BORIS CHARMATZ

IN CONVERSATION WITH LANA WILSON

LANA WILSON (LW): You've done several projects related to how dance is taught and preserved and remembered. Is *Musée de la Danse* a natural progression of your previous work?

BORIS CHARMATZ (BC): In retrospect, it looks like a natural follow-up after Bocal [a temporary, nomadic school based in Lyon, France, 2003–2004]. Angèle Le Grand and I were codirecting Association Edna [a production ensemble started by Charmatz and dancer Dimitri Chamblas in 1992], and she suggested, "Why don't we do a Musée de la Danse?" I was imagining a visual art gallery with props and costumes from contemporary dance projects. For two years, I dismissed this idea completely.

LW: When did she mention this to you?

BC: It must have been 2006. After that, I started rethinking the idea little by little. Angèle stopped working with Association Edna, and spent nearly two years researching what a Musée de la Danse could be. I applied for the directorship of the National Choreographic Center in Rennes with this project. We decided to start it, anyway; we would do it in Rennes if I was granted the position there, or, if not, we would do it only for Performa.

I started *Musée de la Danse* as a long-term project even though some people thought it was a joke.

LW: Did people really think it was a joke?

BC: It was clear to me it would continue for the next two hundred years. Of course, I will die, and this project may die as well, but I imagined it as a

long-term project.

LW: Do you think you'll continue to work on *Musée de la Danse* for the rest of your career? I know that RoseLee considers it an essential and ongoing part of the Performa biennial.

BC: I would love for the *Musée de la Danse* project to continue. We only have an embryo of a collection—artwork, films, scores. One could say that *Expo Zéro* is an exhibition format, but it's also a format that belongs to *Musée de la Danse*. If I quit this, I would like for another artist to take over. My work may go on in different directions, but Musée de la Danse as a place, as a public space, could develop in its own way.

We are becoming more and more permanent. In 2014 in Rennes, we are doing a project called *la permanence*. We want the museum to be open all year. We're working in association with CNAP—the national center of *arts plastiques*, visual art. They have more than 90,000 artworks, and they're lending some of their works to the Musée de la Danse collection, and we will present their works alongside our projects.

LW: Are you choosing works from their collection?

BC: Yes, this is a collaborative project with CNAP. For example, they have Tino Sehgal's *Kiss* (2007) in their collection. I think Musée de la Danse is the right place to display *Kiss*.

LW: So you applied to the Choreographic Centre with the idea of Musée de la Danse, a completely new concept. How did the National Choreographic Centre officials react to this idea?

BC: The city of Rennes chose this project. In the beginning, people thought it would be good to maintain for two or three years, and then choose a new project. But after receiving invitations from Performa in 2009, followed by the Singapore Arts Festival, the Tate Modern, the Festival d'Avignon, and the Museum of Modern Art in New York, it became a more serious project than they had expected. Then they started worrying that we had the name *Musée de la Danse,* but that it wasn't a real museum of dance.

LW: You wrote so beautifully in your "Manifesto for A Dancing Museum"

about expanding the world of dance so that it will go beyond professional dancers and choreographers to reach a broader audience. Why is expanding the parameters of dance so important to you?

BC: When I was in dance school, the history of dance was not important, while in music school, you would read music books; in visual art school, you would learn about the history of art. In dance schools, you only learn physical technique. I wanted to make dance history part of dance itself, so that texts by Tatsumi Hijikata [Japanese creator of Butoh], for example, would be considered part of the dance *patrimoine*, the cultural heritage, of this art form, and that it is interesting to everyone, not only dancers or Butoh disciples.

It was also about how artists like Xavier Le Roy, Jérôme Bel, and myself were working. We need to include Mike Kelley in addition to Martha Graham and Doris Humphrey in our history; we need to include Viennese Actionism, and Vito Acconci biting himself while naked. Vito Acconci is not a dancer—he's a performer, a visual artist, an architect, he is many things—but some of the things he did could help the dancers of now, and they should know about him. I saw Aernout Mik's super-choreographed films. Sometimes I think that he is the choreographer of our time, but he's not;

he's a visual artist, a video artist. He's not part of dance history, but that's okay. Of course, we should know about Judson Church, but dance history should not be limited to that.

LW: Several years ago, RoseLee and I visited you in Rennes during Nuit Blanche, and the city really embraced what you were doing. We wondered whether this experience could translate to New York.

BC: Your visit was super-important for us because not many people were visiting us then. Later on, the people from Festival d'Avignon visited, and they wanted us to get involved in the festival. We were so fragile and insecure, but we knew that it was important for us to be recognized outside of Rennes.

LW: In your manifesto, you wrote about involving teachers, lawyers, and politicians. Do you feel that non-dancers resist participation in Musée de la Danse?

BC: Sure. We've done exhibitions with visual artists and performers, lighting designers, dancers. I wanted to have a laboratory, a place where everything could be connected. The symposia and lectures are connected to our exhibitions, performances, teaching. I thought Musée de la Danse would be a vehicle for broad participation, where dance is not just a class that starts at ten o'clock for twenty

preregistered people, or in the evening at the theater, where you hope it will be good. It would be a place where architects, critics, and visual artists can engage each other critically, collaborate, dissent, and search. We were the first to name it, but it was something in the air.

LW: Art museums are now reexamining their modes of exhibition. This happened a little before that, but as a result . . .

BC: It's great to receive an invitation from a museum, but it's also great that from dance we reflect on what could be a museum, a collection, in terms of dance, which evaporates so quickly. It's not only about what can be done in a museum, but what it could be if it's *our* museum. We started with dance and became a museum. It's completely different from thinking, "What could we do in art galleries and museums?"

LW: It's about respectability too. As you say, dancers are trained physically; they leave intellectual history behind, whereas a visual artist attending art school spends half their time reading art theory and criticism.

BC: But things are evolving quickly, and now dancers have master's degrees, or fine arts PhDs, in Europe. At P.A.R.T.S. [Performing Arts Research and Training Studios in Brussels], the main focus is

still daily physical practice, but they have Bojana Cvejic teaching there. They have Jan Ritsema as a dramaturg.

LW: That brings us to *Expo Zéro*, where people can argue the idea of the Musée de la Danse. When Performa invited you to bring this to New York, what excited you? What did you think the challenges would be? How did you choose the participants?

BC: I wanted half of the participants to be American, and the other half European. Fadi Toufiq is from Lebanon, but he was based in New York at the time, so we considered him a New Yorker.

It was the fifth edition of *Expo Zéro*, so we were prepared. The participants were more relaxed because we'd worked together before, and the work was free to develop in a fantastic way. Valda Setterfield was in a previous edition and I worked with her on *50 Years of Dance* [based on the book *Merce Cunningham: 50 Years*]. I did not know Jim Fletcher at all. He's a fantastic actor who has worked with Tim Etchells and Richard Maxwell, and Tim worked with *Expo Zéro* before, so it was this sort of networking. He's developed such a commanding presence due to his background in performing, and he has this almost magnetic pull around him.

It's good that we had some pillars— pillars that can be moved—and some

Boris Charmatz, Musée de la Danse: Expo Zéro, *2011. Participants Jan Liesegang (architect) and Fadi Toufiq (writer/artist). Photo by Paula Court.*

floating presences, a mix of people, and you didn't know where they were or what they were doing. I remember Fadi describing a map of Beirut—how streets are drawn, how one experiences Beirut differently from New York. It was completely different to speak with Valda. You needed to encounter her in the Old School because she doesn't have a strong voice, but if you met her, it's amazing what she shared with you. I really liked

this double experience.

LW: You had four days together as a group in New York before *Expo Zéro* opened to the public. What were you doing during that time?

BC: We asked that everyone develop an idea for what they would do for Musée de la Danse and *Expo Zéro* before they arrived. It was very important for us

to spend that time together—we were introduced to each other. There was this architect from Berlin, Jan Liesegang, who decided to work with Fadi. Steve Paxton came for one day. He listened the whole day, and at the end he made a little improvised lecture of how he felt about it. It was so great; it was not part of the exhibition, but part of the process. He spoke why at first he didn't very much like the idea of Musée de la Danse. He thought he would be the king, and Yvonne Rainer the queen, of Musée de la Danse. With us though, he realized what it *could* be. It was super-interesting.

Jan is an architect, and Fadi was interested in urban planning and the difference between Beirut and New York. They started to work a bit together. I will always remember Tim Etchells's performance in Rennes. He would ask visitors to give him a movement, and he would add it to the collection at Musée de la Danse. Then, after three, four hours, he stopped and improvised with some kids somewhere else. And one of the other performers took over Tim's position, so his project continued with someone else. This is the opposite of a fixed collection of things, or a fixed exhibition, where you are sure that Tim Etchells is doing this or that, but in *Expo Zéro*, you are never sure. I really like the idea that it's a moving exhibition. You may encounter your own expectations. You don't know what Musée de la Danse is, but we don't

know either, so we can start a discussion there. So, you don't see one artwork, but when you leave, it's like a *train fantôme*, like an affair. You take a train and are visited by ghosts, but when you leave, you were there. If it works well, you leave and you discuss Bruce Nauman with someone and you did something with me about Robert Berry and you watched someone perform Isadora Duncan.

LW: I think people in New York absolutely had that experience. I remember warning everyone beforehand, "New Yorkers just tend to pop in and out." I was stunned to see people staying for hours and hours. What did you feel about the audience in New York in particular?

BC: It was an amazing experience. First of all, after *Expo Zéro*, Claire Bishop wrote an article about visiting Musée de la Danse, which was published in the *Brooklyn Rail*. We met people who were not only interested in, but added things to, the project, and added to our own understanding of it. Visitors would stay with me for two hours, working on this strange moving sculpture that I call *le xxxx accompli*. I was amazed—in New York, everyone is busy, but many decided to stay. It was really a surprise.

ELEANOR BAUER

(BIG GIRLS DO BIG THINGS)

NEW YORK LIVE ARTS / CURATED BY LANA WILSON

What is it that drives someone to perform? For many, going onstage and trying to entertain an audience would be an exercise in pure masochism—especially if doing so alone. But in the hands of American-born, Brussels-based choreographer Eleanor Bauer, the exploration of this desire is rich territory, as seen in a hilarious solo performance that looked unblinkingly at the challenges and charms of "putting on a show."

Inspired by a series of people and events—including a teacher who told Bauer she would never be a ballerina, the phrase "big girls do big things" graffitied on a brick wall, and a man who said she was "an ice bear that dances like a swan"—*(BIG GIRLS DO BIG THINGS)* unfolded inside a space ringed with black velvet curtains that was couched within a larger theatrical proscenium. An enormous furry white costume began as an abstract element on the floor (like a bear rug with sleeves). Bauer crawled into it and created rippling waves across its surface. The same costume later transformed into a magician's cape, a supermodel's cloak, a skirt, and a mink stole–like wrap, just as Bauer herself morphed from one persona into another. Dressed as a big white bear, she started out like a tentative circus performer, crashing a pair of cymbals in the air and striking a big pose for applause that never comes, and ended by growling lyrics from rapper Ice Cube's "Laugh Now, Cry Later" into a microphone: "Im'a do what I wanna do, when I wanna do it, how I wanna do it/ And you better hope I don't do it to you."

Later, Bauer riffed off of Karen Finley's *Nothing Happened* (1986), a classic, sexually graphic monologue, which was up-

At left and following spread: Eleanor Bauer, (BIG GIRLS DO BIG THINGS), 2011. Performance views, 2012. Photos by Ian Douglas. Courtesy American Realness Festival.

SET (BEDDY) STAGE

NEED:
LITTLE CHAIR (HOJOTOHO!)
LADDER (CRAZY!)
CURTAINS + FRONT LIGHTS
+ SOME TOP
CYMBALS (?) WORK
VIDEO CAMERA LIGHTS?
MICROPHONES
UKELELE yes:
RECORDER (?) work
+ TRIPOD! lights +
(...) foot
 lights.
 =
 Half half,
 half
 stage,
 half
 studio

reinforces
feeling
of
trial +
error,
half
doing,
rehearsal,
instant
making of

as tutu – for swan variation?
as shawl – pavlova?

Head? AS RUG
(mask?)

dated for the twenty-first century: She got five part-time jobs, and nothing happened; she did Bikram yoga and drank protein shakes, and nothing happened; she signed MoveOn.org petitions every day for eleven years, and still, nothing happened. Throughout this section, Bauer dipped in and out of accents running the gamut from a 1920s showgirl to a Southern Baptist preacher, in an astonishing bit of showmanship that drew attention to her own virtuosity even as it was simultaneously undercut by her out-of-breath delivery. At another point, Bauer became the absolute opposite type of performer: a calm, graceful ballerina, dancing like a swan, all fluttering arms and slow *bourrées*. Her movements gradually grew more and more awkward, and then she was writhing on the floor, wrapping the entire stage curtain around herself until she was completely enveloped. Some performers never leave this fantasy world.

The remarkable climax of *(BIG GIRLS DO BIG THINGS)* featured Bauer (in heels and glamour-girl configuration of the white fur) belting out Patsy Cline's "Crazy" over and over again, each time finishing the song only to repeat it one key higher—as she simultaneously stepped up a shaky-looking silver ladder at the back of the stage. Through a series of increasingly operatic and out-of-control renditions of the song, she reached the top of the ladder, where she perched precariously as she squeaked out a last, desperate rendition using the tightest parts of her vocal cords. After a long pause, the artist finally spoke: "It's lonely at the top." She paused for a beat. "And it wasn't easy getting here."

In Bauer's gifted hands, we understand exactly why.

—*Lana Wilson*

Eleanor Bauer's sketch for (BIG GIRLS DO BIG THINGS), *2011.*

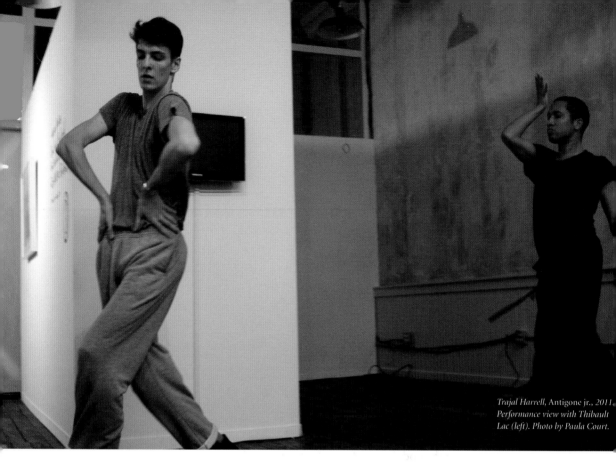

TRAJAL HARRELL

Antigone jr.

THIRD STREAMING

"Though I am African-American, I am not a voguer from Harlem, nor anywhere else. I am Ivy League–educated, Rem Koolhaus–referencing (*S, M, L, XL*), and the self-proclaimed baby boy born from the union of Yvonne Rainer and Lucinda Childs who grew up to have a crush on Steve Paxton."—Trajal Harrell

Choreographer and dancer Trajal Harrell's *Antigone jr.* is one of seven ambitious and compelling performances that comprise the compendium *Twenty Looks or Paris Is Burning at The Judson Church*, a decade-long inquiry into the corresponding aesthetics, concepts, and histories of avant-garde experimentalism of the Judson Dance Theater and voguing of the Harlem ballroom scene. The series includes the solo *(XS)*; *(S)*; *(M) aka (M)imosa* (in collaboration with Cecilia Bengolea, Francois Chaignaud,

and Marlene Monteiro Freitas); *Antigone (jr.)*, an avant-premiere for Performa 11; *Judson Church is Ringing in Harlem (Made-to-Measure) (M2M);* and *Antigone Sr. (L).*

Voguing evolved in competitive balls organized by various "houses" comprised of black and Latino queers who constructed realms of fantasy and projected aspirations of glamour to transcend their daily realities, challenge identity constructs, and supersede the difficulties that accompany racial, sexual orientation, and class biases. The artists of the Judson Dance Theater pioneered postmodern dance by radically questioning classical and modern traditions. Their processes involved a democratic, consensus-driven, and cooperative method that at its core held anti-authoritarian and anti-institutional values. Both Judson and voguing appropriated a range of sources and relied on improvisation to create performances: voguers subverted gender stereotypes, reimagined fashion iconography, and illumined the spectacle of excess, while the Judson choreographers turned to Zen Buddhism, everyday bodily actions such as walking, standing, and squatting, and the then-emerging aesthetics of Conceptual Art and Minimalism.

With *Antigone jr.*, Harrell adds to his motley mix of conceptual references by investigating the theater of ancient Greece, contemplating aesthetic coincidences between voguing and Greek drama. Harrell explained his provocation in the piece as "taking into account that early postmodern dance was also a reaction against Martha Graham and her period of Greek dramas, I wanted to rethink through the lens of voguing: 'What could the mythic drama be about today?'" This exploration began with Harrell and fellow performer Thibault Lac in loose-fitting sweats, but by the end, they were clad in oversize T-shirts vaguely reminiscent of ancient Greek clothing. The two dancers entered the front row for costume changes, full of attitude both fabulous and stylish, repeatedly dressing and undressing, layering and draping. The costume changes raised issues about the body and skin, race and gender. At times, dance—accompanied by a thumping and throbbing score—gave way to theater and humor in unexpected ways, further confusing styles and genres and challenging the audience to figure out what was going on. At one point, Lac read from the Sophocles play while Harrell sat in a chair at the opposite end of the space. Later, Lac donned dark glasses to sing along to "Another Night In" by Tindersticks as Harrell strutted around the space. Harrell's trangressive acts suture the gaps within and around each of these performance styles, rendering something immensely relevant, profoundly dynamic, and compellingly new.

—*Yona Backer and Adrienne Edwards*

Above: Trajal Harrell, Twenty Looks or Paris is Burning at The Judson Church (S), *2009. Performance view, New Museum, 2009. Photo by Miana Jun. At right: Trajal Harrell,* Judson Church is Ringing in Harlem (Made-to-Measure)/Twenty Looks or Paris is Burning at The Judson Church (M2M), *2012. Performance view, PS1 MoMA, 2013. Photo by Ian Douglas.*

At right: Trajal Harrell in collaboration with Cecilia Bengolea, Francois Chaignaud, and Marlene Monteiro Freitas, (M)imosa/ Twenty Looks or Paris is Burning at The Judson Church (M), 2011. Performance at The Kitchen, 2011. Photo by Miana Jun. Far right: Trajal Harrell, Twenty Looks or Paris is Burning at The Judson Church (S), 2009. Performance view, CCS Bard Galleries, Bard College. Part of the exhibition "Anti-Establishment," 2012. Photo by Karl Rabe. Below: Trajal Harrell in collaboration with Cecilia Bengolea, Francois Chaignaud, and Marlene Monteiro Freitas, (M)imosa, Twenty Looks or Paris is Burning at The Judson Church (M), 2011. Performance view, The Kitchen, 2011. Photo by Paula Court.

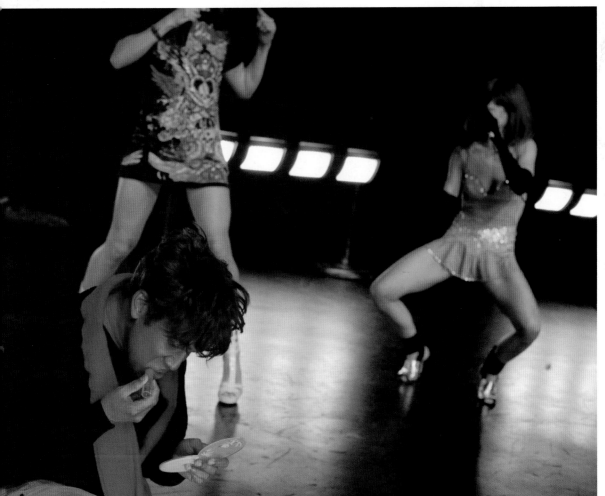

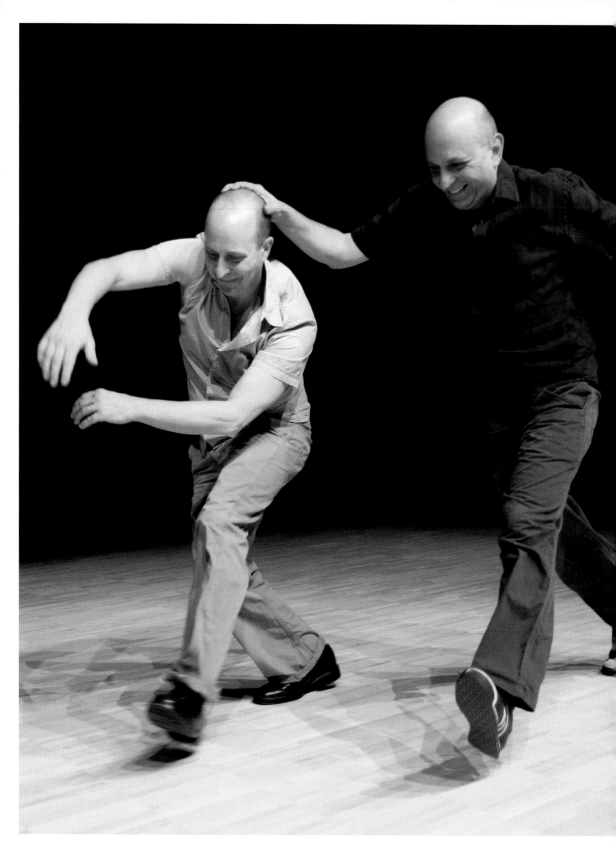

JONATHAN BURROWS & MATTEO FARGION

Cheap Lecture and The Cow Piece

DANSPACE PROJECT / PRESENTED BY DANSPACE PROJECT / CURATED BY JUDY HUSSIE-TAYLOR AND JANET PANETTA & INTERNATIONAL DANCE DIALOGUES

John Cage often made use of chance operations, but he was wary of open improvisation. Thus, somewhere in the middle of *Cheap Lecture*, Jonathan Burrows and Matteo Fargion's homage to Cage, the two say in unison, "We are not the world's best improvisers." Since 2002, Burrows and Fargion have created and performed a series of duets about rhythm. These are *not* improvised.

Burrows, a British choreographer, and Fargion, an Italian-British composer, draw upon their respective backgrounds in ballet and classical guitar to generate performance work in which music and choreography are indistinguishable. In their breakthrough piece, *Both Sitting Duet* (2002), based on a Morton Feldman score, they sit side by side in chairs, gesturing with their hands and arms as they make sounds by rubbing their pants, slapping their thighs, and clicking with their mouths. *Cheap Lecture* borrows text and structure from Cage's 1950 "Lecture on Nothing" and references his *Cheap Imitation*, a piece composed for Merce Cunningham's *Second Hand* after the choreographer was denied the rights to use Erik Satie's *Socrate*.

Burrows and Fargion do not simply borrow or sample—they translate and transform, exploring time and structure, sound and silence through what dance critic Daniela Perazzo Domm has described as "choreomusical compositions."

Five of their duets—*Both Sitting Duet, Cheap Lecture, The Cow Piece, Speaking Dance,* and *Quiet Dance*—were presented for Performa 11.

—*Judy Hussie-Taylor*

Jonathan Burrows and Matteo Fargion, Cheap Lecture and The Cow Piece, *2011. Performance view. Photo by Alistair Muir.*

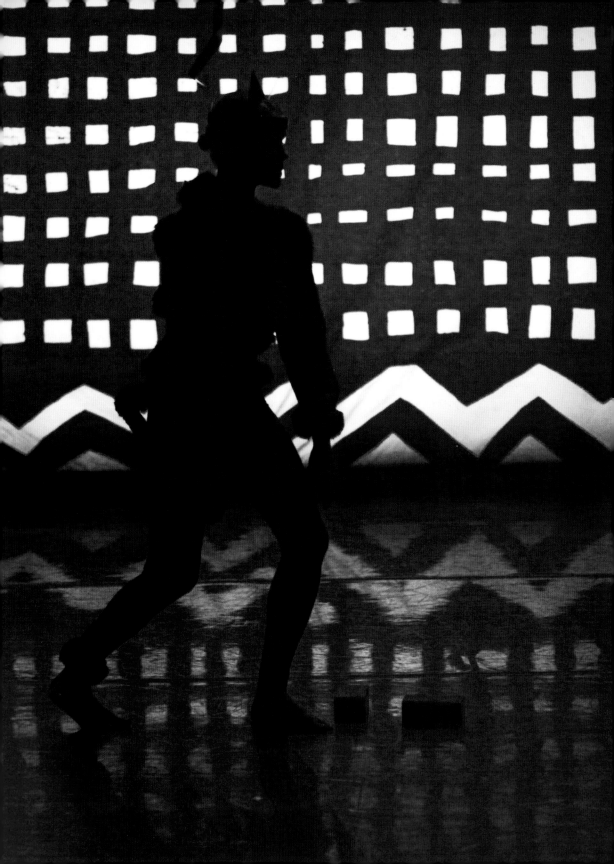

MAI-THU PERRET

Love Letters in Ancient Brick

JOYCE SOHO / PERFORMA 11 PREMIERE / PRESENTED BY
PERFORMA AND SWISS INSTITUTE WITH J PERFORMANCES

Love Letters in Ancient Brick is a witty, whimsical, and surreal performance by Swiss artist Mai-Thu Perret, based on the classic American comic strip *Krazy Kat*, by George Harriman, which ran in the *New York Evening Journal* from 1913 to 1944. This particular story line was published in 1927–1928.

Perret's first dance piece, choreographed in collaboration with Laurence Yadi, tells the story of Krazy Kat, whose obsessive love of Ignatz Mouse is met with disdain. Offissa Bull Pupp, the county policeman, tries to protect the guileless Krazy Kat from the bricks propelled at him by the contemptuous object of his affection, but, blinded by his passion, Krazy Kat interprets the bricks aimed at his head as missives of love. The policeman, on the other hand, is hell-bent on locking the cruel mouse in the county jail for his lawless behavior.

And so the story goes, in an endless loop, with slight variations, over and over again. Like the original comic strip, the performance is about obsession, love, hate, gender confusion, and repetition—all relayed with poetic wit and

*Mai-Thu Perret, Love Letters in Ancient Brick, 2011.
Performance view. Photo by Paula Court.*

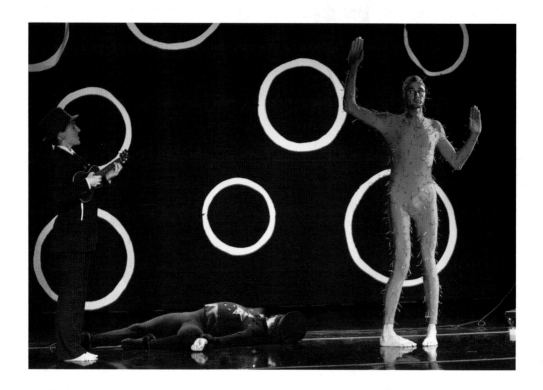

sweet irony, in a primal, almost psychoanalytical drama where genres and categories are constantly jumbled. Staged within a three-dimensional "box" that recalls a frame of a comic strip and evoking Coconino County, the metaphysical desert of Herriman's original story, the set of *Love Letters in Ancient Brick* was composed of lo-fi, oversized graphic black-and-white patterns on canvas evoking the sketched backgrounds of the comic strips—zig zag lines, grids, and polka dots. The costumes were equally caricatures: The artist was dressed in a white bodysuit, complete with pointy cat ears and fuzzy tail, for her portrayal of the Kat; dancer Margaux Monetti wore a gray bodysuit and mouse ears as the Mouse. The costumes and set in *Love Letters* revisit Perret's appropriation of Russian Constructivist aesthetics, seen in *An Evening of the Book*, 2007, three simultaneous film screenings of Vitali Zhemchuzhnyi's 1924 play of the same name, and her interest in the aesthetics of the historical avant-garde, engaging socialist ideology with playful style.

—*Gianni Jetzer*

Mai-Thu Perret, Love Letters in Ancient Brick, *2011. Performance views. Photos by Paula Court.*

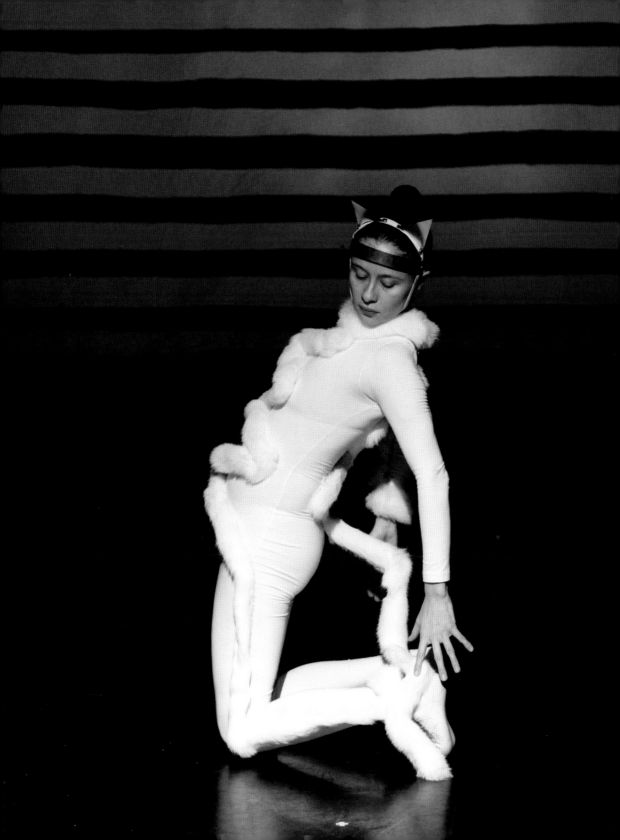

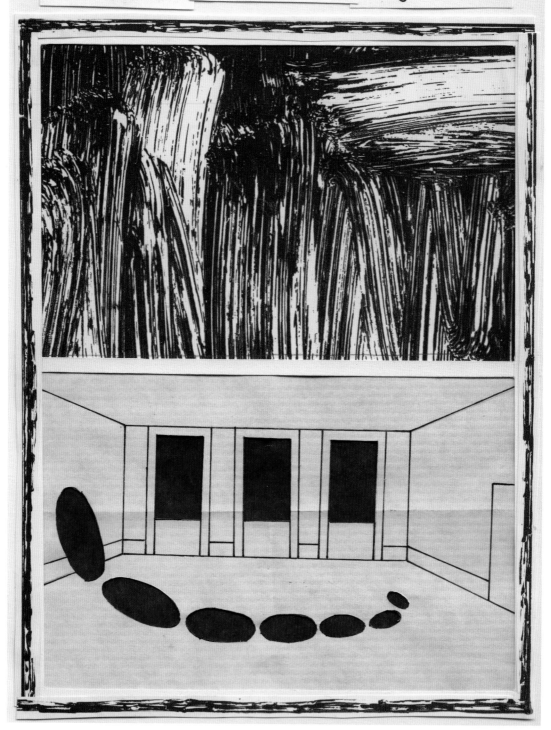

SHELLY NADASHI

Refrigerating Apparatus

PERFORMA HUB

At 6 pm on the dot, Shelly Nadashi solemnly entered an old-fashioned classroom on an upper level of the Performa Hub, where an audience awaited amid an installation of papier-mâché sculptures. Dressed in a bright kimono, Nadashi moved in a slow, methodical *kata*, a pattern of movements from martial arts, among eerily lit chalkboards. She began to recite a monologue on the arrangements for an upcoming laser show—a template email from a guide to online etiquette.

As she spoke, Nadashi collected a series of oblong, black papier-mâché objects from around the room, each smaller than the previous one, and slipped them onto stakes affixed to a narrow platform. At the climax of the piece, the artist began to spin the assemblage, which took on a hypnotic, pulsing, and swelling form. The audience applauded loudly, intimate witness to the cutting-edge performance—at which point the artist (ever-critical, ever-evolving) apologized, said she hadn't done it "quite right," and started the performance again from the beginning. Everybody stayed.

Nadashi's mix of sculptural elements layered over physical patterns derived from sports continued the artist's challenge of theater's tacit rules and conventions, a continuing thread in her work. Before attending the Glasgow School of Art, the Israeli-born, Brussels-based Nadashi studied at the School of Visual Theatre in Jerusalem. *Refrigerating Apparatus* is a demonstration of the artist's strong inclination toward theater, as well as the games that people play.

—*Dougal Phillips*

Shelley Nadashi, Refrigerating Apparatus, *2011. Performance view. Photo by Elizabeth Proitsis. At left: Artist rendering for* Refrigerating Apparatus.

ROBBINSCHILDS

Instruction Construction

ART IN GENERAL / CURATED BY COURTENAY FINN

Instruction Construction was a series of recordings that led viewers through a series of detailed, movement-based scores based on the dimensions and characteristics of the sixth-floor gallery. Taking for granted that our bodies are informed by each new setting, the work explored a range of possibilities drawn from the particularities of the space. Guests wore headphones and held mp3 players loaded with robbinschilds's directives—in the style of recorded museum exhibition guides—which had participants touching columns or walls in the space or stopping to notice the angle of "five photographs to the right of a secret door flush with the gallery wall." The recorded voices of Layla Childs and Sonya Robbins, the artist-choreographers who make up the collaborative duo—known for incorporating their dance training into other mediums, investigating the relationship between human interaction and architecture—instructed viewers to notice their physical presence in the space, rather than provide them with the iconographic narrative of a museum guide. "You are on a journey through space, shuttling your body carefully around the formations," they insisted, positing a visit to an exhibition as a way of heightening the sense of a physical space and viewing the passage through the gallery as a series of exchanges between viewer, objects, and architecture.

—*Courtenay Finn*

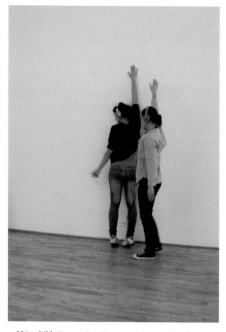

robbinschilds, Instruction Construction, *2011. Performance view. Photo by Paula Court.*

JACK FERVER WITH MICHELLE MOLA

Me, Michelle

MUSEUM OF ARTS AND DESIGN / CURATED BY JAKE YUZNA / PRESENTED AS PART OF MAD'S INAUGURAL PERFORMANCE SERIES RISK+ REWARD

Presented in the sky room overlooking Columbus Circle and Central Park, the American artist Jack Ferver staged a new duet, *Me, Michelle,* with performer Michelle Mola. Continuing Ferver's exploration of performance as a tool for manipulating perception while revealing the darker recesses of the contemporary psyche, *Me, Michelle* constructed a volatile relationship between the two performers that was abusive, controlling, tender, and loving.

Dressed in simple beige and gray costumes that reflected their minimal surroundings, Ferver and Mola seamlessly shifted personas and performance styles. Whether a children's game, the posturing of an adult in a doomed romance, theatrical reenactments of historical moments, or contemporary choreography, Mola and Ferver countered and accommodated each other's mood swings over the course of forty-five minutes.

With Ferver acting as Cleopatra in her final days or as a gay man utilizing Facebook to stalk a lover, and Mola playing the role of soother and plaything, their seemingly disparate performances

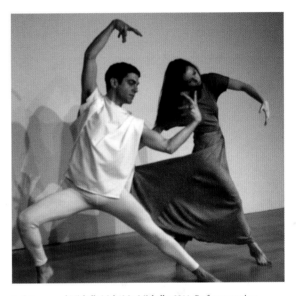

Jack Ferver and Michelle Mola, Me, Michelle, *2011. Performance view. Photo by Elizabeth Proitsis.*

orbited an emotional center of both the fear of, and the desire for, human compassion. Revealing how the closest and most complex of human relationships are formed, from the intentional to the unconscious, Ferver showcases how performance is utilized to feed our monsters, both of the personal and public varieties.

—*Jake Yuzna*

SPEAKING WITH SOUNDS

ROBERT
ASHLEY

That Morning Thing

THE KITCHEN / PERFORMA 11 PREMIERE / CURATED BY
MARK BEASLEY / CO-PRESENTED WITH THE KITCHEN /
PRODUCED BY PERFORMING ARTSERVICES

The opera *That Morning Thing* was composed from 1966 to 1967. The writing of the opera was "caused by" the suicides—in short sequence—of three friends, all women. (The women did not know each other. One lived in a different city. It seemed to me to be nothing but a dark coincidence.) I did not know anything about suicide then, and I still don't, but I found myself having to give it a lot of thought, and I felt a need to express something, without trying to "say something" about suicide. It would have been preposterous to write an opera in which the heroine takes her life. So the early program notes on these compositions have nothing of this information in them. But, after all these years I can say that the opera is in memoriam of the three women who took their lives. They were good friends. I hope I got it right.

There is a tendency to think of suicide as an act of "teaching"—which appropriates

Robert Ashley, That Morning Thing, *1967. Originally performed in 1967. Performance view, 2011. Photo by Paula Court.*

the act to the benefit of the living and robs it of its individuality and courage. I imagined that the act might be thought of as an escape from an "intellectual" problem that could not be solved and that, above all, the notion of the "escape" gave the act the dignity of being totally personal. Maybe this is wrong as an idea—I don't know what persons who have attempted suicide have said that about their motives—but it gave a structure to the opera and allowed me to express my feelings without having to resort to drama.

I tried to construct an "intellectual" problem that would not be solved. It came to be, finally, the dichotomy between the "rational"—whatever can be explained in words—and its opposite—which is not "irrational" or "a-rational," but which cannot be explained in words. The true opposite of the "rational" can be said in words, can be described, but the words are not an explanation.

The opera, *That Morning Thing*, takes the form of an alternation of scenes of "rationalizations" (or explanations) and scenes of "descriptions." (I hope that the meaning of the opera is evident in the struggle between these two modes of understanding things and evident in the fact that these two modes cannot be reconciled.)

—*Robert Ashley*

Adapted from original program and liner notes of That Morning Thing, *1967.*

Robert Ashley, That Morning Thing, *1967.*
Performance view, 2011. Photo by Paula Court.

Frogs is a slow walking-dance involving four stationary women and
four moving women, who are directed in their walk by the sounds
produced by the four men.

The four stationary women are in place when the performance begins.
They are standing in the performance area among the members of the
chorus, who are seated on the floor.) ? I have to check Kitchen space

Each of the moving women enters the performance area following the
"directions" given in the sound-code produced by her man-partner.
(The sound-code and the style of walking are described below.)
She moves through and among the chorus to meetings with stationary
women and other moving women.

The stationary women and the moving women wear "frog glasses"
(described below), which blink randomly when two women meet.

The slow, dance-walk of the moving women, the blinking of the glasses
at the meetings, and the sounds produced by the four men constitute
Frogs, the opening section of THAT MORNING THING. .

Each man directs one moving woman (his partner) by means of a spoken
sound-code, as she walks through the performance area.

The code consists of spoken numbers (one through five) separated by
rhythmic rests, as follows:

$\frac{2}{8}$ ["ONE" 𝄾] means forward

$\frac{3}{8}$ ["ONE" "TWO" 𝄾] means to the left

$\frac{4}{8}$ ["ONE" "TWO" "THREE" 𝄾] means to the right

$\frac{5}{8}$ ["ONE" "TWO" "THREE" "FOUR" 𝄾] means to the rear

$\frac{5}{8}$ ["ONE" "TWO" "THREE" "FOUR" "FIVE"]

means "you are facing another
woman: make contact, and maintain
that contact until next direction.

(note that there is no eighth-rest
in the 5/8 "contact" measure.)

Eighth-note (♪) and eighth rests (𝄾) are constant tempi throughout!
The measures for each direction are repeated continuously until that
movement has been executed. (e.g., if the man is directing the woman
to turn "to the left", the measure $\frac{3}{8}$ ["ONE" "TWO" 𝄾] should
be repeated continuously until she has achieved that direction.

ROBERT ASHLEY AND HIS LEGACY

BY ALEX WATERMAN

In a conversation with John Cage in 1961, Robert Ashley asked if there might be a way to create a new definition for music that need not refer to sound. The elder composer was bemused by the question. Cage's great contribution to contemporary music had been to dispense with old notions of composition and to open up the audience to the noises around them—most famously in his silent piece, *4'33"* (1952). But for Cage, sound was a fact, even if its organization was indeterminate. Ashley, on the other hand, was interested in producing a "music that wouldn't necessarily involve anything but the presence of people.... It seems to me that the most radical redefinition of music that I could think of would be one that defines 'music' without reference to sound," as recounted in Michael Nyman's *Experimental Music: Cage and Beyond.*

While Cage separated the stages of music production in his famous 1955 essay "Experimental Music"— "Composing's one thing, performing's another, listening's a third," he famously stated, querying, "What can they have to do with one another?"—Ashley wanted to bring these divided activities together. In his mind, composing, performing, and listening were all social relations. In practice, this meant foregrounding the social processes, such as conversation, involved in assembling his compositions; the end products seemed to be less about "music" than living and thinking musically.

In the 1960s, Ashley created a number of works that required performers to assemble and construct the compositions from complex but open graphic scores. Several of these were performed by the ONCE Group, which included Ashley and his wife, Mary, Joseph and Anne Opie Wehrer, Harold and Ann Borkin, and Gordon and Jackie Mumma. Mem-

============ arts festival ============

Once Group's 'Morning Thing' Electrifies

By ANDREW LUGG

Devised by Robert Ashley, "That Morning Thing," which is being presented at the Union Ballroom by the Once Group, shows that the group is all that it is cracked up to be. It is two-and-a-half years since this local group last did a piece in town. Some will remember their performances on top of the Maynard Street parking structure. "That Morning Thing" is more modest in certain respects but more devastating in others. This scratched at your soul.

I feel much better now that it is all over. As I see it (and this, no doubt, is only one of many possible interpretations), this event is about a woman's suicide; about getting up in the morning and facing it again; about going through another day.

Afterwards someone told me that it was about memory, beautiful people, reflecting on unattainable ends, magazines, selling cars, the animal world, frogs, and so on.

One performer told me that she felt it was like working in a swamp. It was the "darkest" piece that they had ever done. What is sure however is "That Morning Thing" is very scary.

From my first viewing, I can say a number of things which I think most of the viewers would agree with. Firstly, we saw ordinary, well-known imagery gently transformed and interlocked in an extraordinarily controlled manner.

Second, this was no amateur light show, although some of the ingredients were the same. Third, the piece demanded much involvement. At the end, everyone was quiet, subdued by a weird, mysterious synesthesic outpouring or by the fear that all "private"

emotions are, ultimately, public.

Let me give a few (from many) impressions. I was impressed by the rostrum speaker, who not only defined a structure for the performance — that is verbally defined it — but also discussed the process of its creation. He told us that the American composer comes to terms with himself late in life, at that time when he reflects on death. Thus he combines happiness with nostalgia.

Or again, at the end, a voice repeats over and over "She was a visitor" . . . The suicide over . . . Or the motor car commercial, as recorded with all the retakes . . . The everyday world encroaching . . . Or the frog-people at the beginning . . . Conveyers from one zone to another. Or the singer counting to four and the pianist responding, as though from another world . . . perhaps communicating, but this was nighttime . . . no morning thing.

Mention should be made of some of the mechanisms used. These heightened the quality of the performance. When a speaker said "She said . . ." a time delay unit was employed to give the words a phase overlap, so that you felt that the words were slipping back in time . . . he was trying to remember what she had said before . . .

The "business men" wearing throat-mikes to give their voices a frog-like sound were "scaled down" to animal size . . . frogs representing death.

Although the rostrum speaker announced that the performance was to be symbolic and gave us the "key," no easy answers were apparent. "That Morning Thing" has a complexity and a monumentality which makes it a hard nut to crack.

—Daily—Michael Feldberg

Once Group does 'That Morning Thing'

The Michigan Daily's *review of Robert Ashley's* That Morning Thing, *February 8, 1968.*

bers performed each other's compositions in a manner that seemed to be an extension of their social lives. Over the course of the decade, personal relations became strained and the group broke apart, but between 1961 and 1968, they organized the ONCE Festival in Ann Arbor, Michigan. The most important series of music and performance of its time, ONCE brought together composers, choreographers, and artists from all over the U.S. and Europe, such as Cage, Luciano Berio, Karlheinz Stockhausen, Merce Cunningham, Robert Rauschen-

berg, Andy Warhol, the Velvet Underground, Pauline Oliveros, and Steve Paxton.

Insisting that his friends had a way of talking that was musical already, Ashley felt his main role as composer was to create forms and structures in which stories and conversations could take place. Opera, as he would later say in the liner notes for 1985's *Atalanta (Acts of God)*, is a way of telling stories musically: "These are long stories in the tradition of stories that are to be sung, but are too long to be sung without a musical accompaniment."

The 1964 festival featured Ashley's *in memoriam . . . Crazy Horse (Symphony)*, one of four pieces he composed about important figures in American history. Each work was given a formal reference: In addition to the symphony, the other works in the set include a quartet (Esteban Gomez), a concerto (Kit Carson), and an opera (John Smith). These labels were not relevant to the music in any traditional manner; instead, the performer and listener are intended to take the biographies of these men into consideration and make a connection between musical and social forms. As Ashley recalled to this author in 2009:

> When I was writing the group of pieces known as in memoriam in 1963, I was reading a lot of American and European history, and it occurred to me that the evolution of certain ideas that could be expressed in music in Europe through the forms used in those pieces—the quartet, the trio concerto, the symphony, and the opera—corresponded in a particular chronological way with the social or political forms that were developing in North America at more or less the same time. In other words, an idea that could be expressed in Europe in an art form had to take a social or political form in America, because there was no art in America.

Ashley has described the *in memoriam* compositions as well as others from the early 1960s onward as "drone" music, which he defines as music that is "outside of time" or circular in nature. Constructed out of sparse harmonic changes and alternating sonorities—more like weather systems or fields of action than just "sound complexes"—his music contains slowly changing reference pitches that define the character or temperament of the story being told, and numerical systems that repeat or slowly change over time. Ashley's sound world can feel like psychic residue, or perhaps the internal resonance of the singers' thought processes as they read the music—the operating frequency of their minds. To achieve this effect, Ashley employs complex structuring devices. Many of the rhythmic structures are based upon asymmetric meters (e.g., odd numbers) or the Fibonacci series (0, 1, 1, 2, 3, 5, 8, 13, 21, etc.); such odd meters are common in the sung storytelling of Asia and the Far East.

That Morning Thing (1967)

That Morning Thing, Robert Ashley's first large-form opera, is about the difficulty of waking up every day and putting yourself back together again. It's an exploration in words and music of the morning ritual (*Thing*) that we go through every day as we assemble ourselves in the image that we imagine those around us to have of ourselves. It's the self-reflexive gesture of reconstructing a self-same identity each day in order to be recognized and stay in the game. For some, the "thing" gets harder and harder to repeat; for a few, there appears to be no other choice but finding a way out. The pieces that make up *That Morning Thing* come out of Ashley's experience of losing three close female friends in one year. The coincidence of the suicides was beyond his or anyone's comprehension. Ashley needed to understand why someone gets to the point where they can no longer face another day or another morning thing. In place of finding answers, he began composing.

Our dependence on language and the forms of repetition that it produces are the structural basis of the opera. The speech acts or recitation styles employed throughout the opera are each unique; they include a lecture, a crippled set of dialogues, an intimate personal testimony, and a collective phonemic parsing of a single repeated phrase that creates a spectral drone of polyphonic voices. The first piece, *Frogs,* features a lecture on the impact of hazardous wastes on the eco-system accompanied by field recordings of frogs. Onstage, masked performers with large amphibian eyes walk in grids, occasionally meeting up with one another and touching hands. Their joined hands complete an electrical circuit and their eyes light up.

Other pieces include *Purposeful Lady Slow Afternoon* and *She Was a Visitor.* In the former, we hear a woman's voice telling the story of a sexual encounter in a dry, almost deadpan voice. As audience members, we feel like "third ear" listeners, listening in on a confidential recorded tape from a psychoanalyst's archive. The experience of hearing something so intimate from a private life, recounted so matter-of-factly in a public gathering can be strangely unsettling. *She Was a Visitor* is composed of the four words of the title, spoken in dry and even triplets, repeated over and over again by a male speaker accompanied by chorus. The chorus extracts phonemes from the phrase, sustaining them for indeterminate lengths of time as they move about the hall and out into the audience. In the performance at the Kitchen in 2011, the performers gently invited the audience to sing with them, beckoning softly to individual members of the audience, like peaceful aliens summoning you to come and join them on board their ship.

Interview

ROBERT ASHLEY

IN CONVERSATION WITH MARK BEASLEY

Robert Ashley's legendary and rarely staged opera *That Morning Thing* (1967) was informed by the tragic coincidence of three of his good friends committing suicide in quick succession. Attempting to understand the disturbing confluence of events and the nature of suicide itself, Ashley suggests that suicide is a result of the inability to answer or think one's way out of an intellectual problem, and the opera switches between scenes and texts that contain rationalizations or explanations of events and others that merely describe. For Ashley, "the meaning of the opera is evident in the struggle between these two modes of understanding things" and "the two modes cannot be reconciled." In such attempts to describe the unknowable, language loses the capacity for coherence and ultimately fails. The opera acquired its reputation from

Ashley's recording of two sections of the work, "Purposeful Lady Slow Afternoon" and "She Was A Visitor."

MARK BEASLEY (MB): You describe *That Morning Thing* as an illustrated "tract," where the broader idea is about the decay of spoken language. Can you speak a little bit about that?

ROBERT ASHLEY (RA): A tract is an argument. Hopefully, an organized argument, not a spontaneous one, so that would suggest to the audience what is to come. In other words, I'm arguing about something to the audience. It's a lecture followed by very clearly delineated sections. The lecture, three scenes, then the episode. It's really simple, that's the idea.

The piece is about dramatic contrasts. It's about a rationalized understanding of

occurences as against a physical description—something you understand with your experience that doesn't necessarily follow from an argument. That is the way the piece is organized. In the first act, there's an unrecognized contrast between the speaker and the jungle where the people are moving around unguided. In the second act, the first and third scenes show the same people: a woman who is counting in an irrational meter, and a man with a keyboard who is trying to make something based upon her irrational rhythms. In the next scene, there is a soundtrack, which is entirely a description of an experience, an illustration of an event. There are pictures of good-looking people, models. There's a dancer trying to imitate the poses in the photographs. In the third act, there's audio from an automobile commercial. So, what you hear are the directions for how to illustrate a commercial, and in the same act you have four men who are rationalizing their relationship with a woman. The guy has seen the woman, and he is rationalizing what happened between them. That's the end of the piece . . . these harsh contrasts.

MB: From your past descriptions of the piece, I understand that some part of *That Morning Thing* is about your personal experience of dealing with the death, specifically suicide, of three close friends.

RA: Right, although I don't think it's tactful to overtly foreground this. There were three women, good friends of mine, who didn't know each other, and they all committed suicide within a short period of time. I was trying to figure out why they did it. I knew them as relatively happy people. And that led me to this "thing" that we just described versus experiences that you can't put into words, while other experiences are almost diluted by the amount of word attention they get.

MB: So, we return to the idea of the decay of spoken language. I was interested in your idea of a moral dimension of language, how it is used as a controlling methodology. You give an example in Act One of *That Morning Thing*, a situation described by the narrator as the "Dime Store Misunderstanding" in which a shopkeeper looks to manipulate a customer.

RA: What's not explained in our spoken language is its decay, and how it's being

Robert Ashley, That Morning Thing, *1967/2011. Performance view. Photo by Paula Court.*

replaced by another kind of language—one that's irrational. For instance, in the dime store, the idea is that the person at the counter is indifferent to whether you've been cheated. He's arguing against you, even though there is no profit in it for him. He argues against you because he belongs to a system that requires him to argue. He is a protector, a guardian of that system even though he doesn't profit from it. It's an irrational kind of behavior, in a real sense, but it happens all the time.

MB: Is there a right or wrong way to use language?

RA: Yes. You have to keep language accountable in a moral way. That's exactly what [George] Orwell says: Eight, ten, fifteen volumes of Orwell say the same thing. You have to be respectful and

moral with language. Orwell is famous for that position. I love him. I would read anything I could [of Orwell's] when I was in my twenties, so when I was writing *That Morning Thing*, he came to mind. He wrote, "This is happening and it is bad and I don't like it." He was more like a journalist, but a spectacularly good writer too.

MB: In this instance, do you identify with the shopkeeper or are you pointing out journalistically, like Orwell, the compliance of the shopkeeper?

RA: It's the compliance. This is the part that is not moral; it's amoral. Language doesn't control behavior anymore. That is so common. Orwell was so far ahead of his times because there had been very little international understanding

amongst people back then. It's almost a kind of innocence that people had then, compared to now, when everyone knows everything. Everyone's been everywhere.

MB: So there's something about language's locality that causes it to become diluted? Or does it have this ability to shift?

RA: It's impossible to explain this, but when I grew up I was so ignorant of the world compared to how people are now. Besides being innocent, I'd never been anywhere, never knew anyone [from other cultures]. So now—especially in New York—it's bizarrely wonderful that we all go through our day without particularly understanding one another. I had to go to Chinatown this morning, and had to deal with two women who barely spoke English, but they were doing their job. And you have a British accent, and I'm talking to you As soon as you start moving people around, you start thinking, "What are those people doing?" You know? But you understand that they're communicating. Go over to Chinatown; you can't find one person out of ten who speaks English. But everything functions, hanging on for bare life to whatever language they know. This business of language—the sirens are on, it's gotten so out of hand.

MB: That's why I've always liked cities. I quite like the zone of the post-verbal.

RA: I like it too.

MB: In the past, we've talked about your formative years and the times that you were developing your relationship to performance and language in the late sixties, a time of mass upheaval, violence and change: from Vietnam and the draft, the riots at the DNC and the flowering of rock & roll. Did these events inform your interest in the decay or changing state of language?

RA: I didn't think of it as decay. Everybody was interested in change. Feminists, Martin Luther King—everybody was in agreement: They didn't know what they wanted, but they knew they wanted change. People now don't want things to change—it's the other way around. For seventy years, the U.S. has maintained a remarkable form of socialist democracy, improving life for everyone. All these [Republicans] grew up on it, and now they want to take that away. They want to take that socialist democracy away and replace it with an authoritarian system. I hope they don't do that. But I also recognize that in saying that I want to conserve things I have become conservative. It's an amazing thing to realize this is happening to you.

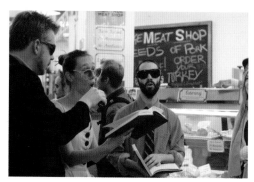
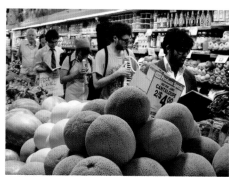

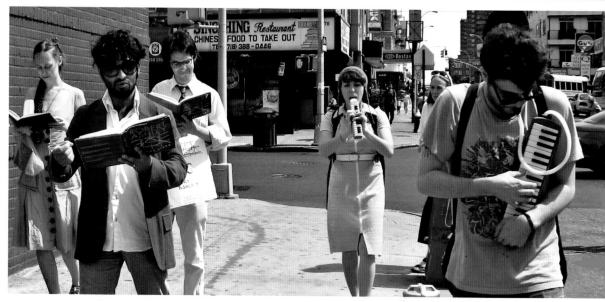
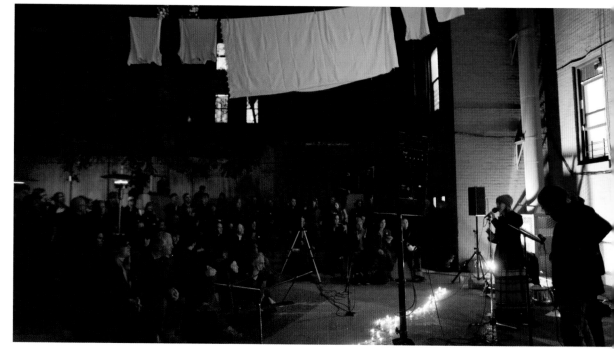

VARISPEED

Perfect Lives Manhattan

THROUGHOUT LOWER MANHATTAN

Perfect Lives Manhattan was a daylong, site-specific performance of Robert Ashley's 1983 work *Perfect Lives*. Originally written as a multimedia television soap opera, Varispeed, a newly formed New York collective of composer-performers Aliza Simons, Dave Ruder, Paul Pinto, Brian McCorkle, and Gelsey Bell, restored the piece into a lively act in the streets of Lower Manhattan under Ashley's guidance, acting out the original script exactly. The odyssey consisted of seven half-hour melodramatic "episodes," each at a different spot in the Lower East Side, SoHo, and adjacent neighborhoods. As performers and audience members made the pilgrimage, participants reimagined the big city as a folksy town where the bank tellers know the captain of the football team and everyone ends up at the same bar every evening.

In addition to doing a lightning-quick costume change—neon color-blocked nylon tracksuits and sunglasses for "The Park (Privacy Rules)," the first scene; jazzy dresses and sharp suits for Scene IV, "The Church (After the Fact)"—and occasional cast change at each location, they quickly set up a drum kit, music stands, and a microphone with stand for each episode. Beginning with Washington Square Park at 11 am, gaining audience members at each stop, the group made their way to the entrance of a bank lobby at 1 pm, the aisles of the Essex Street Market at 3 pm, Trinity Lutheran Church at 5 pm, the courtyard of the Performa Hub at 7 pm, and a neighbor's living room at 9 pm; *Perfect Lives* culminated its twelve-hour ramble of Lower Manhattan at Tom & Jerry's bar at 11 pm. Varispeed used spatial intimacy to animate the story—scenes were enacted inside homes, parks, and quotidian sites of interaction and recognition such as the supermarket and the corner bar, over shared readings, snacks, and pints of beer, rather than on stages or behind lecterns. Rather than stretching the limits of theater vérité inside an auditorium, Varispeed fittingly made the exhilarating city their stage.

—*Performa*

Varispeed, Perfect Lives Manhattan, *2011.*
Performance views. Photos by Esther Neff.

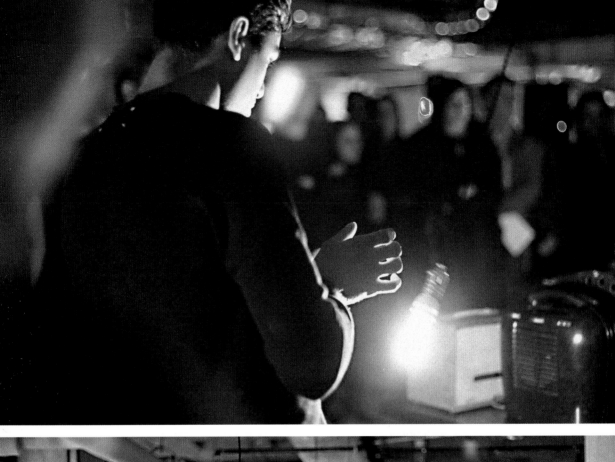
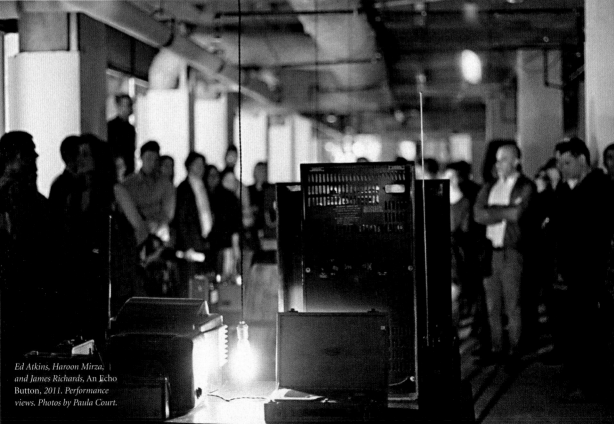

*Ed Atkins, Haroon Mirza,
and James Richards,* An Echo
Button, *2011. Performance
views. Photos by Paula Court.*

ED ATKINS, HAROON MIRZA, & JAMES RICHARDS

An Echo Button

ZABLUDOWICZ COLLECTION / CURATED BY SILVIA SGUALDINI / CO-PRESENTED BY ZABLUDOWICZ COLLECTION

In 1977, in the subway grating of a pedestrian island on Broadway between 45th and 46th Streets, sound art pioneer, percussionist, and artist Max Neuhaus created a powerful sound installation consisting of a deeply resonant drone, suggesting low-pitched chimes or church bells, which can only be heard within a few feet in the urban cacophony. But for four nights, the sound was celebrated, amplified, and incorporated into the work of three young British artists making their New York debut in one of the most spectacular settings that the city offers—Times Square. High above, on the thirty-third floor of 1500 Broadway, with bravado, Ed Atkins, Haroon Mirza, and James Richards commandeered the 130-foot-high Toshiba Vision Screen, four hundred feet above street level, for a half-hour event that featured a five-minute video on a loop as well as random projections from other video works exhibited in the Zabludowicz Collection's exhibition space.

An Echo Button, the installation, sound pieces, and video produced there for the event, was at the crossroad of each artist's research: high-definition video and challenging perceptual experiences for Atkins; Mirza's investigation into the boundaries between noise, sound, and music, and his quest for visual and acoustic empathy; and the sharp editing and distorting processes found in Richards's videos and soundtracks. Viewers gathered on four consecutive nights to experience the exhibition in the space as well as the incomparable view of Times Square from above. Lit only by the flashing of the surrounding advertisements, the dark room served as an "echo chamber" of sorts. Flickering red, blue, and green LED lights were set on tables, Waterford Crystal vases—with the same refracted surface that covers the New Year's Eve ball that drops every year in Times Square—were placed atop speakers, and three incandescent sound-generating light bulbs swayed above vintage radios. The result was a fragmented sculptural installation that provided delicate accents throughout the nearly five-thousand-square-foot room.

—*Performa*

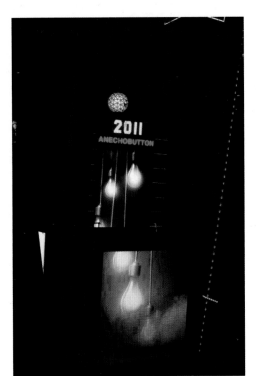
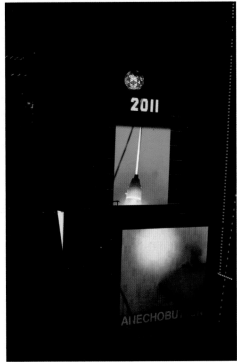

Ed Atkins, Haroon Mirza, and James Richards, An Echo Button, *2011.*
Installation views, Times Square. Photos by Paula Court.

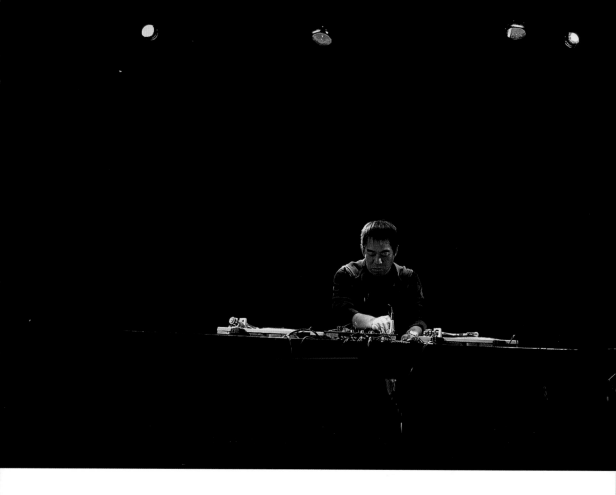

OTOMO YOSHIHIDE & CHRISTIAN MARCLAY

Turntable Duo: Otomo + Marclay

JAPAN SOCIETY / PRESENTED BY JAPAN SOCIETY

Two masters of the multiple turntable performance and sound-oriented visual works, Otomo Yoshihide and Christian Marclay, came together with *Turntable Duo,* playing alongside each other once again for the first time in over a decade. Sitting at separate tables, each with two turntables, stacks of records, and collections of assorted materials with various noisemaking capacities spread out in front of them—paper, wire, credit cards, and foam—the artists improvised a full range of sounds, from loud and abrasive to calm, contemplative, and often humorous phrases of music sampled from the records, some of which were

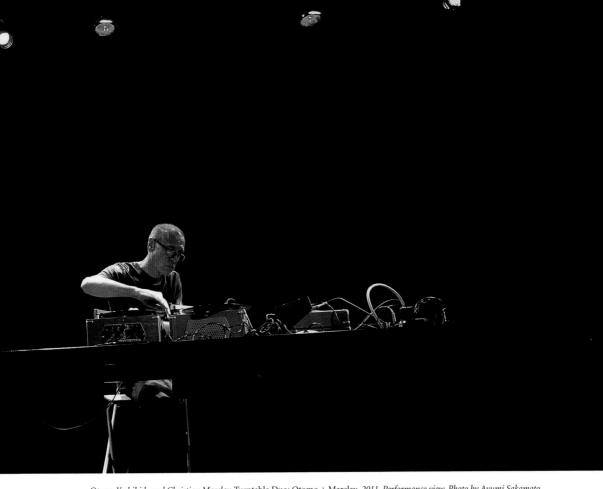

Otomo Yoshihide and Christian Marclay, Turntable Duo: Otomo + Marclay, *2011. Performance view. Photo by Ayumi Sakamoto.*

audible for just a few seconds. Otomo's installation *without records*—empty turntables producing sounds operated by a special computer program—was presented in the lobby of the Japan Society during the week of the performance. The work was created in homage to Marclay's 1985 album *Record Without a Cover*, released without a jacket or sleeve, leaving the record and its sound vulnerable to scratches and dust.

The duo also collaborated on the album *Moving Parts* in 2000, among other earlier projects. The concert exposed both the physical manifestation of their individual approaches to sound and the different ways in which each manipulates equipment to make music. It was also a sign of their friendship and mutual admiration. —*Yoko Shioya*

L'ENCYCLOPÉDIE DE LA PAROLE

Chorale

PERFORMA HUB / CURATED BY LANA WILSON / SPECIAL THANKS TO LILI CHOPRA (FIAF)

L'Encyclopédie de la parole (Encyclopedia of Speech), a conceptual choir initiated by playwright Joris Lacoste in 2007 in Paris, is made up of a group of visual artists, actors, musicians, sociolinguists, and poets, who collect and index thousands of hours of recorded language appropriated from political addresses, voicemail messages, news reports, lectures, and film and television dialogue, which they assemble into live "choral" performances. L'Encyclopédie is interested in the different qualities of speech—pace, rhythm, emphasis, tone, volume, and intensity—much more than the meaning of the words themselves. They revel in the implications of collaged language, adding new meaning and phonic measures to their extensive and ongoing oral sound bank. The other official ensemble members of L'Encyclopedie de la parole are David Christoffel, Valérie Louys, and Elise Simonet. There are also about fifty people who regularly gather and submit recordings to feed the collection.

For their first English language performance, *Chorale*, seven "scores"

were assembled from audio recordings on YouTube, the floor of the U.S. Senate, and calls to the emergency hotline 911, all of which were printed out and notated with markers indicating rhythm, accents, volume, and intensity. With content varying widely from fitness instructions to heated political debate, the choir sometimes chanted in precise, forceful unison; at others, solo voices could be heard taking the lead.

Introduced by Emmanuelle Lafon and Frederic Danos, who began the performance by addressing the audience in a spoken duet, translating each other's lines from French into English and English into French, the twenty-minute performance took the audience through a range of linguistic digressions. A man trying to get his dog to bark "I love you" on YouTube or a speech by politician Robert Byrd condemning dog fighting were memorized and performed by a choir of fifteen who had attended a two-week workshop prior to their debut.

For its finale, L'Encyclopédie de la parole built a rousing song on an exchange between political commentator Jim Cramer and Federal Reserve chairman Ben Bernanke from CNBC's *Street Signs*. "He has *no idea* what it's like out there. *None!*" shouted the choir, using Cramer's exact words to chastise Bernanke for not taking preventative measures against the housing crisis: "He's *nuts!*" they trilled in full voice, repeating the refrain over and over at a time when the country was still reeling from financial collapse. Such imagination in isolating words and phrases from everyday speech and reconstituting them as collective song achieved an unusual balance of heart and head: the emotional pull of music and the intellectual analysis of all forms of verbal communication.

—*Lana Wilson*

Score for Chorale.

At left: L'Encyclopédie de la parole, Chorale, *2011. Performance view. Photo by Elizabeth Proitsis.*

Nicoline van Harskamp, Any Other Business, *2011. Performance view. Photo by Paula Court.*

NICOLINE VAN HARSKAMP

Any Other Business

PERFORMA HUB / PERFORMA 11 PROJECT / CURATED BY DEFNE AYAS

What do political debates accomplish? What is the gap between political conviction and verbal expression? What are the different ways that we can consider the ability of the spoken word to shape thoughts and political ideals? In a darkly lit classroom of the Performa Hub, visitors were confronted with an intriguing narrative around these poignant questions.

The video installation *Any Other Business* by Dutch artist Nicoline van Harskamp aimed for "communicative excellence in civil society and politics." Introducing the piece, one of the actors announced to the audience that the work would attempt to answer the question "How can we communicate better?" The statement was then followed by the documentation of a uniquely structured conference that took place over the course of six hours, with thirty actors participating in a series of nine meetings, enacting rounds of "productive miscommunication." The sessions were recorded before a live audience in different rooms of de Ballie, a conference center in Amsterdam. In reality, however, every single item on the program was entirely scripted and staged by van Harskamp. The script was based on recorded public debates that

considered the relationship between politics and language and engaged the numerous theories of anarchism that are still critical today. As the meetings went on, a dog fight unfolded; an activist denounced nonviolent tactics; an unexpected event shook up the conference, and the self-proclaimed "vanguard of the politically conscious class" was unable to keep its calm. Van Harskamp's durational exercise in communication proposed that the expression of or defense against power via official bureaucratic channels goes not only unchallenged, but completely disregarded and unheard.

Based in Amsterdam, van Harskamp's research-driven artwork often investigates taxonomies of power in the form of pamphlets, videos, and public debates. Van Harskamp's past projects have examined security guards and law enforcement officers in London and Istanbul, surveillance and discipline in Rotterdam and Amsterdam, and self-government in the Danish autonomous community Christiana. Using the aesthetic of the corporate boardroom, she has staged debates among amateur ideologues, rewritten those debates into scripts, and then staged the scripts as a drama.

—*Defne Ayas*

RECORDER PERSONAL TRANSLATOR
 REPRESENTATIVE

ANDREA GEYER, SHARON HAYES, ASHLEY HUNT, KATYA SANDER, & DAVID THORNE

Combatant Status Review Tribunals, pages 002954–003064: A Public Reading

BAUHAUS STAIRCASE, FLOOR 2, MUSEUM OF MODERN ART / CURATED BY SABINE BREITWIESER

On the second floor of the Museum of Modern Art, in a space not typically used for exhibition, beneath what is referred to as the Bauhaus Staircase, eight readers sat facing each other on four sides of a square table, each of whom were identified with nameplates set before them: Tribunal Member A, Tribunal Member B, Tribunal President, Recorder, Personal Representative, Translator, Detainee, and Narrator. A chair labeled "Witness" remained empty. Each read from the transcripts of eighteen trials from the first round of Combatant Status Review Tribunals, proceedings that were conducted by the United States Department of Defense from July 2004 to March 2005, at the U.S. detention center in Guantanamo Bay, Cuba. At the conclusion of each tribunal's transcript, which vary in length from five to thirty minutes, the readers rose from their chairs and rotated one seat clockwise, the Tribunal President becoming the Detainee, the Detainee becoming the

Translator, and so on. Once settled in their new seats, the Narrator, whose role was to read the descriptive and contextual notes of the document's transcriber, announced the start of the next tribunal, simultaneously revealing his or her presence in the document itself.

In Washington, the Department of Defense described the tribunals as administrative hearings whose intent was to determine whether a given detainee had been properly categorized as an "enemy combatant," thus justifying their continued detention without trial. As records of these hearings, the transcripts relay complicated pictures of compromised justice. "I know for sure my destiny is already determined," read the words of one detainee. "The judgment against me is already made up. My presence, me defending myself or not defending myself, will have no importance whatsoever," reads another's.

Over the course of four hours, the eighteen transcripts and the narratives

Andrea Geyer, Sharon Hayes, Ashley Hunt, Katya Sander, and David Thorne, Combatant Status Review Tribunals, pp. 002954–003064: A Public Reading, *2011. Performance views. Photos by Paula Court.*

Andrea Geyer, Sharon Hayes, Ashley Hunt, Katya Sander, and David Thorne, Combatant Status Review Tribunals, pp. 002954–003064: A Public Reading, *2011. Performance detail. Photo by Paula Court. At Right: Script for* Combatant Status Review Tribunals, pp. 002954–003064: A Public Reading.

that unfolded revealed mistranslations, contradictions, communication gaps, and fabrications. The rotation of the readers through the eight speaking positions avoided their singular identification with any one figure, opening up a space in which any neat political tendencies brought by the viewers were interrupted. As the precarious nature of each speaking position became tangible, the documents pointed more acutely to the present moment—to the actual detainees still held in the prison camp at Guantanamo, to the U.S. military and politicians who continue to hold them, and to those of us gathered in the room.

At the time of this writing, almost two years later, President Obama has announced a renewed effort to close the prison at Guantanamo in response to the hunger strike by almost all of the remaining detainees. As of now, the prison camp remains in operation and the indefinite detention of 166 men by the United States military continues.

—Andrea Geyer, Sharon Hayes, Ashley Hunt, Katya Sander, and David Thorne

Staged twice over two days, the readers were scholars and writers, artists and actors, lawyers and activists, including Jane Anderson, Homi Bhabha, Yve-Alain Bois, Cynthia Chris, Kyle deCamp, David Deitcher, Nitasha Dhillon, Allen Feldman, Judy Greene, Patricia Hoffbauer, Amin Husain, Fred Moten, Vyjayanthi Rao, George Sanchez, Sadia Shirazi, and Anna Deavere Smith.

DEPUTY SECRETARY OF DEFENSE
1010 DEFENSE PENTAGON
WASHINGTON, DC 20301-1010

JUL 1 4 2006

MEMORANDUM FOR SECRETARIES OF THE MILITARY DEPARTMENTS
CHAIRMAN OF THE JOINT CHIEFS OF STAFF
UNDER SECRETARY OF DEFENSE FOR POLICY

SUBJECT: Implementation of Combatant Status Review Tribunal Procedures for Enemy
Combatants Detained at U.S. Naval Base Guantanamo Bay, Cuba

References: (a) Deputy Secretary of Defense Order of July 7, 2004
(b) Convening Authority Appointment Letter of July 9, 2004
(c) Detainee Treatment Act of 2005
(d) Deputy Secretary of Defense Administrative Review Board Implemention Order
(current)

Enclosures: (1) Combatant Status Review Tribunal Process
(2) Recorder Qualifications, Roles and Responsibilities
(3) Personal Representative Qualifications, Roles and Responsibilities
(4) Combatant Status Review Tribunal Notice to Detainees
(5) Sample Detainee Election Form
(6) Sample Nomination Questionnaire
(7) Sample Appointment Letter for Combatant Status Review Tribunal Panel
(8) Combatant Status Review Tribunal Hearing Guide
(9) Combatant Status Review Tribunal Decision Report Cover Sheet
(10) Implementation of the Detainee Treatment Act of 2005

1. Introduction

By reference (a), the Secretary of Defense has established a Combatant Status Review Tribunal
(CSRT) process to determine, in a fact-based proceeding, whether the individuals detained by the
Department of Defense at the U.S. Naval Base Guantanamo Bay, Cuba, are properly classified as
enemy combatants and to permit each detainee the opportunity to contest such designation. The
Deputy Secretary of Defense has been appointed to operate and oversee this process.

The Combatant Status Review Tribunal process provides a detainee: the assistance of a Personal
Representative; an interpreter if necessary; an opportunity to review unclassified information
relating to the basis for his detention; the opportunity to appear personally to present reasonably
available information relevant to why he should not be classified as an enemy combatant; the
opportunity to question witnesses testifying at the Tribunal; and, to the extent they are
reasonably available, the opportunity to call witnesses on his behalf.

2. Authority

The Combatant Status Review Tribunal process was established by Deputy Secretary of Defense
Order dated July 7, 2004 (reference (a)), which designated the undersigned to operate and

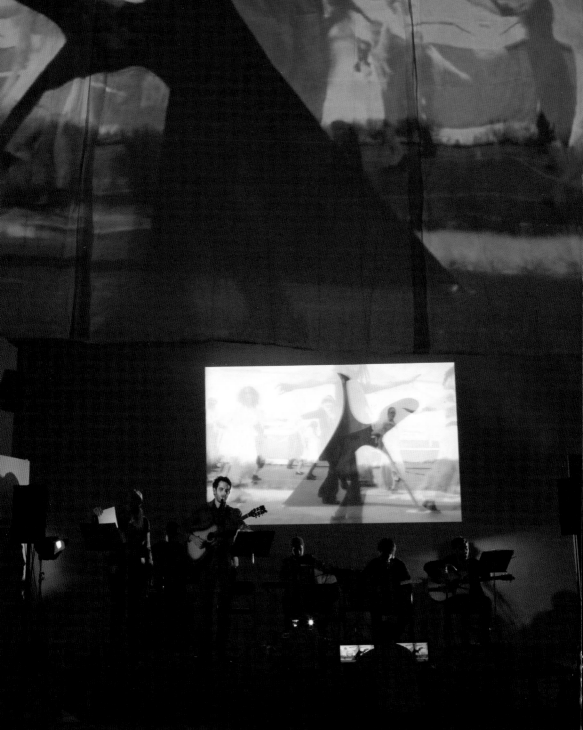

MATEO TANNATT

Pity City Ballet

SAATCHI & SAATCHI / CURATED BY CECILIA ALEMANI

In an unusual setting for a performance—an empty conference room on the ground floor of the Saatchi & Saatchi office building in Tribeca—Los Angeles–based artist Mateo Tannatt staged *Pity City Ballet*, a rock concert featuring five musicians in front of a video projection. For about one hour, in a dark, gloomy atmosphere barely illuminated by dim spotlights, the performers stood on an elevated stage typically used for business conferences while the audience sat on quilted moving blankets stretched out on the floor to weave a large, cozy carpet. The five performers played songs written by Tannatt that recalled the music of Leonard Cohen. But whereas Cohen's ballads speak of love, Tannatt's songs described the many public sculptures that punctuate New York City's streets and parks, images of which were projected on the screen behind the musicians. His ongoing interest in creating landscapes from objects and props, often brought to life by nontraditional actors and passersby, is taken to a new level in *Pity City Ballet*. Massive, conceptual public sculptures by artists such as Mark di Suvero and Alexander Liberman become emblematic monuments within their site-specific homes, but Tannatt is more interested in how these once-complex artworks become reduced to city logos, eventually losing their conceptual depth. With a dry sense of humor, *Pity City Ballet* combined entertainment and critique, drawing an imaginary map of the city in which monuments and sculptures look as lonely as the characters in a sad love story.

In *Piano 1:1* (2011), created for the Hammer Museum exhibition "All of this and nothing," a sound piece consisting of a baby grand piano being dropped eighty feet was recorded with both internal and external microphones; the sound was then slowed to a ratio of one second to one minute, six seconds stretched to six minutes. His 2010 exhibition "Rendezvous Vous" was built around two homeless men claiming a derelict restaurant as their residence, located a few short blocks from the Marc Foxx gallery in Beverly Hills, where the exhibition was held; Tannatt wrote a libretto for one of the men to sing in situ. "Rendezvous Vous" was concerned with the performances everyone acts out daily, whether they are celebrated or invisible to most of society. His work tends to focus on public artwork, using sculpture as a platform for performance, video, photography, and painting.

—*Cecilia Alemani*

STEWART HOME

Psychedelic Noir

WESTWAY / CURATED BY MARK BEASLEY / PRESENTED BY WHITE COLUMNS AND PERFORMA

Perhaps inspired by the quirks of the evening's setting—Westway, a former strip club on the curb of the West Side Highway, now an of-the-moment nightclub—Stewart Home and fellow participants took liberty in their deliveries of poetry and songs, culminating in a particularly agile and spirited evening.

Stewart Home, Psychedelic Noir, *2011. Performance view. Photo by Paula Court.*

UK visual artist and writer Home kicked off the night by shredding one of his books onstage, proving that "art is greater than literature," then addressing the crowd with a brief passage of myth and controversy from his 2010 book *Blood Rites of the Bourgeoisie* while standing on his head. Author Jarett Kobek read from a work titled "Paris Hilton Uses a Computer Topless While Preparing to Smoke Marijuana from a Dragon Shaped Bong with Tommy Hilfiger Model Jason Shaw"; Sadie Laska of the band Growing read Lynne Tillman's piece in lieu of the writer; and Ken Wark re-presented a speech he gave at Zucotti Park during Occupy Wall Street, with Home chiming in with a call to war on the London bourgeoisie. Growing (Joe Denardo and Laska) ended the evening with overwhelming drone and ambient sounds. The unusual program, the room saved from complete darkness by a lone magenta light bulb, unwound slowly, acquiescing to its seedy surroundings for one shadowy evening.

—*Jennifer Piejko*

LILI REYNAUD-DEWAR WITH MARY KNOX & HENDRIK HEGRAY

Interpretation

CALDER FOUNDATION / CURATED BY VICTORIA BROOKS

Paris-based artist Lili Reynaud-Dewar works in film, sculpture, fashion, performance, and dance, often referring to relationships between her family history and various incidents relating to racial political struggles that are nevertheless at a remove from her own background. Though trained in ballet and law, she began to make artwork in 2005, and performs regularly, often within the context of her films, documentation of previous performances, and sculptures. In her New York debut she transformed music and texts from her past in a new context, rewriting her family's history in the process and expanding her personal identity beyond what can be determined by accepted facts.

Interpretation, a thirty-minute work titled after a track on Sun Ra's 1971 album *The Solar-Myth Approach: Vol. 2,* used the structure of free jazz, with its implication of emancipatory ideals, as both form and content. In close proximity to the audience, she crouched at a turntable playing 1970s jazz records collected by her father, avid Black Panther Party supporter and owner of La Grande Oreille (The Big Ear), an independent record shop in La Rochelle, France. Against a backdrop of three

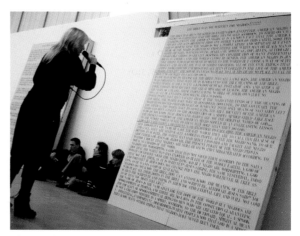

Lili Reynaud-Dewar, Interpretation, *2011. Performance view. Photos by Paula Court.*

oversized panels containing texts written in pencil from Sun Ra's 1950s political pamphlets, Glaswegian club singer and burlesque star Mary Knox joined in her usage of the texts as a loose script for her actions, while Parisian musician Hendrik Hegray responded with improvisations on a large organ. Inspired by Sun Ra's questioning of origins—he has denied the political entanglements of declaring himself an African American, instead proclaiming that he hailed from Saturn—Reynaud-Dewar staged a live exploration of intertwining histories and memories.

—*Victoria Brooks*

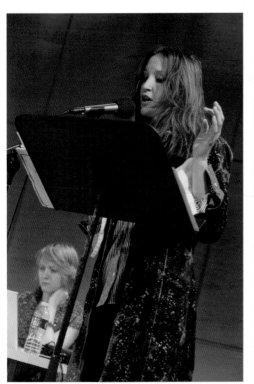

PERFORMA RADIO

Performa Radio was a one-hour-long broadcast, streamed live from the WNYC radio station's Greene Space. It featured five new performances by novelists Masha Tupitsyn and Hari Kunzru, artists Nathaniel Mellors and Marianne Vitale, and musician and writer Jace Clayton, along with a specially commissioned audio work by novelist Tom McCarthy.

The program opened with Tupitsyn's *Times for Nothing*, a monologue meditation on broadcast technology and subjectivity, and closed with Clayton's *Justin Eastman Memorial Dinner*, a short play narrated by Sharifa Rhodes-Pitts, with music by Clayton, Emily Manzo, and Amy Zhang, based on the life and work of composer Julius Eastman. Along the way, a group of children performed a play about pilgrims trapped inside a giant's intestines (Mellors's *Giantbum*, performed by the Brooklyn Youth Company); a chorus of digitally processed and enmeshed voices expressed financial and personal desperation (*99*, by Kunzru, performed by Meg Clixby and this writer); and a deliriously unhinged woman imagined herself as a buffalo (Vitale's *Saving the Buffalo*). Between each performance, McCarthy provided snatches of coded signals, perhaps from lost numbers stations—World War II–era shortwave radio stations broadcasting numbers or Morse code recited by manipulated or artificial voices, or agents of foreign governments transmitting messages to their handlers. Performa Radio tapped into the literary legacy of the first broadcast medium, scanning for new frequencies where Futurist F. T. Marinetti's "wireless imagination" might still be found, in the on-demand digital omnipresent.

—*Dan Fox*

Clockwise from top left: Marianne Vitale, Saving the Buffalo, *2011. Emily Manzo and Amy Zhang performing as part of Jace Clayton's* Julius Eastman Memorial Dinner, *2011. Nathaniel Mellors,* Giantbum, *2011. Performed by Brooklyn Youth Company. Performance views. Photos by Paula Court.*

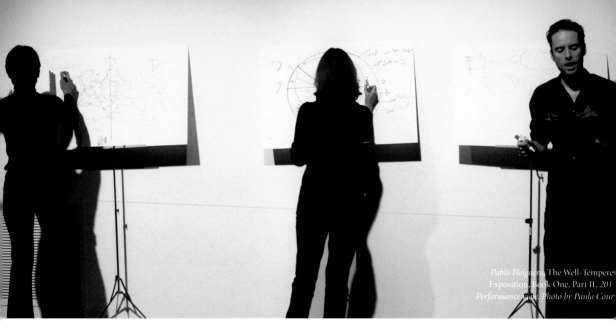

Pablo Helguera, The Well-Tempered
Exposition, Book One, Part II, 201
Performance view. Photo by Paula Cour

PABLO HELGUERA

The Well-Tempered Exposition, Book One, Part II

LOCATION ONE / PRESENTED BY FRANKLIN FURNACE

Pablo Helguera's *The Well-Tempered Exposition* was a methodical investigation of the formal components of performance-art practice. The yearlong project consisted of the creation of forty-eight speech-based scores. The final aim of *The Well-Tempered Exposition* was to exist as a collection of scores addressing the rhetorical, contrapuntal, and compositional structure of performance art as we understand it today.

The Well-Tempered Exposition was structured around the existing forms in Johann Sebastian Bach's *Well-Tempered Clavier* of 1722, a collection of keyboard exercises composed in all twenty-four major and minor keys, originally intended as a pastime for those already skilled in this study. Today, it is considered one of the foundational works of modern Western music. *The Well-Tempered Exposition* seeks to retain Bach's original pedagogical intent while also "translating" the complex formulas of the musical composition into correlating forms such as verbal counterpoint, contextual harmony, movement, and other elements.

The event ran for sixty-five minutes. Musical notations were projected on the walls while pianist Beatriz Helguera played the corresponding *Clavier* piece before each "exposition." These were performed by Katherine Adamenko, Lisa Gross, Ryan Hill, Brian Linden, Laura Lona, Melanie Lockert, Richard Saudek, and Corey Tasmania, translating the fugues of *The Well-Tempered Clavier* into speech.

—*Martha Wilson*

NILS BECH, WITH BENDIK GISKE & SERGEI TCHEREPNIN

Look Inside

NEW MUSEUM OF CONTEMPORARY ART / PRESENTED BY ART SINCE THE SUMMER OF '69 AND RHIZOME

The Norwegian singer and artist Nils Bech describes his work as the "creation of rituals," transforming and elevating emotional circumstances from his own life. For Performa 11, he joined forces with musician Bendik Giske and artist Sergei Tcherepnin to perform two concerts. The first, at the gallery Greene Naftali, was a quiet but powerful affair, with Bech covering The Smiths and others a cappella, with Giske on saxophone and flute. At the New Museum, Bech performed songs from his forthcoming album, *Look Inside*—a chronology of personal events that had transpired over the last year. Interacting with Lina Viste Grønli's angular sculpture *Isadora* (2009), and backed by Giske and Tcherepnin on saxophone, flute, and electronics, Bech's singing was personal, yet humorous.

Working with voice, instruments, movement, and text, in performances both staged and spontaneous in galleries, bars, and public spaces, Bech illustrates the hybridization at play between art, music, and dance today.

—*Hanne Mugaas*

Nils Bech with Bendik Giske and Sergei Tcherepnin, Look Inside, *2011. Performance view. Photo by Paula Court.*

MX. JUSTIN VIVIAN BOND

Full Moon Tranifestation Circle

PARTICIPANT INC / CURATED BY LIA GANGITANO

Coinciding with Justin Vivian Bond's first solo exhibition at PARTICI-PANT INC, "The Fall of the House of Whimsy," *Full Moon Tranifestation Circle* was performed on November 10, 2011—the night of a full moon. The intimate evening-length concert took place within the exhibition installation at the gallery, a partial reconstruction of the House of Whimsy, Bond's recently demolished loft apartment on Second Avenue. V's paintings and photographs, piano, record player, couch, and vanity were included among other personal effects.

Bond was joined by Nath Ann Car-

rera on guitar and Elizabeth Koke, and the three performers formed a "circle casting"—a Wiccan ceremony in which participants form a circle to create a "sacred space" where spells and rituals are performed. *Full Moon Tranifestation Circle* culminated in V's signature rendition of "22nd Century," a song written by Bahamian musician Exuma and made famous by Nina Simone circa 1970. The lyrics describe time passing, loss, and the liberation to come in the twenty-second century.

Bond's achievements in theater and music are made more profound by V's evolving gender identity, an exploration manifested through a reclamation, reinvention, and redefinition of V's own body and identity ("V" is Bond's pronoun of choice). The original House of Whimsy was a dream house decorated with Bond's pencil-and-watercolor paintings of friends, lovers, and members of the "radical faerie" community, many dressed in various forms of drag. The record of these subversive activities serves as a reminder of an era of downtown living that has passed, slowly eradicated by the new economic realities of the city.

—*Lia Gangitano*

Mx Justin Vivian Bond and Nath Ann Carrera, Full Moon Tranifestation Circle with Justin Vivian Bond and Friends, *2011. Performance view. Photo by Rona Yefman.*

MATTHEW STONE

Anatomy of Immaterial Worlds

THE HOLE

In line with his motto, "Optimism as Cultural Rebellion," Matthew Stone is both an artist and shaman working toward a more optimistic future. *Anatomy of Immaterial Worlds* was a sound and light installation, momentarily transforming a gallery into a nightclub—a new-wave temple offering technicolor enlightenment. A heavily synthesized drum 'n' bass soundtrack (traditional drum samples were replaced with recordings of shamanic drumming on deerskin drums) was blasted; after immersing the room in thirty seconds of complete darkness, a neon-colored computer-animated video simulating a "trip" down a tunnel was projected onto the walls and floor, a metaphor for the artist and own shamanic "journeying" into altered consciousness and intense daydreams. Guests were ushered back into reality when a classical score composed by Stone started to play and the lights came on.

Stone creates images and experiences of entangled bodies and midnight parties in search of ecstasy and answers, often in various states of sensory manipulation. *Anatomy* further expands his visual style of pushing photographic techniques onto sculpture, laser engravings, fabric and clothing, magazines, video, and performance.

—*Kathy Grayson and Amanda Schmitt*

DENNIS McNULTY

The Eyes of Ayn Rand

ST. PATRICK'S YOUTH CENTER

Known for his atmospheric installations incorporating sound, sculpture, and performance, visual artist Dennis McNulty took Ayn Rand's *The Fountainhead* as his point of departure for a complex exploration of urban space and memory. In a run-down high-school gym in Little Italy, the stage, bleachers, old-fashioned wall clock, and faded basketball markings on the floor provided four distinct locations for small theatrical tableaus against which a moveable "play" was performed by two actors, a man and a woman. Using found furnishings—table, chair, desk lamp, record player, old TV monitors—each "act" provided a glimpse into Rand's writings, collaged with references to contemporary architects and architecture. As visitors followed the actors around the dark gymnasium from one brightly lit set to another, they gradually accumulated a disjointed but profoundly felt sense of McNulty's fascination with the psychology of architecture and space, and the capacity of language to enhance or distort our experience of both.

THE SCENE: Ayn Rand's face is shown in slow-motion close-up on a TV monitor set on the stage. Loud, abstract sounds play through a PA system from the back of the hall. It is 1958. Images of *The Fountainhead* author's eyes play on the monitor, showing her distracted by details of the television studio's interior, where she is being interviewed by a newscaster.

FIRST LOCATION: Upon entering the darkened space, the audience is led to the edge of a pool of light and given a small, handmade booklet of black-and-white photos of Constructivist architect Konstantin Melnikov and his wife, Anna Yablokova, in front of the construction site for the famous home he designed for them—shaped entirely out of twin cylindrical towers with graphic hexagonal windows. A recorded voice guides the audience through a sequence of images of the house, completed in 1927–29, playing on a second TV monitor.

SECOND LOCATION: A man seated at a table reads a press release for a 1988 exhibition at MoMA, "Deconstructivist Architecture," while slowly tracing the ceiling-tile grid with reflected desk-lamp light. The actor puts a new tape in the cassette recorder, which recounts a story about an architect's house, its windows, and the moon.

Dennis McNulty, The Eyes of Ayn Rand, *2011. Performance view. Photo by Paula Court.*

THIRD LOCATION: A woman stands next to a large square of red light thrown onto a screen from an overhead projector. In darkness except for the reflection of the red light on her face, she has a "conversation" with an unmodulated, prerecorded voice on a vinyl record that describes several obsolete technology ideas, such as the Legacy computer system, the COBOL programming language, and the Y2K bug. An accompanying sequence of images on transparencies is projected.

FOURTH LOCATION: In the final sequence the audience is led up onto the gym's small stage, where they listen to the actors reenact an interview between Peter Eisenman and Frank Gehry. At one point the man asks, "This building, do you want people to be in the place . . . disturbed?," to which the woman responds only with a shrug. The lights come up.

—*Dennis McNulty*

SMALL UTOPIAS

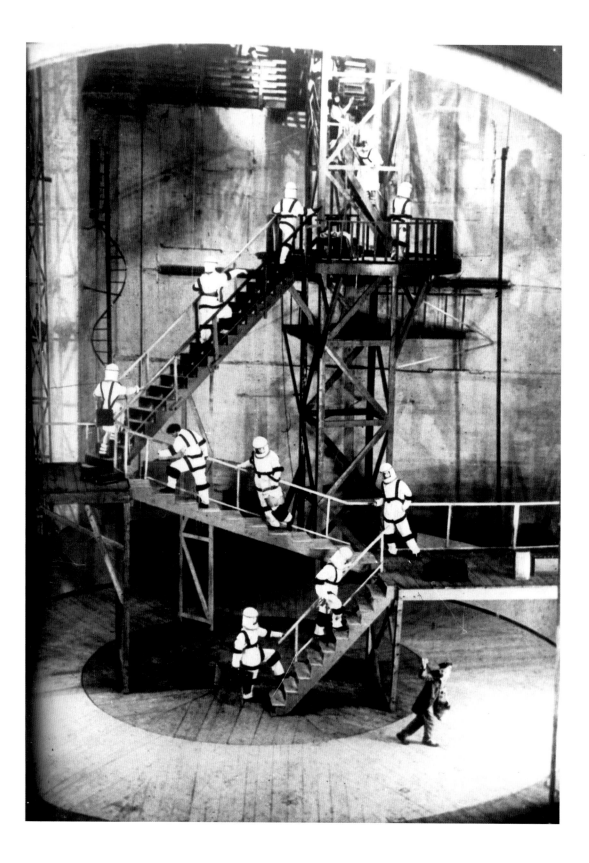

THERE IS NO SUCH PLACE
CONSTRUCTIVIST UTOPIA NOW

BY DOUGAL PHILLIPS

Exploring the Idea of an Island

In 1969, George Maciunas, Milan Knížák, Yoshi Wada, and others traveled to Ginger Island in the British Virgin Islands to scout out a location for establishing a Fluxus colony. Oddly, Maciunas's blueprints for the subdivision of the island reflected the non-tropical grid of Manhattan—the very island from which they were attempting to flee. Maybe it was that Maciunas saw this vacant isle not as a hideaway but as a potential part of the Fluxus archipelago stretching from Tokyo to Berlin.

Although the trip was fraught with difficulties and the plan for taking over Ginger Island was aborted, we can share in Maciunas's vision of the island as a cradle for the avant-garde. This is what links this plan beyond a Fluxus action to a larger and longer quest for an autonomous realm of art and living, one which stretches back to the early decades of the last century. This is the pounding utopian pulse of early Modernism, Russian-style, which emerged from its own "Ground Degree Zero" on the canvases of Kazimir Malevich and evolved into the great spirit of Constructivism, both as we knew it back then, and—as witnessed in Performa 11—now.

Utopia begins with mistranslation. The word itself comes from the Greek ο ῠ ("not") and τ ο π ο ς ("place"), suggesting that utopia is defined by its very unrealizability. The English homophone *eutopia*, from ε ῠ ("good" or "well") gives rise to the double meaning: the ideal

At left: Meyerhold's production of The Bathhouse *by Vladimir Mayakovsky, 1930.*

place/there is no such place. Indeed, Sir Thomas More incorporated the fantastical "entertainment" of the idea of utopia in the long literal translation of his 1516 title: *A Truly Golden Little Book, No Less Beneficial Than Entertaining, of the Best State of a Republic, and of the New Island Utopia.*

The impulse of Constructivism that rocketed out of Moscow in the 1920s was born of this same obsessive and protective "atolling" of art. Early explorer Malevich thought of his work as a beacon across the vast oceans [as quoted in Barbara Rose's 1988 book *Autocritique: Essays on Art and Anti-Art, 1963–1987*: "I have broken the blue boundary of color limits, come out into the white, besides me comrade-pilots swim in this infinity. I have established the semaphore of Suprematism"] and of himself as leading the departure from the shore. "Swim! The free white sea lies before you." Like Maciunas's crew (they from Manhattan to the BVI; Malevich from Moscow to the Skoptsy and Verbovka) he was leaving from one place to another, in search of something out there, even if he thought it abyssal.

Where Malevich landed after exhausting the free white sea was on the Isle of Constructivism, where utopian citizens navigated the smooth architectonic intersections of Lissitzky; radiating graphics from Stepanova's sports clothes; moving under the instruction of Vsevolod Meyerhold; re-seeing the world through Rodchenko's eye. The impulse was to start again in constructing art—to break the visual, theatrical, sculptural, and aural down to their original forms and premiere them stripped of artifice, pretense, and the weight of time. In Russia, the studio/school was the hermetic laboratory for formal experimentation, cut off from the Baroque influence of history. In the laboratory phase, Constructivism remains an island.

But what kind of an island is the avant-garde, and what kind of artist can inhabit it? Is art now akin to Umberto Eco's *Island of the Day Before*: solitary, riddled with atavism and doppelgängers? Or are we living on mutineer Christian Bryant's Tahiti, a sanctuary from a repressive mainstream that ends up bearing a line of inbred descendants? Or can it be future-gazing colony: DJ Spooky on Nauru?

If we follow the Russians, the answer is: Constructivism is Krakatoa, which exploded with such magnitude that the waters sloshed in the English channel and the loudest sound heard in modern history reverberated around the world for several days. Constructivism too reverberated through Europe and around the hemispheres for more than a century, and it reverberates now: for Performa 11, it echoed through the canyons, corners, and intersections of Manhattan, inside and out.

Translations

The Constructivist spirit is found in

the idea that we can put to use the basic tropes of theater to re-see how our (art) world is constructed, and to experiment with what happens when we take it all away and piece it back together from the barest of Beckett bones. **Elmgreen & Dragset** showed us that as we come together as a collective in the theater to have our worldview readjusted through staged revelations, we are making departure as well, together—away from narcissistic art-world fantasy and toward an ironically real place for all. There is a reason there was a giant EXIT sign on the stage.

What made **Liz Magic Laser's** Living Newspaper operate beyond a historical trope is that it was a total channeling of the spirit of a staged Soviet *gazeta* but entirely born from the present moment, existing outside of research, re-presentation, or re-performance. It was of The Now. Inside the cinema, the relation of projection to audience was flipped forward and back, as islands of action popped up simultaneously in the seats and on the screen. Through the use of literal clowns and broad theatrical strokes in the style of the 1920s, we came to hear the emotional grammar of Fox News cohorts in a whole new way.

Julieta Aranda and Carlos Motta's *Broken English* was literally a newspaper, beginning with the aesthetic and utility of an agitprop broadsheet, but repurposing the organ as an international conversation reflecting on New York City. This "witness to New York's cultural history" speaks of the constant cultural translations and negotiations of the urban encounter today, with a complexity of ideology and a matrix of competing hypocrisy and truth that would make the Soviets' heads spin.

L'Encyclopédie de la parole translated for us from the online world, collecting, indexing, and performing archived oratory and viral YouTube clips in a strictly conducted spoken ensemble "choir" of fifteen performers exploring bursts of speech. Despite its insistence on the graphic and the formal, on the purity of the tectonic, Constructivism was always about language at its heart—it was in essence the idea of a radical art language that could be translated between endless media and from the laboratory to the square to the radio and beyond.

Rodchenko, Stepanova, Aleksei Gan, and others all contributed to the development of *faktura*, which gave conceptual body to the Constructivists' approach to creation and material. The transformative, translational faktura approach to synthesizing new content and the new form drove many Performa 11 projects. The ambiguity of *facture* in French (both the making of musical instruments and the way a piece of music is written—at once stage and performance) points to the way the work of art reveals itself simultaneously across a multiplicity of media. **Mai-Thu Perret's** living comic strip was at once a minimal dance piece in the contemporary style, a set of staged graphic elements, and a retelling of

George Herriman's long-running *Krazy Kat* comic strip in one performance. The two dimensions of the backdrop met the three dimensions of the stage-as-comic-frame and the four dimensions of live narration and song. Tyler Ashley and the SARAHS' Constructivist aerobics drill in Times Square and on the High Line brought Meyerhold's biomechanics to bear on the global financial crisis and put Stepanova's sports outfits, updated for 2011 in neon and plastic, into use. Ed Atkins, Haroon Mirza, and James Richards colonized the Square both inside and out, bouncing their broadcast images and sounds between the video billboards and the interior of a skyscraper. For four evenings, small eruptions of art disturbed Times Square's corporate messaging.

This sort of collapse of inside and outside, of multiple dimensions, of avant-garde art and everyday life is the utopian Constructivist moment: the newspaper coming alive; the theater turned into a comic strip; the city turned into a theater. Gerard Byrne flipped the script—literally—in his Performa Commission, creating a temporary archaeology of theater in the operational underworld of the Abrons Arts Center on the Lower East Side. In Byrne's work, modernity is treated as antiquity, with the relics of modernist titans like Beckett and Noguchi rendered liminal props; half onstage, half off. Byrne used the various entrances, dressing rooms, and prop storage spaces to funnel audience and actor together, to create spontaneous theater from well-worn monologues reanimated by chance and spectatorship—theater as a living, breathing, halting organism coming to life and retreating again. Was it the sculptures or the auditioning actors really doing the talking?

This moving, revealing, curtainlike quality was present in **Dennis McNulty's** project as well. Pools of light, blocks of color, tightly scripted mechanical narrative—all of this gave life to abstract ideas reflected in *The Eyes of Ayn Rand*. Rand's perverse utopianism appeared in **Ursula Mayer's** sixty-minute film *Gonda*, brought to life by transgender model Valentijn de Hingh. A different Russian, a different revolutionary Modernism, but still presented to us through a kaleidoscopic space of lyrical imagery mixed with brutal blocks of voice and text.

A stricter approach to the reversibility of camera and actor was on view in Nicoline van Harskamp's *Any Other Business* video installation, where the pretense of documentary hides a fixed script assembled from readymade political debates and management speeches, collaged together to simmer mistranslation and miscommunication under the slick surface of the contemporary corporate scene. **Ming Wong** found his own island to play with reversibility, language, and the camera: the remote Fårö Island, site of Ingmar Bergman's *Persona*, (1966), which the artist disintegrated into a choreographed living film, one actor turning into twenty-four. **Liz**

Glynn mirrored the utopian effort of the Ginger Island crew in a quiet set of performances taking very busy sites as their ground (Times Square and the Financial District). Recreating Buckminster Fuller's own failed utopian experiment (failed on that day, to be clear) in dome building, Glynn's group raised a brief island-monument to the vision of a pure, collective, democratic architecture, straight out of one utopian lab (Black Mountain College) and aimed at the whole world.

This vision could be seen, reflecting history, across the whole plane of Performa 11. Constructivism is almost one hundred years old now, but its singular reimagination of the possibility of avant-garde art and performance still has the power to volcanically break the surface and open up a stage for aesthetic experience and learning. The ultimate place may be no such place, but here and there, now and again in corners of New York City, we keep trying to find it.

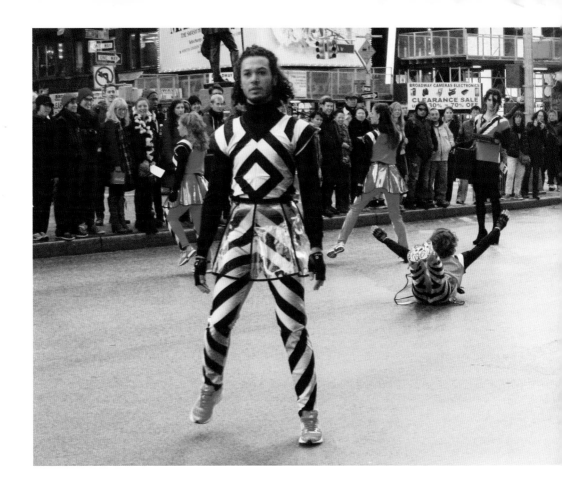

TYLER ASHLEY

Half-Mythical, Half-Legendary Americanism

THE HIGH LINE / CO-PRODUCED WITH FRIENDS OF THE HIGH LINE

With the promise of rock-hard stomach muscles and overall physical fitness and a rejection of disengaged art, Tyler Ashley and the SARAHS (dancers Tyler Ashley, Ethan Baldwin, Hooba Booba, Sarah Donnelly, Zoe Farmingdale, Sarah Holcman, Benjamin Kimitch, Cacá Macedo, Rakia Seaborn, Kris Seto, Ashley Walters, and Theodor Wilson) ambushed the Saturday after-noon crowds in Times Square and on the West Side's High Line with a dynamic workout in Russian Constructivism. Bringing to life visual artist Varvara Stepanova's dynamic geometric designs for sports clothing that she called "the costume of today" and that were produced by the First State Textile Print Factory outside Moscow in 1923, the group of twelve dancers, wearing slim neon pink

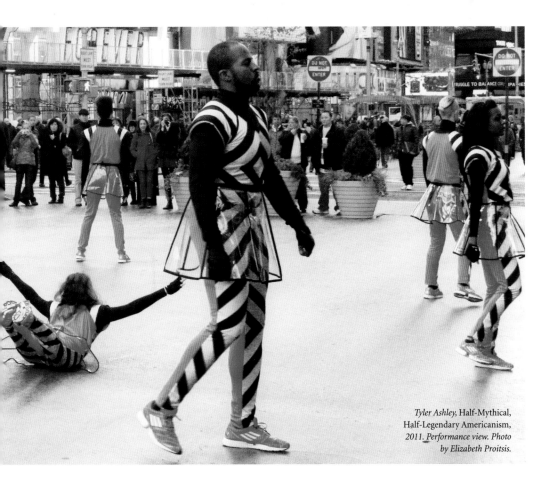

Tyler Ashley, Half-Mythical,
Half-Legendary Americanism,
2011. Performance view. Photo
by Elizabeth Proitsis.

sweat suits with graphic black and white lines and reflective Nikes, formed a rotating line, broke for individual runs, and marched in time to a looping militaristic soundtrack blasting from a small sound system wheeled alongside the performers.

The Midtown and West Side audiences grew spontaneously as the SARAHS performed extended drills and running exercises while Ashley yelped martial orders into a microphone headset. The leader instructed the crowd through several of visionary stage director Vsevolod Meyerhold's biomechanic exercises, and then, just like that, the dancers formed a circle and the piece transformed into a post-Jane Fonda aerobics class. As a Nicki Minaj remix sounded out over the crowd in these tourist hotspots, the audience joined in the movements and Ashley screamed motivational slogans about the power of a new art language. The piece revealed itself as a mix of aerobics class and a nineteenth-century Czech *slet* (an ideological mass gymnastics), and climaxed as a lesson in Constructivist concerns about the arrangement of the body in space. And for the grand finale, a human pyramid!

—*Dougal Phillips*

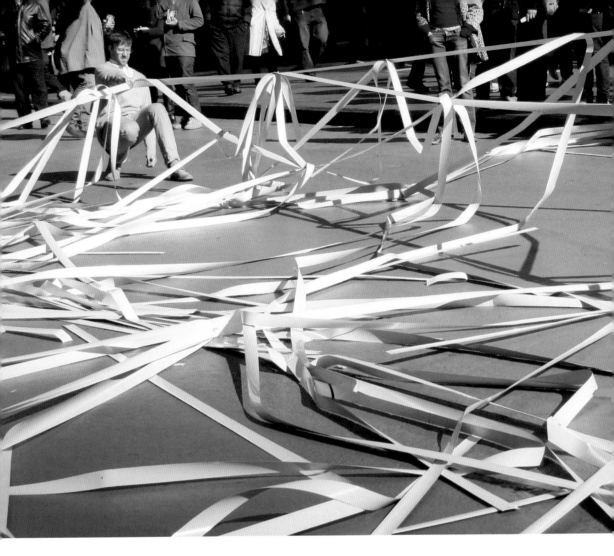

LIZ GLYNN

Utopia or Oblivion: Parts I and II

ROOSEVELT ISLAND, LIGHTHOUSE PARK, DUFFY SQUARE, TIMES SQUARE

In 1948, Buckminster Fuller gathered a group of his Black Mountain College students in North Carolina to construct a human-scale geodesic dome based on his experimental models. That day, incorrectly tensiled material was delivered to the site, so that the students' building sagged and failed (although it did lead one of Fuller's students, Kenneth Snelson, to develop the principle of tensegrity, allowing for the eventual construction of huge functional domes).

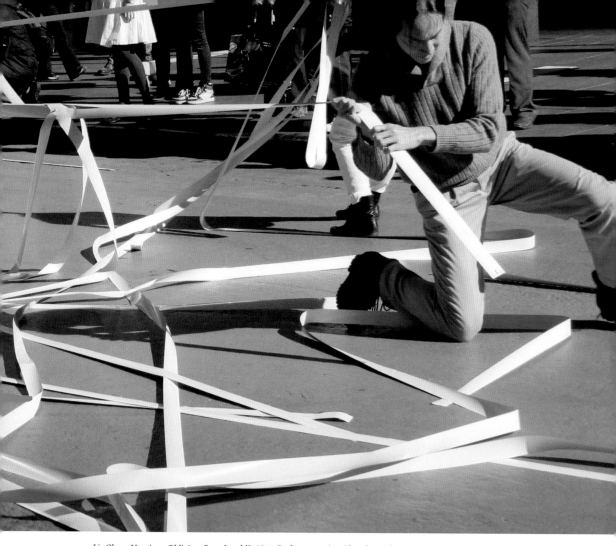

Liz Glynn, Utopia or Oblivion: Parts I and II, *2011. Performance view. Photo by Paula Court.*

Over two Saturdays during Performa 11, at highly trafficked sites, in Times Square and at One New York Plaza in the Financial District, a group of ten dancers costumed in period dress—stiff 1940s sweaters, unflattering coveralls, and high-waisted chinos—silently and slowly laid out strips of white fabric in a complex pattern from memory. As this ritualistic operation drew intrigued onlookers in both the chaos of Midtown and in the cold canyons at the tip of Manhattan, the dancers (led by the Los Angeles–based Glynn, born in 1981) began their attempt to raise the soft dome. Growing in undulating waves, the dome took shape at head height, but then sagged again and again, defeating the utopian desire for it to take perfect form.

Like a breathing membrane, the piece

Liz Glynn, Utopia or Oblivion: Parts I and II, *2011. Performance views. Photos by Paula Court.*

rose and fell until the dancers began to tug and twist in frustration, the material turning and buckling, wrapping around itself, until one by one they abandoned the trashed dome corpse, leaving it as a relic of the engineer's vision. And yet, on the second Saturday, the attempt to raise the dome at One New York Plaza was led by a geodesic expert from Long Island, who had heard of the earlier attempts and who had made a point of being present for the performance. Under his supervision, the crowd lifted the fragile metal dome, which for a few hours remained aloft in the shadows of the banking buildings, a humble monument to another imagined future.

—*Dougal Phillips*

RAPHAËL ZARKA

Free Ride

PERFORMA HUB / PERFORMA INSTITUTE

Imagine a wheel with a marker attached, rolling along a wall. The curve that marker renders on the wall is a cycloid, an elegant elongated inverted scoop. Technically, it is a roulette: a curve generated by a curve rolling on another curve. Paris-based artist-essayist Raphaël Zarka presented a three-part project, housed in the courtyard of the Performa Hub for the duration of the biennial. *Free Ride* brought Renaissance geometry together with both the skating scene of downtown New York and the experimental journeys of that other great downtown culture, Minimalism. Building from his series *Riding Modern Art*, Zarka materialized recent research into the geometry of skateboarding and its relationship to modern sculpture. This took the form of a lecture presented to a packed room at the Performa Institute; an English-language translation of Zarka's book *Free Ride*; and the construction of the world's first cycloid skateboard ramp, which translated the geometric apparatuses of Galileo to a beautiful plywood ramp. Without any publicity, word of mouth spread through the community that something special was hidden in the Old Cathedral School on Mott Street, and day after day new groups of skaters appeared to ride a new/old curve for the very first time.

—*Dougal Phillips*

Raphaël Zarka teaching an Artist Class at the Performa Hub. He introduced his lecture "The Geometry of Skateboarding." Photo by Paula Court.

ATHI-PATRA RUGA

Ilulwane

ASPHALT GREEN / CO-PRESENTED WITH THE MUSEUM FOR AFRICAN ART

From the gallery deck of Asphalt Green's Olympic-size pool, the pulsating red light emanating from the pool below shimmers on the industrial ceiling. A synchronized swimming team of school-aged young women executes a routine for a coming-of-age ceremony of an entirely different sort than the artist would have experienced in his native South Africa. The performance was centered on the *Ilulwane*, a physical manifestation of the Xhosa term, which literally translates to "one who floats at night," and a disdainful term for a young man who avoids the traditional Xhosa circumcision rituals. As the Ilulwane, Ruga, draped in a skin-tight white lace dress with a fifteen-foot trail, was slowly hoisted from the depths of the pool to the rafters above the audience, while an operatic noise soundtrack composed by the artist and Spoek Mathambo created a discordant aria. The Ilulwane suspended above the water is the canvas for a videoscape of night-vision images, creating a lament and homage to this outside figure who was simultaneously admired, reviled, and now strangely at home.

—*Dana Elmquist*

Athi-Patra Ruga, Ilulwane, 2011. Performance view. Photo by Paula Court.

Interview

ATHI-PATRA RUGA

IN CONVERSATION WITH SUE WILLIAMSON

Athi-Patra Ruga is a South African artist whose provocative performances draw on his identity as Xhosa and homosexual. For Performa 11, the artist conceived *Ilulwane*, which took place at an indoor pool at Asphalt Green on the Upper East Side.

SUE WILLIAMSON (SW): Athi, first of all, the title of your work, *Ilulwane*. I know that in the Xhosa tradition, young men between the ages of eighteen and twenty-three traditionally retreat to the bush for a ritual circumcision. This is followed by instruction into the ways of manhood during the days the wound takes to heal. A young man who chooses to be circumcised in a hospital, or goes into the bush and the circumcision goes wrong, is known derogatorily as an "Ilulwane"— neither a boy nor a man—"one who floats at night."

ATHI-PATRA RUGA (APR): Yes, a bat, a creature that is between a bird and a rat. I love working with something that is in between. All of my characters are a celebration, an empowerment of myself, and I create alternative rituals. Most performances I do are more character-based than conceptual. For instance, *Miss Congo* (2006), *Injibhabha* (2007) *Beiruth* (2008), and *Ilulwane* (2011) fit into this. And with most of these shape-shifting characters they, like Marvel superheroes and nightmares, are born from some traumatic revisiting of a collective event. *Ilulwane* is such a story to me.

Ilulwane refers to a boy who either dies or is castrated from accidents resulting from a rite of passage. *Ilulwane*, then, takes on a fantastic tone: perhaps for my self-preservation, I flip these traumatic confessionals into something bearable,

maybe, and also to allow for some kind of space to create an alternative ritual for this afterworld-y fate of the initiate.

SW: So that was one of the sources for your performance. I believe there was another?

APR: The other inspiration was Alvin Baltrop's photographs of homosexual encounters in New York in the 1970s and 1980s, and the cruising which often took place in the piers on the Lower West Side.

SW: Please describe the performance of *Ilulwane.*

APR: On entering, the audience comes into a dark swimming pool gallery, and takes their seats on bleachers. The show begins with a flood of red light on the pool, the only light source. The cast members, including the Ilulwane character, are silhouetted on the water, floating like logs, or Ophelias, in the water. Ilulwane is in the middle, a bloated white figure.

Behind the pool and facing the audience is a video screen with a video that starts and continues through the performance.

Shortly after the video comes on, the synchronized swimmers/performers become animated, and go into a prolonged log roll to reflect the images on the screen—floating fish, detritus, and the old wooden posts of the Hudson River piers sticking up out of the water. The floating in the beginning is not a controlled "synchro move."

The video images then change to a filming of a Xhosa initiation ceremony, and as the piece continues the swimmers go into enactments of the "alternative/ mock ritual." By smashing, or deconstructing, the synchronized swimming of the regiments in old Esther Williams movies and my reenactment of traditional Xhosa dances, I wanted the smash-up to belong to the invented eternity of the Ilulwane. After the Ilulwane's video performance, the Ilulwane in the pool becomes even more animated and his moves become very liberated.

SW: What was the climax of the performance?

APR: The floating figure of the Ilulwane is hoisted from the pool and slowly raised high above it. The figure is inanimate, bent over backwards, and a long red

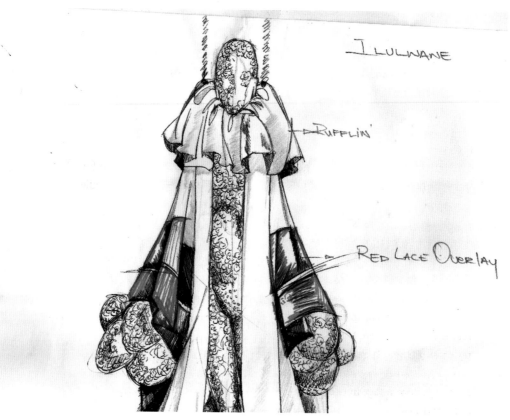

Above and at right: Athi-Patra Ruga's sketches for Ilulwane.

drape falls down into the water. The figure sways gently. The performance ends with the trumpet music of "Taps." "Taps" was played at my school's founders' day for fallen soldiers [all white soldiers].

SW: Thank you for your description of the action. How long did the performance last?

APR: Approximately forty-five minutes.

SW: How did you and the cast rehearse for the performance, and how many were you?

APR: There was a cast of twelve besides my character, Ilulwane, and for a period of two weeks, the team rehearsed, creat-

ing the formations and movements that started with the dead log pose that was reflected on the video projection. By the end of the performance, the movements became chaotic in climax and we introduced jumps and louder splashing to go with the soundtrack and the narrative.

SW: Let's talk about costumes. What were the swimmers wearing?

APR: Glittering leotards, and their faces were made up deathly pale. The costume reflected the "afterlife" theme of the Ilulwane's fate, with references to 1920s Bela Lugosi films and to Esther Williams's surreal synchronized swimming regiments. These were the visual inspirations that met my ends in creating a series of disparate visuals, which collided to create a new image in the viewers' imagination.

SW: And what were you wearing? All details, please.

APR: The character construct of the Ilulwane is in the costume. Ritual requires a lot of costume! It is a cross between the initiate's traditional red-and-white blanket called *umrhaji* that I rendered in parachute fabric, with an eight-meter-long train for theatrical effect and scale.

In comes the Bela Lugosi/Dracula details that I integrated into the finale action. Ilulwane is in my mind and dreams:

this character exists in the edges of people's good feelings. He inspires dread, and this results in isolation. I am always interested in exploring those character constructs. When I was in the initiation school, the colors white and red reoccurred a lot. The lace in my costume was a prettification of the white lime powder that was mixed with water to form a paste to smear all over our bodies. This was to hide the identity of the boy initiates from female/witch spirits and stuff.

SW: And as I recall the work, you were

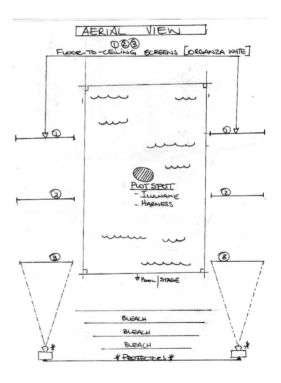

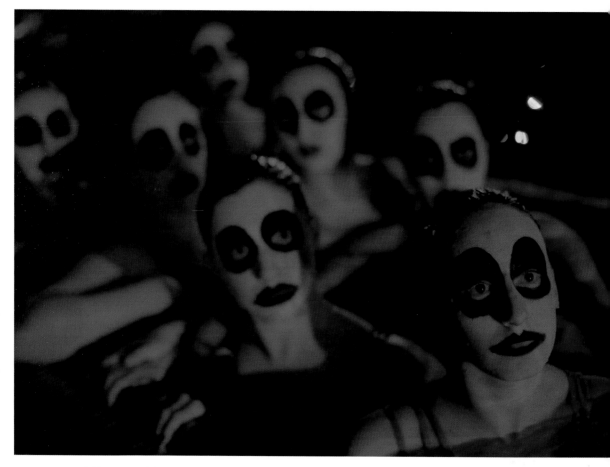

Athi-Patra Ruga, Ilulwane, 2011. Performance view. Photo by Paula Court.

wearing high heels as well. An essential part of your characters' costumes.

And the video? Please tell me more about that.

APR: The video introduction was shot by me of the Christopher Street Pier in New York in the summer of 2011. Once a working part of the New York waterfront, the Pier had physically decayed by the 1980s and had developed a vibrant and clandestine gay social scene for cruising—an alternative ritual that is linked with death, thinking of the AIDS epidemic of the eighties.

The decay of the piers is what drew

me: monuments to a certain time. I wanted to reflect this on both the body of water and in the log pose of the swimmers. Slowly, the video picks up speed along with the soundtrack, the images break up into kaleidoscopic shapes—the images of the piers, which include the bobbing pier remnants, and the insane amount of debris that harbored a floating dead fish.

Ilulwane is then introduced and begins a dance that is a mimicking of the initiates' traditional dance called *umtshotsho*. By the way, I have never participated in this dance, as it is done in the rural areas, but it is of a fascination to me among other processionary acts.

There's something bittersweet about the Ilulwane doing this because we know that his name refers to one that has suffered castration from a ritual of circumcision. The respite before the climax is also a symbolism in the ritual called *ukwaluka*—the white goat is sacrificed along with the spilling of blood from the genital cut. . . a connection and covenant with the ancestors: they are the link with the afterworld. I didn't feel the need to use blood. The pool served that purpose.

SW: And the soundtrack to the video?

APR: I wrote the story from the many stories I had heard growing up about the Amalulwane (the plural of Ilulwane). It had always been a fear of mine before I went to circumcision school and during the initiation process that there were friends who died in the bush. Assuming the character of Ilulwane, I then went on to write the monologue of the dead initiates' story, from the first day to the day I imagined that they die.

I then recorded the speech with musician Spoek Mathambo. I go into exploring the idea of the castrati with reference to Handel's "fascination" in relation to the genders we perform in public, especially with reference to the gray areas of masculinity in my environment. I also do some singing in the track as somehow a way of just shouting it out of me. Finally, there is an emancipation of both me and of the Ilulwane who transcend death by rising to another world, ending with the trumpet solo of "Taps."

SW: My last question: How many people came to your performance in New York?

APR: Unfortunately I had no field of vision from the pool. The lace covered my face. In the later Cape Town performance at the Long Street Baths, there were about 1,300 people over two events. Please confirm for me, Sue?

SW: Yes, I was in one of those audiences, and it was definitely a full house! The line was all the way down the block. Thank you very much, Athi.

TAMAR ETTUN

One Thing Leads to Another

RECESS AT KIDD YELLIN / ORGANIZED AND PRESENTED BY RECESS

Tamar Ettun traces her interest in labor and peripatetic movement and themes of voyage and exploration to her time in the Israeli army. Tying itinerant wandering to ancient Greek texts such as Homer's *The Odyssey,* Ettun abstracted material and content from narratives of journey into a durational performance. Moving though Red Hook's ubiquitous construction sites, visitors passed large cranes, orange cones, and caution tape to enter the converted warehouse. Once inside, a jackhammer down the block could still be heard against the whirr of a fan inflating an enormous red-and-blue hot-air balloon. Visitors entered the capsized cocoon to find Ettun, along with six performers, slowly working through a set of laborious, ineffectual tasks, such as moving a large clay sphere around the perimeter of the balloon. Participants completed their duty only to begin again. For the choreography for *One Thing Leads to Another,* Ettun was inspired by various dance traditions such as Trisha Brown and Yvonne Rainer's postmodern movements, and Ohad Naharin's Gaga technique and its emphasis on complete fluidity throughout the body. The audience was encouraged to move inside and outside of the balloon to witness the abstracted narrative evolve into an animate sculpture featuring a video projection, live music, and dance. Performers included Tamar Ettun with Danielle Agami, Yoni Kretzmer, Jaeeun Lee, Jesse Wintermute, and Netta Yerushalmy.

—*Allison Weisberg*

Tamar Ettun, One Thing Leads to Another, *2011. Installation view. Photo courtesy the artist.*

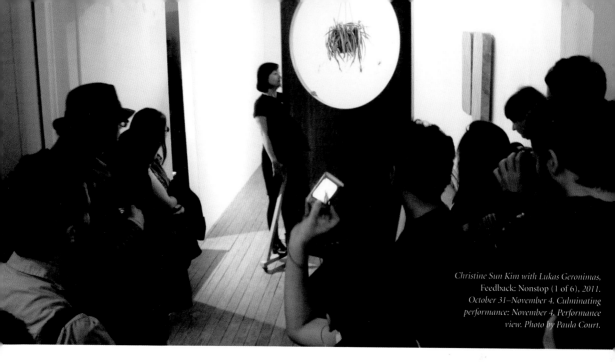

Christine Sun Kim with Lukas Geronimas,
Feedback: Nonstop (1 of 6), 2011.
October 31–November 4. Culminating
performance: November 4. Performance
view. Photo by Paula Court.

CHRISTINE SUN KIM, WITH LUKAS GERONIMAS

Feedback: Nonstop (1 of 6)

RECESS / ORGANIZED AND PRESENTED BY RECESS

Deaf since birth, artist Christine Sun Kim uses visual art and performance to explore her personal relationship to sound and silence. For *Feedback: Nonstop (1 of 6)*, dozens of visitors packed into a small artists' workspace in SoHo, tightly gathered around a series of proplike sculptures Sun Kim had built with artist Lukas Geronimas out of wooden planks, c-stands, cups and bowls, microphones, speakers, and other workmanlike pieces of equipment. The performance began when Sun Kim turned on a disarmingly loud and unintelligible slew of sounds, emanating from an iPad's read-aloud function, which speaks written text. Sun Kim and Geronimas then manually brought their sculptures, all on casters, to life, wheeling them in urgent, choreographed movement through the dense crowd. These peripatetic objects, and the riotous sounds that accompanied them, enwrapped the viewers in an "out-of-control" sensation, plunging them briefly into an experience perhaps similar to what Sun Kim goes through every day: different layers of aurality emerging, receding, and sometimes even made visual.

—*Allison Weisberg*

ASLI ÇAVUŞOĞLU

Words Dash Against the Façade

THE OBELISK (CLEOPATRA'S NEEDLE) / CURATED BY DEFNE AYAS

Why are floors of a building called "stories"? Can the fortune of a building be interpreted through its architectural symbols? Buildings are no longer constructed to be read like books, as Victor Hugo complained on the demise of architecture in the nineteenth century.

On November 11, 2011, or 11.11.11, at 11:11 am, a group of thirty art lovers gathered by Cleopatra's Needle, the famous Egyptian obelisk behind the Metropolitan Museum of Art, a mysterious presence in Central Park since it was transported from Ottoman Egypt in the late nineteenth century, signifying the birth of U.S.–Middle East relations. Suddenly surrounded by myriads of people, including yoga practitioners, healers there for divination and meditation purposes on this auspicious day yet undistracted by the mayhem, Istanbul-based artist Asli Çavuşoğlu embarked on a number of prophetic rituals to kick off her walking tour of three buildings in the city: Hearst Tower; 21 Club; and 55 Central West, the *Ghostbusters* building.

Inspired by the ancient Assyrian and Greek fortune-telling practices, functioning through the scrutiny of ornaments carved on building façades, Çavuşoğlu was accompanied by writer Adam Kleinman, wearing a jacket emblazoned with a giant NASA Apollo logo, in leading the tour. At 11.11 am on the dot, Çavuşoğlu lit a small bonfire in a red bucket emblazoned with the word "FIRE," and burned a stack of texts, including the publication *Broken English*. An opera singer recited a hymn in homage to the Greek god Apollo, invoking his oracle powers. Soon after, "chariots," in the form of pedicabs, arrived at the site, and spurred the participants to the first stop, Hearst Tower. Despite the very cold wind, Çavuşoğlu invited everyone to continue the façade-gazing, while filling everyone's Anthora cups—New York City's iconic blue-and-white paper coffee cups depicting an image of an ancient Greek amphora, a meander design on the top and bottom rim, and the words "WE ARE HAPPY TO SERVE YOU" in a font that resembles ancient Greek writing—with water and encour-

Asli Çavuşoğlu, Words Dash Against the Façade, *2011. Performance views. Photos by Paula Court.*

aging everyone to create their own rules of fortune-telling through the use of potentially disputable sources, such as reflections on the water.

The *Ghostbusters* building was next, where a musician and drummer read the façade as if it were a musical score. The final location, New York institution 21 Club, featured a façade lined with colorful jockey statues. At 21 Club, where John Steinbeck and Ernest Hemingway were regulars and now-prominent television

and movie producers, advertising executives, and titans of the record industry dine, a woman passed out pieces of paper with news stories, marked with "11/11/2011 NYC" in small font. The group in the meantime continued to listen to the jockeys and examined the colors of their cheerful satins, while the annual Veteran Parade walked by and marched in the background.

—*Defne Ayas*

LAURENT MONTARON

The Invisible Message

SOCRATES SCULPTURE PARK, ROOSEVELT ISLAND

Laurent Montaron, The Invisible Message, *2011. Performance view. Photo by Elizabeth Proitsis.*

In 1886, dentist and inventor Mahlon Loomis, who held patents for artificial teeth and wireless communication using atmospheric electricity, claimed to have transmitted signals through the air between two Blue Ridge Mountains, fourteen miles apart, using two kites, thus constituting the first unofficial wireless communication in history. Laurent Montaron, a Paris-based artist who explores through the history of media the relationship between the tools of modernity and the narratives that reinforce them, set out to replay Loomis's experiment in New York City, situating one kite-holder on the tip of Roosevelt Island and another at Socrates Sculpture Park in Long Island City, a distance of approximately one mile.

More than one hundred years later, the artist and his crew set their kites into the air above the river, subject to the whims of the wind in New York's waterways, and barely visible to one another across the divide. On three occasions over three days, each kite with its copper wiring acted as an antenna, which transmitted the static electricity in the atmosphere to a metal rod in the ground, registering spikes of connection from both kites.

For Montaron, Loomis's first, unwitnessed, wireless transmission was not only the true discovery of radio waves but also the crossing of an invisible divide into our modern world. "Technology and its tools have changed the world we live in," Montaron says, but "imagination is the most important part of the interpretation we give to things." In a contemporary atmosphere saturated with wireless signals, the tiny registers of communication between these lone kites invited the passing audience to question the paradoxes of technology, including how, and if, we really talk to each other.

—*Dougal Phillips*

PUBLIC MOVEMENT

Positions

UNION SQUARE SOUTH, WASHINGTON SQUARE PARK / CURATED BY EUNGIE JOO
CO-PRESENTED BY THE NEW MUSEUM AND ARTIS CONTEMPORARY ISRAELI ART FUND

"I want to work for an NGO!" "I want to date a CEO!" So a man and a woman repeatedly shouted at each other, through megaphones, in what appeared to be a tense face-off in New York's Union Square Park. A crowd of onlookers divided themselves among the two, as each person moved toward the speaker whom they most agreed with, a process that repeated itself with new sets of opposing ideas every few minutes. Four additional performers held two long strips of black cloth stretched into narrow "lines," which began as a dividing bar in the center of the crowd, and then moved with the camps of people as they chose their "positions," transforming from an abstract symbol into a corralling fence.

Public Movement, Positions, *2011. Performance view. Photo by Paula Court.*

Public Movement, an Israeli action and research group founded in 2006 by Dana Yahalomi and Omer Krieger, created this performance as a choreographed demonstration inviting people to take a stand on a number of issues. Previously presented in Warsaw, Holon, Bat-Yam, Eindhoven, Heidelberg, and Stockholm, the goal of *Positions* is to physically embody the conflicting preferences, aspirations, and beliefs of a diverse group of people, turning social and intellectual divisions into something made visually real. By forcing people to choose only one side or the other, and nothing in between, the New York performance also threw into relief the futility of always splitting people into such polarizing camps. When "Israel" and "Palestine" are the only available options, and everyone, as the woman with the megaphone said, "must choose a position," there sadly isn't much room for movement at all.

—*Lana Wilson*

CONSTRUCTIVIST SOURCING

33 FRAGMENTS OF RUSSIAN PERFORMANCE

BY YULIA AKSENOVA AND ANYA HARRISON

PERFORMA HUB

As suggested by its title, the exhibition "33 Fragments of Russian Performance," presented at the Performa Hub, showcased episodes from a century of live art in Russia. Like its Western counterpart, performance in Russia flourished during the time of the historical avant-garde in the 1910s to the '30s, and then experienced a resurgence in the '60s and '70s. The most immediate art form, performance has reflected and responded to Russia's turbulent political history of the past hundred years.

Today's artists working in performance, such as Andrey Kuzkin and Elena Kovylina, are part of a genealogy that reaches as far back as the radical experimentalism of the Russian Futurists and Constructivists in the 1910s. Aware of European trends in visual art, dance, theater, and technology, Russian artists created innovative performances that were fueled by the desire to make art erupt into life and to place it on equal footing with the scientific, social, and political changes that were quickly taking place. From the opera *Victory Over the Sun* (1913) to the wild promenades of artists Natalia Goncharova and Mikhail Larionov and poets Vladimir Mayakovsky, David Burlyuk, and Vasily Kamensky that shocked public taste, Russian Futurism fought for a violent break with the past by radically reshaping the recognized forms of culture.

For a brief moment, aesthetic and

Playbill from the Blue Blouses Theater Troupe, Moscow, 1925–1926. Reproduction of a photograph from an album of Boris Yuzhanin (Head of the Blue Blouses Theater Troupe), 1957. © The State Museum of V.V. Mayakovsky, Moscow.

political aims were allied. During the 1917 revolution and the ensuing years, culture became a mouthpiece for politics. It addressed the mass public in an easily comprehensible format: from Arseny Avraamov's public sound artwork *Symphony of Sirens* (1922), to Living Newspaper performances by amateur agitprop theater troupe Blue Blouse, to parades of athletes that gave visual form to the state's idealization of the indestructible Soviet body. When performance reemerged in the 1970s, it did so as an underground movement. Artists who engaged in performative gestures, actions, and events demonstrated a variety of tactics for either engaging with or distancing themselves from the gray monotony and cultural repression that characterized Leonid Brezhnev's years in power as the head of the Soviet Union.

However, the most informative way of looking at performance in Russia is not via chronology but instead through constellations, creating dialogues between past and present practitioners with similar interests and attitudes.

The Artist as Thinker

If Conceptual Art in Western Europe and the United States was largely concerned with the dematerialization of the artwork, in the Soviet Union, where the state drew its power not from the market economy but from its manipulation of language, conceptualism dealt with linguistic signs. Moscow Romantic Conceptualism, a term originally coined

by philosopher Boris Groys in 1979 to delineate the unique character of this work, came to signify a move away from dealing with the reality of everyday life toward lyricism and esoteric self-reflection.

For Collective Actions Group, this meant a literal self-distancing, as members left Moscow to travel to the countryside, where they performed quasi-ritualistic activities. The group's members, who included artists, philosophers, and art historians, focused on the study of visual apprehension and turned abstract concepts—time, space, duration—into the subject matter of their art. Spectators were invited to participate in performances during which they were asked to follow mysterious instructions. Each new project maintained a state of suspense, a mix of anticipation and incomprehension. The analysis and discussion that closed each event formed a crucial element of the performance.

Andrey Kuzkin's work has prompted direct comparison with these artistic predecessors. Combining minimalist, repetitive action with an existential self-questioning, Kuzkin has walked in circles for hours in a slowly solidifying pool of concrete (*Walking Circles*, 2008) and spent an entire day drawing a single line on the walls of a gallery (*Space-Time Continuum*, 2008).

The Artist as Parodist

While a distinctive trait of Conceptualism is its conscious retreat from a direct engagement with the poli-

"33 Fragments of Russian Performance," 2011. Exhibition view, Performa Hub. Photo by Ken Goebel. © Garage Center for Contemporary Culture.

tics of everyday life into linguistic and philosophical terrain, artists have also used the gestural freedom that performance provides to question the status quo. Occasionally veering into the shocking, their subversive tactics, imbued with humor, demonstrate a way of thinking borrowed from the insouciant spirit of the Futurists. The duo Komar and Melamid present the quintessential figures of the artist as parodist. Branding their work "Sots art," an amalgamation of Socialist Realism and Pop Art, they appropriate visual and linguistic symbols of Soviet culture and politics, as well as the agitprop style of Soviet propaganda, to deconstruct and challenge the omnipresence of the state. By turning figurative ideas into literal objects and gestures, the artists make ridiculous the propagandistic messages at their heart. In *Hamburgers Made Out of the Newspaper Pravda* (1974), performed in a private apartment, the USSR's most widely circulated newspaper was literally put through a meat grinder, cooked, and eaten by the artists and their public as a form of everyday "soul food." Beyond the brazen farce of the action, *Hamburgers* was a direct mockery of the Soviet Union's claims to success in food production—a success that existed only in state rhetoric.

Clockwise from top left: Gnezdo (The Nest) Group (Mikhail Federov-Roshal, Viktor Skersis, and Gennady Donskoy), The Nest, *1975. © L. Palmin. Andrey Kuzkin,* Walking Circles, *2008. © Andrey Kuzkin. Alexander Brener,* Boxing Champion (The First Glove), *1995. © Alexander Brener. Elena Kovylina,* The Medal, *2003. © Elena Kovylina.*

Mockery was directed at all types of authority, from political to artistic. By the late 1970s and '80s, a younger generation of artists was creating its own brand of performance, featuring hooliganism and risk-taking that were a far cry from the quiet, meditative actions of Moscow Conceptualism. The Toadstools, a collective of young Moscow-based artists, immersed themselves in the daily urban life in actions such as *Metro* (1979) in which they spent twenty-four hours riding underground. *The Treasure* (1979) bears a clear formal resemblance to the events organized by Collective Actions Group, in that guests were invited to join the Toadstools in a forest on the city outskirts. The similarity ends there—while the older group's activities centered on discussion and interpretation, the Toadstools asked participants to frantically dig up the field in search of the "treasure," which turned out to be Sven Gundlach, one of the collective's members, who had been buried overnight and nearly suffocated in the process.

The Artist as Madman

The art that emerged in the 1990s was symptomatic of the chaos that characterized the dissolution of the Soviet Union, and Russia's overnight transformation into a democratic, capitalist society. Although a spirit of optimism had marked the '80s as social and cultural barriers came down with Perestroika, the

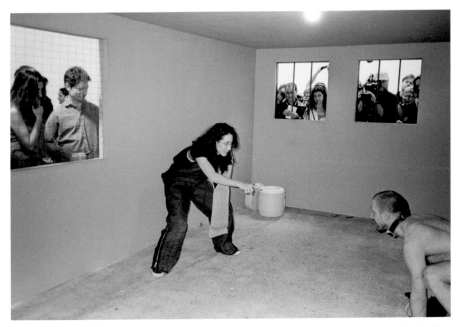

Oleg Kulik (in collaboration with Mila Bredikhina), I Bite America and America Bites Me, *1997. Performance view, Deitch Projects, New York, April 12–26, 1997. Courtesy Regina Gallery.*

next decade witnessed the demolition of social and political infrastructures, leaving an enormous vacuum. The free-for-all nature of privatization and the sudden acquisition of enormous wealth by individuals were reflected in the attitude of artists such as Oleg Kulik, Alexander Brener, and Anatoly Osmolovsky, for whom no barriers existed in their attempts to provoke outbursts from their audience. The Moscow Actionists, as they came to be called, tested the boundaries of the public's patience and notions of propriety.

These artists believed their role was to play the madman, a human governed solely by emotions and intuition, incapable of distancing himself from action to analyze a situation. This was played out to its logical extreme by Kulik, who, for the better part of the '90s, performed as a "man-dog." Both in Russia and abroad, he appeared naked at gallery openings and events, on all fours, and attempted to bite anyone who came too close to him.

These artists' aggressive tendencies reached a pinnacle during the 1996 exhibition "Interpol" at Färgfabriken in Stockholm. Aimed at creating a dialogue between East and West, the exhibition instead came to symbolize the traumatic gap that still separated the two. Brener tore through the exhibition space, wrecking another artist's work in the process, while Kulik's man-dog actually bit visitors. Although their actions seemed to cite the Dadaists' destruction of works as symbolic protest, their extreme behavior was heavily criticized for simply courting controversy.

Today, this ethos has been taken up by contemporary artists such as Elena Kovylina. She has invited the public to a boxing match (*Boxing*, 2005); danced with members of the audience, downing shots of vodka until she collapsed from exhaustion and inebriation (*Waltz*, 2001); and engaged viewers in conversation around a table ornately laid out for tea, only to set it on fire (*Voulez vous un café? ou Feu le monde bourgeois*, 2009). These performances turn the individual into a social body: The artist is no longer the aggressor but the victim—of political and social injustice, gender discrimination, and history.

By teasing out certain behavioral characteristics that appear time and again in Russian performance, we can begin to construct a history that avoids a purely chronological perspective. "33 Fragments" did not claim to cover the genre's entire history in Russia. Yet through selected examples, the exhibition presented performance as an indicator of the spirit of the times and asserted its power to shock, challenge, and produce new forms of knowledge.

Alexander Rodchenko, Pyramid of Women, *1936. © Estate of Alexander Rodchenko/RAO, Moscow/VAGA, New York. Courtesy A. Rodchenko & V. Stepanova archive.*

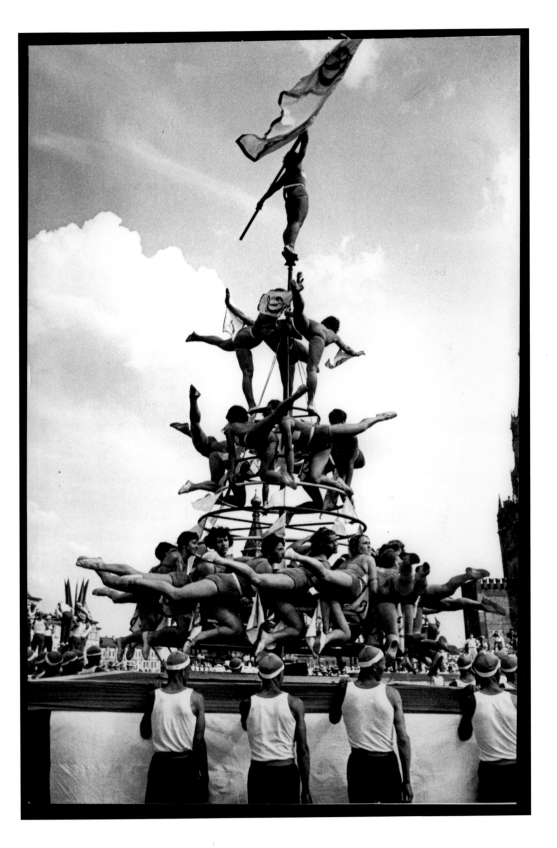

Collective Actions, The Slogan, *1977.*

ANDREI MONASTRYRSKI

"Out of Town: Andrei Monastyrski & Collective Actions"

E-FLUX / CURATED BY BORIS GROYS / PRESENTED BY E-FLUX

Poet, writer, and theoretician of art, Andrei Monastyrski is most closely associated with the group Collective Actions that he organized in Moscow in the middle of the 1970s and which still exists today. The group's activities have had a great influence on the Russian art scene throughout this entire period. At different times nearly all the important representatives of the Moscow art scene of recent decades were involved in the artistic practices of this group in one form or another, including Ilya Kabakov, Erik Bulatov, and Dmitri Prigov. The most interesting members of the current milieu of younger Russian artists began their artistic career under Monastyrski's direction.

The theoretical texts that Monastyrski wrote to justify and explain his practices have profoundly influenced the discourse on art in Russia today. The Collective Actions group was a genuine artistic school, not just for many artists but also for many writers and art critics. But the influence of the group, and in particular of Monastyrski himself, is much broader than the circle of those who worked with him directly. The explosion of performance art in Russia in the 1990s would have been inconceivable without the performance practice of Collective Actions. Today Monastyrski is considered a guru of the new Russian art in Moscow, and his decisive influence on its origins and development is indisputable.

Adapted from Empty Zones: Andrei Monastyrski and Collective Actions, *2011, the exhibition catalog for the Russian Pavilion at the 54th International Art Exhibition— la Biennale di Venezia. Courtesy Black Dog Publishing.*

The following is a transcript from Boris Groys's lecture accompanying "Out of Town: Andrei Monastyrski & Collective Actions."

Instead of a formal talk, I wanted to say something about the context in which this practice emerged in Moscow at the

beginning of the seventies. I want to give a short description of the political, social, and artistic situation of Moscow at that time, and I'll also show some examples of art produced and shown in Moscow at that time, just to situate Andrei Monastyrski's work in a certain context.

When Russians today hear the name Andrei Monastyrski, they associate it with the group of people and the movement known as Moscow Conceptualism. This group was part of the unofficial art scene after the death of Stalin, at the end of the fifties, so it was relatively early. This, let's say, underground scene, although it wasn't really underground, consisted of artists and poets and writers and philosophers, and critics who didn't want to follow the rules of Socialist Realism. They had no chance to present their work publicly in the official media, so they tried to organize alternative exhibitions and publications. They were not forbidden as such; they were tolerated by the authorities. They were under the radar of the official media and did not have a Western art audience to react to what they were doing. They existed from the middle of the fifties until the end of the eighties in their own kind of culture. This was not pleasant because it was a ghetto, but at the same time it was comfortable in a way because they were not persecuted by the authorities. So they existed in a limbo.

After the so-called *perestroika*, they began to be known to the Western public and the Russian public. It was after thirty years of hibernation and incubation for Russian production, and they were taken into consideration to be included in international art history as it relates not only to Soviet art but to any art produced in a communist country during the Cold War. So it was the same situation of course, in Polish and Czech art, Romanian art, and Chinese art to a degree. We are still trying to fill these gaps in our understanding of art history in the twentieth century during the Cold War, and this exhibition ("Out of Town") is part of this process of learning about this period. This exhibition is a quotation in a certain way, a compressed version of the Monastyrski and Collective Actions group's exhibition that I made at the Venice Biennale for the Russian Pavilion, and you can look at the accompanying catalog that was published.

So now I would like to show you some images from the seventies, to show the art of people who were associated very closely with Monastyrski, so you may get an impression of the aesthetics and interests of these artists.

If you look at the development of un-

official Russian art in the fifties, sixties, and up to the beginning of the seventies, there was an attempt to reconstruct the history of European modernism. If you look at the Moscow and Petersburg art scenes, you will find everything there—Surrealism, Cézanneism, Cubism, Constructivism, Expressionism. Whatever happened in art history also happened in the form of a small quotation in Russia. At the same time, this group of Russian artists was rather immune to mainstream culture. In fact, mainstream culture was something they were against. They tried to create their own criteria of appreciation of an art that was an alternative to the Soviet culture. The Soviet culture of fear is precisely what changed in the seventies: instead of looking to the West and trying to reconstruct in their circle the aesthetics of these different forms, they began to be interested in their own culture, to look at it, to analyze it, and they began to work with it. It was in a critical sense, but not in a dissident sense, in protest against the specific artistic strategies that in *ad absurdum* any form of ideological speech or ideologically determined art. It was about the structure of ideological images through a strategy for familiarization, a strategy of irony *reductio ad absurdum.*

The Moscow Conceptualists tried to investigate the structure of ideological language, and the structure of the ideological image as such. In this way, they continued a long tradition of Russian ironic absurdist culture of the twenties and thirties, when artists such as [Kazimir] Malevich and OBERIU were involved—very absurdist, very Dadaistic, very pre-Fluxus, very ironic. That was the tradition that Moscow Conceptualism tried to reestablish, resituate, and continue. It was a play on official imagery and official language.

—*Boris Groys*

ANDREI KUZKIN

Natural Phenomenon

PERFORMA HUB

The opening of the exhibition "33 Fragments of Russian Performance," a collaborative project between Garage Center for Contemporary Culture and Performa, was marked by a durational performance by the young Russian artist Andrei Kuzkin. A direct inheritor of the aesthetics and philosophy of Moscow Conceptualism, Kuzkin's performance-based practice centers on the banality and entropy of life, but imbues it with a touch of humor and romanticism. For *Natural Phenomenon*, which Kuzkin has performed in myriad environments, the artist braved the crisp New York autumnal air to present the public milling around the school's courtyard with a tableau vivant. Completely naked, Kuzkin balanced upside-down in a garbage bin, his legs the only visible body parts sprouting from the bin, with a heap of rubbish preserving his modesty. He stayed this way—stock-still—for nearly an hour before repeating the whole scene. In all, it was a tiny gesture of the artist's inextricable ties to organic, natural life forms and an epitome of consciousness, a state of high alertness and awareness.

—*Yulia Aksenova and Anya Harrison*

Andrey Kuzkin, Natural Phenomenon, *2011.*
Performance view. Photo by Elizabeth Proitsis.

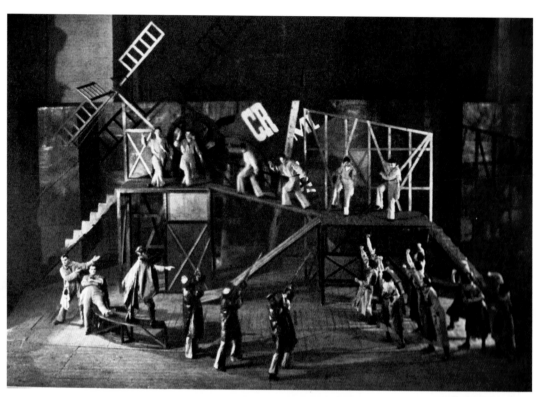

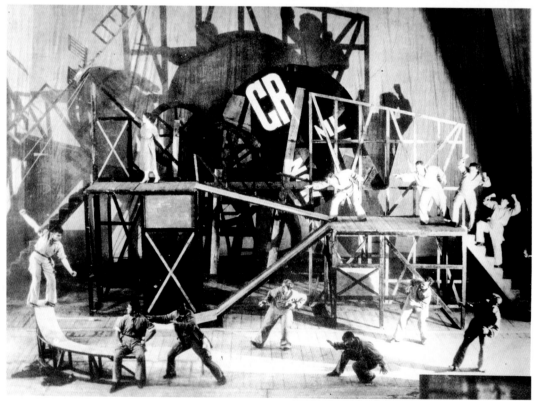

THE MAGNANIMOUS CUCKOLD

Reflections on an iconic work

When it was staged in 1922, Vsevolod Meyerhold's *The Magnanimous Cuckold* marked the marriage of Constructivist aesthetics and theater, becoming a landmark production that would trigger more than a decade of collaborations between directors and revolutionary artists of the avant-garde. Commissioned by director Meyerhold, Constructivist artist Lyubov Popova responded to his checklist of "must-haves" for a new theater: a mobile stage that could easily be dismantled and transported to other theaters in the country, an active set that could respond to the athletic gestures and twists and turns of his stylized "biomechanic" acting exercises developed specifically as a nonverbal form of theatrical communication, and a colorful theater for the future that would herald the new utopian society. A rollicking production by Belgian dramatist Fernand Crommelynk, *The Magnanimous Cuckold* was a tragic farce about a desperately cuckolded husband who punished his wife by insisting that she sleep with every man in the village.

It opened on April 25, 1922 in the Actor's Theater in Moscow. As presented by Meyerhold on Popova's interactive set, consisting of multilevel platforms, staircases, revolving doors, and three wheels, the largest containing the letters "CR ML NCK" (the playwright's name), that could be spun by the performers, it was a hilarious, circuslike performance that was part vaudeville and part athletic demonstration. Popova also designed the boxy, primary-colored worker uniforms of the actors.

Seven decades later, in 1981, historian and theater director Mel Gordon restaged the production based on Meyerhold's extensive notes and a replica of the set in the Guggenheim Museum's main lobby. Video documentation of this reconstruction was screened during Performa 11 at CUNY's Segal Center, followed by a talk with Mel Gordon and Daniel Gerould. Gerould also presented his lecture "Adrian Piotrovsky, Soviet Mass Spectacles, and Festive Performance" at the Performa Hub.

—*Marc Arthur*

Vsevolod Meyerhold, The Magnanimous Cuckold, *1922. Production stills.*

Chapter Six

UNTITLED

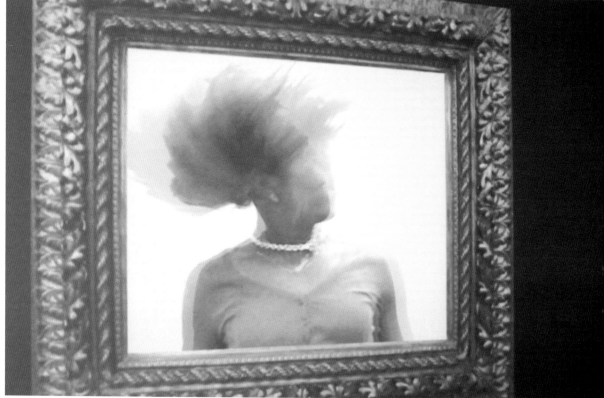

RASHAAD NEWSOME

Tournament

MALBOROUGH CHELSEA

Rashaad Newsome's exhibition "Herald" was comprised of large photo collages and videos displayed in customized antique frames on the wall, as well as heraldic flags that conjured the pomp and pageantry of an imagined medieval castle. It formed the backdrop to a lively rap joust between ten emerging emcees who had responded to an open call for rap teams to compete for cash, an artwork by Newsome and a track on his forthcoming mixtape, *Swag Vol. 2.*

The performance—*Tournament*—began with Newsome dressed in an ornate black costume, with full cape and hat, appearing on a low stage while two rows of musicians added live instrumentation to the opening proceedings. Onstage, seated on five "thrones" were the judges, MoMA PS1 founder Alanna Heiss, *Wild Style* director Charlie Ahearn, style icon Andre J, Creators Project editor Julia Kaganskiy, and *W* magazine editor Karin Nelson, who watched as the string of rappers took turns freestyling on the floor in front of them. As they ranked the performances,

the audience joined in, shouting their support or rejection through several eliminating rounds, finally awarding a rapper named Cream from Coney Island's Cipha crew, who was crowned and "knighted" by Newsome.

For Newsome, whose work frequently isolates the mannerisms of hip-hop culture, transforming them through repetition and highly stylized choreography into memorable productions, *Tournament* showed his incisive pairing of correspondences between "high" art and popular culture. Within the setting of Newsome's exhibition, other oppositions became apparent: his fascination with medieval and contemporary iconography; the contrast between live performance and objects on a wall; the contestants who battled one another in lyrical form; and the panel of judges from the art and fashion worlds who defended their hip-hop credibility, acutely aware of the situation's contradictions.

—*Andrea Hill, Betina Bethlem, and Serena Qiu*

At top: Rashaad Newsome, Tournament, *2011. Performance view of winning emcee, Cream. Photo by Paula Court. Below: "Herald," 2011. Exhibition view, Marlborough Gallery. Both courtesy Marlborough Gallery.*

WILL COTTON

Cockaigne

PRINCE GEORGE BALLROOM / CURATED BY STACY ENGMAN

Known for his surreal and irresistible high-gloss painted landscapes made of a delirium of cotton-candy clouds, sugary lollipops, melting mountains of ice cream, and bonbons of all kinds, as well as languidly posed and breathtakingly beautiful women, Will Cotton often begins his day baking the gingerbread houses, pastries, and giant cakes that will become the stilllifes of his canvases. These "metaphors for pleasure and desire," as he calls them, are "the dreams of paradise…the thread that runs through all of human history, not just in the affluent times, but in fact very often in the lean as well." For Cotton, whose exquisitely rendered paintings are inspired as much by Francois Boucher and Fragonard as by advertising and pop imagery (he art-directed singer Katy Perry's music video for the song "California Gurls"), there is an experiential element, even an olfactory one, that goes into constructing the imagined worlds they depict. These paintings also explore themes of temptation, gluttony, and indulgence. Interested in cultural iconography, Cotton's art makes use of the language of our culture of nonstop easy consumption.

Cockaigne (a term from medieval poetry that denotes a mythical land of plenty) was Cotton's first live performance. It took place in an appropriately Rococo-style ballroom with over six hundred people in attendance. Freshly made rounds of cotton candy were served to guests by dreamy ladies reminiscent of those in Cotton's paintings, with the addition of a special perfume, Whipped Cream, created in collaboration with International Flavors & Fragrances, sprayed through the air to increase the hedonistic pleasures of the sugar-filled night. With sets, costumes, and props designed by the artist, Cotton employed both ballet and burlesque for his elegant and playful *Whipped Cream Dance,* choreographed and performed by Miss Ruby Valentine (a burlesque dancer whom Cotton has often painted), with a violin score composed by Caleb Burhans. Immediately following, *Cotton Candy Dance* was performed by three ballerinas and choreographed by Charles Askegard to music composed by John Zorn.

—*Stacy Engman*

Will Cotton, Cockaigne, 2011. Performance views. Photos by Paula Court.

WU TSANG

Full Body Quotation

NEW MUSEUM OF CONTEMPORARY ART

Full Body Quotation was a lively soiree in the Skyroom at the New Museum that incorporated the Los Angeles–based artist Wu Tsang's impressions of the Silver Platter, a colorful local bar in the MacArthur Park neighborhood of Los Angeles that has served as an underground meeting place for both transgender performers and undocumented immigrants from the Americas since the 1960s. Having discovered the scene while an Interdisciplinary Studies MFA student at UCLA, Tsang soon was hosting his own weekly parties at the bar that included drag shows and impromptu performances by a diverse community of immigrant performers and artists. He is now best known for *Wildness* (2012), a feature film documenting this lush subterranean culture.

For *Full Body Quotation*, five dancers began performing in the middle of the crowd, striking poses amidst colorful minimalist stools and eventually writhing over and under each other, ending in a tousled heap on the floor. Meanwhile, under low lights and with booming music blaring, guests were handed slips of paper listing landmark pieces of transgender cinema, such as transvestite beauty pageant documentary *The Queen* (1968), from which some of the dancers' posed tableaux vivants were derived. Inspired by Jenny Livingston's 1990 film *Paris is Burning*, a documentary on the Harlem drag balls of the 1960s and '70s, and the experience of creating this performance, Tsang later made a sixteen-minute film, *For how we perceived a life (Take 3)* (2012), that examined the complex power dynamic operating among Livingston (a white filmmaker), the black and Latino communities she documented, and the "white" glamour that ball culture reinterpreted—a perfect representation of the multilayered, accumulative approach Tsang takes to all of his work.

—*Marc Arthur*

Wu Tsang, Full Body Quotation, *2011. Performance view. Courtesy the artist and Clifton Benevento.*

Daido Moriyama, Printing Show–TKY, *2011. Installation view. Courtesy Aperture Foundation.*

DAIDŌ MORIYAMA

Printing Show

APERTURE FOUNDATION

In 1971, Japanese photographer Daidō Moriyama was just starting to make a name for himself in the world of photography when he briefly visited New York. Inspired by the prominence of Pop Art in the city, Moriyama returned to Tokyo and held an exhibition of the images that he shot during his trip. Instead of mounting prints on the walls of a gallery, the photographer stationed himself at a Xerox photocopy machine, arranging his photographs on the machine and making copies. The output sheets were shuffled together and staple-bound; a folded silk-screen print served as a cover.

Nearly forty years later, an updated version of this performance was staged at the Aperture Foundation. Whereas at the original event gallery visitors chose between two cover options, this time the entire editorial process was opened up to them. A grid of photocopied sheets on the gallery walls served as a menu from which participants made a selection and sequence. In the middle of the room, in a cordoned-off production area, staff assembled, collated, and bound each book according to the individual specifications. Every copy was signed by Moriyama and handed back directly to the gallery visitor.

—*Ivan Vartanian*

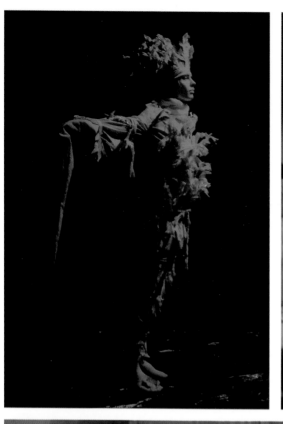
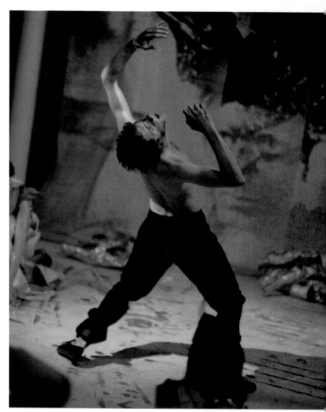
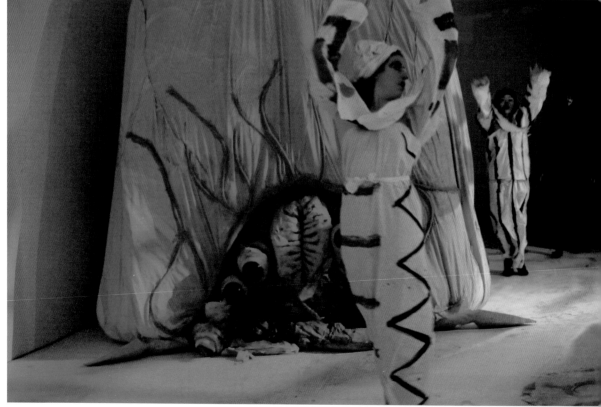

SPARTACUS CHETWYND

The Lion Tamer

STUDIO 231 AT NEW MUSEUM / ORGANIZED BY GARY CARRION-MURAYARI

Utilizing handmade costumes and sets, the London-based artist Spartacus Chetwynd has realized a number of exhibitions and performances throughout Europe over the past ten years with her traveling band of amateur actors and family members. Drawing on a wide range of influences from film and television, literature, art history, and philosophy, her performances and installations create a carnivalesque world where figures such as Emperor Nero, Mae West, Karl Marx, and Jabba the Hutt can comfortably commingle together. For Performa 11, Chetwynd used a variety of historical theatrical forms, from Brechtian drama to puppet shows, to create *The Lion Tamer*, a piece influenced by the 1983 film *The Dresser*, which tells the story of an aging actor's personal assistant who struggles to keep his charge's life together; and by *I'm No Angel* (1933), in which Mae West plays Tira, a lion tamer who tames the beasts onstage and the "society swells" offstage.

Presented by the New Museum in their Studio 231 space, a storefront next to the museum, Chetwynd, who initially studied anthropology, and uses the idea of bricolage as both a physical practice and the organizing principle to bring together the disparate images and characters within her work, created a space of cardboard boxes and crudely constructed dioramas that functioned as set pieces. On the wall, nude bodies were loosely outlined in primary colors. Organically shaped cardboard mobiles, painted white and patched together with cloth and yarn, were suspended from the wall by cloth strips, and a tent with an octopus's face rested in the corner. Then a cast of about ten characters laboriously put on long-sleeved red shirts and tied bands of cut-paper feathers around their limbs. Chetwynd, wearing a tin-foil top, feebly mimed the role of a lion tamer while the others crouched on all fours. Chetwynd attempted to tame the crazed egos of her performers while also breaking the performance and giving directions. At times the audience was invited into a large human-sized puppet orifice that was at the base of a tree sculpture. The audience members were both onlookers to the action and invited participants to this anarchistic and colorful event.

—*Marc Arthur*

Spartacus Chetwynd, The Lion Tamer, *2011. Performance views. Photos by Paula Court.*

URSULA MAYER

Gonda

CENTER548 / CURATED BY KARI CONTE / PRESENTED BY ISCP

The first live work by Austrian artist Ursula Mayer—known for film projects that often use an obsession with an old text or movie as a jumping-off point, as well as related sculpture and photography—*Gonda* translated Mayer's work-in-progress film of the same name into a performance.

The arrestingly tall and thin transgender performer Valentijn de Hingh walked onstage and began to recite a disjointed but highly dramatic monologue: "I have been dead for thirty years. I can see clearly what state I am in… No. Still not right…I make to scream, to issue, to swallow space with my voice." On a sixteen-by-nine-foot screen in the background, a wild rush of excerpts from the filmed version of *Gonda*, also starring de Hingh, were projected: de Hingh running up and down Sicily's ashy Mount Etna, statues of Egyptian cats, abstract fields of color, de Hingh sitting at a table in front of stacks of mysterious minerals. The monologue she performed live was written by author Maria Fusco, and inspired by Ayn Rand's 1934 play *Ideal*, about a movie star who pretends to murder someone to test which of her fans are the most devoted—a typical Randian examination of self-interest and objectivism. The images, while in many ways functioning independently of the monologue, could also be seen as a representation of this strange woman's psyche, nonlinear and kaleidoscopic.

—*Kari Conte*

Ursula Mayer, Gonda, 2011. Performance view.
Photo by Gabriella Csoszó.

MARIA PETSCHNIG

See-saw, seen-sawn

AUSTRIAN CULTURAL FORUM / CURATED BY ANDREAS STADLER
PRESENTED BY THE AUSTRIAN CULTURAL FORUM PROJECT

In *See-saw, seen-sawn,* Petschnig staged a physical exploration of sexuality and gender. She and other performers silently danced and mimed in a curtained-off corner above the Forum's Theater; the real-time footage from behind the curtain was intercut with a video projection below, footage from a handheld camera exploring a private home. The piece focused on a group of several protagonists stumbling in a very narrow hallway of the house. Their faces were cut off or otherwise obscured, leaving only their awkward torsos in the frame, which were somewhat covered with see-through pantyhose and minimal bondage attire. Their tense movements revealed a certain level of discomfort with their own bodies while moving steadily up and down the tiny space along the rhythm of a silent, sensual procession. The voyeuristic video tour extended to a bedroom, bathroom, and closet of the house, revealing more strange characters in various states of undress engaged in mundane household activities. The activity was continuously interspersed with entrances and exits, footsteps, and snippets of overheard conversations, which were not interruptions, but rather a part of the performance, an oscillation between public and private.

Maria Petschnig's recent work has been testing the limits of viewers' endurance by exposing them to—and involving them in—obscure, intimate experiences. Her performance at the Austrian Cultural Forum was part of the "Beauty Contest" exhibition, which explored identity and aesthetics in contemporary art.

—*Claude Grunitzky*

Maria Petschnig, See-saw, seen-sawn, *2011. Installation view. Photo by Paula Court.*

JONATHAN VANDYKE

With One Hand Between Us

SCARAMOUCHE / CURATED BY DAVID EVERITT HOWE / PRESENTED BY SCARAMOUCHE

Unfolding over eight hours a day for five days, *With One Hand Between Us* featured three actors improvising a sexually charged, silent psychodrama within an architectural framework of wooden partitions and burlap scrims. This work elaborated upon VanDyke's performance *The Long Glance* at the Albright-Knox Art Gallery, in Buffalo, New York, for which the artist stood in silent opposition to Jackson Pollock's seminal painting *Convergence* for one workweek, a nod to traditional labor practices. At Scaramouche, the performers—David Rafael Botana, Laryssa Husiak, and Anthony Wills Jr.—engaged both with objects and each other.

Three geometric sculptures punctuated the space, performing the action of "painting" by slowly dripping paint on the floor through a system of pipes and orifices. The first sculpture was partially covered by a black rubber sheath, folded back to reveal a complex woven surface that rearticulated a nineteenth-century "spider weave" chair-back pattern; a second sculpture, woven from the inner bark of an ash tree, visually referenced Shaker design; the third sculpture abstracted wooden flooring with diagonal planks of green fiberboard. Over time, each sculp-

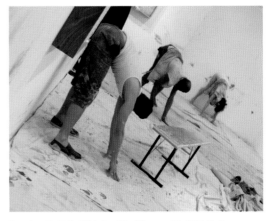

Jonathan VanDyke, With One Hand Between Us, *2011. Performance view. Photo by Paula Court.*

ture (and the floor beneath it) became intensely stained and streaked by paint, slow accumulations of color disorienting both surface and substrate in a manner that upended the dynamics of the New York School of abstract painting.

Inspired, according to the artist, by Rainer Werner Fassbinder's films, where hierarchies of power and gender are constantly in flux, the actors' performances were marked by protracted glances, fraught eroticism, and shifting dynamics, as verbal communication was exchanged for an almost illegible syntax of looks, gestures, and actions.

—David Everitt Howe

MPA AND AMAPOLA PRADA REVOLUTION

Two marks in rotation.

LEO KOENIG, INC. / CURATED BY ALHENA KATSOF AND DEAN DADERKO

At the start of *Two marks in rotation.*, the assembled audience watched through the plate-glass window of a storefront space as artists MPA and Amapola Prada marched over lines taped onto the floor of the otherwise bare gallery. One followed the east-west axis while the other walked north-south. The gallery door was then opened, and audience members were instructed to enter the tape rectangle and sit in close proximity to one another. After the last person squeezed into the demarcated space, the door was locked, leaving the remaining audience on the sidewalk. MPA and Prada next engaged in a series of actions that included manipulating scaffolding poles as percussive instruments and as tools to stab a hole in the gallery wall, breaking sheets of glass, and moving the audience from the center of the room toward its margins. The negotiation of power that followed between the audience and performers spoke of violence, the use of force, and the edges of antagonism and permissibility. The Occupy Wall Street movement was present in people's minds.

MPA lives between New York and the Mojave Desert. Her installations and performances rely on presence and energy to confront the intimacy in collected publics.

Amapola Prada lives and works in Lima, Peru. Her practice navigates the intimate spaces of consciousness and expressions of nonrational impulses to create works that resonate with social conflicts. She received a BA in Social Psychology from Pontifica Universidad Católica del Perú.

—*Alhena Katsof and Dean Daderko*

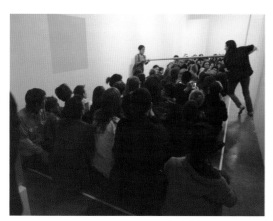

MPA and Amapola Prada Revolution, Two marks in rotation., *2011. Performance view. Photo by Paula Court.*

ELENA BAJO

A Script for a Form

SCARAMOUCHE

Plan for a Movement, Script for a
Sculpture, the Music of Thoughts

The Object is a Pointer
It is a still image
that reflects on
the momentary location
of the work in its
movement trajectory
through
Past-Present-Future event
The Dancer reflects
on the steps-movement
of this trajectory, it follows
a secret choreography
that follows
a secret political Manifesto
—Elena Bajo, excerpt from *An Anarchist*
Manifesto, 2008–present

Elena Bajo, A Script for a Form, *2011. Performance view. Photo courtesy Scaramouche.*

Bajo translated the musical syntax of her text *An Anarchist Manifesto* into a choreography of materials and body movements. In tandem with paintings and appropriated objects in the gallery space, including a structure of rectangular glass panes and construction bricks, Bajo's building materials became the armature for "blind performances" in which dancers, an actor, and a musician interpreted a text through bodily move-ment and sound.

Orchestrating her manifesto in real time with improvised movement and music, three black-clad dancers took turns moving within Bajo's installation while a cellist played in the background. A fourth performer slowly walked through the installation, reciting lines from Jorge Luis Borges's "A New Refuta-tion of Time," 1946, as the music con-jured the dark mood of his text. A mo-ment later, the cellist ceased to play and the figures stood frozen.

—*Scaramouche NY*

ERIC STEEN

Brew Day / Brew Pub

PERFORMA HUB / CURATED BY ESA NICKLE

B*rew Day* was an informal confer-ence of home brewers from around New York City in the courtyard of the Performa Hub at the Old School. Steen convened twenty-seven home brewers to brew a batch of their favorite beer, exchange tips, and sample each other's beers under the watchful gaze (and with the participation) of Performa audiences. By bringing this unique subculture of

home-brewing into the public realm, Steen sought to amplify the social dy-namics of a normally solitary activity.

The brewers were offered a mini-shop-ping spree of approximately fifty dollars at Brooklyn Homebrew for supplies and then transported their brewing "rigs" to the Performa Hub. Over the course of the day, they demonstrated their brew-ing techniques, varying from simple to

elaborate. Three friends from Staten Island wheeled in a hand-wrought brewing machine that resembled a small locomotive, while someone from the Upper West Side brought a single propane burner, a wooden spoon, and a pot.

Two weeks later, Steen gathered the group together again for *Brew Pub*, a two-night public event attended by an eager audience, displaying and serving samples of thirty-three craft beers with names like Madame Psychosis by Christopher Lehault, Self-made Thousandaire by Joe Tracy, Fumado Aji by Matt Chan and Big Bumpkin by Sam Burlingame.

With all of the brewers present, full of pride and ready for conversation, Steen conjured up an atmosphere of celebration and an experience that several attendees described as "the best bar in New York City."

—*Esa Nickle*

Participants: Bernie Gilbert, Brandon West, Brett Taylor, Chris Cuzme, Christopher Lehault, Craig Shuster, Daphne Scholz, Fritz Fernow, Gregory Faljean, James Kinnie, Jason Sahler, Joe Tracy, Jonathan Moxey, Keith McCullum, Kyler Serfass, Lucienda Chung, Mark Zappasodi, Mary Izett, Matt Chan, Michael Spitzer-Rubenstein, Paul Kaye, Peter Kennedy, Richard Scholz, Sam Burlingame, Scott Shimomura, Sean Megna, Velvet Hammer Homebrew

Above: Eric Steen, Brew Pub, *2011. Beer brewed at the Brew Pub. Photo by Paula Court. At left: Eric Steen,* Brew Day, *2011. Performance view. Photo by Paula Court.*

Ben Kinmont, An Exhibition in Your Mouth, 2011. Detail, Nicolas Boulard's Specific Cheeses (2009) based on Sol LeWitt's Forms Derived from a Cube (1982). Photo by Paula Court.

BEN KINMONT, WITH IGNACIO MATTOS & DAVID TANIS

An Exhibition in Your Mouth

ISA / PERFORMA 11 PREMIERE / ORGANIZED BY KUNSTVEREIN NY WITH THE EXHIBITION PROSPECTUS: NEW YORK AT THE FALES LIBRARY, NEW YORK

Presenting a dinner of six courses made from recipes written by artists over a period of more than six decades, each dish an artwork designed to be eaten, Ben Kinmont transformed a meal into an evening-length performance. The entire process of eating out—making reservations, arriving at the front desk, ordering from the menu, eating, paying, and leaving—was considered a collaborative experience in which guest, artist, and chef were equal partners.

For Kinmont, *An Exhibition in Your Mouth* is what he calls "a third sculpture," an expanded form of relational aesthetics in which every part is fully dependent on the participants. It took place in two seatings of sixty people. Menu selections included Aerofood (1931), a starter by Luigi Colombo Fillia, followed by Steak Tartare (1961) by Marcel Duchamp; Basque Bass (1971), from Gordon Matta-Clark's restaurant Food; Geoff Hendricks's Mashed-Potato Clouds (1969); Louise Bourgeois's Cucumber Salad (1977); Philip Corner's Fig Pervert (1965); and finished with Salvador Dalí's Toffee Pine Cones (1973). The procession of dishes was interspersed with tastings of Glace de Crème, adapted from M. Emy's *L'Art de bien faire les glaces d'office* (1768), as well as Nicolas Boulard's Specific Cheeses (2009), based on Sol LeWitt's *Forms Derived from a Cube* (1982). A specially designed menu by Kinmont provided a hard-copy memento of this gastronomic exhibition.

—*Sarina Basta*

Interview

BEN KINMONT

IN CONVERSATION WITH SARINA BASTA

SARINA BASTA (SB): Let's talk about the notions of social sculpture, thinking sculpture, and third sculpture. What is that genealogy, and how do you make these terms specific to your work?

BEN KINMONT (BK): Social sculpture, to put it very simply, is a concept that addresses the way in which society shapes the individual and the individual shapes society. [Joseph] Beuys maintained that "every man is an artist." This idea of the individual and his or her relationship to the group was syntactically interesting to me. The concept of the thinking sculpture was to refer to the cognitive process as a sculptural process: the receiving of stimuli and shaping it into an idea that is then again shaped through subsequent experience.

The part I was most interested in was what I called "the third sculpture." In the mid-1980s, my college classmates were discussing spaces in between as a void that rendered communication impossible. Instead, I wondered if the spaces in between weren't what *made* communication possible, spaces from which to construct new possibilities.

SB: Can you give us examples of the space "in between"?

BK: The moment that you define two objects, a subculture and a dominant culture, two individuals or two ideas, a space is created between those two points. But as soon as you become conscious of that space in between, a place that you are traversing, physically, from

the institutional space to out on the street, or conceptually, joining two ideas together, it becomes a point itself. In this way, the third sculpture is always in motion.

SB: You speak about subculture and dominant culture. How do you measure these terms?

BK: I grew up in the art world—my father is an artist. It is the history and point of reference that I know. In terms of my origins, art would be considered dominant. But I also work as an antiquarian bookseller specializing in the history of food and wine. David Tanis was helping chef Ignacio Mattos and I on the night of *An Exhibition in Your Mouth*. David Tanis is an important voice, a famous chef from a well-known restaurant [Chez Panisse]. But looking at art history and its discourse, what David does with food operates within a different economy and value structure.

SB: When you take people's time, you actually give them something in exchange, anything from a waffle to a signature on a wall. For *An Exhibition in Your Mouth*, people have to pay for their meal, which

seems normal in any other context outside of an art event.

BK: I was always conscious that I was asking a lot from my participants. The "gift sculpture object" was my way of giving something back in acknowledgement for what they had given me. And it was also, for the participant, a sort of memento. It was also a criticism of the gallery system, a chance to say, "Look, we can make things that are meaningful and just give them away; we don't need the galleries for our distribution."

But then, with a project like *An Exhibition in Your Mouth*, there are things that cannot be totally free. If, for example, this event were a fundraising dinner, the ticket would be probably four times as expensive, whereas at Isa, we are working with the economics of running a restaurant—the price of a dinner is based upon the cost of the ingredients and the restaurant's overhead, not the luxury market of contemporary art. It also opens up the experience to people who aren't from the art world, who might just drop in.

SB: There is transparency here to what the $65 ticket corresponds to: cost of

produce, cost of employees, costs to run the restaurant.

BK: The costs of that meal would be the same whether I use recipes from younger artists or recipes from Marcel Duchamp or Louise Bourgeois; there is no difference. So, for the meal itself, it is a bit closer to a use-value than luxury market.

However, the menus that will be given out for free during the meal sometimes circulate in the art market and are sold for more than the cost of the meal itself. I don't mind this because each has its own purpose. There is a reason for objects to be preserved, because there is something that can be read in the original object that cannot be seen in a digital representation, for example.

SB: In *An Exhibition in Your Mouth* there is also this idea of direct experience within food art.

BK: Yes, and in a very ahistorical way, it also allows you to challenge the usual notion of the author. A new "maker" enters into the matrix: the one who follows the recipe, the one who follows the composition, the one who refabricates the instruction piece. After I worked with seven Parisian chefs in the *On becom-*

ing something else project for the Centre Pompidou [in 2011], we explored the tension between recipes and instruction pieces, and what happens to the idea of a single author, the connection to musical scores and variations on previous scores by other musicians, and so on. We also evoked the limitations that exist in the art world, the prejudice in favor of the myth of the single author that has to be maintained for the capitalist system of the galleries. There is this idea that there needs to be a single author and that we can sell and resell that idea.

SB: You mention that you have had an impact on the values of antiquarian books in your field and on research collections in various libraries. Do you believe in a positive impact of the artist on the art institution?

BK: There is a positive role to be played by the artist in relation to the institution. It is one of the reasons I did not totally leave the art world. What we do has to have an impact, to encourage the institution to open itself up and be more flexible, more agile. Both efforts are worthwhile.

Menu for An Exhibition in Your Mouth.

ACTION ACTUAL

"The (S) Files 2011"

EL MUSEO DEL BARRIO / CURATED BY ELVIS FUENTES, ROCÍO ARANDA-ALVARADO, TRINIDAD FOMBELLA, AND JUANITA BERMÚDEZ

This performance series featured artists who participated in El Museo's Biennial. Rafael Sánchez and Kathleen White's *TABLE Project* performance had poems and readings by Gypsy Joe and artists. Juan Betancurth's *Living Room* transformed the Galería into a sitting room with elegant furniture and delicate porcelain figurines exploring bondage in glass cases. His actions were narrated by a Spanish-language commentator and live-streamed on a stack of televisions nearby. VJ Demencia's *Play NYC* was a two-hour video projection with "salsa-tech," an ambient, electronic, salsa, bomba y plena, and vintage trio music soundtrack. In *Dating Game*, Irvin Morazán was dressed as a postmodern shaman while snacking on cheese puffs, guiding would-be lovers through the quiz-show ritual, flanked by malt liquor-guzzling masked cherubs. In Alicia Grullón's *Pick-It*, the artist invited the audience to form a picket line with signs announcing their personal and divergent messages. Although developed before Occupy Wall Street, the performance took place with magnified resonance. —*Stephanie Spahr LaFroscia*

Migdalia Luz Barens-Vera, "The Shooting Series," 2010–2011. Courtesy the artist.

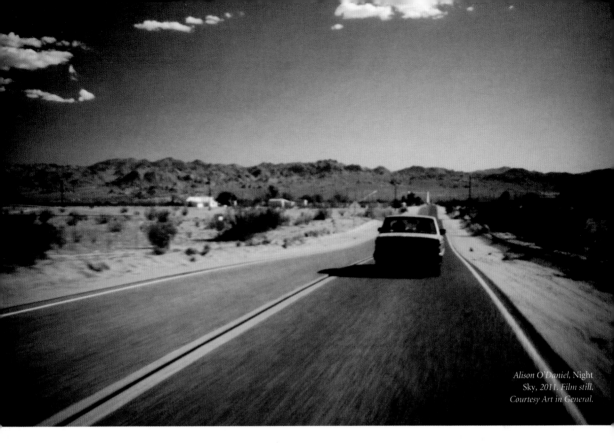

Alison O'Daniel, Night Sky, 2011. Film still. Courtesy Art in General.

ALISON O'DANIEL

Night Sky

ANTHOLOGY FILM ARCHIVES / PRESENTED BY ART IN GENERAL

Los Angeles filmmaker Alison O'Daniel's *Night Sky* is an hour-long narrative film about two friends on a road trip through Joshua Tree. After their vehicle breaks down in the desert, Cleo and Jay enter another dimension where a dance marathon never ends, time collapses, and exhaustion is rampant. The girls find themselves in a sound chamber in the desert, where they encounter a speaking dog. A final monologue in sign language ends the film: "Tomorrow there will be plenty of water, dictators will be deposed, and the mundane will be extraordinary." For the artist, who is partially deaf, sound is a central character throughout the film.

Night Sky was screened with sign language interpretation by Lisa Reynolds, directly translating the sounds of the film into movement; and live music performed by Ethan Frederick Greene, the composer of the film's score.

— *Courtenay Finn*

Chapter Seven

STAND UP

Participants in Performa Ha!, *2011, clockwise from top left: Reggie Watts, Dina Seiden, Bedwyr Williams, and Lumberob. Photos by Paula Court.*

CLUB NUTZ (TYSON AND SCOTT REEDER)

Performa Ha!

HA! COMEDY CLUB / CURATED BY MARK BEASLEY

Don't be fooled. A sense of humor is a serious thing, and it isn't funny, not having one. Watch the humorless closely: their furtive glances and flashes of panic as irony or exaggeration elude them and the relief with which they submit to the babble of unanimous laughter. Presented in a comedy club off Times Square, *Performa Ha!* encroached upon the sticky carpets, black walls, and standard stand-up fare of such midtown Manhattan venues. Over three consecutive Sunday evenings, *Ha!* explored both the funny and plain strange, looking for humor and satire in the muddied ground between performance art, stand-up comedy, and histrionic address.

The house band that never played a note—Mike Smith and Title TK (Cory Archangel, Howie Chen, and Alan Licht)—discussed the evolution of rock-and-roll drumming while Smith, drum sticks in hand, considered the pros and cons of being a drummer. Bursting onstage with a hail of vocalizing tweaked by numerous echoes and digital delay pedals, Lumberob's improvised narratives moved from peer pressure in kindergarten to the corny decor of comedy clubs. Dina Seiden's onstage breakdown segued into a description of one of her first writing jobs—ghostwriting allegedly reader-submitted anecdotes of erotic encounters for pornographic magazines, a job from which she was eventually fired for suggesting that the female subjects of these stories weren't satisfied by their suitors. Chicago's Club Nutz presented a black Rymanesque painting that, with accompanying horror and zombie music provided by artist Spencer Sweeney, came alive with the artist puncturing the canvas with whips and fluorescent-colored abstract shapes cut from cardboard. Dressed in clerical garb, Bedwyr Williams presented *Methodist to my Madness,* a satiric monologue regarding the day-to-day job of the performance artist, from selecting costumes that would enable fleeing should the audience rebel against the performer to dealing with peculiarly spectacled curators. YouTube artist Hennessey Youngman (Jayson Musson) took the audience through a humorously pointed history of performance art; while Reggie Watts, the one and only jobbing comedian on the bill, summoned the endless characters and musical genres at his disposal to surreal effect. His act ran the gamut from lounge singing and beatboxing to club compere philosopher.

—*Mark Beasley*

Interview

MICHAEL SMITH & JAYSON MUSSON

IN CONVERSATION WITH MARK BEASLEY

MARK BEASLEY (MB): The first thing I wanted to ask is how you both arrived at your performance characters, which for Michael would be Mike and Baby, and for Jayson, Hennessey Youngman. What is the DNA of your chosen characters? Jayson, you've talked about two contributing factors, the ten years you spent with the band Plastic Little—would you describe the band as hip-hop?—and the column you wrote for the *Philadelphia Weekly*.

JAYSON MUSSON (JM): Yeah, it was definitely hip-hop. Being aware that you're a part of this community also means that you're aware of the confines of the community, and you can poke fun at its behavior and mannerisms. This definitely translated into Hennessey: Once I was in grad school, rather than accept-

ing the ideas about art or the culture of art that was presented to me as reality, I perceived it as another small community that was high off its own vapors.

It was the column that really helped me—the "Black Like Me" column that I wrote for the *Philadelphia Weekly* was the first time I worked with an editor, so it really trained my voice.

MB: Do you mean your writing voice?

JM: The writing voice transformed into the performing voice. Before that, my writing experience was limited to making posters for the "Too Black for BET" series. I was writing without an editor; I just approved everything myself. When working with the *Philadelphia Weekly*, I had a really, really good editor. He recognized and supported the humor and

had more experience working with a broader public than, say, a hip-hop or art audience. For the posters, I used my rap name, Pack of Rats, but once I started writing there, I wanted to be professional, so I just went by Jayson.

MIKE SMITH (MS): Were they in the same paper? Were they weekly comics or something?

JM: No, the column was about anything that I wanted to write about; most of the time, it was politics or personal. I was there for a little under a year and I only had two columns rejected.

MB: Jayson, did you have a background in the arts? Did you go to art school?

JM: I went to the University of the Arts in Philadelphia. I concentrated on photography and also did a lot of printmaking. "Too Black for BET" started around my junior or senior year.

MB: Mike, you studied as a painter in Colorado.

MS: I studied at Colorado College, a small liberal arts college. The second semester of my freshman year, I took a drawing class taught by my older brother Howard at a University of Colorado outpost. Almost immediately, I was transformed into this committed abstract painter. Howard was a serious, formal painter and I was very much under his influence. At the end of my sophomore year, I went to the Whitney program. I was only eighteen but acted like I was about fifty. Over the next few years I matured and gradually started to act more like my actual age. Maybe that has had something to do with my transition to performance.

MB: You've mentioned that you felt you'd exhausted painting, engaged in a research phase, reading a lot of Beckett and Joyce alone in the studio, and became interested in the structure of broken-up and minimal dialogue and language.

MS: I was mostly looking at the dictionary while reading Joyce. I really liked the loaded-down characters of Beckett, and found them to be very funny. My initial interest in stand-up was somewhat fortuitous. A friend mentioned there was an open-mic night at this club in Chicago, and one night I ended up there. People getting up

in front of an audience and trying to make them laugh intrigued me. It was definitely a nice change from a lot of performance stuff I was seeing back then; much of it was like watching paint dry.

JM: Some people want to return to that.

MS: Someone challenged me to do something at the club and I figured, what the hell. So, like, when I was painting, I set up a problem to solve; instead of coming to terms with the flat surface, I set out to be funny with flat humor. I made a bunch of audio recordings and worked on my timing and voice. Many friends found them distressing but they made me laugh. Basically, the tapes were about me trying to figure out how to work the damn tape recorder and make sense of the traffic outside my window.

MB: At that point, Mike, had you gotten a clear sense of a different take on stand-up, coming from an arts background? Were you interested in breaking the code of stand-up?

MS: I don't think so, but I did get a routine together. Fortunately, the club closed down before I could perform there. I would have totally bombed. Jokes about figure/ground or walking the perimeter of the stage are not material for a comedy club. My routine was basically the live version of obtuse notes and sketches from my notebooks.

JM: So, did you ever get the chance to present that material, the notes that would have been your first routine, anywhere live?

MS: I performed them in my studio. Most of my material had hidden meanings and references. Very few people got them, and when they did, I began to wonder if it even mattered. What I realized was important was that they laughed.

When I met Marcia Tucker about participating in the performance series "Four Evenings/Four Days" she organized at the Whitney in early 1976, the first thing she said to me was, "So you're the stand-up?"

MB: So at this point, there wasn't a conception of an alternative comedy format or genre?

MS: I don't know about that. What about Wegman? Or even Steve Martin? I loved how he mixed deadpan with outrageous and dumb. [Andy] Kaufman was active but I was unaware of him. Coincidentally, I did a "100 bottles of beer" performance without knowing he had done one. These things were in the air. I grew up when comedians were making hugely successful record albums, people like Shelley Berman and Bob

Newhart. I am sure I got a lot from them without realizing it.

MB: I have a bunch of George Carlin records from around that time, which have the feel of language-based conceptual art. They're equally effective in focusing attention upon the structural and controlling use of language. They're also very funny.

MS: I don't have the writing chops that Jayson has. Stand-up appealed to me because it allowed for non sequiturs. I did not have to stay on topic. It's also a very reactive form. Not so different from a lot of performance art. The climate was incredibly serious in the art world in the '70s, and often I'd find myself to be the only one laughing during performances, most likely out of discomfort.

JM: I always find those people that work with the most extreme seriousness to be quite comical. The man with the mission makes me laugh.

MB: Recently, I've been thinking and writing about the Shakespearean fool. The court jester was the one figure in medieval life that was allowed to poke fun at or deliver bad news to the king or queen. Hennessey Youngman has allowed you to do that, Jayson. Do you feel that comedy, humor, and stand-up tropes are useful tools for the artist? I'm wondering what other forum other than performance would have allowed you to ridicule a figure like Damien Hirst?

JM: It wouldn't manifest in the way it did in the Hennessey video because any critique of Damien would show up in the form of a review, and the writer reviewing his show isn't going to review his personality. It wouldn't demean his smile for five minutes and show the clip of him saying "money is my material." The art world is super-mannered. As Hennessey, I can just pass a judgment and don't really have to back it up because it's funny.

MB: I read a critical piece in *Frieze* about the 2012 around-the-world spot painting show of Hirst's that finishes with a mention of your video. It's clear from the tens of thousands of people who watched it that people are interested in that kind of discussion and appraisal.

JM: The reason that video got a lot of hits is definitely because Damien is just who Damien is. I think for people who aren't consumers of or participants in the art world, the discussion of money is always the thing that pulls them in: It's always about some ridiculous, absurd, jaw-dropping price.

MS: Hennessey sports bling and talks about money. He is what he eats; a smart, straightforward strategy.

JM: Hennessey understands the world through the lens of the media, like in the relational aesthetics video, where he blatantly admits that he is a besotted creature of capitalism or something, and shows his chains and gun. I never wanted Hennessey to be above the thing he was critiquing.

MS: BTW Is Hennessey on hiatus?

JM: I got to the point where I knew the character, and I was like, "Fuck this character. I've figured this out. I'm going to move onto the next thing." So, he's on hiatus now, but I don't think it's a permadeath.

MB: And Mike must be in his middle years, maybe?

MS: I guess if I'm middle age, he must be too. I have been working with the Mike persona for about thirty-five years and it ain't getting any prettier.

MB: I was thinking about Bedwyr Williams, who was also part of *Performa Ha!* We staged a second *Performa Ha!* event in Miami in 2011. The local press turned up for an interview, and instantly, Reggie Watts and Jibz (Dynasty Handbag) sprang into this comedic mode, and Bedwyr looked absolutely confused and appalled. They were on a playing court and the points are laughs, but for Bedwyr there was no court. I wondered if that's something you've both felt?

MS: When I was hosting a monthly variety show at Carolines Comedy Club in the late '80s, Caroline always treated me like an artist, probably because she didn't consider me a comic. My L.P.M. (laughs per minute) numbers were very low. I dealt with the long, shaggy dog stories that never quite made it to the punch line.

JM: Laughs Per Minute…that's a scary formula. I would definitely like the laugh, but the way my work is structured the laugh may or may not come. When I did *How to Be a Successful Black Artist*, the end is this unrequited-love spiel to Kara Walker.

MS: Not to get off topic, but do you mind if I ask if that's a real gun in *The Sublime*?

JM: No, it's a blank-firing handgun. When you shoot it, a small flame comes out of the front so it looks real on camera, but it's totally fake. It's insanely loud. But I'm glad it disturbed you and maybe you lost a little bit of faith in him as a character.

MB: Do you think there's a line which comedy or satire should not cross?

JM: Not really. Most of the time when it makes the appearance of crossing a line, it's just veiled racism or sexism or something.

MB: Did you ever see the British comedian Sacha Baron Cohen's Ali G character? What did you make of that? I was interested in how he reveals the people he interviews, their absolute intolerance.

JM: I first saw his work in 2000 or 2001. I had friends in Philly whose family was British, and they brought back, like, a VHS tape [from the UK], and I lost my mind, it was really, really funny. I thought he might have been like a Jamaican dude of mixed descent, not this well-bred, well-educated Jewish guy, that's how great his performance was. I loved it. He's really good at lowering people's guards, which is really, really hard to do.

MB: It strikes me that there is a target for Hennessey, and also for Mike. If there is some anger or ire that you're trying to expel or exercise within these characters, what are the targets?

JM: I'm not going to tell you!

MS: Hard for me to answer that. Sometimes I take time off from targeting myself to highlighting absurdities in everyday life. It can make researching a lot easier.

JM: Even though Hennessey focuses on art, I've always found disdain in homogeny, whether it's in underground hip-hop culture, or the prevailing mannerisms of this art world that I've entered postgraduate school. It's kind of like in the film *Quadrophenia*, when the main character sees Sting, the king of the Mods, and he's this bellhop and he flips out. It turns out he's just a fucking monkey getting people's suitcases.

MB: You're against faux cool, the Ace Face. That was Sting's character's name. And Mike, you just love the world, right?

MS: Yeah, that's me. You can ask Jayson. He spent a summer with me at Skowhegan. Unlike Jayson, I like homogeneity. It helps me to see the playing field better.

JM: Yeah, he loves the world.

MB: I know you said Hennessey might not appear again, but could anything resurrect him?

JM: I'll deal with him again only with Mike. We're going to do a buddy cop movie.

MS: Sounds good. I got shotgun.

NOT FUNNY

PERFORMA FILM PROGRAM

BY LANA WILSON

In the 1960s, the typical American co-median was Rodney Dangerfield—a middle-aged guy in a suit, telling jokes written by others: Borscht belt–style one-liners like, "My wife and I were happy for twenty years . . . then we met."

In the late 1960s, a radical new group of comics emerged. These performers wrote their own material, which was of-ten laced with daring social and political commentary that took the audience into uncharted territory. They weren't just doing stand-up routines—some of them were pushing the limits of free speech, and showing that popular entertain-ment could engage serious issues. Others were actually deconstructing the *idea* of a stand-up routine, bringing an ironic, very postmodern awareness to the job of entertaining people. And all of them were shaking up traditional ideas about

what was funny, and about where enter-tainment ended and life began.

During the same period, another revolution was occurring in visual art, as performance and conceptual art began to gain traction and the first consumer video cameras made it possible for artists to record themselves. In reaction to what they saw on television, some delivered deadpan routines that felt like a decon-structed version of stand-up. *Not Funny* was a six-evening film program that looked at some of the key works pro-duced during this remarkable era, both in the stand-up scene and the art world, and at the artists and the comedians who are still influenced by this material today.

• • • • • • • • • • • • • • • •

In 1965, after numerous arrests for ob-scenity, Lenny Bruce was America's most

controversial comedian, and he could only get bookings in San Francisco. *The Lenny Bruce Performance Film* (1973) documents the comic's second-to-last live concert in 1966, in which he rails against the charges filed against him in his most recent court case, using the judge's docket as a framing device for presenting some of his most famous bits and directly addressing the hypocrisy of dividing comedy from high art.

Inspired by Bruce's provocative performances, a new wave of comedians in the 1970s shocked audiences with everything from obscenity to brutal personal confession to performance art–inspired antics that left some wondering what the joke was. Even so, these comedians—including Richard Pryor, George Carlin, Albert Brooks, and Andy Kaufman—gained enormous popular followings.

The first-ever comedy concert film, and still arguably the best, *Richard Pryor: Live in Concert* (1979) features the iconic artist in top form, using his foul-mouthed, wildly imaginative style to skewer issues of race and class, deliver impersonations of everyone from his grandmother to a pet monkey, and above all, ruthlessly deconstruct his own past

mistakes with the daring and rawness for which he was known.

Carlin brought comedy to another level with his faster and tighter monologues; his most notorious, *Seven Words You Can't Say on Television* (1978), got him arrested for public profanity and led to the creation of television's "Family Hour," in which the first hour of prime-time every night was required to be only "family-friendly" material. Brooks, on the other hand, pioneered a kind of anti-comedy in which the joke was frequently how bad the jokes were. In *Audience Research* (1976), for example, he investigates why no one thinks his films are funny, and in *Albert Brooks' Famous School for Comedians* (1972), he hawks a "university" where aspiring comics are taught how to do a double take and spit out their coffee in shock; how to throw a pie in someone's face; and how to donate to a respectable charity once fame is achieved.

Kaufman, however, pushed the audience to extreme new levels, performing brilliant conceptual acts that toyed with character and expectation. *Not Funny* included many of Kaufman's classic performances on television as well as

From top, left to right: Michael Smith, Mike Builds a Shelter, *1985. Courtesy Electronic Arts Intermix (EAI), New York. Albert Brooks,* Audience Research, *1976. Video, 7 minutes. Andy Kaufman,* Saturday Night Live, *1975, from* Selected Works 1975–82. *Video, approximately 45 minutes. William Wegman,* Joke Paper, *1973. Courtesy Electronic Arts Intermix (EAI), New York. Sacha Baron Cohen,* Throw the Jew Down the Well, *2006. Video, 3 minutes. Albert Brooks,* Albert Brooks' Famous School for Comedians, *1972. Video, approximately 10 minutes. George Carlin,* "Seven Words You Can Never Say on Television," *1978. Video, 19 minutes. Cynthia Maughan.* Scar/Scarf, *1973–1974. Courtesy Electronic Arts Intermix (EAI), New York.*

Jon Dore and Rory Scovel on Conan, *2011. Zach Galifianakis, "Preschool," excerpt from "Late World with Zach," 2002. Video, 4 minutes. Harry Dodge and Stanya Kahn,* Can't Swallow It, Can't Spit It Out, *2006. Courtesy Electronic Arts Intermix (EAI), New York. Richard Pryor: Live in Concert, 1979. Directed by Jeff Margolis. Video, 78 minutes, 35mm. Kristen Schaal and Kurt Braunohler,* Kristen Schaal is a Horse!, *2009. Video, 2 minutes. Tim and Eric,* What Am I Going to Get?, *2010. Video, 3 minutes. Reggie Watts, excerpt from* Why S#!+ So Crazy?, *2010. Video, 11 minutes. Andy Kaufman, excerpt from* Wrestling Match with Jerry Lawler, *1982. Video, 8 minutes.*

excerpts from rare live shows and several clips that traced the arc of his short-lived career of wrestling women.

• • • • • • • • • • • • • • • • • • •

The seventies also saw several California-based artists begin making minimalist videos of themselves performing humorous conceptual experiments. Whether through deadpan monologues (William Wegman), comic task-based structures (John Baldessari and Martha Rosler), absurd comments and confessions (Cynthia Maughan), or psychologically charged role playing (Eleanor Antin), all of these artists played in some way with the delivery style of stand-up. *Piece to Camera*, one evening in the *Not Funny* film series, collected rare works by Wegman, Baldessari, Rosler, Maughan, and Antin.

In the following two decades, artists such as Michael Smith tried to move from the visual art context into the mainstream comedy world. Smith—primarily known for deadpan videos and performances starring himself as the hapless everyman character "Mike"—came perhaps closer than any other artist to successfully making this leap. *Saturday Night Live* signed off on his proposal for a fake commercial for the TV show, and he created an hour-long special for Cinemax. *Doug and Mike's Adult Entertainment* (1991–96) was a hilarious variety show that Smith thought would finally help him achieve his desired crossover. Created

in collaboration with artist and composer Doug Skinner, the show featured stand-up, performance art, drag routines, and puppets, and was performed at both downtown galleries and the comedy club Carolines on Broadway.

A little earlier, performer and writer Eric Bogosian had traveled an opposite route, crossing from acting into the art world and then back again, beginning with his character Ricky Paul, a Lenny Bruce–inspired entertainer who spent his time onstage ranting about contemporary problems. With Ricky Paul, Bogosian planted the "comedy routine" firmly in the art world, offending audiences with late-night performances at art-oriented venues like the Kitchen, Artists Space, and the Mudd Club. (Bogosian later left, returned to theater, creating acclaimed plays such as *Talk Radio* in 1987 and *subUrbia* in 1997, going on to act in a wide variety of movie and television roles.)

Today, in the visual art world, many artists have again turned to the format of stand-up comedy, whether for inspiration or presentation style. Because aspiring comedians can now find a mass following on YouTube or can present internet-based shows that are free from the content and format restrictions of television, the pressure of having to appeal to a mainstream audience has in many ways been removed, giving comics the freedom to be weirder and more experimental than

ever. *Stand-Up, Sit Down, and Visual Art Comedy Today* presented several short contemporary works by both artists and comedians in an evening-length program that concluded *Not Funny*.

Stanya Kahn performs as different characters in videos made in collaboration with Harry Dodge, another Los Angeles–based artist. In *Let the Good Times Roll* (2004), Kahn plays Lois, a woman wandering through the desert in search of a rock concert. She winds up in a hotel room, where she confesses several heartbreaking and hilarious drug-induced experiences to another lost traveler.

Much of the best comedy in the art world is actually *about* the art world, as in Alex Bag's *Untitled Fall '95*. Monologues by the main character—a hopelessly immature New York art student—are interspersed with brief visits with a pretentious conceptual artist giving a guest lecture and a duo of Brits trying to write lyrics for a punk band, among others. Kalup Linzy also plays the role of an aspiring artist, in drag, in his *As da Artworld Might Turn* (1995), a show from his popular multi-episode internet soap opera *All My Churen*. And in *Time and Space* (2011), Tamy Ben-Tor—who began her career as a stand-up comic in Tel Aviv before translating her skills to the art world in Jerusalem and New York—spoofs the labored, over-wrought self-presentation of the contemporary artist, obsessed with connecting her laughably mundane work of writing emails, applying for grants, and sitting in coffee shops to "time and space" using any means possible.

In terms of more conventional comedy, the program included Sacha Baron Cohen, all of whose work is deeply indebted to Andy Kaufman, performing a classic "put-on" routine as Borat; Zach Galifianakis taking his comedy routine into a preschool classroom, in a gimmick that Albert Brooks would have loved; Kristen Schaal and Kurt Braunohler performing an endurance-based sketch in which the joke is that the joke never ends; Tim & Eric, whose wild sets, garish color palette, and freaky spoofs of twentieth-century Americana suggest the work of Mike Kelley; and Jon Dore and Rory Scovel, whose conceptual performance on *The Conan O'Brien Show* in 2010 made a joke of the basic structures and conventions of the stand-up routine as they pretended to be "double-booked" and forced to perform their routines simultaneously.

Finally, there was material by Reggie Watts, a virtuosic performer who blends comedy, music, and improvisation into shows that defy categorization. At one point, he was in character as the most general comedian "type" of all time: "You know what I'm sayin'? . . . People so different, you know what I'm sayin'? Men and women and shit People so different. You know, you know what I'm sayin'." The art is in the delivery.

NATHANIEL MELLORS

Ourhouse

THE GREENE SPACE WNYC / CURATED BY MARK BEASLEY AND DAN FOX

London-based artist Nathaniel Mellors's *Ourhouse* is an ongoing series of exaggeratedly comic absurdist films. The six-part video project, began in 2010, centers upon the character of "The Object," an older man in tennis whites wearing two watches, as "it" occupies a British home, and its relation to its fellow inhabitants, the wealthy, bohemian Maddox-Wilson family. Employing the look and feel of BBC television shows—gloomy lighting, somber music, rolling landscape shots—Mellors's surreal films consider the distinct language and unwieldy power dynamics of the upper-class family. The Object invades the house in much the same manner of Terence Stamp's character The Visitor in Pier Paolo Pasolini's *Teorema* (1968)—just as The Visitor appeared unannounced at the home of a wealthy Milanese family, slowly seducing and transforming each family member, The Object appears without explanation, affecting the behavior of all of the eccentric Maddox-Wilsons.

For Mellors, who is as much a sculptor as he is a filmmaker, The Object as a piece of unwieldy sculpture is fundamental to the essence of this film series. The Object ingests political texts from the house library and has "cultural indigestion," leading to the birth of new sculpture. Presented at Westway, a former strip club off the West Side Highway, the first four episodes of Mellors's film series were interspersed with live music by Socrates that Practices Music; Big Legs; and God in Hackney, Mellors's own band, all groups whose albums are distributed by Junior Aspirin Records, the label co-founded by Mellors, Dan Fox, and Andy Cooke.

—*Mark Beasley*

Nathaniel Mellors, Ourhouse, *2011. Performance view. Photo by Paula Court.*

JONATHAN MEESE

WAR "SAINT JUST (FIRST FLASH)"

BORTOLAMI GALLERY

An accomplished painter, sculptor, and performer, Jonathan Meese explores what he terms the "Dictatorship of Art," a vehicle for the artist's fluid persona where art is viewed as the ultimate expression of power. Aggressive and confrontational yet with a childlike sense of humor and irreverence, Meese embodies a multitude of characters, evoking pop-cultural and military references from Noël Coward and Scarlett Johansson to Hitler and Napoleon, rendering all culture equally horrifying and banal.

The German multimedia artist's performance at Bortolami Gallery, part of the exhibition "HOT EARL GREEN SAUSAGE TEA BARBIE (FIRST FLUSH)," found the artist at his theatrical best, in the midst of a cacophonous installation that riffed on the semiotics of staging, complete with quotidian props, poorly constructed cardboard tableaus and a cartoonish pulpit for Meese as the master of ceremonies/"Diktatur der Kunst." A former student at Hochschule für bildende Künste Hamburg, Meese's imperial ambition has led to projects of grandeur, such as his stage design for Wolfgang Rihm's 2010 opera *Dionysus* and presentation of *De Frau: Dr. Poundaddylein - Dr.*

Jonathan Meese, War "Saint Just (First Flash)", 2011. Performance view. Photo by Paula Court.

Ezodysseusszeusuzur (2007), a full-length play in which he acted as set designer, playwright, and star.

Meese unleashed a raw monologue with the unhinged intensity and unwavering dedication of an exorcist preacher (or motivational speaker), complete with his own brand of nonsensical sloganeering: "Art is total propaganda! Art is toysoldierism! The melting pot is this most imprecise, democratic reality's shitty chamber pot!" As Meese grows increasingly confident as a performer, his infantilized and transformative role-playing continues to riff on the perversions of the modern age.

—Dmitry Komis

Chapter Eight

FLUXUS

FLUXUS WEEKEND

MULTIPLE VENUES / ORGANIZED BY MARK BEASLEY, ANTHONY ELMS, ESA NICKLE, LANA WILSON, AND BIENNIAL CONSORTIUM MEMBERS WITH LIUTAURAS PSIBILSKIS

In the creative and "indeterminate" spirit of Fluxus, Performa produced an intensive fifty-two-hour program across New York City in collaboration with the Performa Consortium, beginning with the opening of the Fluxus Shop at the Hub on Friday and ending with the Fluxus Concert at Clemente Soto Vélez Cultural and Educational Center on Sunday evening. Honoring the history of a movement, a sensibility, and a large group of artists, musicians, poets, and writers who gathered regularly throughout the 1960s and '70s in New York, Paris, Dusseldorf, Amsterdam, Copenhagen, and elsewhere, creating Fluxus events, objects, concerts, and manifestos, but also bringing together contemporary artists whose understanding of the legacy and ethos of Fluxus continues to thread through their work, projects ranged from small gestures to in-depth exhibitions, including New York University's Gray Art Gallery "Fluxus and the Essential Questions of Everyday Life," and "Thing/Thought: Fluxus Editions, 1962–1978," at the Museum of Modern Art.

At the Hub, Performa operated the Fluxus Shop, commissioning eight artists to produce Fluxus objects for sale, while the Performa Institute presented Burak Arikan's Artist Class: "Creative Networking Workshop." The Fluxus Concert, a multigenerational concert demonstrating the birth of "Action Music" through multiple approaches, perspectives, and methods, closed out the weekend.

—*Performa*

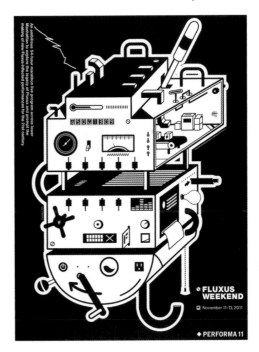

Above: Fluxus Weekend program. At left: MV Carbon performing TV Cello for Nam June Paik & Charlotte Moorman.

THE GINGER ISLAND PROJECT

EMILY HARVEY FOUNDATION AND STOREFRONT FOR ART AND ARCHITECTURE

The Ginger Island Project was a three-part reflection on Fluxus artist George Maciunas's much-imagined but never-realized vision of a Fluxus artists colony on Ginger Island in the British Caribbean. Ginger Island was revived in spirit in 2011, when a group of New York–based visual, performance, and sound artists responded to Maciunas's initial concept by presenting their own vision of what a contemporary artists colony might be, using whatever medium they preferred to illustrate their proposals.

Maciunas began sketching out his idea of developing Ginger Island throughout the late sixties, and in the summer of 1969 he and friends Yoshi Wada and Milan Knížák set out on an exploratory trip to the uninhabited Ginger Island to investigate the island with the possibility of acquiring it. Maciunas hired a boatman to ferry them from a neighboring island, and arranged to have the group picked up in ten days' time. The artist believed he was sufficiently prepared for such an adventure, bringing ten days' worth of water and powdered food for the group, and maps detailing the island's topography, including approximately sixty squares of land demarcated for each "Fluxhouse," prefabricated structures which were to comprise the colony on Ginger Island. After a long first day of exploration, the group lay down to sleep under a cluster of trees; when they awoke, Maciunas had apparently gone blind and several of the group members had swollen limbs. The trees had rained down droplets of poisonous sap over the artists while they slept. Luckily, the effects wore off a few days later, but this episode was discouragement enough to postpone indefinitely the island's acquisition and development. Even so, Ginger Island persists as a utopian attempt, gaining status as a symbolic adventure in which artistic vision clashed with reality.

Maciunas would later realize his utopian community in New York City itself, with the purchase in 1967 of an entire building at 80 Wooster Street. Though it did not become the Fluxhouse Cooperative, apartments, movie theater, and recording studio that he had envisioned, this purchase encouraged fellow artists to move into the cast-iron buildings downtown that would become the all-

Storefront for Art and Architecture screens A Walk *(1990) by Jonas Mekas and* Ginger Island *(1969) by Milan Knížák as part of Liutauras Psibilskis's Ginger Island Project.*

important SoHo of the 1970s, with its enormous influence on the art community of then and today.

The exhibition included work by Amy Granat, Sissel Kardel, Milan Knížák, George Maciunas, Jonas Mekas, Lisa Oppenheim, Michael David Quattlebaum Jr. (Mykki Blanco), and Flora Wiegmann. Marina Rosenfelt and Raz Mesinai's

DJ sets at Red Egg produced a sound installation, remixing sixties and seventies sounds by original Ginger Island explorer Milan Knížák into dance music, while the original seven-minute, 16-millimeter picturesque film shot by Knížák on that first trip to Ginger Island was projected behind them.

—*Liutauras Psibilskis*

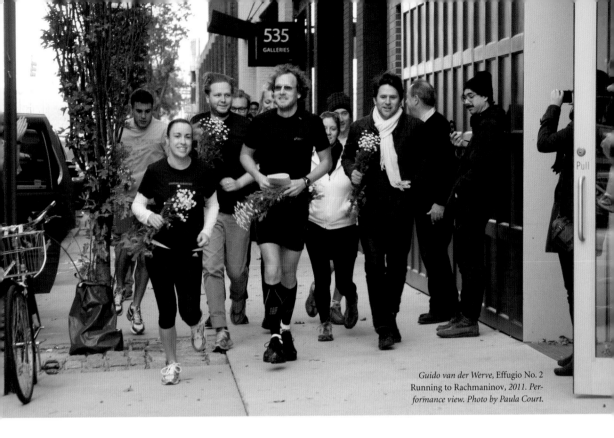

Guido van der Werve, Effugio No. 2 Running to Rachmaninov, *2011. Performance view. Photo by Paula Court.*

GUIDO VAN DER WERVE

Effugio No. 2 Running to Rachmaninov

LUHRING AUGUSTINE

Classical scores have always played a part in Guido van der Werve's work: His 2012 film *Nummer veertien, home* is modeled after a classical Requiem: three movements and twelve acts. The film narrates the escape and exile of Frédéric Chopin, whose dying wish was to have his heart buried in his native Warsaw. His sister smuggled it out of France in a brandy bottle, and it was interred in the Church of the Holy Cross in Poland. In 2010, van der Werve initiated an annual thirty-mile run from Manhattan to Kensico Cemetery in Valhalla, New York, paying homage to pianist and composer Sergei Rachmaninov, who died in 1943, and who is buried there. As seen in the photograph, van der Werve made the second run with a group of long-distance runners and endurance art enthusiasts. For van der Werve, also a classically trained pianist, the Second Annual Run to Rachmaninov is the synthesis of meditative long-distance running and paying tribute to a figure of Romantic mythology.—*Jennifer Piejko*

ZEFREY THROWELL

I'll Raise You One...

ART IN GENERAL / CURATED BY COURTENAY FINN

Transforming Art in General's storefront project space into a stage, artist Zefrey Throwell's performance *I'll Raise You One . . .* was a public seven-day-long game of strip poker. For a week during gallery hours, seven players gathered around a white table in the storefront window to gamble away their clothes. At the end of each round, the players got dressed and began again, a repeat performance that occurred many times during the course of the day.

A photographer, video artist, and painter, Throwell's notorious public improv projects often involve nudity and light-handed commentary on capitalist culture. In the summer of 2011, he and more than forty participants undressed in an early morning action near the base of Occupy Wall Street, which he said had to do with "work and the economy." Several months later, his week-long game of poker, which combined a favorite gambling pasttime with the flirtations of a teenage party dare, also exhibited an as-

Zefrey Throwell, I'll Raise You One..., 2011. Performance view. Photo by Elizabeth Proitsis.

pect of Fluxus game playing and chance. Staged on the heels of the financial crisis, Throwell's event established a world of absurdity and purposelessness, allowing the casual onlooker to participate in guilt-free voyeurism while teasing out a different outlook on our personal interactions and day-to-day routines.

—Courtenay Finn

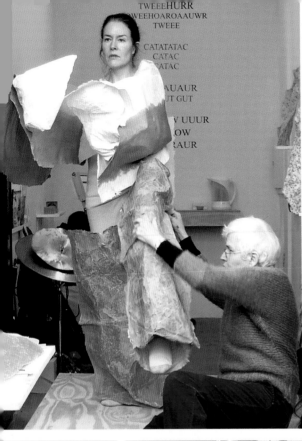

TWEEeHURR
QWEEHOAROAAUWR
TWEEE

CATATATAC
CATAC
CATAC

AUAUR
GUT GUT

UUUR
OW

RAUR

PLICK

TWEEeHURR
QWEEHOAROAAUWR
TWEEE

CATATATAC
CATAC
CATAC

HUUUAUAUR
GUT GUT GUT

WOWUARW UUUR

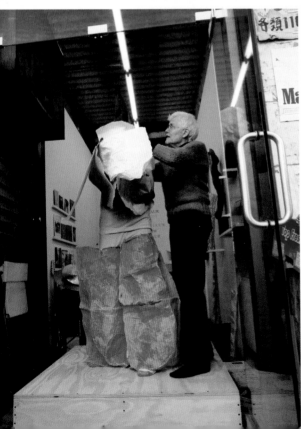

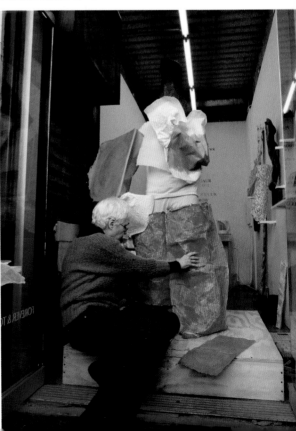

ALISON KNOWLES, WITH JESSICA HIGGINS, JOSHUA SELMAN, & CLARA SELMAN

Beans All Day

FOREVER & TODAY, INC. / CURATED BY INGRID CHU AND SAVANNAH GORTON

Spilling out of Forever & Today, Inc.'s tiny storefront at the nexus of Canal, Ludlow, and Division Streets in Chinatown and onto the bustling sidewalk, three generations of Fluxus artist Alison Knowles's family—Knowles herself; her daughter, performer Jessica Higgins, and son-in-law, sonic artist Joshua Selman; as well as her granddaughter, Clara Selman—performed together for the first time. The daylong affair featured performance scores, sound, poetry, artist books, a free limited-edition bookmark by Knowles, and food—with beans of all kinds serving as the primary material of these actions and objects.

Appreciating beans' aptitude for both artistic and physical nourishment, Knowles has used dried legumes in her work since the 1960s, in such works as *Rice and Beans for Charles Curtis* (2008), a musical score written for handmade rice paper, beans, lentils, fabric, and string. For *Beans All Day,* dried legumes were arranged with books on display, as interactive sound instruments, in miniature boxed editions, and also as a savory stovetop dish that was cooked onsite and served to the audience. In *Shoes of Your Choice*, granddaughter Clara placed her purple Converse sneakers atop a music stand and described why she liked them, accompanied by the sounds of crinkling paper, which could be heard as Knowles performed *Loose Pages*, dressing daughter Higgins in handmade flax-paper garments over a white bodysuit. Joshua Selman amplified the sounds with a guitar and amp, using a repurposed fax machine and paper shredder to produce his own abstract musical compositions as well as mountains of shredded paper. Amid the delightful cacophony, Knowles read aloud from a bean-sound poem: "Plick . . . tweehurr . . . qweehoaroaauwr . . ." as all gathered around to listen to the beans "speak."

—*Ingrid Chu and Savannah Gorton*

Alison Knowles with Jessica Higgins, Loose Pages, *1983. Part of the daylong performance* Beans All Day. *Performance views, 2011. Photos by Paula Court.*

JONAS MEKAS

Fluxus Cabaret

ANTHOLOGY FILM ARCHIVES

Innovator of avant-garde cinema and Lithuanian compatriot of Fluxus founder George Maciunas, Jonas Mekas presented *Fluxus Cabaret,* a seventy-five-minute excerpt from his ongoing visual diary. Covering two decades of Fluxus activities, Mekas's selection captured Fluxus artists' anecdotes about each other.

The thirteen scenes feature friends and collaborators. In one, Nam June Paik performs his *Piano Piece,* an ongoing cycle of the artist knocking over a piano and a stage crew propping it up again; in another, Paik performs onstage with Joseph Beuys, while in a final Paik segment, Yoko Ono performs her *Promise Piece—Bones* at a memorial service for the artist.

Ben Vautier recants the limitations and surprises of early Fluxus concerts over dinner; Mekas recalls taking a flask of ocean water from the Long Island Sound, where Maciunas's ashes were scattered, and pouring it into the Vilnele River, in Vilnius, Lithuania, near both artists' birthplaces. He also takes a wistful stroll down Wooster Street, reminiscing about Maciunas's planting of two saplings in front of 80 Wooster in the 1960s, when such acts were outlawed. The trees now hold a memorial plaque detailing the history of the building, purchased by Maciunas in 1968 in the hopes of establishing an artists cooperative community.

—*Jennifer Piejko*

RAINER GANAHL

Credit Crunch Meal

JACK HANLEY GALLERY

Serving up lentil soup along with slogans such as "too big to fail" or "junk status" carved into vegetables, Austrian artist Rainer Ganahl's *Credit Crunch Meal* was a frugal public supper reflecting the new "normal" of the ongoing fiscal crisis. Accentuated with a large pig's head, the simple yet provocative display was the artist's response to the Occupy Movement and the greed and indifference of the 1%. Serving lentils was his single optimistic gesture. "Lentils are eaten in Italy at the end of the year," Ganahl explained, "in the hope that money will come in the New Year."

—*Jennifer Piejko*

Rainer Ganahl, Credit Crunch Meal, *2011. Installation view. Courtesy Jack Hanley Gallery.*

PHILIP VON ZWECK

A Project by Philip von Zweck

INVISIBLE-EXPORTS

A painter and artist who lives and works in Chicago, Philip von Zweck once produced a weekly radio program named Something Else for WLUW in Chicago and ran a gallery out of his living room. *A Project by Philip von Zweck* for Fluxus Weekend was an exhibition opportunity for multiple participants.

For the weekend-long performance, von Zweck recruited a wide range of artists who each produced a work for display with the understanding that the pieces were not for sale. Instead, they would be "master copies" to be printed upon request. Copied on-site, each was stamped and numbered, and given free of charge to the person who had requested it. The print run for each was limited to the total number of copies given away during the weekend.

Artists who participated include Tim Bergstrum, Michael Bilsborough, Holly Cahill, Jeff DeGolier, Andreas Fische, Katy Fischer, Carson Fisk-Vittori, Pamela Fraser, Erik Frydenborg, Paul Gabrielli, Bill Gross, Magalie Guerin, Danielle Gustafson-Sundell, Kevin Jennings, Brian Kapernekas, Lisa Kirk, Christian Kuras & Duncan MacKenzie, Gareth Long, Heather Mekkelson, Matthew Metzger, Melissa Oresky, Steve Roden, Amanda Ross-Ho, Steve Ruiz, Brian Taylor, Scott Treleaven, and John Wanzel.

—*Philip von Zweck and INVISIBLE-EXPORTS*

Philip von Zweck, A Project by Philip von Zweck, 2011. Performance view, work by Amanda Ross-Ho. Courtesy the artist and INVISIBLE-EXPORTS, New York.

NAM JUNE PAIK

Global Groove

BIG SCREEN PLAZA

As part of Fluxus Weekend, Korean American Film Festival (KAF-FNY) and White Box paid homage to the twentieth century's foremost video art innovator and avant-garde visionary, Nam June Paik, with an outdoor screening of his legendary work *Global Groove* (1973) at the Big Screen Project. First broadcast in 1974 on WNET/Thirteen and made in collaboration with John J. Godfrey, *Global Groove* was produced through WNET's groundbreaking Artist's Television Laboratory, an artist-in-residence/workshop program inspired by Paik, where artists were invited to use broadcast studio facilities in the creation of video art to push the boundaries of television. With this film, Paik conceived a kinetic sound-and-video collage that sculpturally overturned the medium of television into a futuristic neo-Dada vision of a global media landscape, proclaimed as such in the opening statement: "This is a glimpse of a video landscape of tomorrow when you will be able to switch on any TV station on the earth and TV guides will be as fat as the Manhattan telephone book." Using such experimental techniques as disruptive and associative editing, colorization, and audio and video synthesis, Paik introduced a revolutionary approach to image-making through compositing forms of art, technology, and mass media, foretelling all developments of our current globalized media culture and contemporary art practices.

—*Susie Lim*

"BIBBE HANSEN ON AL HANSEN"

Growing Up Fluxus

GOLDEN GALLERY, INC.

Kicking off a special Fluxus Weekend, artist and performer Bibbe Hansen, daughter of Fluxus and Happenings "professor and pedagogue" Al Hansen who formed the so-called "Ultimate Academy" in 1987 in Cologne to continue the legacy of a generation of maverick artists from the sixties, regaled an audience with tales of her own "growing up Fluxus."

First, she recounted her artist father's formative years including an explanation of the origins of one of the works with which he is most identified, *Yoko Ono's Piano Drop* in 1970 in Frankfurt—a monumental concert act during which he pushed a piano off the roof of a five-story building while being stationed as a paratrooper in Germany.

Bibbe Hansen also performed several of her father's performances, including *Alice Denham in 48 Seconds* (1959), in which each letter of the 1960s author Denham's name was assigned a numerical value and a corresponding sound and performed with members of the audience, who had each been handed toy noisemakers. This homage to her father was backed by a projection of Al Hansen performing the same work in the early

Bibbe Hansen on Al Hansen, 2011. Bibbe Hansen performs Al Hansen's Elegy for the Fluxus Dead. *Photo by Paula Court.*

nineties. Bibbe's following performance, *Elegy for the Fluxus Dead*, detailed the names of Fluxus artists and figures in front of a 1990s recording of Al wrapping masking tape around his head, another action she similarly performed. "(I Can't Help) Falling in Love With You" by British reggae group UB40 played in the background.

—*Andrew Blackley*

FLUXUS SHOP

The blue interior of the Performa 11 Hub, designed by Berlin-based architecture firm nOffice, was turned into a makeshift market of curiosities during Fluxus Weekend, breaking with the staunchly non-commercial values of Fluxus, even if only for a mere fifty-two hours. Eight artists, including Adam Chodzko and Bedwyr Williams, were asked to each create "a portable object or idea that can be man-made or machine-made easily and economically" in an edition of one hundred. Crates and shelves at the Hub were filled with constructions with low production value and of oblique utility. Kelly Nipper sold personal patch pockets; Marianne Vitale made labels for each *FLUXUS CAN-O-WEB*, a can of spray cobwebs; and, along the lines of Fluxus instruction pieces, Michael Portnoy presented a bright red cow bell with a paper tag reading: *This must be brought, instead of wine, to the next dinner you are invited to. And they must be told to bring it, instead of wine, to the next dinner they are invited to. And so on.*

—*Jennifer Piejko*

Top: Bedwyr Williams, Circumflex, *2011. Bottom: Marianne Vitale,* FLUXUS CAN-O-WEB, *2011.*

FLUXUS & OTHERWISE

A concert in triangle

CLEMENTE SOTO VÉLEZ CULTURAL & EDUCATIONAL CENTER

On the final evening of Fluxus Weekend, performers got together to consider the musical legacy of the movement, making new sounds from old toys. A concert in three parts restaged historic works by Yoko Ono and George Brecht, among others, performed by Luciano Chessa; Bibbe Hansen took the stage of the small auditorium to present her father's legendary performance *Elegy for the Fluxus Dead* by covering her own head with tape, an encore of her performance two evenings before; MV Carbon performed *TV Cello for Nam June Paik & Charlotte Moorman,* using a magnet to manipulate the screens of a tower of old television sets into screeching static; and La Monte Young's *Composition 1960 #7,* presented by Zach Layton. Improvisational vocal performances in the spirit of Fluxus by Lumberob, Chris Mann, and Felix Kubin and Martha Colburn as well as contemporary music by bands and artists Lary 7, Sergei Tcherepnin and Lucy Dodd, XXX Macarena, and Haribos followed. The chords of old monitors, ramshackle electronic gadgets, and gnarled voices assured the crowd that

Lumberob performs. Photo by Paula Court.

Fluxus musical traditions were alive and well on the Lower East Side.

—*Jennifer Piejko and Mark Beasley*

Chapter Nine

PERFORMA INSTITUTE

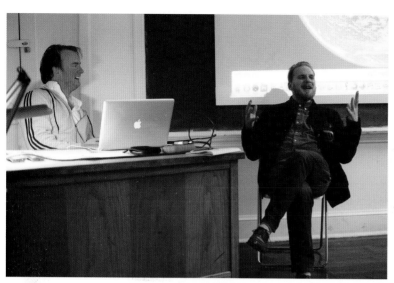

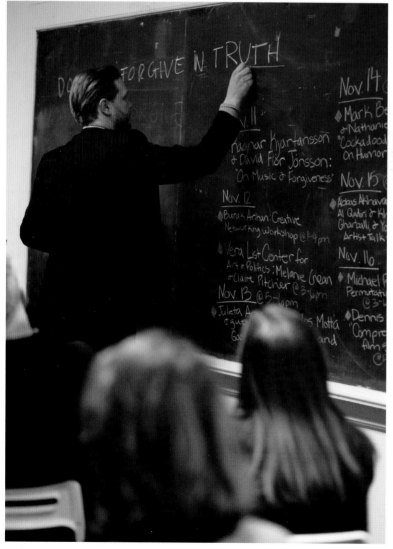

DO[] FORGIVE IN TRUTH

Nov. 11

Ragnar Kjartansson
& David Þór Jónsson:
"On Music & Forgiveness"

Nov. 12

◆ Burak Arikan: Creative
Networking Workshop @ 1-4pm

◆ Vera List Center for
Art & Politics: Melanie Crean
& Claire Pitcher @ 3-6pm

Nov. 13 @ 5-6pm

◆ Julieta A[]
& gus[]is Mottia
Go[] and

Nov. 14

◆ Mark Be[]
& Nathanie[]
"Cockadood[]
On Humor[]

Nov. 15

◆ Abbas Akhava[]
Al Qadiri & Kh[]
Gharballi & Y[]
Artist Talk[]

Nov. 16

◆ Michael P[]
Permutatio[]
@ 3-4[]

◆ Dennis []
"Compr[]
film []
C[]

THE PERFORMA INSTITUTE

Since its inception, Performa's comprehensive vision for setting the medium of performance in an art historical context has not only entailed commissions and presentations, but has also demonstrated a strong commitment to offering performance education and history, cultivating a consortium of educational institutions since 2004. Performa has been spearheading this integration of education in the field of contemporary art, not limited to performance onstage, but in the classroom as well.

The seeds of Performa's educational programming were planted with Performa 05, aligning itself with New York University's Steinhardt School of Culture, Education and Humanities for the Not for Sale series in 2004; then partnering with the School of Visual Arts for Writing Live: Writers Hub in 2007; later fostering partnerships with Cooper Union, Columbia University, Hunter College, and Parsons The New School for Design, presenting projects live or in the form of film screenings, seminars, or Web productions. With each edition, Performa has been strengthened by the participation of schools, artists, and scholars, creating a site for reception, learning, and contemplation. Each edition has also exponentially increased the amount of inspiration the biennial can offer, both to the art and academic worlds.

Artist Classes at the Performa Institute, clockwise from top left: Performa Curator Mark Beasley with artist Nathaniel Mellors, a view of the audience, Michael Portnoy, Mika Rottenberg and Jon Kessler, and Ragnar Kjartansson. Photos by Paula Court.

With Performa 11, the Performa Institute was established, providing a class schedule packed with opportunities for examination and experimentation for the duration of the biennial. Situated in the Performa Hub, a former elementary school in Nolita, downtown New York, the Performa Institute managed to create a dynamic space for the presentation and exploration of ideas inherent to the biennial, as Performa 11 artists, curators, and writers functioned as most-inspired educators across disciplines, offering insight into exhibition-making, historical research, and visions for the future of art and ideas in New York City and around the world.

The motivation to forge a new intellectual culture around contemporary performance was highlighted especially with master classes led by Commission artists Ragnar Kjartansson and *Bliss* orchestra conductor Davíd fiór Jónsson, who came in equipped with guitars and sang about forgiveness through Mozart and Madonna; or Elmgreen & Dragset, who gave us backstage access to their theatrical production, *Happy Days in the Art World*; as well as Mika Rottenberg and Jon Kessler, who took us through their chakra-based logic systems and research in the mist of South Africa for the production of *SEVEN*.

Traditional art history came to the fore most when looking at the historical anchors of Performa 11. Russian Constructivism was the highlight, with Alexandra Obukhova's class "Action vs. Performance: A short history of Moscow performances, 1970–2000s," in reference to the exhibition "33 Fragments of Russian Performance," which was installed one floor above at the Hub; so was Fluxus with curator Liutauras Psibilskis leading a conversation with Michael David Quattlebaum Jr. (Mykki Blanco) and Sissel Kardel on blindness and Ginger Island, based on Fluxus artist George Maciunas's plans in the late 1960s to convert an uninhabited island in the Caribbean into a Fluxus artist colony. He planned to buy the island and parcel squares of land to Fluxus artists; Maciunas prepared for this by producing an urban-development sketch strangely reminiscent of the Manhattan grid, composed of numbered plots of land.

A special screening of *Compression Fern* (1970) from *Tooth and Nail: Film and Video 1970–1974* by the late Dennis Oppen-

Views of the Performa Hub, designed by nOffice. Photos by Ken Goebel.

heim turned into a proposed curriculum on contemporary art and performance in the form of three conversational seminars centered in the artist's practice and the art of survival, each session bringing distinct vantage points to the discussion of his lifelong interrogation of the idea of performance and body projects.

Artist Antonio Manuel led a conversation about the conceptual Brazilian art scene with Claudia Calirman and Gabriela Rangel, curators of his first solo exhibition in the U.S., "I Want to Act, Not Represent!," on view at the Americas Society at the time. The class revealed the intimate relationships between friends and fellow artists Rogério Duarte, Hélio Oiticica, Lygia Pape, Luiz Carlos Saldanha, and Caetano Veloso. In 2012, the symposium "Portrait of the Artist: Lorraine O'Grady" examined the remarkable work and life of artist Lorraine O'Grady in the context of feminism, politics, and art of the 1980s and today.

As artists explored historical and research themes, such as "Talking About Sculpture," Serkan Ozkaya proceeded with explaining Speech Acts and 3D modeling in his class, taking inspiration from philosopher J. L. Austin's *How to Do Things With Words* and the three-dimensional modeling of Michelangelo's *David*. Ozkaya's talk examined the ways in which language replaces the world, and representation replaces the object. Liz Glynn explored the relationship between human scale and iconic monumental form, the messiness of collective negotiation, and the tensions and desires around structural perfection and monumentality. Raphaël Zarka, whose installation *Free Ride*, the world's first cycloid skateboard ramp, was a stone's throw away from the classroom where his class was held as it was situated in the courtyard of the Hub, talked at length about the geometry of skateboarding and its relation to modern sculpture.

Exploring fertile directions for the art world, Michael Portnoy set up a Permutation Riff Tank, leading participants in a bit of "conceptual horticulture," identifying trends and developing new breeds of practice from the seeds of works presented in Performa 11. Not unlike Portnoy but demonstrative of digital tooling, Burak Arikan led a workshop focused

on the design of large-scale networks as a creative activity, and expanding the individual's thinking about the network as a creative medium.

As part of the program surrounding the publication of *Broken English*, Julieta Aranda and Carlos Motta explored performative and technological strategies of facilitating speech in groups that are affected by political transformation or upheaval, investigating how issues of identity and power can be communicated as a form of text, through gesture, and through socially based technical frameworks in a form of collective action. "Thank You and Good-Bye," a public discussion with Julieta Aranda, Carlos Motta, and guests Naeem Mohaiemen, Adam Kleinman, and this writer used *Broken English* as a point of departure to shift the focus from Constructivism as a movement in art and design to constructivism as a sociological theory of knowledge focused on group interactions.

On the linguistic front, Nathaniel Mellors and Mark Beasley's class "Cockadoodledon't!!!: On Humor and Language" discussed the serious nonsense and surreal side of humor and language, from vaudeville, Samuel Beckett, and Monty Python to the absurdist scripts and psychedelic theater of Mellors's works *Giantbum* and *Ourhouse*. On the conceptual front, ArteEast presented Middle Eastern artists Abbas Akhavan, Fatima Al Qadiri, and Khalid al Gharaballi, and Youmna Chlala in their "Anti-Artist Talk Series," curated by Barrak Alzaid, Artistic Director of ArteEast. These artists explored themes tangential to their own work in an attempt to dismantle the predominance and formulaic structure of the conventional artist talk.

Ben Kinmont and cultural anthropologist Laurel George presented "Ethical Considerations in Project Art Practices," considering interactional art practices outside of institutional space, a mode in which Kinmont has been working for the past two decades; while Liam Gillick and Anton Vidokle shared their film *A Guiding Light (Part II)*. Gillick and Vidokle reframed the piece by creating a "behind-the-scenes" conversation that was part screening, part sincere critique, and part promotional staging for the film.

—*Defne Ayas*

8 41

ARCHITECTURE SUB-COMMITTEE OF ARTS + CULTURE AT OCCUPY WALL STREET

1—Nader Khalili (2008), Sandbags, California
2—Gaia (2010), Wearable, Toronto
3—Yona Friedman (1960 + 1994), Continent-City Europe
4—A. Conglomerate (2011), Streetwearable, New York

JULIETA ARANDA & CARLOS MOTTA

Broken English

PERFORMA HUB, PUBLICATION / CURATED BY DEFNE AYAS

As with each biennial, Performa produced a newspaper publication, commissioning artists to provide their own interpretation of delivering news. For artists Julieta Aranda and Carlos Motta, both known for their prolific discursive and editorial work, *Broken English* responded to the theme of Constructivism as an art and design movement and a platform for artist activism, at a pivotal moment in the generalized climate of protest represented by Occupy Wall Street. They produced a hand-crafted forty-eight-page newsprint publication that brought together a selection of historical critical writing, commissioned essays, and visual contributions by twenty-five artists, collectives, and writers, who reflected on the notion of "city" as cross-cultural terrain, illustrating the complexity of this malleable urban field of possibilities.

The result was a tabloidlike publication whose title refers to the elasticity that exists in public space when negotiating urban exchanges, and specifically "broken English"—both a pejorative term for a limited register of English used by a non-native speaker, which may be fragmented, incomplete, or marked by faulty syntax, as well as inappropriate diction, a language that is ubiquitously used, constantly repurposed, and forced to function.

With articles such as "The Picture of Homelessness" by Martha Rosler, Anton Vidokle on Andrei Platanov's 1929–30 Constructionist novel *The Foundation Pit*, and other highlights such as Jeff Weintraub's "Jewish Christmas: The Chinese Connection," and a reprint of Julio Camba's "La ciudad automatica" (1932), among other historical texts, the list of contributors included Julieta Aranda, Joey Arias/Carlos Motta, Defne Ayas, Michael Baers, Sarnath Banerjee, Andy Bichlbaum, Julio Camba, Asli Çavuşoğlu, Carolina Caycedo, Samuel R. Delany, Jimmie Durham, Liam Gillick, Ashley Hunt, Adam Kleinman, Runo Lagomarsino, Yates McKee, Naeem Mohaiemen/Visible Collective, Shirin Neshat and RoseLee Goldberg, the Occupy Wall Street Architecture Committee, Raqs Media Collective, Martha Rosler, Kim Turcot DiFruscia and Elizabeth Povinelli, Anton Vidokle and Andrei Monastyrski, Jeff Weintraub, and Carla Zaccagnini.

—*Defne Ayas*

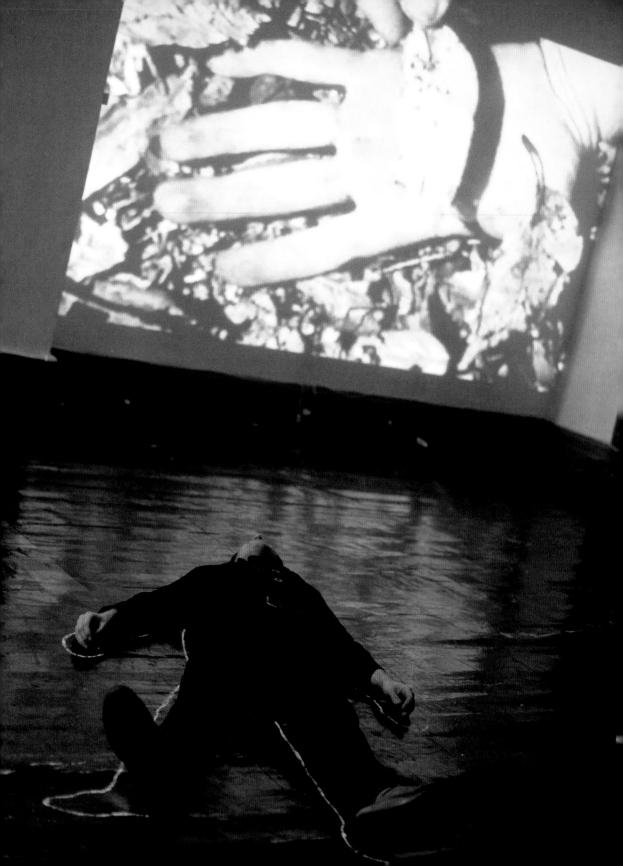

DENNIS OPPENHEIM

PROPOSED CURRICULUM ON CONTEMPORARY ART AND PERFORMANCE

PERFORMA HUB

Much admired and a beloved figure in the New York art world, Dennis Oppenheim passed away from cancer in January 2011. A true friend to arts organizations across the city, including Performa, we paid tribute to Dennis's contribution to performance history, with special attention to his early video works.

Historian and poet Thomas McEvilly participated in *PROPOSED CURRICULUM*, one of his last public events before his passing in March 2013. These pages are a tribute to both.

Dennis Oppenheim and the art of survival, Day 16 and 17

An evening screening of works and an action, followed by a daylong series of provisional seminars

Presented by Slought Foundation and Dennis Oppenheim Estate

Overview
"In some way our individual objectives gave way to a union of investigation, our work became an instrument to combat what seemed to be happening to us. The 80s bred 'the art of survival.'"—Dennis Oppenheim, *Lecture #1, 1976*

The proposed curriculum was developed in response to particular works by the artist that in and of themselves have a performative dimension. It is focused on the artist's lifelong interrogation and redefinition of the idea of performance as expressed through the frequent use of surrogate performers. Friends, colleagues, and cultural practitioners will engage in facilitated conversations, and will each bring distinct vantage points to the discussion of the artist's work and practice. Suggested areas for conversation include current art world conditions, the relationship between collaboration and survival, surrogate performance, and the semiotics of radicality. Seating and choreography will upset the conventional pedagogical dependence on a podium or stage. Successful completion of the proposed curriculum will symbolically

Dennis Oppenheim, PROPOSED CURRICULUM ON CONTEMPORARY ART AND PERFOR-MANCE: "Dennis Oppenheim and the Art of Survival," *Slought Foundation and Oppenheim Studio, 2011. Three-channel video installation paired with a restaging by Maja Rajenovich in collaboration with Amy Oppenheim. Screening and action. Photo by Paula Court.*

Proposed curriculum on contemporary art and performance: Dennis Oppenheim and the art of survival, Day 16
Compression-Fern (Hand), 1970, 5:38 min
Compression-Fern (Face), 1970, 5:13 min
Leafed hand, 1970, 3:35 min
Tooth and Nail: Film and Video 1970-74, 111 min.

Compression Attempt

Leafed body

Organic Matter

Dennis Oppenheim, floor plan for Compression Fern, *1970. Screening and action, 2011.*

"*Instead of grabbing clay, you grab your stomach. For the first time, instead of imposing form manually, you are feeling what it is like to be made. You might have felt your hands picking up a piece of wood and stacking it, but you have never felt what the wood felt.*"

-- Dennis Oppenheim

designate each participant as a live surrogate and a newly defined member of the union of investigation.

Dennis Oppenheim and the art of survival, Day 16

Screening and Action

On the left chalkboard, "Proposed curriculum on contemporary art and performance: Dennis Oppenheim and the art of survival, Day 16" is written.

Below that, the featured works are listed: *Compression-Fern (Hand)*, 1970, 5:38 min / *Compression-Fern (Face)*, 1970, 5:13 min / *Leafed hand*, 1970, 3:35 min / *Tooth and Nail: Film and Video 1970–74*, 111 min.

On the right chalkboard is written, "Instead of grabbing clay, you grab your stomach. For the first time, instead of imposing form manually, you are feeling what it is like to be made. You might have felt your hands picking up a piece

of wood and stacking it, but you have never felt what the wood felt.—Dennis Oppenheim."

The complete compilation of the artist's films from 1970 to 1974 is shown on a monitor in the private screening room (closet). Two adjacent monitors in the southwest corner of the classroom resemble the artist's use of the split-screen technique, so as to upset the viewer's habitual relationship to the single image and the preciousness of the work.

Three areas of activity in the classroom correspond to organic material, a covered body, and a compression, all developed by artist Maja Rajenovich in response to the selected works. They are facilitated practices involved with the art of endurance.

The seminar will run for sixty minutes.

Setting and Procedure for "Provisional seminar 517: Dennis Oppenheim, *Lecture #1*, 1976"

Class begins at 1 pm.

On the left chalkboard, "Provisional seminar 517: Dennis Oppenheim, *Lecture #1*, 1976" has been written (Class Monitor). On the right chalkboard, "In some way our individual objectives gave way to a union of investigation, our work became an instrument to combat what seemed to be happening to us. The 80s bred 'the art of survival.'" has been written (Class Monitor).

Forty-eight chairs in four rows of twelve fill the room. The last chair is reserved (Artist Surrogate). In the front of the room is a table with two chairs. In front of the table and facing the chairs is a podium. As people (Students) enter, they are directed (Class Monitor) to stand to the sides of the room and behind the chairs.

Lecture #1 is performed from behind the podium (Artist's Live Surrogate). After the lecture, notebooks and a printed copy of the lecture are placed on the seats (Class Monitor) and people (Students) are invited to take their seats. Meanwhile, the podium is removed and table adjusted (Janitor).

An interrogation begins at the table (Guest Instructor #1 and Commentator). The interrogation centers on the experience of hearing the lecture. The dialogue grows to include different participants (Class Monitor, Artist's Live Surrogate, Students, Janitor, Guest Instructors, Commentator).

At 2:20 pm, the end of the class and the start time of the next class (2:40 pm) is announced (Class Monitor). People (Students) are asked to stack their chairs as they leave the room (Class Monitor). The last chair remains (Artist Surrogate). Setting and Procedure: "Provisional

seminar 294: Dennis Oppenheim, Theme for a Major Hit, 1974"

Class begins at 2:40 pm.

On the left chalkboard "Provisional seminar 294: Dennis Oppenheim, Theme for a Major Hit, 1974" is written (Class Monitor). Also written on the left chalkboard is "It ain't what you make....", and on the right chalkboard "It's what makes you do it" (Guest Instructor).

Only one chair is in the room (Artist Surrogate) and the soundtrack is playing. People (Students) are invited to place a chair randomly in the room and to sit (Class Monitor).

After everyone is seated the sound is lowered slightly (Guest Instructor 2), who then moves freely through the classroom, reading RoseLee Goldberg's authorative account of the work (in *Peformance Art: from Futurism to the Present*, 1979, page 158). Further remarks on the piece with an emphasis on intention and motivation are offered, and lyrics as written on the chalkboard are highlighted (Guest Instructor 2).

People (Students) are invited to reposition their chairs in relation to their identification with one phrase or the other ("what you make" versus "what makes you do it") (Guest Instructor 3). Two long rows preferred, with the exception of the Artist Surrogate which remains

seated in the same position. Discussion follows (Class Monitor, Artist's Live Surrogate, Students, Janitor, Guest Instructors, Commentator).

At 3:40 pm, the volume of the soundtrack is increased (Class Monitor). Collective singing follows (Students). A microphone is passed around for individual articulation of lyrics.

At 4:00 pm, the end of the class and the start time of the next class (4:20 pm) is announced (Class Monitor). People (Students) are asked to stack their chairs as they leave the room (Class Monitor).

Setting and Procedure: "Provisional seminar 301: Dennis Oppenheim, Radicality, 1974"

Class begins at 4:20pm.

On the left chalkboard "Provisional seminar 301: Dennis Oppenheim, Radicality, 1974" has been written (Class Monitor). Chairs have been placed in an amphitheater style of three semicircular rows (Janitor). On the right chalkboard, a photo print of Radicality has been placed (Janitor).

Remarks are made on the idea of radicality in art and life (Guest Instructor 4). Discussion follows (Class Monitor, Artist's Live Surrogate, Students, Janitor, Guest Instructors, Commentator), with a focus on the importance of our indi-

Dennis Oppenheim, PROPOSED CURRICULUM ON CONTEMPORARY ART AND PERFORMANCE: *"Dennis Oppenheim and the Art of Survival," Slought Foundation and Oppenheim Studio, 2011. Three-channel video installation paired with a restaging by Maja Rajenovich in collaboration with Amy Oppenheim. Screening and action. Photo by Paula Court.*

vidual artistic objectives giving way to the union of investigation. This collective union functions as an instrument to combat what seems to be happening to us and thus constitutes an art of survival.

Box of white bow ties is circulated (Artist's Live Surrogate), symbolically designating each participant as a live surrogate and a newly defined member of the union of investigation. The location and time of the first meeting of the union to

be discussed.

School Staff

Class Monitors: Pamela Sharp (1), Amy Oppenheim (2)

Artist Surrogate: Artist Surrogate

Artist's Live Surrogate: Aaron Levy

Janitor: Maja Rajenovich

Guest Instructors: Les Levine (1), Steve Poser (2), Roger Welch (3), Bill Beckley (4)

MALCOLM AWARD

THE MALCOLM McLAREN AWARD

Architect of punk, antifashion designer, musician, manager, filmmaker, sartorialist, storyteller, and unruly artist, Malcolm McLaren avoided simple definition, elegantly side-stepping the grip of the category monster. He simply turned his hand, head, and heart to whatever caught his attention. McLaren understood synthesis, or, to put it another way, a good look combined with great sound combined with youthful energies equaled "a situation." Malcolm's early situation was the Sex Pistols, a social collage of antifashion, working-class kids, and punk rock. It's difficult to overestimate the effect of McLaren and the Pistols; they helped cause a seismic cultural earthquake in British popular history whose force was felt around the world. His antifashion clothing stores on the King's Road, from Let It Rock through Sex to World's End, deserve equal billing alongside such earlier rebellious venues for antisocial gatherings and encounters with the new, as did Gustave Courbet's Pavilion of Realism in

1850s Paris or Andy Warhol's Factory in 1960s New York. His stores were both his canvas and his club. A student of British art schools in the sixties, he mixed the revolutionary tenets of the Situationist International with the burgeoning spirit of punk rock, letting the class consciousness of seventies Britain and its turbulent street culture do the rest.

If McLaren's influence started in London, it soon took root in New York, from his early days managing the New York Dolls (dressing them in Communist-red rubber) to his championing of Afrika Bambaataa, hip-hop, and "all that scratching." New York was a key part of his story, and the place where he spent more and more of his time in the aughts. When this writer invited him to participate in Performa 09, his first proposal was a lecture whose title, "History is For Pissing On," was as willfully confrontational as ever; another was a grand talent show, featuring bands and performers from all corners of the globe, with McLaren acting as judge. "With the

right acts and the right setting this could be big!," he said. "A TV series, HBO…a movie, I know a producer who would get behind it!" But it was not to be. Malcolm McLaren died on April 8, 2010.

The court of Malcolm was never mawkish or sentimental; "nostalgia is dead tissue," he said, which makes memorializing him with an eponymous award both compelling and awkward. Would Malcolm have approved a prize in his name? Yes, maybe…. It's fitting, then, to think of the Malcolm McLaren Award this way: that the whole of Performa, its multitude of performers, curators, producers, and audience are pressed to step up and produce a work that challenges the times in which we live. The ultimate punk takeover: Performa presents *The Malcolm McLaren Talent Show*! He might have gone for that. I can hear him laughing about it, or talking it up, or thinking of ways to turn the idea on its head.

Ragnar Kjartansson received the first Malcolm McLaren Award for his twelve-hour operatic performance *Bliss*, an epic performance that repeated to hypnotic effect the final three-minute aria from Mozart's ecstatic opera *The Marriage of Figaro*, "Contessa Perdono." Selected by judges, historian Claire Bishop, curator Jay Sanders, and McLaren's longtime

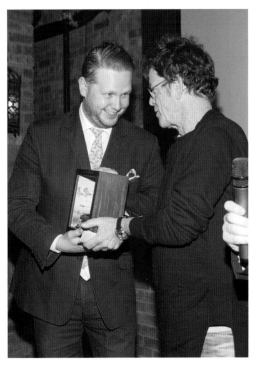

Lou Reed presents The Malcolm Award to Ragnar Kjartansson. Photo by Paula Court.

creative and life partner, Young Kim, the award, a lacquered box containing pebbles from England's River Thames and designed by Marc Newson, was presented by recording artist Lou Reed at a special evening where guests toasted and remembered their great antihero. Invited to pay public tribute were the writers Michael Bracewell and Greil Marcus.

—*Mark Beasley*

Malcolm McLaren, top: photo by David Parkinson. Bottom: photo by Jérôme Schlomoff.

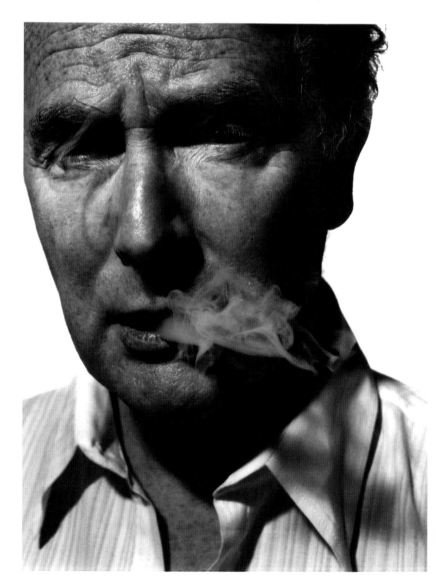

MALCOLM McLAREN

EXCERPTS FROM TRIBUTES BY GREIL MARCUS AND MICHAEL BRACEWELL

THE BOWERY HOTEL

GREIL MARCUS:

Malcolm McLaren was one of the few people I've known who left the world more interesting than he found it. He took nothing at face value.

I think of a moment in his 1991 TV film *The Ghosts of Oxford Street* as a perfect version of rewriting the story, or rewriting history. One of the tales he told was of Gordon Selfridge, the American entrepreneur who came to London and founded the great Oxford Street department store that bore his name—and how, after he'd been forced out of his own creation, for mismanagement, even embezzlement, he wandered the city broke, traveling through London by bus or on foot, standing outside Selfridge's, a bum staring into his own windows. Malcolm put Tom Jones on the screen, dressed him up like a raggedy Gordon Selfridge, and had him sing what, in the context Malcolm made, was the most soulful, heartbreaking, and self-mocking version of "Nobody Knows You When You're Down and Out" anyone has ever heard.

The power of the Sex Pistols' singles— "Anarchy in the U.K.," "God Save the Queen," "Pretty Vacant," "Holidays in the Sun"—came partly out of Malcolm's sense that there was another history hidden inside the history written down in books and newspapers—something louder, more unlikely, more crazy, more desperate, more unsettled—unfinished. And out of that—that conviction that anyone could retell the story he or she had been told all his or her life—came Johnny Rotten's will to rewrite history itself in one poetic flash: "God save history, God save your mad parade."

You can see that mad parade unfold in Malcolm's last great work, the film *Paris:*

Capital of the 21st Century—a trove of advertisements made for French cinemas from the late nineteenth century through the twentieth, all cut up, recombined, repeated, slowed down, made to sing secret songs and perform forbidden dances, turning the long romance of consumer culture into a field of spells cast and spells broken. A commercial for a toilet paper boutique—the original filmmakers want you to buy a new line of perfumed, multicolored toilet paper rolls, so they come up with the idea of a shop that sells nothing else—is turned into a frenzied gavotte of buyers and sellers discovering, indulging, and satisfying every erotic fantasy, fetishizing a thing until they're body-snatched by the product itself. It's a nice little piece as it was originally made—but as Malcolm re-cut it, making every repeated frame and interchange odd, strange, impossible, extending the tale into realms of hilarity and dread until you cannot believe what you're seeing, the actors turn into aliens and modern life feels like a plot foisted on us by visitors from another planet—the planet inside our own.

Nothing was as it seemed, Malcolm said all his life, in all of his work—it's more than it seems. It's scarier. It's funnier. The world is scarier than anyone ever told you, and it can be more fun than you ever dared believe. In every conversation I ever had with him, that belief, the foundation of his art, came out of him with every word, every gesture—his voice going higher as he fluttered his hands in the air.

MICHAEL BRACEWELL:

Malcolm comes from an astonishing lineage of artists from London. He was born in Northeast London in 1946, and the first thing that he ever put his eyes on was ruin. In the few conversations I had with him, he talked endlessly about ruins. He talked about the fact that when he was a young man—when he was a teenager—his first amusement would be to go and look at bombsites.

Malcolm was the ultimate art student. A little while ago, I was in Brian Eno's office in London, going through his notebooks, and I found written on one page the single line "I was a teenage art school." In Malcolm's case this was true, because he attended seven art schools by the time he was twenty-five, and he finally abandoned art education in 1971. Believe it or not, the two most important people, he said, when he was an art student were the visionary Victorian writer John Ruskin, and the visionary poet William Blake. I think that if we look at

William Blake's writings, at his profound Romanticism, which he summarized in the phrase "energy is eternal delight," you get a little premonition of the things that Malcolm was interested in —the idea that in energy, in power and momentum, there is terrific artistic force and terrific joy.

In Ruskin, it's more complicated. Ruskin wrote that all great and beautiful work must come from staring unflinchingly into the darkness. One of Malcolm's great achievements is that he recognized in the mid-1970s that the old idea of modernity had reached critical mass, and was about to start shuddering and implode. In a sense, that was what punk rock was about. That's why the music was either sped up to a ridiculous caricatured speed, or slowed down to an equally ridiculous dirge.

Malcolm believed that a subcultural lifestyle can be the medium with which you make art. Yes, Malcolm will be remembered in many ways for punk rock, for the Sex Pistols, for his idea of cash from chaos, the idea of debris, the idea of ruins. But more importantly he was extending the project that belonged to Marcel Duchamp, that had to do with hilarity, with hoaxing, with skewed personae, with playing games. He'll be

remembered for having shown a generation an art form that was like a mirror. I know so many people whose formative years were defined in London by punk, and each one of them saw their own reflection in the ideas that Malcolm created.

So, for some people, in 1976 and '77, when they looked into punk, they saw class war. Others saw a reclamation of the Dadaist Ballets Russes. Still others saw nothing more than a circus or a pantomime. Malcolm realized that if you treat the debris and detritus of popular culture as a found object, you can indeed—through the alchemy of art—turn it into something quite extraordinary. To take the text that is inside yourself, as Samuel Beckett put it, and translate it into something that everyone can understand. Malcolm achieved that. It was a very rare gift, and he will be greatly, greatly missed.

POSTSCRIPT

Afterword
PERFORMANIA

When Performa comes to town, the city steps up a gear. The collective insanity that accompanies the opening days of a regular art biennial is now sustained for nearly a month, during which time everyone carries on with their usual high-adrenaline, overachieving, head-of-the-rat-race New York selves—but ramps it up a gear by adding the extra pressure of trying to fit in two (or three, four, five) performances a day. Every day. For three weeks.

It's hard to explain, especially to those who come and visit Performa for just a few days, quite what this biennial does to our system. Clearly, sleep is the first thing to go, then regular meals, and as for exercise—well, trips to the gym are replaced by last-minute, sidewalk-pounding sprints from one venue to the next. The mania isn't helped by the fact that Performa tends to spread its umbrella to encompass almost everything to do with performance in the entire city, so that even if you weren't planning to go to an event, you get carried along by the twitch of anxiety that you might just be missing out—and besides, you know someone who's performing, and there might be a party afterward, and you really can't not show up.

Of course, as in any biennial, there are hits and misses—but this is a defining characteristic of contemporary performance. Only a small percentage of works are likely to be great, but you never know which one it will be. It's a form of cultural gambling. Performance is an addiction you have to keep chasing, because when you find a good one, the rush is unforgettable. And when you encounter the less interesting ones . . . well, at least you walk away with a story.

And this, in the end, is what keeps us all coming back for more Performa. Whether we clock-watched or were convinced that the performance we were watching was unmissable, texting our friends to get over here right now, the best part of performance art is the sociability: the communal intensity of going through it all together, in the same space and time. Performa temporarily turns New York into a different type of creative capital—one where art is not stifled by the collecting classes but returned to artists and viewers as the generative force behind an eccentric, heartfelt, irrepressible community of shared experience.

—*Claire Bishop*

ABOUT PERFORMA

Performa, a nonprofit multidisciplinary arts organization established by RoseLee Goldberg in 2004, is dedicated to exploring the critical role of live performance in the history of twentieth-century art and to encouraging new directions in performance for the twenty-first century. In 2005, Performa launched New York's first performance biennial, Performa 05, followed by Performa 07 (2007), Performa 09 (2009), and Performa 11 (2011).

PERFORMA STAFF

RoseLee Goldberg,
Founding Director and Curator
Esa Nickle,
General Manager / Producer
Defne Ayas,
Curator at Large
Mark Beasley,
Curator
Adrienne Edwards,
Associate Curator, Performa Institute
Charles Aubin,
Assistant Curator
Lana Wilson,
Film and Dance Curator
Marc Arthur,
Research and Archives
Luisa Gui,
Development and Special Events

Jessica Massart,
Communications Manager
Jennifer Piejko
Editor, Performa Magazine
Job Piston,
Director's Office, Special Projects
Mike Skinner,
Technical Director, Performa 13
Bret Tonelli,
Production Assistant
Tali Wertheimer,
Membership and Development
Anna Cline, Debbie Huang, Lily Randall, Cara Stewart
Interns

PERFORMA BOARD OF DIRECTORS

Noam Andrews
Laurie Beckelman
Irving Benson
Todd Bishop
Amy Cappellazzo
Wendy Fisher
Stephanie French
Amanda Fuhrman
Emily Glasser
RoseLee Goldberg
Jeanne Greenberg Rohatyn (Chair)
Ronald Guttman
Barbara Hoffman
Aditya Julka
Michael Kantrow
Toby Devan Lewis (Honorary Chair)

Maria Pessino

PERFORMA VISIONARIES STEERING COMMITTEE

Candice Madey (Chair)
Rhiannon Kubicka
Jessica Mitrani
Karen Boyer
Zoe Jackson
Colleen Leth

PERFORMA CURATORIAL ADVISORY BOARD

Marina Abramović
Massimiliano Gioni
Yuko Hasegawa
Jens Hoffmann
Chrissie Isles
Joan Jonas
Lois Keidan
William Kentridge
Joseph V. Melillo
Paul D. Miller
Meredith Monk
Hans Ulrich Obrist
Yoko Ono
Lisa Phillips
Catherine Wood
Octavio Zaya

PERFORMA 11 CREDITS

PERFORMA 11 CONSORTIUM
Abrons Arts Center
Americas Society
Anthology Film Archives
Aperture Foundation
Art in General
Art Since the Summer of '69
ArteEast
The Artist's Institute
Artists Space
Asphalt Green
Austrian Cultural Forum
Bortolami Gallery
Bronx Museum
Calder Foundation
Columbia University
Danspace Project
e-flux
Emily Harvey Foundation
Fales Library & Special Collections,
New York University
Film Society at Lincoln Center
Forever & Today, Inc.
Franklin Furnace
Friends of the High Line
Garage Center for Contemporary
Culture, Moscow
Grey Art Gallery, New York University
Independent Curators International
International Studio & Curatorial
Program
ISSUE Project Room
Japan Society
Joyce Soho
KAFFNY
Kunstverein New York
Leo Koenig Inc.
Location One
Marlborough Chelsea
El Museo del Barrio
Museum of Arts and Design
The Museum of Modern Art
Museum of the Moving Image
National Arts Club
New Museum of Contemporary Art
Nicole Klagsbrun Project Space
PARTICIPANT INC.
The Performing Garage
Recess Activities, Inc.
Rhizome
Scaramouche
School of Visual Arts
SculptureCenter
Sharjah Art Foundation
Storefront for Art and Architecture
Swiss Institute
The Hole
The Kitchen
Third Streaming
Times Square Alliance

The Vera List Center for Art and Politics, The New School
White Box
White Columns
Zabludowicz Collection

PERFORMA 11 CURATORS
Chief Curator:
RoseLee Goldberg
Performa Curators:
Defne Ayas
Mark Beasley
Esa Nickle
Dougal Phillips
Lana Wilson
Yulia Aksenova
Melanie Crean
Cecilia Alemani
Yona Backer
Sarina Basta
Sergio Bessa
Stefania Bortolami
Sabine Breitwieser
Victoria Brooks
Claudia Calirman
Gary Carrion-Murayari
Mary Ceruti
Ingrid Chu
Kari Conte
Lauren Cornell
Dean Daderko
Stacy Engman
David Everitt Howe
Courtenay Finn
Scott Foundas
Kate Fowle
Eva Franch i Gilabert
Lia Gangitano
Eric Gleason
Savannah Gorton
Kathy Grayson
Boris Groys
Anthony Huberman
Judy Hussie-Taylor
Gianni Jetzer
Eungie Joo
Alhena Katsof
Carin Kuoni
Fionn Meade
Hanne Mugaas
Liutauras Psibilskis
Juan Puntes
Davide Quadrio
Gabriela Rangel
Silvia Sgualdini
Danya Sherman
Yoko Shioya
Andreas Stadler
Allison Weisberg
Glenn Weiss

Martha Wilson
Jake Yuzna

PERFORMA 11 SUPPORT
Lead support has been provided by Toby Devan Lewis; Lambent Foundation Fund of Tides Foundation; and The Andy Warhol Foundation for the Visual Arts. Major support has been provided by Sharjah Art Foundation; National Endowment for the Arts; The David and Elaine Potter Foundation; Christie's; Imagine Ireland; Paddle8; Outset Contemporary Art Fund; and The Brown Foundation, Inc., of Houston. Additional support has been provided by Depart Foundation for the Discussion, Exhibition, and Production of Art; Royal Norwegian Consulate General in New York; The Cultural Services of the French Embassy/Maison Francaise and Institut Francais; New York City Department of Cultural Affairs; New York State Council on the Arts; Consulate General of Denmark in New York; Etant Donnés Contemporary Art; FUSED: French U.S. Exchange in Dance, a program of the National Dance Project/New England Foundation for the Arts and the Cultural Services of the French Embassy in New York, and FACE (French American Cultural Exchange), with lead funding from Doris Duke Charitable Foundation and the Florence Gould Foundation; The Dedalus Foundation; The Gilbert MacKay Foundation; Office for Contemporary Art Norway; Danish Arts Council Committee for International Visual Arts; Arts Council Norway; SAHA–Contemporary Art Initiative; Toshiba; Dorothea Leonhardt Fund, Communities Foundation of Texas; Foundation for Contemporary Arts; Mondriaan Foundation, Amsterdam; Office of Cultural Affairs, Consulate General of Israel in NY; Artis – Contemporary Israeli Art Fund; The American-Scandinavian Foundation; Helena Rubinstein Foundation; Moon and Stars Project of The American Turkish Society; the Performa Board of Directors; the Performa Producers Circle; the Performa Curators Circle; and the Performa Visionaries.

PERFORMA 11 PATRONS
Sheikha Hoor Al-Qasimi
Julie Blakeslee and John Spong
Toby Devan Lewis

Wendy Fisher
Amanda and Glenn Fuhrman
Jeanne Greenberg Rohatyn and
Nicholas Rohatyn
Amy and Ronald Guttman

PERFORMA PRODUCERS CIRCLE
Shelley Fox Aarons and Phil Aarons
Mimi Brown and Alp Ercil
David Campbell
Carla Chamas and Judi Roaman
Olivia Douglas
Gladstone Gallery
Agnes Gund
i8 Gallery
Maurice Kanbar
Lisson Gallery
Luhring Augustine
Massimo De Carlo Gallery
Julie Mehrutu
Victoria Miro
Nicolai Wallner Galleri
Nicole Klagsbrun Gallery
Emmanuel Perrotin
Rivka Sakar
Laura Skoler
Shelley and David Sonnenberg
Christine Stanton and Mitch Wasterlain
David Teiger

PERFORMA CURATORS CIRCLE
Joanne Cassullo
Frances Kazan
Maria Pessino
Kate Robinson
Jeremy E. Steinke
Lisa Ungar
Esther Kim Varet and Joseph Varet
Jane Wesman and Don Savelson

IN-KIND SPONSORS
Tekserve
Center548
JBL by Harman
ARUP
Icelandair
Tanteo Tequilas
NIROX Foundation
Saatchi & Saatchi
Artlog

PERFORMA 11 STAFF
RoseLee Goldberg, *Founding Director
and Curator*
Esa Nickle, *General Manager / Producer*
Defne Ayas, *Curator*
Mark Beasley, *Curator*
Dougal Phillips, *Curatorial Manager*
Lana Wilson, *Publications Manager and
Film Curator*

Ashley Tickle, *Press and Marketing
Manager*
Shelley Gross, *Assistant to the Director /
Special Events*
Adrienne Edwards, *Strategic Develop-
ment*
Mike Skinner, *Production Manager,
ARUP*
Lillie DeArmon, *Production Manager*
Anthony Elms, *Associate Producer*
Tyler Myers, *Associate Producer*
Austin Shull, *Associate Producer*
Jennifer Piejko, *Assistant to the Producer*
Leonor Torres, *Production Assistant*
Kay Ottinger, *Production Assistant*
Hyatt Mannix, *Press and Marketing
Assistant*
Yasha Wallin, *Web Editor*
Sara Campot, *Press and Archival Intern*
Chloe Rossetti, *Marketing Assistant*
Livia Carpeggiani, *Development As-
sistant*
Sarah Stout, *Development Assistant*
Job Piston, *Assistant to the Director*
Loren Mullins, *Director's Office /
Special Events*
Marc Arthur, *Front of House Manager*
Alexandra Delage, *Production Assistant*
Clara Touboul, *Intern*
Rebecca Schwebel, *Intern*

PERFORMA ARCHIVAL
PHOTOGRAPHY
Paula Court

PHOTOGRAPHY
Elizabeth Proitsis

PERFORMA TV
Pierce Jackson

VIDEOGRAPHY
Georg Scherlin

PERFORMA DESIGN DIRECTION
AND PRINT
APFEL (A Practice for Everyday Life)

PERFORMA WEBSITE
Perry Garvin Studio

PERFORMA MEDIA RELATIONS
Fitz & Co.

PERFORMA COMMISSION CREDITS
Performa Commissions were sup-
ported by Toby Devan Lewis, The Andy
Warhol Foundation for the Visual Arts,

Lambent Foundation Fund of Tides
Foundation, National Endowment for
the Arts, and The Dedalus Foundation.

Tarek Atoui's *Visiting Tarab,* a Performa
11 Commission, with the Sharjah Art
Foundation, was supported by the
Sharjah Art Foundation, Performa
Producers Circle members Carla
Chamas and Judi Roaman, and by
Nayla Hadchiti and Hutham Olayan.
Featuring musicians and sound artists
Anti-Pop Consortium, Uriel Barthe-
lemi, Jonathan Butcher, Mira Calix,
DJ Spooky, Lukas Ligeti, Robert Lowe,
Raz Mesinai, Zeena Parkins, Ikue Mori,
Sara Parkins, Elliott Sharp, Zafer Tawil,
and George Ziadeh.

iona rozeal brown's *battle of yestermore,*
a Performa Commission, was sup-
ported by Salon 94 and Performa
Producers Circle members Edward
Tyler Nahem and Christine Stanton
and Mitch Wasterlain. Additional con-
tributions from Elizabeth Dee Gallery,
Sara Fitzmaurice, Amanda and Glenn
Fuhrman, Paula Hayes, Venetia Kaper-
nekas, James Cohan Gallery, Nicole
Klagsbrun, Krink, Eric Lane, Candice
Madey, Allen Moore, Nadine Peyser,
Barry Rosen, Beth Rudin DeWoody,
Cassie Rosenthal, and Rivka Saker.
Music composed by iona rozeal brown.
Cast: Benny Ninja as EIN; Javier Ninja
as KAE; Attendants: Rockafella, G.I.
Jane, and Beasty; and the Demon:
MonaLisa, SnowBunny, and Lady
Beast. Cinematographic advisor: Mon-
stah. Sound Designer: Keith Obadike.
Text: Mendi Obadike. Costume styling:
Brent Barkhaus. Lighting Designer:
Eugene Tsai.

Gerard Byrne's *In Repertory* was sup-
ported by Imagine Ireland.

Elmgreen & Dragset's *Happy Days in
the Art World,* a Performa Commission,
was co-commissioned by the Royal
Danish Theater, Denmark and the
Bergen International Festival, Norway.
Co-presented by Skirball Center for the
Performing Arts. Supported by Toby
Devan Lewis, Outset Contemporary
Fund, Royal Norwegian Consul-
ate General in New York, Consulate
General of Denmark in New York,
Office for Contemporary Art Norway,
Danish Arts Council Committee for

International Visual Arts, Arts Council Norway, The American-Scandinavian Foundation, and Producers Circle members Victoria Miro, Emmanuel Perrotin, Galleri Nicolai Wallner, Massimo De Carlo, The Andy Warhol Foundation for the Visual Arts, National Endowment for the Arts, and The Dedalus Foundation. Cast: Joseph Fiennes as ID, Charles Edwards as ME, and Kim Criswell as BI. Directed by Toby Frow. Script: Elmgreen & Dragset. Script Advisor & additional material: Tim Etchells. Set and costume: Elmgreen & Dragset. Original lighting design: Nigel Edwards. Lighting design (New York): Sarah Brown. Sound Designer: John Avery. Wardrobe Supervisor: Anna Josephs. Wardrobe Assistant: Laura Flannery. Music arrangement and recording: David Motion. Company Stage Manager: Veronica Berg. Production Manager: Hester Chillingworth. Fight Director: Malcolm Ranson. Casting Director: Joyce Nettles. Special thanks to Aileen Corkery and Adam Clayton (U2), Blue Mountain Music (UK) and Universal (worldwide) for music rights to "One" by U2; flying by Foy; and Erin Manns, Victoria Miro Gallery.

Simon Fujiwara's The Boy Who Cried Wolf, a Performa 11 Commission with HAU, Berlin and The San Francisco Museum of Modern Art (SFMOMA) was supported by Performa Producers Circle members Shelley Fox Aarons and Phil Aarons and Curators Circle member Jeremy E. Steinke. Cast: Phineas Pett, Isaac Jin Solstein, and Thomas Holzhausen.

Jon Kessler and Mika Rottenberg's SEVEN, a Performa 11 Commission was supported by Performa Producers Circle member Salon 94, Nicole Klagsbrun Gallery, NIROX Foundation, and Office of Cultural Affairs, Consulate General of Israel in New York. Additional support by Rebekah Bowling, Melva Bucksbaum and Raymond Learsy, Beth Rudin DeWoody, Suzanne Morsfield, and Third Streaming. Produced with the cooperation of the Government of Botswana. Cinematography: Mahyad Tousi. Technical Consultant: Steve Hamilton. Special effects: Alex Lemke. 2D Animation: Erik Mitgartz. 3D Animation: Mickey Roth. Sound Designer: Nati Taub. Recording Mixer: Ronen Nagel. Camera Assistant: Richard Uren, AfriScreen Films. Performers: Empress Asia, Marshall Factora, Esteban Jefferson, Jason Liles, Chris McGinn, Cecil Parker, Sunita Sharma, Juan Valanzuela, and Alex Wynne.

Ragnar Kjartansson's Bliss, a Performa 11 Commission, was supported by Luhring Augustine, i8 Gallery, and Performa Producers Circle members Jane Wesman and Don Savelson. Cast: Kriistján Jóhannson as Conte, Kristján Ingi Jóhannson as Figaro, Jóhanna V. Þórhallsdóttir as Marcelina, Unnur H. Möller as Cherubino, Erla Björg Káradóttir as Barbarina, Rósalind Gísladóttir as Contessa, Hörn Hrafnsdóttir as Susanna, Aðalsteinn Már Ólafsson as Bartolo, Gunnar Björn Jónsson, and Ragnar Kjartansson. Conductor: Davíð Þór Jónsson. Musicians: Viola: Nadia Sirota, Violin: Michi Wiancko, Violin: Caroline Shaw, Violin: Emily Ondracek, Violin: Caleb Burhans, Violin: Keats Dieffenbach, Violin: Courtney Orlando, Viola: John Pickford Richards, Cello: Clarice Jensen, Bass: Doug Balliet, Flute: Alex Sopp, Oboe: Arthur Sato, Bassoon: Rebekah Heller, Flugelhorn: Mike Gurfield. Makeup and aesthetics: Dick Page. Wigs: Hrafnhildur Arnardottir. Lighting Design: Eugene Tsai. Food design: Marianne Vitale. Costumes: Asdis Gudny Gudmundsdottir. Stage painters: Ragnar Kjartansson and Alterazione Video. Musical Coordinator: Nadia Sirota.

Liz Magic Laser's I Feel Your Pain, a Performa 11 Commission, was co-presented by the School of Visual Arts' Visual and Critical Studies and BFA Fine Arts Departments. Supported by Performa Curators Circle members Joanne Cassullo/Dorothea Leonhardt Fund and Esther Kim Varet and Joseph Varet. Special thanks to Tom Huhn, Suzanne Anker, Hong-An Truong, Dafna Maimon, Anthony Gedrich, Jonathan Wendt, and the SVA Theatre. Cast: Lynn Berg, Audrey Crabtree, Ray Field, Annie Fox, Kathryn Grody, Rafael Jordan, Liz Micek, and Ryan Shams. Video made with Polemic Media. Produced by David Guinan. Cinematography: Alex Hadjiloukas, Matthew Nauser, and Collin Kornfeind (Polemic Media). Production Manager: Brandon Polanco. Techinical Director: Will Chu. Sound Mixer: Tristan Shepherd. Video Technician: Irwin Seow. Production Assistants: Lucia Hinojosa and Jamie Kelly. Still Photographer: Yola Monakhov. Costume styling: Felicia Garcia-Rivera. Makeup: Danielle Klatsky. Editorial contributions by Scott Indrisek, Wendy Osserman, Jess Wilcox, and Tom Williams.

Guy Maddin's Tales from the Gimli Hospital: Reframed. a Performa 11 Commission with National Arts Centre of Canada Prairie Scene, was co-presented by the Film Society of Lincoln Center. Supported by Performa Producers Circle members Ronald and Amy Guttman and Maurice Kanbar, and Andrea Krantz. Production support provided by the Experimental Media and Performing Arts Center (EMPAC). Special thanks to Ronald and Amy Guttman; Maurice Kanbar; John Roche; Heather Moore, National Arts Centre Prairie Scene; Kathleen Ford, EMPAC; Nancy Gerstman and Emily Russo, Zeitgeist Films; Monica Lowe, Winnipeg Film Group; Scott Foundas, Glenn Raucher, and Don Schul, Film Society of Lincoln Center; Hildur Ársælsdóttir; Dan Bora; Christian Rutledge; and Christophe Landon. Directed by Guy Maddin. Score composed by William Satake Blauvelt, Borgar Magnason, Dean Moore, Matthew Patton, Naho Shioya, Maria Huld Markan Sigfúsdóttir, Gyda Valtýsdóttir, and Kristín Anna Valtýsdóttir (formerly of múm, and also known as Kria Brekkan). Performed by Kristín Anna Valtýsdóttir, string and vocals score by Icelandic musicians Gyda Valtýsdóttir (cello), Borgar Magnason (double bass), and Maria Huld Markan Sigfúsdóttir (violin). Sound effects plus additional musical atmosphere created by the Aono Jikken Ensemble (William Satake Blauvelt, Dean Moore, and Naho Shioya). Narrated by Kristín Anna Valtýsdóttir. Live electronics: Paul Corley. Music Consultant: Matthew Patton. Audio Technician: Steve McLaughlin. Additional editing: Jaimz Asmundson.

Laurel Nakadate and James Franco's Three Performances in Search of Tennessee, a Performa 11 Commission, was supported and co-commissioned by Paddle8. Produced by John Morrow. Music by Rick Moody. Lighting

by Eugene Tsai. Special thanks to Miles Levy, Vince Jolivette, Leslie Tonkonow Art Works + Projects, Klaus Biesenbach, Anna Kooris, Iris Torres, Ronni Minnis, Dylan Goodwin, Bruce Thierry Cheung, Alexandra Slattery, Sarah Hindsgaul, Nina Ljeti, Lauren Sharpe, Lizzie Gorfaine, David Rysdahl, Adam Fleming, Matthew Faber, Kalup Linzy, Ryan McNamara, Brad Lohrenz, Betsy Cohen, Daniel Kennedy, Prairie Glass Works, Samuel French, Inc., Abrons Arts Center, MoMA PS1, Gucci…and Tennessee Williams.

Shirin Neshat's *OverRuled,* a Performa 11 Commission, was co-produced by Change Performing Arts. Supported by Performa Producers Circle members Olivia Douglas, the Farouki Family, Gladstone Gallery, and Curators Circle member Frances Kazan. Special thanks to Mahdis Keshavarz, Fahimeh Gooran, Nariman Hamed, Lanna Joffery, Kaufman's Army Navy, and Charta Art Books. Created in part at the Watermill Center. Directed by Shirin Neshat. Playwrights: Shoja Azari and Behrang Azari. Music by Mohsen Namjoo. Production design by Shahram Karimi. Lighting design by AJ Weissbard. Cast: Mohammed Ghaffari as Judge, Sherief Elkatsha and Rodin Hamidi as Confidants; Mohsen Namjoo, Kambiz Hosseini, Shadi Yousefian, and Lanna Joffery as Defendants; Ehab Ammar, Tarek Aylouch, Arian Azarmgin, Miro Caltagirone, Neimah Djourabchi, Ash Maxime Goldeh, Abraham MaKany, Aein Mradi, Colin Mulligan, Sina Nayeri, Hassan Nazari-Robati, and Adam Shiri as Officials; Ardavan Arfaei, Ali Baba Attaie, Amine Benfradj, Adham Elkady, Ahmed Farid, Aden Hakimi, Pourang JahanShahi, Jonathan Hooks, Ahmad Ibrahim, Ariel Jara, Lucas Leto, Essam Mohammed, Azim Moollan, Ali Nazemian, Andrew Pistella, Kamran Rahmani, Farshad Rostambek, Kamrouz Saifi, Sadra Shahab, and Ali Sharma as Military. Musicians: Yhaya Alkhansa, Behrang Azari, Salmak Khaledi, James Riotto, and Robert Shelton. Stage Manager: Nicole Green. Costume design: Natasha Noorvash. Art direction: John Bonafede. Hair and makeup: Mina Ghoraishi.

Frances Stark's *Put a Song in Your Thing*, a Performa 11 Commission, was supported by the Performa Visionaries and Performa Curators Circle member Kate Robinson. Special thanks to Gavin Brown, Bridget Donahue, Stuart Bailey, James Mullord, Hudson Lines, David Gunian, and the Abrons Arts Center. Featuring dancer, DJ, and Major Lazer "Hype Man" Skerrit Bwoy and artist Mark Leckey's *BigBoxSoftSculptureTelephoneAction.* Movers: Natasha Thomas and Rachel Richman. Photographer: Nadya Wasylko. Mise-en-scène: Kameron Steele. Lighting: Eugene Tsai. Hair: Peter Matteliano. Makeup: Aki Maekubo. Music: "Das Echo," Haydn; "March of the Big White Barbarians," donAtelier; "Don Giovani," Mozart; "Pon De Floor," Major Lazer; "Duckrog," Von Südenfed; "Piano Improv," (anon) AKA the laziest man you'll ever meet from *My Best Thing;* "Backwards Telephone," Frances Stark; "Telephone," Lady Gaga featuring Beyoncé; and "Hundred Stab," Aidiona.

Ming Wong's *Persona Performa*, a Performa 11 Commission, co-commissioned by Vitamin Creative Space, Guangzhou, China, and co-presented with the Museum of the Moving Image, was supported by Performa Producers Circle members Mimi Brown and Alp Ercil. Developed during a residency by Wong at Museum of the Moving Image. Cast: Monique Andress, Loganne Bond, Tony Carlson, Irene Hsi, Shang-ho Huang, Serena Kadyena-Beny, Bushra Laskar, Andy Miyamotto, Maarouf Naboulsi, Sari Nordman, Josh Palmer, Carolina Rivera, Laura Riveros, Letha Rose, Patrick Scheid, Susie Simpson, Lauren Ashlee Small, Katharina Stenbeck, Tatiana Suarez-Pico, Meridith Leigh Szalay, Savina Theodorou, and Nodoka Yoshida. Directed by Ming Wong. Stage Manager: Donald Butchko. Costumes: Vitor Ramalhão. Technical Director/Videographer: Carlos Vasquez. Assistant Videographer: Lorena Kraus. Assistant Director: Elena Hecht. Lighting: Natalie Robin. Sound: Nathan Wheeler.

PERFORMA PREMIERE CREDITS
Robert Ashley's *That Morning Thing* was a Performa 11 Premiere co-presented with the Kitchen. Produced by Performing Artservices, Inc. and Performa 11.

Boris Charmatz's *Musée de la Danse:*

Expo Zéro was a Performa 11 Premiere supported by FUSED: French U.S. Exchange in Dance, a program of the National Dance Project/New England Foundation for the Arts and the Cultural Services of the French Embassy in New York, and FACE (French American Cultural Exchange), with lead funding from Doris Duke Charitable Foundation and the Florence Gould Foundation. Participants: Alex Baczynski-Jenkins (dancer/choreographer), Eleanor Bauer (dancer/choreographer), Heman Chong (visual artist/curator), Jim Fletcher (actor), Lenio Kaklea (dancer/choreographer), Jan Liesegang (architect), Valda Setterfield (dancer/actress), Marcus Steinweg (philosopher), and Fadi Toufiq (writer/artist).

Ben Kinmont's *An Exhibition in Your Mouth* was a Performa 11 Premiere made possible with special thanks to the restaurant Isa and Ignacio Mattos and Taavo Somer. Organized by Kunstverein NY for Performa 11, with the exhibition "Prospectus: New York" at the Fales Library, New York.

Mai-Thu Perret's *Love Letters in Ancient Brick* was a Performa 11 Premiere supported by Pro Helvetia; Swiss Arts Council, Geneva City; Fonds Municipal d'Art Contemporain (FMAC), Geneva State; Department of Education, Schweizerische Interpretenstiftung (SIS); and David Kordansky Gallery. Co-produced by Association Feu Pâle, Geneva and Swiss Institute, New York. Presented by Performa and Swiss Institute with J Performances. Featuring singer-narrator Tamar Barnett-Herrin and musician Vincent de Rouuin. Costumes: Ligia Dias.

THE RED PARTY
The Red Party took place at SIR Stage37 on November 6, 2010. Event co-Chairs: RoseLee Goldberg and Jeanne Greenberg Rohatyn. Honorary co-Chairs: Yoko Ono, Toby Devan Lewis, Cindy Sherman, and Maria Baibakova. Master of Ceremonies: Alan Cumming. Performers: Dancers Pat Catterson, Patricia Hoffbauer, Yvonne Rainer, Keith Sabado, and Sally Silvers performed excerpts of Yvonne Rainer's *Assisted Living: Good Sports 2;* Barbara Sukowa, Robert Longo, Jon Kessler, and Mike Skinner; DJ Tikka Masala; DJ Pierce Jackson. *Padded Cell* installa-

tion by Jennifer Rubell. Banners by Kyle Goen. Hats and "quickie couture" by Karelle Levy (KRELwear). Set by Zach Rockhill. Food by bite. Wine by Wines of Chile. Lighting and sound: SIR Stage37. Event management: MF Productions. Program design: Kyle Goen. Special thanks to A Practice for Everyday Life; Ayla, Peter, Baker, and Bo at S.I.R.; Gelly Walker.

PERFORMA ADDITIONAL CREDITS
Abbas Akhavan's *Phantom Head* was presented by ArteEast.

Fatima Al Qadiri and Khalid Al Gharaballi's *Going Over* was commissioned by *DIS* magazine and Bidoun Projects. It was presented by ArteEast.

Julieta Aranda and Carlos Motta's "Thank You and Goodbye" was a public discussion with Julieta Aranda and Carlos Motta and guests Naeem Mohaiemen, Adam Kleinman, and Defne Ayas.

Tyler Ashley's *Half Mythical, Half Legendary Americanism* was co-produced with Friends of the High Line. Directed by Tyler Ashley. Choreography by Tyler Ashley and the SARAHS: Sai-Rah (Tyler Ashley), Syrah (Ethan Baldwin), Sår'a (Hooba Booba), RahSa (Sarah Donnelly), Say...Rah? (Zoe Farmingdale), (Sarah Holcman), Sodah (Benjamin Kimitch), Sore (Cacá Macedo), Srrrrrr (Rakia Seaborn), Share-ah (Kris Seto), Saheera (Ashley Walters), and Salah (Theodor Wilson). Music and sound: Theodor Wilson. Costume design: Alyssa Tang and Sole Salvo, inspired by Varvara Stepanova. Production Manager: Sarah Donnelly. Press Manager: Victoria Michelotti.

Ed Atkins, Haroon Mirza, and James Richards's *An Echo Button* was co-presented by Zabludowicz Collection. Supported by Lisson Gallery, Toshiba, and Times Square Alliance.

Nils Bech, Sergei Tcherepnin, and Bendik Giske's *Look Inside* was presented by Art Since the Summer of '69 and Rhizome. Supported by Royal Norwegian Consulate General in New York.

Juan Betancurth and VJ Demencia (René Juan de la Cruz-Napoli)'s *El Museo Program* was presented by El Museo del Barrio.

Jonathan Burrows and Matteo Fargion's *Cheap Lecture* and *The Cow Piece, The Quiet Dance* and *Speaking Dance,* and *Both Sitting Duet* were presented by Danspace Project. *Both Sitting Duet* featured a translation of *For John Cage* by composer Morton Feldman.

Asli Çavuşoğlu's *Words Dash Against the Façade* was supported by SAHA - Contemporary Art Initiative and Moon and Stars Project of The American Turkish Society.

Spartacus Chetwynd's *The Lion Tamer* was organized by Gary Carrion-Murayari, New Museum Associate Curator.

Youmna Chlala's *X cannot exist without Y* was presented by ArteEast.

Jace Clayton's *The Julius Eastman Memorial Dinner* featured Emily Manzo, Amy Zhang and Sharifa Rhodes-Pitts. A tribute to the life of NYC composer Julius Eastman. Curated by Mark Beasley for Performa Radio.

Club Nutz's (Tyson and Scott Reeder) *Performa HA!* featured Reggie Watts, Dina Seiden, Bedwyr Williams, Lumberob, Hennessey Youngman, Houseband: Title TK and Michael Smith. Curated by Mark Beasley.

Will Cotton's *Cockaigne* was made in collaboration with composer John Zorn and choreographer Charles Askegard.

Melanie Crean and Marie-Claire Picher's *Building Better Speech Performance Workshops* was presented by The Vera List Center for Art and Politics. The workshop was designed with a group of high school girls associated with Turning Point for Women and Families, a Queens-based organization that supports Muslim American families dealing with issues of domestic violence.

Tamar Ettun's *One Thing Leads to Another* was funded by Recess Activities, Inc., Artis, and the Consulate General of Israel. It was organized and presented by Recess. Performers included Danielle Agami, Netta Yerushalmy, Luke Murphy, Yoni Kretzmer, Jaeeun Lee, and Tamar Ettun.
Jack Ferver and Michelle Mola's *Me, Michelle* was presented as part of MAD's inaugural performance series "Risk + Reward."

Rainer Ganahl's *Credit Crunch Meal* featured readers Andrea Geyer, Sharon Hayes, Ashley Hunt, Katya Sander, and David Thorne.

Stewart Home's *Psychedelic Noir* was presented by White Columns and Performa. Featuring invited guest speakers Lynne Tillman, Ken Wark, and Jarett Kobek, plus music by Joe Denardo and Sadie Laska (Growing).

Mika Rottenberg and Jon Kessler's "Artist Talk: Mika Rottenberg and Jon Kessler" was co-presented with Columbia University School of the Arts.

Ben Kinmont and Laurel George's "Ethical considerations in project art practices" was made possible due to the support of Kunstverein NY, the Fales Library, the Faculty at NYU, and Performa 11. Organized by Kunstverein NY for Performa 11.

Milan Knížák's "The Ginger Island Project: Films by Jonas Mekas and Milan Knížák" was part of The Ginger Island Project, which included an exhibition at the Emily Harvey Foundation of work by a group of artists directly or indirectly relating to the Ginger Island trip, a film installation at the Storefront for Art and Architecture, and a sound project by Marina Rosenfeld at a pop-up venue in SoHo/Chinatown.

Hari Kunzru's *99* was performed by Meg Clixby, Dan Fox and Hari Kunzru. Curated by Mark Beasley for Performa Radio.

L'Encyclopédie de la parole's *Chorale* was supported by Cultural Services of the French Embassy. Special thanks to Lili Chopra (FIAF). Four of the key artists in L'Encyclopédie de la parole—artist and playwright Joris Lacoste, curator Grégory Castéra, actress Emmanuelle Lafon, and poet and performer Frédéric Danos—held a two-week workshop in New York City

for the project.

The Malcolm McLaren Award was presented to Ragnar Kjartansson by musician Lou Reed. Special thanks to Claire Bishop, Michael Bracewell, David Campbell /Tanteo, Young Kim, Eric Goode/The Bowery Hotel, Marie Lusa, Greil Marcus, Marc Newson, Karla Otto, Lou Reed, Jay Sanders, Emily Thompson, and Michael Wadsworth. Award design and creation: Marc Newson. Program design: Marie Lusa. Media production: Final Cut NY, Michael Wadsworth, Viet-An Nguyen. Floral artistry: Emily Thompson Flowers.

Antonio Manuel's "A Discussion with the Artist and Screening of his short films *Arte Hoje, Semi Ótica*" was held with Claudia Calirman and Gabriela Rangel, curators of his first solo exhibition in the U.S., "Antonio Manuel: I Want to Act, Not Represent!," which was concurrently on view at the Americas Society.

Ursula Mayer's *Gonda* was presented by the International Studio & Curatorial Program (ISCP). Supported by Brooklyn Arts Council, Bundesministerium für Unterricht, Kunst und Kultur (bm:ukk), Center548, The Greenwich Collection, National Endowment for the Arts, and New York City Department of Cultural Affairs. The film *Gonda* was commissioned by FLAMIN Film London Artists' Moving Image Network. Starring transgender model Valentijn de Hingh. Score: Charlie Looker and Caley Monahon-Ward, both members of the band Extra Life.

Dennis McNulty's *The Eyes of Ayn Rand* was supported by Imagine Ireland. Cast: Jenn Dees and Benjamin Holbrook. Production Assistant: Diana Matuszak.

Andrei Monastyrski's *Empty Zones* was presented by e-flux as part of the exhibition "Out of town: Andrei Monastyrski & Collective Actions." Videos from *Podjachev's Youtube channel* (2010–2011) were shown at e-flux in New York in conjunction with Performa 11.

Laurent Montaron's *The Invisible Message* was supported by Etant Donnés

Contemporary Art and the Cultural Services of the French Embassy. Shelly Nadashi's *Refrigerating Apparatus* was supported by Artis – Contemporary Israeli Art Fund and Office of Cultural Affairs, Consulate General of Israel in New York.

Performa Radio was curated by Mark Beasley and Dan Fox. Thanks to Erin McReady and the Brooklyn Youth Company.

"RoseLee Goldberg in Conversation with Shirin Neshat and Wangechi Mutu" was a conversation between Performa Founding Director and Curator RoseLee Goldberg, Performa 09 Commission artist Wangechi Mutu, and Performa 11 Commission artist Shirin Neshat. The event was in celebration of the publication of *Performa 09: Back to Futurism* and was hosted by the New York Public Library.

Dennis Oppenheim's *Proposed Curriculum on Contemporary Art and Performance: Dennis Oppenheim and the Art of Survival* included Interim Principle Amy Plumb, Substitute teacher Aaron Levy, Guest Instructors Les Levine, Bill Beckley, Roger Welch, and Steve Poser, and Commentator Tom McEvilley. Presented by the Dennis Oppenheim Estate and Slought Foundation, Philadelphia. Dennis Oppenheim's *Compression Fern* (1970) screening and action featured Maja Rajenovich.

Michael Portnoy's "Artist Class: Permutation Riff Tank" was supported by IBID Projects.

Public Movement's *Positions* was made possible with support from The Ostrovsky Family Fund. Travel made possible through the Office of Cultural Affairs, Consulate General of Israel in New York. Co-presented by the New Museum and Artis Contemporary Israeli Art Fund. Public Movement was founded in 2006 by group leaders Dana Yahalomi and Omer Krieger.

Lili Reynaud-Dewar's *Interpretation* was a Calder Foundation Project. Kindly supported by Galerie Kamel Mennour, Paris and Mary Mary, Glasgow. The performance featured

iconic Glaswegian club performer Mary Knox and Parisian experimental musician Hendrik Hegray.

Athi-Patra Ruga's *Ilulwane* was co-presented and co-produced with the Museum for African Art. Supported by Whatiftheworld / Gallery. The New Canaan YMCA Aquianas: Emma Baranski, Renee Collett, Amelia Clark, Kate Dalia, Natalia Londono, Alexandra (Alie) Lin, Selena Liu, Isabella Montgomery, and Emily Rooney. Head Coach: Jen Muzyk. Coach: Jayme Delancy. Sound: Spoek Mathambo. Photo/video: Kope | Figgens. Lighting: Seth Kirby and Brock Monroe. Crew: Brendan Hendry, Rigging Technician; Juliana M. Statius Muller, Rigging Technician; Omercan Sakarand, Rigging Technician; Charles Moses, Audio Engineer; and Art Williams, Audio Engineer.

Michael Smith, Doug Skinner, and Eric Bogosian's *Not Funny: Crossing Over* was part of the film series "Not Funny: Stand-Up Comedy and Visual Artists." Special thanks to Josh Kline (EAI), Jed Rapfogel (Anthology Film Archives), Doug Skinner, Michael Smith, and John Migliore (The Kitchen).

Eric Steen's *Brew Pub* was supported by Brooklyn Homebrew.

Christine Sun Kim and Lukas Geronimas's *Feedback* was an inaugural performance of a six-event series, organized and presented by Recess.

Wu Tsang's *Full Body Quotation* featured DJ Total Freedom.

Masha Tupitsyn's *Times for Nothing* was performed by Claire Lebowitz.

Nicoline van Harskamp's *Any Other Business—A Scripted Conference, Video Installation* was supported by the Mondriaan Foundation.

Raphaël Zarka's *Free Ride* was supported by Etant Donnés Contemporary Art and Cultural Services of the French Embassy/Maison Francaise and Institut Francais.

Book Contributors

RoseLee Goldberg

Yulia Aksenova
Cecilia Alemani
Marc Arthur
Nana Asfour
Defne Ayas
Yona Backer
Sarina Basta
Mark Beasley
Betina Bethlem
Claire Bishop
Andrew Blackley
Michael Bracewell
Victoria Brooks
Ingrid Chu
Kari Conte
Dean Daderko
Adrienne Edwards
Dana Elmquist
Stacy Engman
Courtenay Finn
Dan Fox
James Franco
Lia Gangitano
Andrea Geyer
Savannah Gorton
Agnieszka Gratza
Kathy Grayson
Boris Groys
Claude Grunitzky
Sharon Hayes
Andrea Hill
Jens Hoffmann

David Everitt Howe
Ashley Hunt
Judy Hussie-Taylor
Scott Indrisek
Gianni Jetzer
Alhena Katsof
Dmitry Komis
Liz Magic Laser
Susie Lim
Greil Marcus
Hanne Mugaas
Risa Needleman
Esa Nickle
Dougal Phillips
Jennifer Piejko
Liutaurus Psibilskis
Serena Qiu
Jerry Saltz
Katya Sander
Amanda Schmitt
Yoko Shioya
Katie Sonnenborn
Stephanie Spahr LaFroscia
David Thorne
Sarah Thornton
Ivan Vartanian
Alex Waterman
Allison Weisberg
Tom Williams
Sue Williamson
Lana Wilson
Martha Wilson
Jake Yuzna

Index

21 Club, 258–259

33 Fragments of Russian Performance, 264–271

55 Central West, 258–259

A

Abrons Arts Center, 54–65, 92–97, 114–121, 130–135

ACTION ACTUAL: The (S) Files 2011, 304

Akhaven, Abbas, 351

Aksenova, Yulia, 264–271, 276–277

al Gharaballi, Khalid, 351

Al Qadiri, Fatima, 351

Alemani, Cecilia, 220–221

Anthology Film Archives, 305, 334

Antin, Eleanor, 320

Aperture Foundation, 287

Aranda, Julieta, 352–353

Aranda-Alvarado, Rocío, 304

Archangel, Cory, 309

Art in General, 186, 331

Arthur, Marc, 278–279, 286, 288–289

Asfour, Nana, 108–113

Ashley, Robert, 190–205

Ashley, Tyler, 240–241

Asphalt Green, 248–249

Atkins, Ed, 206–209

Atoui, Tarek, 108–113

Austrian Cultural Forum, 292

Ayas, Defne, 146–151, 214–215, 258–259, 346–353

B

Backer, Yona, 174–177

Bag, Alex, 321

Bajo, Elena, 295

Baldessari, John, 320

Basta, Sarina, 298–303

Bauer, Eleanor, 156, 168–173

Beasley, Mark, 118–129, 190–195, 200–203, 222, 308–315, 322, 326–339, 343

Bech, Nils, 227

Ben-Tor, Tamy, 321

Bermúdez, Juanita, 304

Betancurth, Juan, 304

Bethlem, Betina, 282–283

Bibbe Hansen on Al Hansen, 339

Big Screen Plaza, 338

Bishop, Claire, 58–61, 154–161, 371

Blackley, Andrew, 339

Bogosian, Eric, 320

Bond, MX. Justin Vivian, 228

Bortolami Gallery, 323

The Bowery Hotel, 362–367

Bracewell, Michael, 366–367

Braunohler, Kurt, 319, 321

Breitwieser, Sabine, 216–219

Broken English, 352–353

Brooklyn Youth Company, 224–225

Brooks, Albert, 318, 321

Brooks, Victoria, 223

brown, iona rozeal, 98–107

Bryne, Gerard, 114–117

Burrows, Jonathan, 178–179

Bwoy, Skerrit, 118–129

C

Calder Foundation, 223

Carlin, George, 318

Carrion-Murayari, Gary, 288–289

Çavuşoğlu, Aslı, 258–259

Cedar Lake, 66–69

Center548, 290–291

Charmatz, Boris, 154–167

Chen, Howie, 309

Chessa, Luciano, 342

Chetwynd, Spartacus, 288–289

Childs, Layla, 186

Chlala, Youmna, 351

Chodzko, Adam, 340–341

Chu, Ingrid, 333

Clayton, Jace, 225

Clemente Soto Vélez Cultural & Educational Center, 342–343

Cleopatra's Needle, 258–259

Clixby, Meg, 225

Club Nutz, 308–309

Cohen, Sacha Baron, 318, 321

Conte, Kari, 290–291

Cotton, Will, 284–285

Crean, Melanie, 378

de la Cruz-Napoli, René Juan (VJ Demencia), 304

D

Daderko, Dean, 294

Danspace Project, 178–179

Dennis Oppenheim: PROPOSED CURRICULUM ON CONTEMPORARY ART AND PERFORMANCE, 354–359

Dodd, Lucy, 343

Dodge, Harry, 319, 321

Dore, Jon, 319, 321

Dragset, Ingar, 34–38

Duffy Square, 242–245

E

e-flux, 272–275

Edwards, Adrienne, 98–107, 174–177

Elmgreen, Michael, 38–43

Elmgreen & Dragset, 28–43

Elmquist, Dana, 248–249

Elms, Anthony, 326–339

The Emily Harvey Foundation, 328–329

L'Encyclopédie de la parole, 212–213

Engman, Stacy, 284–285

Ettun, Tamar, 256

F

Fargion, Matteo, 178–179

Ferver, Jack, 187

55 Central West, 258–259

Finn, Courtenay, 186, 305, 331

Fluxus & Otherwise: A Concert in Triangle, 342–343

Fluxus Shop, 340–341

Fluxus Weekend, 326–327

Fombella, Trinidad, 304

Forever & Today, Inc., 332–333

Fox, Dan, 225, 322

Franco, James, 130–135

Fuentes, Elvis, 304

Fujiwara, Simon, 92–97

G

Galifianakis, Zach, 319, 321
Ganahl, Rainer, 335
Gangitano, Lia, 228
Geronimas, Lukas, 257
Geyer, Andrea, 216–219
Gillick, Liam, 351, 353
The Ginger Island Project, 328–329
Giske, Bendik, 227
Glynn, Liz, 242–245
Goldberg, RoseLee, 13–17, 20–25,
 34–43, 55, 66–77
Golden Gallery, Inc., 339
Gorton, Savannah, 333
Grayson, Kathy, 229
Greene Naftali, 227
The Greene Space, WNYC, 224–225,
 322
Groys, Boris, 272–275
Grullón, Alicia, 304
Grunitzky, Claude, 292
Gypsy Joe, 304

H

Ha! Comedy Club, 308–309
Hansen, Al, 339
Hansen, Bibbe, 339
Haribos, 343
Harrell, Trajal, 174–177
Harrison, Anya, 264–271, 276–277
Hayes, Sharon, 216–219
Hearst Tower, 258–259
Hegray, Hendrik, 223
Heidecker, Tim (of Tim & Eric),
 319, 321
Helguera, Pablo, 226
Higgins, Jessica, 333
The High Line, 240–241
Hill, Andrea, 282–283
Hochmuth, Martina, 154–161
Hoffman, Jens, 92–97
The Hole, 229
Home, Stewart, 222
House of Ninja, 98–107
Howe, David Everitt, 293
Hunt, Ashley, 216–219
Hussie-Taylor, Judy, 178–179

I

Indrisek, Scott, 142–145
Invisible-Exports, 336–337
Isa, 298–299

J

Jack Hanley Gallery, 335
Japan Society, 210–211
Jetzer, Gianni, 180–183
Joo, Eungie, 261
Joyce Soho, 180–183

K

Kahn, Stanya, 319, 321
Katsof, Alhena, 294
Kaufman, Andy, 318–319
Kelley, Mike, 321
Kessler, Jon, 78–91
Kidd Yellin, 256
Kinmont, Ben, 298–303
The Kitchen, 190–195
Kjartansson, Ragnar, 54–65, 362–363
Knížák, Milan, 328–329
Knowles, Alison, 333
Knox, Mary, 223
Komis, Dmitry, 323
Kunzru, Hari, 225
Kuzkin, Andrei, 276–277

L

Lary 7, 343
Laser, Liz Magic, 44–53
Lawler, Jerry, 319
Leo Koenig, Inc., 294
Licht, Alan, 309
Lighthouse Park, 242–245
Lim, Susie, 338
Linzy, Kalup, 321
Location One, 226
Luhring Augustine, 330
Lumberob, 308–309

M

Maciunas, George, 328–329
Maddin, Guy, 136–145
The Magnanimous Cuckold, 278–279
The Malcolm McLaren Award,
 362–363
Mann, Chris, 343

Manuel, Antonio, 350
Manzo, Emily, 224–225
Marclay, Christian, 210–211
Marcus, Greil, 365–366
Marinetti, F. T., 258–259
Marlborough Chelsea, 282–283
Mattos, Ignacio, 298–299
Maughan, Cynthia, 318
Mayer, Ursula, 290–291
McCarthy, Tom, 225
McNulty, Dennis, 230–231
Meese, Jonathan, 323
Mekas, Jonas, 334
Mellors, Nathaniel, 224–225, 322
Mirza, Haroon, 206–209
Mola, Michelle, 187
Monastryrski, Andrei, 272–275
Montaron, Laurent, 260
Morazán, Irwin, 304
Moriyama, Daidō, 287
Motta, Carlos, 352–353
MPA, 294
Mugaas, Hanne, 227
El Museo del Barrio, 304
Museum of Arts and Design, 187
The Museum of Modern Art,
 216–219
Museum of the Moving Image,
 146–151
Musson, Jayson, 309–315

N

Nadashi, Shelly, 184–185
Nakadate, Laurel, 130–135
Needleman, Risa, 336–337
Neshat, Shirin, 66–77
New Museum of Contemporary Art,
 227, 286, 288–289
New York Live Arts, 168–173
Newsome, Rashaad, 282–283
Nickle, Esa, 296–297, 326–339
Nicole Klagsbrun Project Space,
 78–80
Nipper, Kelly, 340–341
Not Funny, 316–321

O

The Obelisk, 258–259
O'Daniel, Alison, 305

The Old School, 264–271
One New York Plaza, 242
Oppenheim, Dennis, 354–359
Otomo, Yoshihide, 210–211
Ozkaya, Serken, 350

P
Paik, Nam June, 338
PARTICIPANT, INC., 228
Performa Hub, 154–161, 184–185,
 212–215, 246–247, 264–271, 276–
 277, 296–297, 340–341, 346–359
The Performa Institute, 346–351
Performa Radio, 224–225
Performania, 371
Perret, Mai-Thu, 180–183
Petschnig, Maria, 292
Phillips, Dougal, 114–117, 184–185,
 234–247, 260
Picher, Marie-Claire, 378
Piejko, Jennifer, 222, 330, 334–335,
 340–341, 343
Portnoy, Michael, 340–341
Prince George Ballroom, 284–285
Pryor, Richard, 319
Psibilskis, Liutauras, 326–339
Public Movement, 261

R
Recess Activities, Inc., 256–257
Red Egg, 328–329
The Red Party, 20–25
Reeder, Scott, 308–309
Reeder, Tyson, 308–309
Revolution, Amapola Prada, 294
Reynaud-Dewar, Lili, 223
Rhodes-Pitts, Sharifa, 225
Richards, James, 206–209
Robbins, Sonya, 186
robbinschilds, 186
Roosevelt Island, 242–245, 280
Rosler, Martha, 320
Rottenberg, Mika, 78–91
Ruga, Athi-Patra, 248–255

S
Saatchi & Saatchi, 220–221
Saltz, Jerry, 62–65
Sánchez, Rafael, 304

Sander, Katya, 216–219
Scaramouche, 293, 295
Schaal, Kristen, 319, 321
Schmitt, Amanda, 229
Scovel, Rory, 319, 321
Seiden, Dina, 308–309
Selman, Clara, 333
Selman, Joshua, 333
Serena, Qiu, 282–283
Sgualdini, Silvia, 206–209
Shioya, Yoko, 210–211
SIR Stage37, 20–25, 108–113
Skinner, Doug, 320
Skirball Center for the Performing
 Arts, 28–33
Skylight West, 98–107
Smith, Michael, 308, 310–315, 318,
 320
Socrates Sculpture Park, 260
Sonnenborn, Katie, 78–91
Spahr LaFroscia, Stephanie, 304
St. Patrick's Youth Center, 230–231
Stadler, Andreas, 292
Stark, Frances, 118–129
Steen, Eric, 296–297
Stone, Matthew, 229
Storefront for Art and Architecture,
 328–329
Studio 231 at New Museum,
 288–289
Sun Kim, Christine, 257
The SVA Theater, 44–50
Sweeney, Spencer, 309

T
Tanis, David, 298–299
Tannatt, Mateo, 220–221
Tcherepnin, Sergei, 227
There Is No Such Place:
 Constructivist Utopia Now,
 234–239
Third Streaming, 174–177
33 Fragments of Russian
 Performance, 264–271
Thorne, David, 216–219
Thornton, Sarah, 28–33
Throwell, Zefrey, 331
Tim & Eric, 319, 321
Times Square, 242–245

Tsang, Wu, 286
Tupitsyn, Masha, 225
21 Club, 258–259

U
Union Square South, 261

V
van der Werve, Guido, 330
van Harskamp, Nicoline, 214–215
VanDyke, Jonathan, 293
Varispeed, 204–205
Vartanian, Ivan, 287
Vidokle, Anton, 351, 353
Vitale, Marianne, 224–225, 340–341
VJ Demencia, 304
von Zweck, Philip, 336–337

W
Walter Reade Theater, 136–141
Wareheim, Eric (of Tim & Eric),
 319, 321
Washington Square Park, 261
Waterman, Alex, 196–199
Watts, Reggie, 308–309, 319, 321
Wegman, William, 318, 320
Weisberg, Allison, 256–257
Westway, 222
White, Kathleen, 304
Williams, Bedwyr, 308–309, 340–341
Williams, Tom, 44–50
Williamson, Sue, 250–255
Wilson, Lana, 136–141, 154–173,
 212–213, 261, 316–321, 326–339
Wilson, Martha, 226
Wong, Ming, 146–151

X
XXX Macarena, 343

Y
Youngman, Hennessey, 309
Yuzna, Jake, 187

Z
Zabludowicz Collection, 206–209
Zarka, Raphaël, 246–247
Zhang, Amy, 224–225

Acknowledgements

Performa books are written as a record of three action-packed weeks of performances, panel discussions, seminars, exhibitions, concerts, and outdoor parades and spectacles, as recall for those who attended, inspiration for those who did not, and for art historians thirty years from now, who will want to understand a particular cultural moment from the past. It is with such an understanding of these many functions that contributors to the book—artists, critics, curators, writers, and photographers—bend to the task of capturing history and the creative process. For their insights and sensitivities, I thank them profoundly.

To the Performa team, led by our multitalented Producing Director Esa Nickle; Performa Curators Defne Ayas, Mark Beasley, Dougal Philips, and Lana Wilson; producer Mike Skinner, and the more than twenty-five Consortium members and their curators, including Yulia Aksenova, Cecilia Alemani, Anne Barlow, Sergio Bessa, Judy Hussie-Taylor, Boris Groys, Gianni Jetzer, and Lia Gangitano. Gratitude for their vision, intellectual camaraderie, and collaborative spirit cannot be summarized here; suffice to say that each member of the Consortium is essential to the ongoing success of the entire Performa enterprise and the biennial that emerges, following two years of close-knit conversations and research.

Paula Court for her photographs; Pierce Jackson for directing Performa TV; A Practice for Everyday Life for their graphic design; the Performa Board, led by chair Jeanne Greenberg Rohatyn and Honorary Chair Toby Devan Lewis, for their unstinting generosity and leadership, my heartfelt thanks. For my family, Dakota, Zoe and Pierce Jackson, my thanks are beyond measure.

For the Performa book itself, this document, these pages, I thank five people whose diligence and dedication produced it: Jennifer Piejko, lead editor, who picked up the baton when Lana Wilson took leave to direct a prize-winning documentary film of her own; Marc Arthur, Head of Performa Research and Archives, whose assistance with all aspects of the book and intimate knowledge of the projects made him an essential sounding board; Stacy Wakefield, book designer, who makes each page sing and tell a story, and my invaluable assistant Job Piston, whose persistent energy and grace kept everyone in sync.

—RoseLee Goldberg